PORTRAITS IN THE
MASSACHUSETTS
HISTORICAL SOCIETY

PORTRAITS

in the Massachusetts Historical Society

An Illustrated Catalog with Descriptive Matter by

ANDREW OLIVER (1906–1981)

ANN MILLSPAUGH HUFF

EDWARD W. HANSON

PUBLISHED BY THE SOCIETY

Distributed by Northeastern University Press

BOSTON · 1988

A BICENTENNIAL PUBLICATION OF THE
MASSACHUSETTS HISTORICAL SOCIETY

This project is supported by grants from the
National Endowment for the Arts
and the
Charles E. Culpeper Foundation

LIBRARY OF CONGRESS CATALOGING-IN-PUBLICATION DATA

Massachusetts Historical Society.
 Portraits in the Massachusetts Historical Society.
 Bibliography: p.
 Includes index.
 1. United States—Biography—Portraits—Catalogs.
2. United States—Biography. 3. Massachusetts—
Biography—Portraits—Catalogs. 4. Massachusetts—
Biography. 5. Massachusetts Historical Society—
Catalogs. 6. Portraits, American—Massachusetts—
Boston—Catalogs. I. Oliver, Andrew, 1906–1981.
II. Huff, Ann Millspaugh. III. Hanson, Edward W.
(Edward William), 1951– . IV. Title.
CT217.5.M37 1988 920'.0744 88–2936
ISBN 0–934909–26–1

 Printed in the United States of America by
 Meriden-Stinehour Press, Lunenburg, Vermont

CONTENTS

COLOR PLATES

FOREWORD

THE COLLECTION OF PORTRAITS documented here in their entirety for the first time provides a vivid index of the cultural identity and aspirations respectively of Boston, Massachusetts, and America. Aside from including images of some of our nation's most famous figures by many of our greatest artists, this group of often stern and worthy faces tells much about Boston's role as a first seat of learning and culture in the New World. Additionally, their lives and circumstances illuminate the powerful political traditions shaped by Massachusetts minds but extended to the other colonies and ultimately to the republic at large. More broadly, these collective presences inform us about our early and ongoing sense of confidence, ambition, self-reliance, and individual achievement.

Portraiture, it might be argued, was America's first art. In the hardships of settlement and survival for the early colonists, art for its own sake was a superfluity, though decorative impulses found expression in well-designed and crafted utensils, furniture, and occasional architectural embellishments. Rare landscape scenes or floral motifs do survive from before the 18th century, for example in painted overmantels and firescreens, but in general aesthetics were subsumed in the utilitarian. Portraiture, however, both as genre and profession emerged as a fundamentally American expression for two key reasons: it was democratic and it was practical. Portraits celebrated the famous and the anonymous, the wealthy and the humble alike. During the centuries of discovery, settlement, independence, and growth as a young nation, American history unfolded around the ideas, exclamations, and deeds of individuals. At the same time portraits served the very functional purpose of recording likenesses for posterity; as such, their directness and usefulness embodied a characteristic national need.

There is another trait which seems to emerge as we survey the accumulated holdings of the Massachusetts Historical Society, a sturdy New England sense of accomplishment. In some instances it is an imagery of social or professional standing, as in the portraits of John Singleton Copley; in other cases it is the evidence of sheer human endurance, as exemplified in the early landmark likeness of Anne Pollard, 1721. Believed to have been painted on the occasion of her 100th birthday, it commemorates personal strength and historical continuity. Said to have been one of the first settlers in the Bay Colony under Governor Winthrop, Pollard was both a tie with the past and assurance for the future. Her straightforward posture, rugged features, and stark

coloring convey spiritual and physical force. In such a face we see the firmness equally of Puritan piety and New England rock.

We find a comparable strength of character showing in another well-known portrait in the Society's collection, that of Lemuel Shaw, Massachusetts chief justice for three decades during the mid-19th century, painted by William Morris Hunt. Here is an instance where the powers of a great artist were matched with an equally commanding sitter. Elsewhere, as might be expected in a collection gathered as much for historical as for artistic reasons, the distinction of work varies. But throughout there are pleasures and instruction to be found. Not least, these holdings give us images of Boston's great names: the Adamses, Winthrops, Dudleys, Faneuils, Hutchinsons, Paines, Lorings, and Quincys. Present are the faces of important artistic figures—Washington Allston, George Berkeley, Joshua Johnson, and e.e. cummings—and towering political or historical personalities—Edward Everett, Daniel Boone, John Hancock, and Daniel Webster. The latter group is occasionally represented by several portraits, as in the case of George Washington. Frequently, interesting comparisons are possible, as with the oil and crayon renderings of Everett, or the images of John Temple respectively done in oil by Gilbert Stuart after John Trumbull and in pastel by James Sharples.

As a resource, the collection also boasts examples by most of the major artists in the history of American portraiture. Representing the precedent of the English tradition imported to the New England colonies is the portrait of William Hayley attributed to Sir Godfrey Kneller. Kneller's bust formats were known through originals, copies, and engravings, and the influence of his style extended into the work of many early colonial painters. Among the important figures included here are John Smibert, Joseph Blackburn, and Joseph Badger from the early 18th century; John Singleton Copley and John Trumbull in the latter half of the century; Gilbert Stuart and Chester Harding in the early 19th century; G. P. A. Healy, Ralph Earl, and William Matthew Prior at mid-century; and from the later 19th century William Morris Hunt, William Page, Lilla Cabot Perry, and John Singer Sargent.

Additionally interesting are those portraits by painters better known for their work in other subjects, for example, Henry Sargent, painter of conversation pieces; William H. Beard, illustrator of anecdotal animal scenes; and Henry Cheever Pratt, landscapist. Some works call attention to little known names worthy of more attention, such as John Rubens Smith's watercolor of L. M. Walter. As both a very competent draftsman and telling delineator of individual posture and features, Smith emerges as one of the more interesting graphic portraitists from the first half of the 19th century. It is just this variety of medium, talent, and subject that makes the Massachusetts Historical Society's collection at once appealing and important.

In the late Andrew Oliver, whose work Ann Millspaugh Huff and Edward W. Hanson completed after his death, the perfect match of author and project was found. Himself the direct descendant of the first New England Olivers painted by John Smibert and Joseph Blackburn, he was fully informed about genealogy, colonial American

history, art, and biography. As a lawyer, churchman, scholar, bookman, and collector, Andrew Oliver embraced most of the professions represented in the array of portraits he researched. In some 20 years of prolific scholarship he investigated systematically and comprehensively the lives of his own forebears and the portraits of celebrated American families. To him biography was as fascinating as art, the sitter and the painter equally worth documenting. His work on this portrait collection was a natural culmination of previous research, published in virtually definitive essays or books on John and Abigail Adams, John Quincy Adams, Samuel Curwen, John Smibert, John Marshall, and Auguste Edouart. The result is a volume that evidences, as soon as one turns these pages, a labor of love no less than intelligence.

JOHN WILMERDING
Deputy Director
National Gallery of Art

PREFACE

ANDREW OLIVER (1906–1981) first perceived the need for a new and complete portrait catalogue to describe the important collection of the Massachusetts Historical Society as he became acquainted with its character many years ago. An authority on early American portraiture and a long-time member of the Society, he began work on the present volume in 1977 and had written initial descriptions of much of the collection before his untimely death. Although he may not have envisioned a volume of such encyclopedic scope, I am certain he would have approved the additions and inclusions suggested and made by the latest editor and third co-author. The Society is fortunate to have Edward W. Hanson, a tireless and precise researcher, as its associate editor. For a number of years, I have been responsible for the documentation and care of the portraits at the Society. My involvement in the catalogue project began at its inception and continued through its evolution. It is a great satisfaction to see it in print.

As the "sandwich" author, it is my pleasure to single out those who merit praise and thanks for contributions to the catalogue. I begin with Ross Urquhart, the Society's graphic arts specialist, who helped with the technical information in each entry and the selection of illustrations. Marjorie F. Gutheim, former associate editor of the Society, gave particular help on the portraits associated with the Winthrop family and made useful comments on many of the other portraits. Dr. Ella M. Foshay, curator of painting and sculpture at the New-York Historical Society, provided an art historian's perspective on the catalogue at an early stage of compilation. The overview given in the Foreword by John Wilmerding of the National Gallery of Art underscores the importance of this collection. I am indebted to Malcolm Freiberg for his wise counsel to me over the years.

The Society also owns fine collections of miniatures, silhouettes, daguerreotypes, and sculpture. These could all have been included quite properly in this catalogue, but they have been deliberately omitted here and will be used as subjects for future publications. Also omitted from this catalogue are any portraits on deposit, regardless of the duration of such a deposit. The Copley copy of Rev. John Rogers's portrait, for example, has been at the Society since 1854, but is still formally a deposit and therefore not described here.

Black-and-white and color photograph credits are due to George Cushing, Richard

Cheek, Stephen Kovacik, David Bohl, and the Fogg Art Museum. The Society also acknowledges with thanks the loan and use of the color transparencies made by Helga Studios of the portraits reproduced in the November 1985 issue of *The Magazine Antiques*, specifically those of George Berkeley, Daniel Boone, Samuel Cooper, Mrs. Nathaniel Dowse, Peter Faneuil, Mrs. John Gray, John Hancock, John Joy, Jr., Benjamin Pollard, and the Gullager portrait of George Washington.

Without generous donations over the course of nearly two centuries from many members and friends of the Society, this collection of portraits could not have been built, and we are grateful to all those mentioned individually in the provenance notes. Without the more recent support of the National Endowment for the Arts, the Charles E. Culpeper Foundation, and David R. Godine this catalogue would not have been published, and we are also grateful for their support.

Finally, three editors are to be commended: Mary Beth LaDow, a former associate editor at the Society, for her careful checking and preliminary editing; and Conrad Edick Wright, editor of publications, and Edward W. Hanson have shown patience, consideration, and occasional editorial latitude. For example, the names of female sitters, are written my way, not theirs. Together we hope we have shaped a worthy and useful reference guide.

ANN MILLSPAUGH HUFF

INTRODUCTION

PORTRAITS were not among the desiderata of the Massachusetts Historical Society at its founding in 1791. Its stated aims then were to collect, preserve, and communicate materials — primarily books, pamphlets, manuscripts, and records — for a history of the United States. Similarly, there was no allusion to portraits in the Society's 1792, 1794, and 1813 circular letters, which publicly solicited materials for its holdings. Not until 1838 did it mention portraits as a desirable field of collecting. Yet the organization which outwardly ignored portraits for so long had been collecting them almost from the beginning. "Let us not condemn the Bostonians," the French visitor J. P. Brissot de Warville had written in 1788; "they think of the useful before acquiring the agreeable."

That streak of utilitarianism found expression in the Massachusetts Historical Society, then as now a private organization exercising public functions. Its first circular letter promised access under reasonable conditions to *Any person* wanting to use its materials. Its second promised to "plant a forest, into which every inquirer may enter at his pleasure, and find something adapted to his purpose." At incorporation in 1794, the organization, first of its kind in the United States, indicated its purposes to be "of publick utility."

The process of portrait collecting that began early has continued to this day. The collection—a "national treasure," one observer has described it—now numbers over 300 items, the majority oils on canvas acquired mostly by gift from donors willing, among other reasons, to allow their holdings to go on display in a private institution with avowed public functions. The sources and sociology of such giving appear more fully in the entries that follow.

The book in your hands is the fourth catalogue of the Society's portrait collection and the first to carry illustrations and entries, alphabetically arranged by sitter, that meet current canons of description. It supersedes compilations appearing in 1838, 1885, and 1949 that are now out of date but still of use in documenting the growth of the collection.

It is a collection that contains examples of likenesses by artists notable in the history of American art—Blackburn, Blyth, Copley, Harding, Smibert, and Stuart, to name but a few—and of subjects significant in the history of American life—Daniel Boone, Peter Faneuil, Thomas Hutchinson, the Marquis de Lafayette, Increase Mather, Samuel

Sewall, George Washington, and Daniel Webster, for example. The Society is well-known for its superb holdings of American manuscripts and rare books and a strong supporting library of printed materials. Its portrait holdings, now comfortably housed at its 1154 Boylston Street headquarters in Boston, are less well-known. This volume attempts to remedy that condition.

PORTRAIT COLLECTING began early, and its growth never faltered. The first donation came in 1792 and consisted of "twelve pictures, heads of ancient philosophers, poets, orators, &c." Early in 1793 came the gift of a copper medal of "Mr. Pitt" and, late in 1793, of an engraving of Johan Jakob Ankerstroom, the Swedish nobleman who had assassinated Gustavus III in 1792 and whose act of regicide Giuseppe Verdi immortalized in his opera entitled *A Masked Ball*. The first oil on canvas came in October 1796: it was of Thomas Hutchinson, historian of Massachusetts, its governor before the American Revolution, and a refugee in England during it. An unnamed donor gave the unsigned likeness in exchange for "some of the shells belonging to the Society," which then and for a few decades later collected specimens of natural history for its cabinet, so-called, the repository also of its portrait collection. By 1796, then, the Society was embarked on its unannounced role as collector and repository of portrait likenesses.

In 1838 the first printed account of the Massachusetts Historical Society appeared in a Boston periodical. Later that year the Society reprinted it in its *Collections*, accompanying it there with a "List of Portraits in the Hall of the Historical Society," a tally that constituted the first catalogue of the Society's portrait holdings. The list indicated that 44 of its "principal" portraits hung in the "much visited" hall of its Tremont Street building, apparently arranged there in seven categories: discoverers (4 likenesses); the Winslow family (7); governors and lieutenant governors (9); generals (3); distinguished laymen (8); clergymen (11); and aged women (2). The Society had come a long way by 1838, when its historian (who was also one of its members) observed of its portrait collection that "It is very desirable that this department be increased." Soon, it was.

At mid-century the collection of the Massachusetts Historical Society numbered 70 portraits, now hung in one of the rooms, 84' x 40' in size, of its Tremont Street building. (Its other holdings, which in 1838 had numbered some 6,000 items, in 1850 included about 7,000 volumes of books and bound newspapers, 2,000 pamphlets, 300 maps and charts, and 450 volumes of manuscripts.) The library, together with the portrait collection, was open daily from 9 A.M. to 1 P.M. and from 3 to 6 P.M. to Society members and "others pursuing historical investigations."

By 1858 the Society was referring, apparently for the first time, to its "Gallery of Historical Paintings." Into that gallery, two years later, strode Great Britain's visiting Prince of Wales, together with his entourage. Sturdy Society hearts pounded at the regal presence. His Royal Highness glanced at the original manuscript of George

Washington's Newburgh Address of 1783, then "intimated a disposition to possess an autograph of Washington." (To wish was to have. The next morning, the future Edward VII received, from the Society President Robert C. Winthrop's personal collection, not only a Washington autograph but one of Benjamin Franklin as well.) The Prince also "looked at the portraits of the Winslows and Winthrops and Endicott and Saltonstall. He glanced, in passing, . . . at the sample of tea . . . thrown into Boston Harbor; and he paused longer to learn the story" of the crossed swords, the Society's symbols of reborn British-American goodwill. "And lastly, the Prince inscribed his name in our Visitors' Register . . . and called on all his suite to write their names after his own, including the British consul at Boston, and the Mayor of Montreal." Winthrop had charmed a prince, not slain the Jabberwock, and the Society's looking glass was full of reflected glory that day in 1860. If its president in his joy was heard to chortle, "O frabjous day! Callooh! Callay!," who would then have said him nay?

Nay-sayers were apparently few among potential donors, and so the Society's portrait collection continued to grow, despite increasingly inadequate display space and deterioration of treasures already on hand. In 1861, the "most valuable department" of the organization's entire cabinet was the "picture-gallery, comprising portraits of individuals . . . connected with the political and ecclesiastical history of New England" and "containing paintings . . . illustrating . . . the cultivation and progress of art" in America. Midway into the Civil War, the 74 portraits on display "upon the walls of the upper hall and the Librarian's room" took up nearly all available space. Three years later, after noting more portraits donated (among them that of Society founder Jeremy Belknap), its cabinet-keeper warned, "Many of the paintings deserve better places than they now occupy, and others will soon require the attention of a skilful artist to protect them from the further ravages of time." The proper care and feeding of the Society's portrait collection seemed now to be in order.

Such came shortly. On January 1, 1867, philanthropist (and newly elected honorary member) George Peabody wrote President Winthrop that he was donating a $20,000 trust fund to the Society, its income to be used to illustrate Society publications and for the "preservation of their Historical Portraits." (That fund still exists, and its income is still used for the same purposes.) Come 1873, the Society had a new house. It replaced the previous one and was on the same Tremont Street site. The old building had three floors and an attic, of which the organization had occupied all but the ground floor; the new structure had five levels, of which it occupied four. More space for pictorial display was now available.

Or was it? Witness these two entries from the Society's records, written five days apart in April 1873, shortly after it occupied its new home:

Voted, That in the opinion of the Standing Committee the upper room of the Society's Building should be devoted mainly for the accommodation of the pictures and other articles of the Cabinet—and that in their opinion there must be a reduction of the shelving as it now stands.

Decided not to remove the shelving for books in the upper room, but to arrange a covering on which to hang pictures in front of them.

At the start of the next decade, the Society's cabinet-keeper noted that he had hung portraits "upon the walls of the staircase to the Society's rooms," presumably to spare visitors the long trudge upward to the room where the cabinet was kept. "The portraits now exhibited," he reported in June 1880, "included, among others, those of Vespuccius, Sebastian Cabot, John Endicott, Governor Winthrop, Sir Richard Saltonstall, Edward Winslow, Dudley, Hutchinson, Pownall, Washington, and Lafayette."

At approximately the same time, the Society had in preparation a description of the items in its cabinet. The work appeared in 1885 as *A Catalogue of the Paintings, Engravings, Busts, and Miscellaneous Articles, Belonging to the Cabinet of the Massachusetts Historical Society*. Its paintings section, which comprised the second catalogue of the Society's portraits, enumerated 109 items, of which 100 were portraits and 9 were "Miscellaneous Paintings." As in the 1838 catalogue, the portraits were again arranged by occupation, and their sitters were again stratified in death by their economic, social, or political class levels in life. The six categories in 1885 were: governors (18 likenesses); judges (3); clergymen(21); U.S. presidents (6); distinguished statesmen (5); and miscellaneous (47). A century later, it is tempting but unfair to denigrate this catalogue, "the result of long, patient, not to say painful research," with no table of contents, no illustrations, and no index. It has in fact been of much utility to the compilers of the present catalogue.

The Society's portrait collection was never static. In 1890 a committee report noted approvingly that its "PICTURE GALLERY" was now hanging on the topmost floor of the Society's house, again "classified to some extent, bringing those of the same rank and condition together, such as governors, clergymen, and scholars." As some of the pictures were "newly framed and repaired," the gallery now presented an "interesting and attractive appearance." Yet five years later, the same committee reported in some alarm that the prior arrangement meant that the portraits were not now available for easy public viewing and, even worse, were "not even conveniently accessible to members of the Society." By 1899, the Massachusetts Historical Society was installed in another building, its seventh (and present) home in Boston. A former cabinet-keeper soon thereafter reported:

The Museum, Gallery, or Cabinet of the Society contains many objects of value and interest, but it does not receive so many additions as it ought. Much has of late years gone to the Bostonian Society and the Genealogical Society which should have come here; and it has gone to those institutions because, as I think, in comparison with them this building and its contents are an unknown quantity. Our Cabinet-keeper has lately proposed to undertake to be here on two or three days of each week, for the purpose of showing and explaining to all visitors our objects of interest, — a highly honorable aspiration on his part. But I think he could not easily find a surer way of wasting his time, unless his intention were advertised in the daily papers.

Truth to tell, according to a delicious committee report of 1901, the Society had too much, not too little, in its cabinet, and it was difficult to justify retaining items of mere sentimental value or of no historical importance. For the benefit of the curious, the report advised, deposit those items elsewhere. "The Bostonian Society naturally suggests itself as such a place. Its rooms are central, its collections are well housed, and its quarters are thronged by the very people who would be most interested in a lock of hair, the buckle of a shoe, the belt of some general, or similar object of personal use." The Bostonian Society's gain would also be the Historical Society's gain and "permit a better display of the portraits, engravings, and remaining objects" at 1154 Boylston Street.

Twentieth-century problems of display and maintenance proceeded apace with increasing accessions. Midway into World War I, for example, the Society owned some 200 portraits in oils. By war's end, there was no wall space left to display them in a structure not yet two decades old and already inadequate. It became even more so as time went on and the collection increased even more. The Boylston Street building was later described as "something of an architect's triumph of design over vulgar convenience because of its total unsuitability for housing the Society's possessions." It was constantly being cobbled over "in attempt to make it more habitable." Pictures were displayed "wherever the architectural limitations of panelling" permitted. Although not a museum, the Society continued to receive gifts from owners of portraits who donated them willingly but not "with the expectation of having them stowed in an attic." (Ironically, even attic storage space soon came to be at a premium.)

World War II brought temporary relief, when some of the Society's most important portraits were removed from its premises for safekeeping elsewhere and were returned only after the war was over. In the fall of 1949, Society Director Stewart Mitchell mischievously reported on the collection in his keeping:

. . . the portraits and pictures of the Society . . . were all surveyed by experts during the past year, and twelve of them were sent over to the Museum of Fine Arts for cleaning and repair. Some other pictures were given away, a few were sold. Most of the good ones were rehung on the strangely limited wall space of the building, and the third-rate ones were stored in the new racks built for that purpose in the fourth floor tower room of the building. Now old ladies can be shown the images of their ancestors—significant or insignificant—in a matter of a few moments. The beautiful works are visible to any visitor.

Director Mitchell produced the third catalogue of the Society's portraits and paintings. It was embedded in his 1949 *Handbook* of the organization and was an alphabetical listing of 185 sitters, with artists where known, and of 11 scenes. It was incomplete, of idiosyncratic selectivity, and unillustrated.

A measure of the significance of the Society's portrait holdings was that the first of its illustrated *Picture Books*, which recorded annual spring reception exhibitions, was a booklet in 1954 on portraits of women; one on portraits of men followed in

1955. Other *Picture Books* over the ensuing three decades recorded other yearly shows, with virtually every one reproducing portraits from the Society's holdings. The publication by the Society in 1969 of *The Notebook of John Smibert*, from the original manuscript in the Public Record Office, London, was a measure of increasing sophistication in the field of art history. Long the owner of a number of Smiberts, the Society achieved happy success as publisher of a book which curators, collectors, and reviewers uniformly welcomed.

The process of functional cobbling over its building wound down in 1972, when the Society occupied a splendid new addition to the 1899 structure. Now, among other amenities and for the first time in its long history, the institution had proper storage facilities, in a humidity- and temperature-controlled environment, for its works of art. Rotation of paintings on display, primarily portraits, soon followed. Donors began to seek out the Society, knowing that items given could ultimately be displayed. Significant accessions followed and included Darius Cobb's likeness of Senator Charles Sumner, John Smibert's painting of Mrs. Daniel Oliver, and John Greenwood's paired portraits of Captain Patrick Tracy and Hannah (Gookin) Tracy, his wife. In its November 1985 issue, *Antiques* magazine published a handsomely illustrated article on "Paintings in the Massachusetts Historical Society" by Ann Millspaugh Huff and Ross Urquhart. Their article succeeded in calling deserved attention to a national treasure, consisting mainly of portraits, which had come of age.

EN ROUTE to that status, the portrait collection had grown mostly, but not exclusively, by gifts. Occasionally, likenesses arrived on deposit or were acquired by subscription. Sometimes, the Society refused to acquire items offered; at others, it was known to sell an item for cause. And in one famous instance, it passed judgment on some forged portraits.

Perhaps the best-known deposit was a group of seven Winslow family portraits, which the Society accepted "with pleasure" from descendants in 1828. The portrait of Governor Edward Winslow was especially important, being the only known likeness of an early Pilgrim. Over time, the Society proved itself a competent custodian of the collection, and the Winslow family in gratitude was generous with funds to maintain it. Such gratitude extended to 1882, when the family recalled the deposit and turned the portraits over to the Pilgrim Society at Plymouth, "whose hall had lately been made a secure depository for memorials of the Pilgrim Fathers." So ended, amicably, a 54-year-long deposit, but only after the Historical Society had the Edward Winslow likeness copied for its own collection.

An even longer deposit was of the portrait of the 17th-century Boston physician Dr. John Clark, which a descendant deposited in 1833 and which his daughters reclaimed in 1901 for transfer to the Boston Medical Library. No copy was taken, as the portrait was merely moving next door, the Historical Society and the Medical Library then being neighbors. So ended, apparently amicably, a 68-year-long deposit.

(Meanwhile, back at the Society, a trustee moved to request a "By Law for adoption, which shall define the conditions on which articles shall be received on deposit in the Library or Cabinet." The motion was no surprise; its issue remains unknown.) A still longer deposit is the John Singleton Copley copy, from an unknown and unlocated original source, of the 16th-century English martyr, the Rev. John Rogers, which Andrew Eliot deposited in 1854. So continues, quite amicably, a 134-year-long deposit.

Acquisition by subscription was uniformly amicable. In 1806, for example, friends of Benjamin Lincoln commissioned Henry Sargent to paint two portraits of him, one for the Historical Society, the other for Mrs. Lincoln, in grateful recognition of the general's many virtues and public services. The cost was $300 for both portraits; 26 friends oversubscribed $313.40 for them. When in 1844 a John Trumbull likeness from life of the deceased Christopher Gore, diplomat, Massachusetts governor, U.S. senator, and Society president, came up for sale in Boston, 14 individuals promptly subscribed $100 to acquire it for the Society. The Society then authorized a suitable frame for the portrait "provided that the expense does not exceed fifteen dollars."

In the next decade, the Society itself commissioned and paid for the Moses Wight portrait of its benefactor Thomas Dowse, as well as the frame for it, setting no dollar limit on either. The young artist had captured his sitter's cherubic countenance just in time, for Dowse, then almost 85, died shortly after the canvas was completed in 1856. Only Edward Everett's eulogy a few years later soured the sweet melancholy of Thomas Dowse and his portrait:

You, gentlemen of the Historical Society, appreciated the value, you felt the importance, of the gift of this library, and received it as a sacred trust. You have consecrated to it . . . an inner room in your substantial granite building, approached through your own interesting gallery of portraits and . . . historical library. . . . There his benignant countenance—admirably portrayed by the skilful artist, at the request of the Society, in the last weeks of his life—will continue to smile upon the visitor that genial welcome, which, while he lived, ever made the coveted access to his library doubly delightful. There the silent and self-distrusting man . . . will hold converse with studious and thoughtful readers, as long as the ear drinks in the music of the mighty masters of the English tongue,—as long as the mind shall hunger, with an appetite which grows with indulgence, for the intellectual food which never satisfies and never cloys.

As its portrait repository reputation grew in the 20th century, numerous unsolicited offers came the way of the Massachusetts Historical Society. Most were refused. When in 1924 a Mrs. Jones, widow of a Boston merchant, offered a portrait of her late consort, the Society "regretted" that it could not accept it. In 1928 the Society was offered a bequest of $1,000 if it would raise $9,000 more and use the total "for a portrait in oil of Gov. William Bradford of Plymouth Colony." The Society respectfully declined the proposed gift. During the Depression came the offer of a Gilbert Stuart portrait of George Washington for only $60,000. "No action was taken in the matter," reads the laconic entry in the Society's 1934 records. And on one memorable occasion in 1949, the Society was asked to pay for and donate elsewhere a copy of a portrait

it did not even own. This was the Frederic P. Vinton three-quarter length of the historian Francis Parkman, member of both the Society and the St. Botoloph Club in Boston, and owned by the latter organization. The American Historical Association was soliciting on behalf of the Pan American Institute of History in Mexico City, in whose headquarters there it hoped the copy might hang. Such was not to be, as the Society "had no funds for this purpose." Funding was forever a problem. In 1950, for example, the Society's cabinet-keeper reported selling, with permission, "the portrait of the unknown gentleman by an unknown artist, acquired at a time unknown" to a willing (and presumably knowledgeable) purchaser for $100.

More than half a century earlier, one Major James Walter had arrived in Boston from England with three Washington likenesses, two of George and one of Martha, allegedly by James Sharples. Walter had documentation of sorts for them, which he hoped to sell to the United States government. Present "by permission" at the November 1886 Historical Society meeting, Walter "made a statement in regard to them." He did not reckon with Francis Parkman, appointed chairman of a committee to report on the historical value of the paintings. Parkman's masterful report of January 1887, printed in the Society's *Proceedings* and in the Boston dailies, left the Englishman's reputation in shreds.

One item of Walter's documentation, a putative George Washington letter, bore no resemblance to the general's well-known style of composition but bore a "striking resemblance" to Walter's, marked by "frequent and conspicuous solecisms." Further, Walter told the committee when queried, the so-called Washington letter "had been destroyed, at the writer's request, for political reasons." If so, the committee asked, how was Major Walter able to reconstruct it a century later? When the alleged portraits had been displayed in Boston in 1882, Washington's eyes were brown, but in 1886 they were blue, their correct color. Walter could provide no satisfactory explanation for the change. The committee wholly rejected his documentation and with it the authenticity of the portraits he hoped to peddle. His mission a failure, he returned to England in disgrace. Francis Parkman, his committee, and the Massachusetts Historical Society had served scholarship and the nation well.

SERVICE was the key. Over time, it evolved into a liberal copying policy, a generous lending policy, and an awareness of the need to maintain and safeguard the Society's portrait collection.

Almost from the start, the Society permitted copies of its portraits to be made, early on by hand-painting, later by camera. One of the first, if not the first, was in 1829, when permission was granted to copy, for a relative in England, the Thomas Hutchinson portrait, the first oil on canvas received at the Society. A quarter-century later came a request to copy the Benjamin Lincoln portrait at the Society for the Boston customs house, its sitter having been the first customs collector in Boston under the Federal Constitution. Did the Harvard Corporation want a copy of the Society's

Christopher Gore portrait for the use of the college? It did, and permission was forthcoming. Did the Bostonian Society want a copy of the Society's portrait of Governor Jonathan Belcher? It did, and permission was forthcoming. When Kenneth B. Murdock, biographer of Increase Mather and master of Leverett House at Harvard University, requested permission in 1931 to have a copy made of the Society's 1688 van der Spriett portrait of Increase Mather for Leverett House, it was granted "with the understanding that if a copy is made it shall be indelibly marked *copy* on the back of the canvas."

By the latter half of the 20th century, the volume of requests for photographic copies of portraits in the Society had become so large that a policy to regulate the flood came into being: it separated non-profit from commercial requests, charging only costs to the former source, and costs plus use fees to the latter. Income from the latter source continues to be channeled into Society funds that service its portrait collection.

The organization's lending policy was and remains liberal whenever possible. In 1865 the Society of the Cincinnati was granted the loan of the Benjamin Lincoln portrait for display at a Fourth of July dinner. In 1876, four unspecified Historical Society portraits went with other items to the Centennial Exposition at Philadelphia and came back safely enough but without the thanks President Winthrop thought due the Society. At a meeting later in 1876, he "enquired why the Historical Society had been ignored in the recent awards connected with the Centennial. No one could answer the question."

The oversight rankled only temporarily, for the Society continued to be a generous lending source to all manner of institutions—churches, colleges, universities, museums—on all manner of occasions—celebrations, anniversaries, and exhibits—as time went forward. The policy allowed those nearby or at a distance to view some of the Society's treasures without having to trek to Boston. Thus, those at the 1936 Harvard tercentenary exercises in Cambridge could see there Harvard items from the Society's holdings in Boston; and thus the Corcoran Gallery displayed, in a 1937–1938 loan exhibition on 150 years of the U.S. Constitution, the Society's Christian Gullager life portrait of George Washington. That likeness went back to the District of Columbia for the National Portrait Gallery's Gullager show in 1976. A few years after that, the Portrait Gallery showed, in its American portrait drawings exhibition, the Society's drawing of Henry Adams by his nephew John Briggs Potter, the only known likeness from the life of the historian.

Occasionally, museum requests for their blockbuster exhibitions left the Society without some of its portrait likenesses for months at a time. This occurred in 1975, with the loan of the Society materials to the Museum of Fine Arts for its Paul Revere's Boston exhibition, one to which the Society was the largest institutional lender and one whose fulfillment stemmed from its cooperation and that of its then director, Stephen T. Riley. It occurred again in 1976, with the loan of Society materials to the National Gallery for its bicentennial exhibition on Thomas Jefferson. And it occurred

once more in 1982, with the loan of Society materials to the Museum of Fine Arts for its exhibition on 17th-century New England.

A careful preservation policy occasionally dictated refusing loan requests, as in 1892, when Dudley family members wanting to borrow the portraits of Governor Joseph Dudley and his wife for private use were instead invited to come see them at the Society, or as in 1936, when the Society declined to lend its Ninigret portrait, even though only a copy, to a Rhode Island anniversary group that had no fireproof storage or display facilities. The Society's portrait of Anne Pollard went to a world's fair in Belgium in 1958, but it has remained in Boston ever since, her likeness now being too precarious for further travel.

THE SOCIETY has also been home, for a century and a half now, to four portraits—two originals from life and probably two copies—that Thomas Jefferson commissioned and which hung in the parlor at Monticello, his hilltop home on the outskirts of Charlottesville, Virginia. The originals are the Joseph Wright portrait of George Washington at age 52 and the Joseph Boze portrait of the Marquis de Lafayette at age 33. The copies are of Christopher Columbus and possibly that of Amerigo Vespucci. All four, along with many others Jefferson owned, were put up for sale by his family after his death in 1826 and shown at the Boston Athenaeum two years later. Friends purchased the Columbus, Lafayette, and Washington likenesses and gave them to the Society in 1835. Accession data on the Vespucci copy are incomplete; it was, however, listed in the Society's first portrait catalogue and described there as "*A fine old painting.*"

In 1949, the Thomas Jefferson Memorial Foundation, owner and administrator of Monticello, requested from the Massachusetts Historical Society the "permanent loan" of the Washington and Lafayette portraits to Monticello. The Society felt it could not grant the request but indicated a willingness to allow copies to be made at the Foundation's expense. The offer was not acted on then, for a decade later the Foundation asked "for the loan to Monticello of the portraits painted for Thomas Jefferson in the Society's collection." The late Walter Muir Whitehill, a Society officer and Memorial Foundation director, "suggested that this very broad request was made on the theory that there was no harm in asking." While opposed to releasing the Washington and Lafayette portraits, he said he "was prepared to believe that Jefferson's copy of the supposed portrait of Columbus might make more sense in Monticello than on the staircase of 1154 Boylston Street." With building changes in prospect and the Society's president "emphatically in opposition to lending any pictures at present," the Society voted to decline the 1959 request from Charlottesville.

Another decade passes, more building charges are in prospect, and the Massachusetts Historical Society seeks funds to accomplish them. Why not use the Washington and Lafayette originals and the Columbus copy to persuade some philanthropically minded individual to "make a substantial gift to the Society on condition that these

paintings return to their former home" at Monticello? No such philanthropically minded individual appears in 1968, and the paintings remain in Boston.

A decade and a half more now pass. A new Polaroid photographic process, using a room-size camera, is available. Would the Historical Society, the Memorial Foundation asks, allow that process to be employed to copy the four portraits, formerly Jefferson's, such copies to hang in the parlor at Monticello? Yes, the Society is willing to accede to this latest request. And there the trail ends. Somehow, no Polaroid copies are made in 1982 for Monticello, and the four portraits once the property of Thomas Jefferson remain uncopied in their old Boston home.

IN A WAY, the negotiations provide a paradigm and summation of the Massachusetts Historical Society as collector, preserver, and vigilator of a portrait collection grown into a national inheritance over almost two centuries and tell much about the functions of a private organization with public responsibilities. If overlooked for whatever reason when the Society began, portraits as a field of collecting did not remain so for long. The organization that received, commissioned, displayed, catalogued, nurtured, serviced, safeguarded, fretted over, removed, returned, lent out, withheld, published, assessed, and occasionally refused portraits aimed initially at purposes "of publick utility." It still does. Users of this catalogue will determine how well the Society has met those goals.

MALCOLM FREIBERG
Editor of Publications Emeritus

THE PORTRAITS

NOTE ON ORGANIZATION
Entries are arranged alphabetically by sitter. A woman is listed under her husband's name (e.g., Mrs. John Adams) unless her portrait is thought to have been painted before the marriage (e.g., Mary Ann Faneuil). An asterisk (*) denotes an individual whose portrait is also in the collection. Reference titles used more than once are given in short form with full bibliographical data provided in the "Short Title List" at the end of the volume.

Ashur Adams

Born in Canterbury, Connecticut, in 1781, son of Eliashib and Mary (Webb) Adams. Married three times: to Nancy Bissell of Windsor, Connecticut; to her sister, Catherine Bissell; and to Amelia Wyllys.* Lived in Roxbury. President for many years of the Trader's Bank of Boston. Died in West Roxbury in 1860.

ARTIST: James Frothingham, about 1850. In pencil on lower stretcher: "Ashur [A]dams / Painted by [F]rothingham found by Susan."

DESCRIPTION: Oil on canvas, 70.9 x 59.8 cm. Head-and-shoulders view, turned slightly left, eyes front. Black hair, white shirt and tie under black coat.

PROVENANCE: The portrait was inherited by the sitter's daughter, Mrs. Joshua Lawrence Chamberlain (Caroline Adams), of Brunswick, Maine; by her daughter, Mrs. Horace Gwynne Allen (Grace Dupee Chamberlain), of Boston; and by her daughter, Miss Rosamond Allen of Duxbury.
 Gift of Miss Allen, 1974.

REFERENCES: Adams, *Henry Adams*, 539; *Proc.*, 86(1974):121; correspondence of Rosamond Allen, MHS.

Mrs. Ashur Adams
(Amelia Wyllys)

Born about 1785, daughter of Col. Hezekiah Wyllys and Amelia (Dyer) (Trumbull) Wyllys, who was previously the widow of Joseph Trumbull, oldest brother of artist John Trumbull. Married, as his third wife, Ashur Adams* of Roxbury and was mother of four of his seven children. Died in 1859.

ARTIST: Unknown.

DESCRIPTION: Oil on canvas, 38.7 x 31.1 cm. Half-length view, turned slightly right. Grayish hair in ringlets under narrow lace veil, eyes front, pink tone to cheeks and lips, dark dress with pointed lace collar. Gray background. A note on back reads: "She is wearing earrings and a brooch depicting acorns from the Charter Oak on the old Wyllys estate in Hartford."

PROVENANCE: Same as for Ashur Adams (q.v.).

REFERENCES: *NEHGR*, 37(1873):36; Adams, *Henry Adams*, 539; *Proc.*, 86(1974):121; correspondence of Rosamond Allen, MHS.

Charles Francis Adams
(1807–1886)

Born in Boston in 1807, son of John Quincy Adams* and Louisa Catherine (Johnson) Adams. Graduated from Harvard in 1825; studied law and was admitted to the bar but did not practice. Married Abigail Brown Brooks in 1829, and their children included Charles Francis Adams II* and Henry Adams.* Active in politics and diplomacy, he was ambassador to Great Britain during the American Civil War. The first editor of the family papers, he published the works of his grandfather, President John Adams,* and the diary of his father, President John Quincy Adams. Elected to membership in the Society in 1841. Died in Boston in 1886.

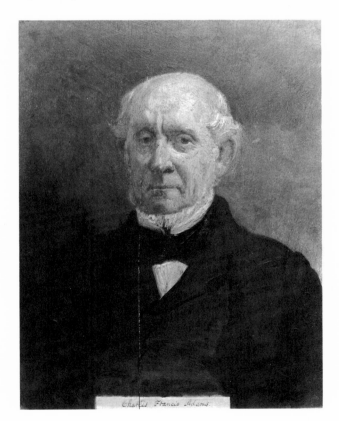

ARTIST: Edouard Armand-Dumaresq. Signed, upper right: "Armand Dumaresq." Inscribed, bottom center: "Charles Francis Adams."

DESCRIPTION: Oil on panel, 31.8 x 24.2 cm. Head-and-shoulders view, facing front. Fringe of white hair,

3

high white collar, black stock, black coat. Label on back of panel from "M. de Couleurs, Rue Bréda 30, Paris."

PROVENANCE: Gift of Thomas Boylston Adams, about 1971.

REFERENCES: *DAB*, 1, pt. 1:40–48; Bénézit, *Dictionnaire*, 1:240; *Proc.*, 2nd ser., 13(1899–1900):198–207

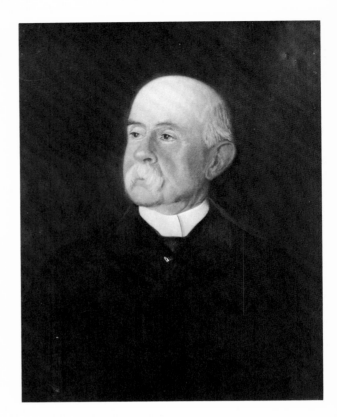

Charles Francis Adams II (1835–1915)

Born in Quincy in 1835, son of Charles Francis Adams* and Abigail (Brooks) Adams. Graduated from Harvard in 1856, served as a cavalry officer in the Civil War. Married Mary Ogden in 1865, and their children included John Adams (1875–1964).* Primarily engaged in the railroad business, he was president of the Union Pacific Railroad from 1884 to 1890. He was also a financier, educational reformer, conservationist, and historian. Elected to membership in the Society in 1875, he served in many capacities and was president for 20 years. Died in Washington, D.C., in 1915.

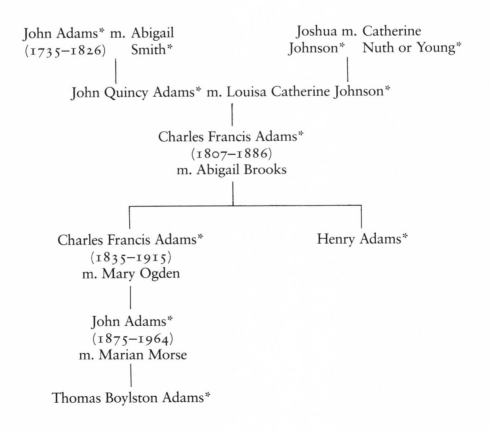

John Adams* m. Abigail
(1735–1826) Smith*

Joshua m. Catherine
Johnson* Nuth or Young*

John Quincy Adams* m. Louisa Catherine Johnson*

Charles Francis Adams*
(1807–1886)
m. Abigail Brooks

Charles Francis Adams*
(1835–1915)
m. Mary Ogden

Henry Adams*

John Adams*
(1875–1964)
m. Marian Morse

Thomas Boylston Adams*

I

ARTIST: Baldwin Coolidge, about 1911. In pencil on back of stretcher: "*Unfinished* Portrait of / Hon Charles Francis Adams / By Baldwin Coolidge. / Given by / Mr. Coolidge / 10 Dec. 1918."

DESCRIPTION: Oil on canvas, 70.9 x 55.6 cm. Head-and-shoulders view, head turned slightly right. Fringe of gray-white hair and drooping mustache, ruddy skin tones. Stiff white collar with black stock, black double-breasted coat with black buttons.

PROVENANCE: Gift of Baldwin Coolidge, 1918.

II

ARTIST: Robert Vonnoh, 1913. Signed, bottom left: "Vonnoh - 1913." A replica of this portrait, also by Vonnoh, is in a private collection.

DESCRIPTION: Oil on canvas, 315.5 x 153.5 cm. Full-length, standing view. Black academic robe, hood lined with red, turned-down white collar, white waistcoat.

PROVENANCE: Gift of Thomas Boylston Adams, 1983.

III

ARTIST: Robert Vonnoh, 1913. Signed, lower left: "Vonnoh 1913 – C –."

DESCRIPTION: Oil on canvas, 76.8 x 60.8 cm. Half length, seated view. Head turned slightly left, same robes as above.

PROVENANCE: Gift of Thomas Boylston Adams, 1983.

REFERENCES: *Proc.*, 48(1914–1915):383, 395, 90(1978):22–24; Catalogue of American Portraits, NPG.

Henry Adams

Born in Boston in 1838, son of Charles Francis Adams* and Abigail Brown (Brooks) Adams. Graduated from Harvard in 1858. Served as his father's secretary from 1860 to 1868 in Washington and London. Married Marian Hooper in 1872. Professor of history at Harvard from 1870 to 1877 when he moved to Washington, D.C., where he lead the life of a scholarly observer. He wrote widely and among his best known books are *Mont-St.-Michel and Chartres* and the autobiographical *Education of Henry Adams*. Died in Washington, D.C., in 1918.

ARTIST: John Briggs Potter, 1914. Signed, lower right: "J.B. Potter, del. 1914." Inscribed, lower left: "Henry Adams." Adams's "adopted niece," Eileen Tone, recalled that Mr. Adams was persuaded to sit, somewhat

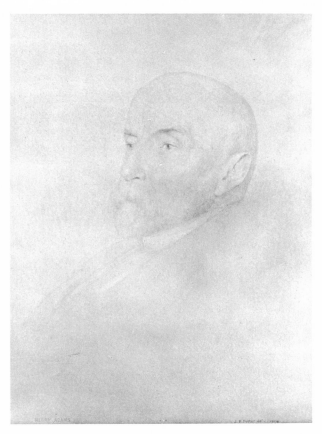

reluctantly, for this portrait, and that the artist, his nephew, felt somewhat ill at ease in his presence. She described the result as a "disgruntled subject drawn by an uncomfortable artist."

DESCRIPTION: Crayon and pencil drawing, 43.8 x 31.0 cm. Head, turned three-quarters to the right. Dark eyebrows, white shirt front.

PROVENANCE: The portrait once belonged to Mrs. Abigail Adams Homans.
Gift of Miss Eileen Tone, 1964.

REFERENCES: *Letters of Henry Adams*, edited by Worthington C. Ford, 1:frontisp., 231, 2:622, 632; *Proc.*, 76(1964):202; *DAB*, 1, pt. 1:61–67; Marvin Sadik and Harold Francis Pfister, *American Portrait Drawings* (Washington, D.C., 1980), 118–119.

John Adams (1735–1826)

Born in Braintree in 1735, son of John and Susanna (Boylston) Adams. Graduated from Harvard in 1755. Married Abigail Smith* in 1764, and their children included President John Quincy Adams.* Elected to the General Court of Massachusetts in 1770, chosen delegate to first Continental Congress in 1774 and to the second Congress from 1775 to 1777. Aided in preparing the Declaration of Independence. Served as a peace com-

missioner at the negotiations for the Treaty of Paris and for three years was the first American envoy to the Court of St. James. Served as vice president under George Washington for two terms. Second president of the United States from 1796 to 1800, after which he returned home to Quincy. Elected to membership in the Society in 1800. Died in Quincy in 1826.

I

ARTIST: Benjamin Blyth, probably 1766. Label on reverse, in unidentified handwriting: "John Adams / 2nd President of the United State / Picture drawn by Blythe / English Artist / In America in 1763 / (Colored Crayon)"; a second label, also in an unidentified handwriting: "John Adams / Drawn by Blythe 1763 / (Coloured Crayon) / Presented to Thomas B. Adams / By his Mother."

DESCRIPTION: Pastel on paper, 57.3 x 44.8 cm. Head-and-shoulders view, turned slightly right. Full gray wig, narrow turned-down collar on shirt, white stock, dark gray waistcoat and coat, both with large buttons. (*See Color Plate 1*).

PROVENANCE: Abigail Adams gave the portrait to her youngest son, Thomas Boylston Adams (1792–1832) before 1818. From him it passed to his daughter Elizabeth C. Adams (1808–1903), to Elizabeth's cousin's son Charles Francis Adams (1835–1915), to his son Henry Adams (1875–1951), and to John Adams (1875–1964).
 Gift of John Adams, 1957.

II

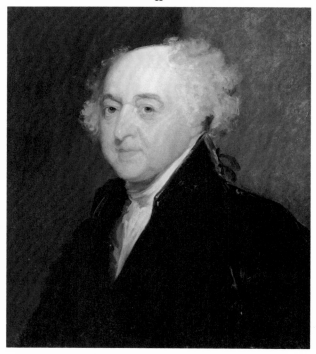

ARTIST: Gilbert Stuart Newton, about 1815. Copy of the original 1798 portrait by Gilbert Stuart, now in the National Gallery of Art, Washington, D.C. Inscribed in ink on back of canvas: "E.A. [—]62"; in pencil, below: "*Newton.*" The Boston Athenaeum also has a copy of the same portrait done by Newton about 1815.

DESCRIPTION: Oil on panel, 60.9 x 53.6 cm. Head-and-shoulders, turned one quarter left. Gray fringe of hair clubbed in back, pink tone to cheeks and prominent nose, black coat, white stock.

PROVENANCE: Gift of Edward A. Newton, brother of the artist, 1862.

REFERENCES: Oliver, *Portraits of John and Abigail Adams*, 5–9, 252; *Proc.*, 1st ser., 6(1862–1863):3; *DAB*, 1, pt. 1:72–82; letter from Edward A. Newton, April 7, 1862, MHS.

John Adams (1875–1964)

Born in Quincy in 1875, son of Charles Francis Adams* and Mary (Ogden) Adams. Graduated from Harvard in 1898. Moved to Kansas City, Missouri, in 1902 and engaged in business there. Married Marian Morse in 1905, and their children included Thomas Boylston Adams.* Returned to Massachusetts in 1913 to look after family affairs. Elected a member of the Society in 1945, served as its president from 1950 to 1957, and was instrumental in establishing its endowment fund. Died in Concord in 1964.

I

ARTIST: Pietro Pezzati, 1961. Signed in pencil, lower left: "Pietro Pezzati, 1961."

DESCRIPTION: Crayon on paper, 57.5 x 46.0 cm. Head-and-shoulders view, facing front, bow tie.

PROVENANCE: Purchased by the Society in 1964 with gifts received from members.

II

ARTIST: Pietro Pezzati, 1962. Signed, lower right: "Pietro Pezzati 1962." Printed on back in white chalk: "John Adams II / b. July 17, 1875. / d. Aug. 30, 1964 / President Mass. Historical Soc.y / 1950–1957 / Pietro Pezzati pinx. 1962 / Boston. Mass."

DESCRIPTION: Oil on canvas, 99.0 x 76.3 cm. Half-length view, facing front. Pair of eyeglasses in left hand with right on top, cane resting against knee, brown suit, blue-and-white striped shirt, blue bow tie with paisley print, white handkerchief in breast pocket.

Mrs. John Adams (Abigail Smith)

Born in Weymouth in 1744, daughter of Rev. William and Elizabeth (Quincy) Smith. Married John Adams* in 1764. Stayed in Braintree to tend her family of five children and the farm while her husband was absent during the Revolution but joined him in Paris after the signing of the peace treaty. Went with him to London for the three years of his ambassadorship there. During the 12 years of her husband's vice presidency and presidency, she moved back and forth between Braintree and the successive capitals of the country, and served briefly as the first hostess of the White House. One of the great letter writers of all time, she was a charming and spirited commentator on the life and events of her time. Died in Quincy in 1818.

I

ARTIST: Benjamin Blyth, probably 1766. Label on reverse in an unidentified handwriting: "Abigail Adams / Wife of John Adams. / Picture drawn by Blythe / English Artist / In America in 1763 (Colored Crayon)"; a second label, also in an unidentified hand: "Abigail Adams /

Drawn by Blythe 1763 (English Artist) / Presented to her son Thomas B. Adams."

DESCRIPTION: Pastel on paper, 57.3 x 44.8 cm. Head-and-shoulders view, turned slightly left. Dark hair tied in back, brown eyes. Blue dress with lace collar, 3 strands of pearls. (*See Color Plate 2*).

PROVENANCE: Same as for the companion portrait of John Adams* (I).

II

ARTIST: Gilbert Stuart, 1800. Preliminary unfinished sketch for the final portrait which hangs in the National Gallery of Art, Washington, D.C. In pencil on frame back: "This portr. I have given to my son John Quincy Adams / John Adams / Feb. 28, 1964."

DESCRIPTION: Oil on canvas, 56.6 x 46.6 cm. Head-and-shoulders view, turned slightly left. Flowing gray head cover, gray dress, individual curls above forehead, pink tone to cheeks.

PROVENANCE: Charles Francis Adams (1835–1915) purchased the portrait for $500 from Catherine Carlton Manson, daughter of the painter William T. Carlton of Dorchester. Inherited by his son, John Adams (1875–1964) and by his son John Quincy Adams.
 Gift of John Quincy Adams, 1964.

REFERENCES: Oliver, *Portraits of John and Abigail Adams*, 5–13; *Proc.*, 71(1953–1957):64–107, 342; *Notable American Women*, 1:6–9.

John Quincy Adams

Born in Braintree in 1767, son of John Adams* and Abigail (Smith) Adams.* Graduated from Harvard in 1787, practiced law for a time. Married Louisa Catherine Johnson, daughter of Joshua Johnson* and Catherine (Nuth or Young) Johnson,* in 1797, and their children included Charles Francis Adams.* Served as American minister to Prussia, the Netherlands, and Russia, and as a peace commissioner in the War of 1812. Was secretary of state under James Monroe from 1817 to 1825. Sixth president of the United States from 1825 to 1829. Member of Congress from 1831 until his death. Elected to membership in the Society in 1802. Died in Washington, D.C., in 1848.

I

ARTIST: Nahum Ball Onthank, probably after Stephen Henry Gimber's 1848 engraving. Handwritten on frame: "John Quincy Adams by Nahum B. Onthank, after Stuart Portrait of him / given by Arthur B. Onthank, his son, June 14, 1928."

DESCRIPTION: Oil on canvas, 76.0 x 63.5 cm. Head-and-shoulders view, turned one-quarter left. Gray-white hair and sideburns, white shirt with black stock, black waistcoat and double-breasted coat.

PROVENANCE: Gift of Arthur B. Onthank, son of the artist, 1928.

II

ARTIST: Unknown. Copied from the same source as the portrait by Onthank.

DESCRIPTION: Oil on canvas, 43.4 x 35.8 cm. Same pose as above.

PROVENANCE: Gift of Thomas Boylston Adams, 1969.

REFERENCES: Oliver, *Portraits of John Quincy Adams and His Wife*, 302; *DAB*, 1, pt. 1:84–93; *Proc.*, 61(1927–1928):213, 81(1969): 243.

Thomas Boylston Adams

Born in Kansas City, Missouri, in 1910, son of John Adams* and Marian (Morse) Adams. Attended Harvard in the Class of 1933. Married Ramelle Frost Cochrane in Boston in 1940. Served in the U.S. Army Air Force from 1942 to 1946. Vice president of the Sheraton Corporation from 1946 until 1962. Fellow and treasurer of the American Academy of Arts and Sciences. Writer and columnist for the *Boston Globe* on historical subjects. Elected to membership in the Society in 1951, served as its president from 1957 to 1975.

ARTIST: Pietro Pezzati, 1976. Signed, lower right: "Pietro Pezzati, 1976." In white chalk on back of canvas: "Thomas Boylston Adams / born Kansas City, Missouri 25–VII–1910 / President 1957–75 Massachusetts Historical Soc. / Pietro Pezzati pxt. / 1976."

DESCRIPTION: Oil on canvas, 101.5 x 71.5 cm. Seated in front of library bookshelves, half-length view facing left. Wide forehead with gray-white hair, brown eyes. Striped shirt, bow tie, blue suit with blue pocket handkerchief, watch fob also in pocket.

PROVENANCE: Commissioned by the Society in 1976 with the aid of gifts from members.

REFERENCES: *Harvard Class of 1933: 50th Anniversary Report* (Cambridge, Mass., 1983), 6–7; *Proc.*, 89(1977):199.

James Allen

Born in Boston in 1739, son of Jeremiah and Elizabeth (Oulton) Allen, and brother of Jeremiah Allen.* Attended Harvard College with the Class of 1758 but left in the middle of his sophomore year. A dilettante poet, he published *Lines on the Massacre* in 1772 but never

8

carried his other works to publication, and lived on the proceeds of his family's real estate holdings. In 1797 William Dunlap, the playwright and painter, described him as "odd in his manners & appearance & very slovenly. . . he is an Atheist & the popular report is that he keeps his Coffin in his bed chamber & sometimes sleeps in it." Died unmarried in Boston in 1808.

ARTIST: John Singleton Copley, about 1768–1770.

DESCRIPTION: Oil on canvas, 76.5 x 63.5 cm. Half-length view, facing full front; head turned one-quarter left. Curly, black hair, brown coat and waistcoat, white neckcloth, and black tie. The spandrels are olive brown.

PROVENANCE: Same as for Jeremiah Allen (q.v.).

REFERENCES: Prown, *Copley*, 64, 74, 75, fig. 268; *Sibley's Harvard Graduates*, 14:245–247; *Diary of William Dunlap (1766–1839)*, 3 vols. (New York, 1931), 1:177; *Proc.*, 1st ser., 2(1835–1855):65.

Jeremiah Allen

Born in Boston in 1750, the same day his father died, son of Jeremiah and Elizabeth (Oulton) Allen and brother of James Allen.* High sheriff of Suffolk County when the duties of that office ranged from arresting actors for violating Boston's theatrical ban before 1793, to attending Governor Hancock on his last visit to the legislature shortly before his death. Characterized by a

successor as "a rich and moral old bachelor. . . [who] 'knew very well how to arrest men and to attach women.'" Died unmarried in Boston in 1809.

ARTIST: Gilbert Stuart, about 1808.

DESCRIPTION: Oil on panel, 70.9 x 57.2 cm. Half-length view, seated facing one-quarter left. Brown eyes, white hair tied with a black bow. Dark blue coat with brass buttons, buff waistcoat with double row of small brass buttons, white neckcloth and ruffled shirt. Olive-green background.

PROVENANCE: In his will, the sitter left to his nephew, James Allen, Esq., "all the family Portraits including his Uncle James's taken by Copley, and my own, by Stuart."

Gift of Mrs. Susan Allen, widow of James Allen, Esq., 1836.

REFERENCES: James Spear Loring, *The Hundred Boston Orators* (Boston, 1855), 330; Samuel Adams Drake, *Old Landmarks and Historic Personages of Boston* (Boston, 1873), 261; Suffolk Co. Probate, 107:69; *Proc.*, 1st ser., 2(1835–1855):65, 289.

Mrs. Stephen Merrill Allen (Ann Maria Gridley)

Born in Boston in 1818, daughter of William and Elizabeth Gridley. Married Stephen Merrill Allen, a Bos-

ton banker and merchant, in 1841. They lived on the Myles Standish farm in Duxbury and spent part of each year in Roxbury. Died in Woburn in 1865.

ARTIST: Unknown.

DESCRIPTION: Pastel and egg tempera, 33.2 x 28.2 cm. Oval frame in shadow box under glass. Seated, half-length view, turned left, face turned one-quarter right. Black hair parted in middle, black dress with lace collar and cuffs, red shawl.

PROVENANCE: Gift of Miss Rosamond Allen, grand-daughter of the sitter, 1980.

REFERENCES: *NEHGR*, 10(1856):227, 48(1894):472–473.

Washington Allston

Born in Georgetown, South Carolina, in 1779, son of William and Rachel (Moore) Allston. Married twice: to Ann Channing of Newport, sister of Rev. William Ellery Channing, in 1809, and to her cousin Martha Dana, sister of novelist Richard Henry Dana, in 1830. Graduated from Harvard in 1800, studied under Benjamin West at the Royal Academy, London, from 1801 to 1803, and continued his studies in Paris and Italy. After living briefly again in America, he returned to England, where he painted his greatest landscapes. Financial reverses, from which he never recovered, forced his return to America in 1818. Highly regarded as the first of the romantic painters in America. Died in Cambridge in 1843.

ARTIST: Sophia Amelia Peabody, after Chester Harding, 1830.

DESCRIPTION: Oil on canvas, 68.5 x 55.4 cm. Unfinished. Head-and-shoulders view, full front, head turned slightly to right. Curly gray hair, green robe with brown, fur collar, pleated white shirt front, white standing collar, white cravat.

PROVENANCE: When the painting was given, it was described as "an unfinished but admirable portrait of Washington Allston, by Chester Harding, which our late associate had purchased at the sale of the artist's effects." It is now considered to be the 1830 copy by Peabody of the 1828 original which now hangs in the Providence Athenaeum. A later copy by Harding is in the Cambridge Historical Society.

Gift of Mrs. George T. Bigelow, 1879.

REFERENCES: Louise Hall Tharp, *The Peabody Sisters of Salem* (Boston, 1950), 50, 344–345; *Proc.*, 1st ser., 17(1879–1880):51; *DAB*, I, pt. 1:224–225; Jared B. Flagg, *The Life and Letters of Washington Allston* (New York, 1969), 81, 109–110, 239.

John Albion Andrew

Born in Windham, Maine, in 1818, son of Jonathan and Nancy Green (Pierce) Andrew. Graduated from Bowdoin College in 1837, studied law at Boston, admitted to the Massachusetts bar in 1840. Married Eliza Jones Hersey of Hingham in 1848. An ardent anti-slavery man, he became a leader of the abolitionists when elected to the Massachusetts legislature in 1857. Was a delegate to the 1860 convention that nominated Lincoln for president. Elected governor of Massachusetts in 1860 but declined renomination in 1865. Helped to organize the first black regiment in the country, the 54th Massachusetts Regiment. Elected to membership in the Society in 1866. Died in Boston in 1867.

ARTIST: William Morris Hunt, 1867. A similar, but life-size, portrait by Hunt is owned by the City of Boston and hangs at Faneuil Hall.

DESCRIPTION: Oil on canvas, 49.7 x 30.5 cm. Full-length figure, standing one-third right on a raised platform with upholstered armchair behind. Curly black hair, eyeglasses, white shirt and tie, frock coat, black shoes, papers with official seal in left hand.

PROVENANCE: Bequest of Justice Horace Gray, 1902.

REFERENCES: *DAB*, 1, pt. 1:279–281; *Proc.*, 1st ser., 18(1880–1881):41–64, 2nd ser., 17(1903):229, 16(1902):265, 9(1894–1895):67.

John Appleton

Born in Salem in 1809, son of John Sparhawk and Mary (Lander) Appleton. Married Elizabeth Marshall Messer of Boston in 1831. Graduated from Harvard Medical School in 1833 and in addition to practicing medicine, was a lecturer in medicine, temperance, music, and biography. In 1855 became assistant librarian of the Society, where he served until the end of 1868, during which time he produced a two-volume catalogue of the library. Since he could receive no compensation for services ren-

dered as a member, he was not elected to the Society until January, 1869, after his resignation and a few days before his death. Died in Cambridge in 1869.

ARTISTS: Cyrus and Darius Cobb, 1868. Inscribed on back: "Dr. John Appleton / Sketched by / C & D Cobb / 1868 / And presented by them to the / Massachusetts Historical Society / March 9th 1871."

DESCRIPTION: Oil on panel, 25.3 x 19.9 cm. Brown monochrome. Right profile with long white hair and long wavy beard against a dark brown background.

PROVENANCE: Gift of the artists, 1871.

REFERENCES: *Proc.*, 1st ser., 15(1876–1877):365–367, 12(1871–1873):56; W. S. Appleton, *A Genealogy of the Appleton Family* (Boston, 1874), 37.

Mrs. Randolph Morgan Appleton (Helen Kortright Mixter)

Born in Boston in 1864, daughter of Charles and Frances Louisa (Curtis) Mixter, of Boston and Newport, Rhode Island. Went to Europe with her family in 1873 aboard the steamer *Ville du Havre*, but the ship was wrecked and her parents and grandfather were drowned. She and

her sister Madeleine survived. Married in Boston in 1888 to Randolph Morgan Appleton, an 1884 Harvard graduate, and had three children. Lived in Venice, Italy, with her children until the outbreak of World War I when she returned to Boston. Died in Boston in 1939.

ARTIST: Louise Wheelwright Damon, 1940. Signed on reverse: "Mrs. Helen K. Appleton / pint. Louise Wheelwright / LWD." From a photograph.

DESCRIPTION: Crayon on paper, 26.5 x 21.5 cm. Oval. Head-and-shoulders view, turned three-quarters left. Brown hair, blue eyes. Wears white earring, gray dress with high collar and brooch, furs draped over left shoulder. Dark background.

PROVENANCE: Probably a gift of the artist, about 1948.

REFERENCE: Lucius R. Paige, *History of Hardwick, Massachusetts* (Boston, 1883), 423–424; *Harvard College, Class of 1884: Twenty-Fifth Anniversary Report* (Cambridge, Mass., 1909), 24; *Proc.*, 69(1947–1950):455.

Samuel Appleton

Born in New Ipswich, New Hampshire, in 1766, son of Isaac and Mary (Adams) Appleton. In 1794, started a shop in Boston with his brother Nathan. "S. & N. Appleton" became a large and prosperous firm of imported and domestic goods and expanded through investments in the cotton industry and railroads. Married Mrs. Mary

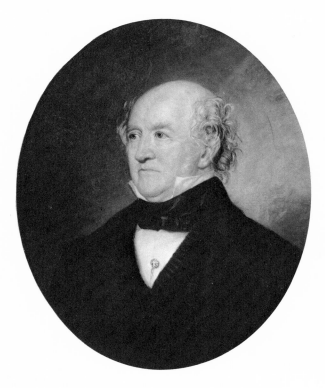

(Lekain) Gore in 1819. Retired at the age of 60 to devote his time to philanthropy. Through his estate's trustees, he became a benefactor of the Society which established the Appleton Publishing Fund in his honor. Died in Boston in 1853.

ARTIST: George Peter Alexander Healy, 1857. Copy of his original (about 1847), now at the Boston Athenaeum.

DESCRIPTION: Oil on canvas, 68.3 x 56.1 cm. Oval. Head-and-shoulders view, turned one-quarter right. Black coat and vest, stiff white shirt front with a breast pin, standing white collar with a broad black cravat. Straggly, faded, brown hair on back of bald head.

PROVENANCE: Commissioned by the Society, 1857.

REFERENCES: *Proc.*, 1st ser., 2(1835–1855):597, 3(1855–1858): 7–18, 130, 168; *DAB*, 1, pt. 1:332–333.

Alice Bacon

Born in Boston in 1870, daughter of Francis Edward and Louise (Crowninshield) Bacon. Married William Sturgis Hooper Lothrop in 1891 and had four children. Followed her banker-businessman husband to Puerto Rico in 1899 and became active in encouraging local handicrafts by arranging export of embroideries through the Benevolent Society of Porto Rico. Her husband died suddenly in Puerto Rico in 1905. She died in Wellesley in 1945.

ARTIST: Frank Weston Benson, 1891. Signed, upper left: "Frank W. Benson / '91."

DESCRIPTION: Oil on canvas, 91.4 x 73.3 cm. Three-quarters length seated figure facing right, eyes front. Brown hair parted in the middle, hands folded in lap. White dress with lace collar and cuffs, wide belt. Dark background. (*See Color Plate 3*).

PROVENANCE: Unknown.

REFERENCE: Louisa Crowninshield Bacon, *Reminiscences* (Salem, 1922), 82–85.

John Bailey

Born near Blackburn, Lancashire, England, in 1643/4, son of Thomas Bailey. Preached in England and Ireland as a non-conformist minister. Came to Boston in 1683 and was one of the signers of the Association of Ministers at Charlestown in 1690. Was minister of the First Church in Watertown from 1686 to 1692. Returned to Boston as assistant minister of the First Church where

he remained until his death. His first wife, Lydia, died in Watertown in 1690; married second Susanna Wilkin, who later married Peter Thacher, minister of the church in Milton. Died in Boston in 1697.

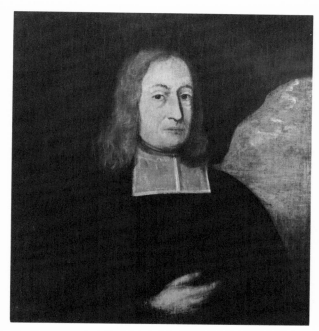

ARTIST: Unknown.

DESCRIPTION: Oil on canvas, 74.2 x 72.3 cm. Head-and-shoulders view facing front, head slightly left. Grayish brown hair hanging to shoulders, brown eyes, right hand held in front, black robe, square white collar. Dark brown curtain as background, cloudy sky at left.

PROVENANCE: Gift of Nathaniel Willis, Jr., between 1825 and 1830. On loan to the First Church, Boston, since 1964.

REFERENCE: Bolton, *Portraits of the Founders*, 2:347–348; *DNB*, 1:879–880; *Proc.*, 1st ser., 2(1835–1855):449n; *MHS Coll.*, 3d ser., 2:368.

Mrs. Baker

Given name unknown, born about 1605 in England. She was the mother of Mrs. Nicholas Roberts.*

ARTIST: Unknown, painted in England, about 1675. Inscribed, lower right, "Ao 1675 70."

DESCRIPTION: Oil on canvas, 76.7 x 64.9 cm. Half-length view facing slightly right. Large black pointed hat with underhood edged with lace, black dress with broad lace collar, white undersleeves tied with black ribbons. Holds a small book in left hand, a ring on her thumb. Colored flowers lie on table at right.

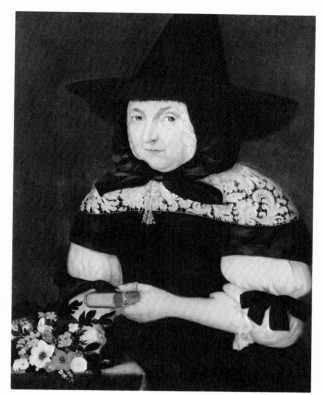

PROVENANCE: In 1854, this portrait of Mrs. Baker was presumably one of the two misidentified as "female portraits of the Yeamans family" owned by Benjamin Welles of Boston. His wife, Mehetable Stoddard (Sumner) Welles, was a daughter of Gov. Increase and Elizabeth (Hyslop) Sumner, and granddaughter of Mrs. Samuel Shrimpton, Jr., (Elizabeth Richardson) by her second husband, David Stoddard. The portrait was later inherited by Welles's granddaughter, Elizabeth Welles Perkins.

Bequest of Miss Perkins, 1920.

NOTE: The portrait of Mrs. Baker is part of a remarkable group of documented family portraits which were sent from Nicholas Roberts of London to his daughter and son-in-law, Col. Samuel and Elizabeth (Roberts) Shrimpton, in Boston. In July 1671 Roberts wrote "My pictur is drawn to send you if I could prevail with your mother to have hers drawne would have sent it now but if I cannot prevaile I shall send you mine (therefore tell Betty) I have not forgot my promise." He wrote again on September 4, 1674, to "tell my daughter that her mother's picture is now drawn and mine also and I shall send them by the next conveyance that we have if Capt. Foster goe not before the frames are finished shall come by him your two sisters will send afterwards if desired." Once the shipping arrangements were made, the Shrimptons were informed that "You will receive by Capt foster case sewed up in canvas wh your marke upon it in which is mine & your mother's picktures your mother is dun well & I leav you to give your judgment

of mine." The set was completed the next year with six additional portraits. A letter, dated May 3, 1675, indicates "I have sent you in a case yours & your wifes picktures with your grandmothers & your three sisters when your sister Katherines was drawn wee littell thought the curtaine would have been soe soon drawne ovr that yet being intended for you hath sent it you that you may see by the shadow what a likly sweet babe it was to live."

Of the eight portraits, this one is "your grand-mothers"; those of Nicholas Roberts* and his wife Elizabeth (Baker) Roberts* are also in this collection; as is the portrait of Col. Samuel Shrimpton.* The companion portrait of Elizabeth (Roberts) Shrimpton in 1854, when it was incorrectly called Elizabeth (Shrimpton) Yeamans, her granddaughter, was in the possession of Eliza (Sumner) Gerard of New York as was the original portrait of Katherine Roberts,* of which a copy by De-Luce is in this collection. Of the two remaining portraits, one was in the possession of Malcolm Greenough in 1921, and the other was not located. These two represented the other daughters of Nicholas and Elizabeth (Baker) Roberts: Sarah (who married John Richardson, and was the mother of Mrs. Samuel Shrimpton, Jr.) and Mary (who married Sir Robert Breeden).

REFERENCES: Shrimpton Papers, MHS; *NEHGR*, 9(1855):303; *Proc.*, 61(1927–1928):129.

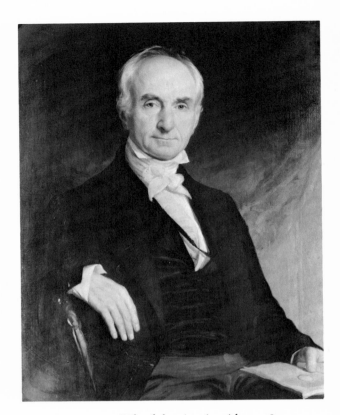

PROVENANCE: Gift of the sitter's widow, 1871.

REFERENCES: *NEHGR*, 16(1862):368–369; *Proc.*, 1st ser., 12(1871–1873):67.

James Fowle Baldwin

Born in Woburn in 1782, son of Loammi and Mary (Fowle) Baldwin. Married in 1818 Sarah Parsons Pitkin of East Hartford, Connecticut. Educated in Billerica and Westford, and became a merchant in Boston. Turned to engineering, and in 1828 was appointed to a commission to make surveys for a new railroad from Boston to Albany. Superintended construction of the Boston & Lowell Railroad from 1830 to 1835. Considered his chief professional works to be the plan and construction of the Western Railroad and the supply of pure water to the city of Boston from Lake Cochituate. Served as a state senator from Suffolk County and held the office of water commissioner. Died in Boston in 1862.

ARTIST: George Peter Alexander Healy, 1848. Signed, lower left: "G.P.A. Healy pinxt. / 1848."

DESCRIPTION: Oil on canvas, 91.6 x 73.6 cm. Half-length seated figure, facing front, right elbow on chair back. Gray hair, black coat and vest, white shirt with stand-up collar, white cravat, brownish trousers. Holds papers in left hand. Red background drapery behind red upholstered chair.

Robert Ball

Born about 1700. Married Elizabeth Davison* in 1728. Was in command of the brig *Poultney* in 1745 and of the *Post Boy* in the same year. Described as a "mariner of Concord" in a 1746 lawsuit. Died off the coast of Guinea in 1753.

ARTIST: Unknown, attributed to John Smibert. Smibert recorded in his notebook that he painted a "Mr. Ball" in February and a "coppie" of Mr. Ball the next month in London in 1727. Inscribed on the middle stretcher: "A Portrait of Capt. Robert Ball [one] of the first settlers in America / Taken in England He was [my great-gr]eat Grandfather / [] Willis." Label on reverse: "The Portrait of Capt. Robert Ball, / born in London about the year 1700 - / was a ship master in the Africa / trade. came to America & sailed / [*tear*] of Boston. admitted to the Church / in Charlestown, Mass. 1728. married / Elizabeth Davidson of Maryland / June 26, 1728 1st child Elizabeth born / March 11, 1729; Mary his 5 [*illegible*] / grandmother of Wm Willis, bo[rn] / Sept. 16, 1742 / the portrait is said to have / been painted in London - / Capt. Ball died 1753 aged 53."

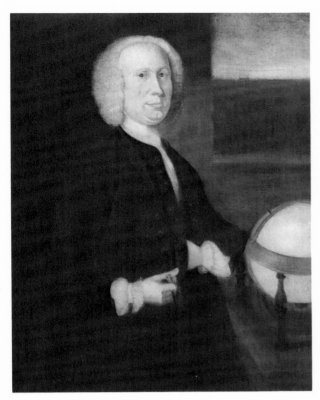

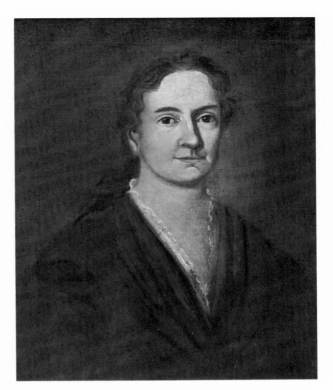

DESCRIPTION: Oil on canvas, 102.0 x 84.0 cm. Three-quarter length figure, facing left, eyes front. White wig, dark coat and waistcoat with buttons on each, white shirt with cascading ruffle at neck and ruffles at wrists. Left hand thrust into waistcoat, right holding dividers. Window at left with globe standing below.

PROVENANCE: This portrait and that of Mrs. Ball were "among the few canvases that escaped destruction June 17, 1775," when the British burned Charlestown. They were inherited by William Willis of Portland, Maine, a great-grandson of the sitters, and from him went to Henry Herbert Edes of Charlestown, another descendant of the couple. They passed from Edes to his first cousin, James Atkins Noyes of Cambridge, father of Miss Penelope B. Noyes, the donor.

Gift of Miss Noyes, 1972.

REFERENCES: Wyman, *Charlestown Genealogies*, 1:50–51; Smibert, *Notebook*, 84; *Proc.*, 84(1972):139.

Mrs. Robert Ball (Elizabeth Davison)

Of Charlestown when she married Robert Ball* in 1728. Her identity is uncertain. According to the label on Capt. Ball's portrait she was from Maryland, or she may have been the daughter of Nicholas and Anne Davison of Newbury. Had seven children. Died after 1757.

ARTIST: Unknown, attributed to Joseph Blackburn. Inscribed on upper stretcher: "Painted by/Smybert."

DESCRIPTION: Oil on canvas, 55.7 x 48.0 cm. Head-and-shoulders view, facing slightly left and front. Dark wavy hair parted in the middle and tied in back, brown eyes, cleft in chin. Dark dress with v-neck edged with lace. Dark background.

PROVENANCE: Same as for Robert Ball (q.v.).

REFERENCES: Wyman, *Charlestown Genealogies*, 1:50–51; *Proceedings of the Colonial Society of Massachusetts*, 6(1899–1900):39n; *Proc.*, 84(1972):139.

Jonathan Belcher

Born in Cambridge in 1681/2, son of Andrew and Sarah (Gilbert) Belcher. Graduated from Harvard in 1699. Married twice: to Mary Partridge, daughter of former Lt. Gov. William Partridge of New Hampshire, in 1705/6; to Mary Louisa Emilia Teal in Burlington, New Jersey, in 1748. After several years in Europe, returned to Boston and in 1729 was elected to the Council. Appointed governor of the provinces of Massachusetts and New Hampshire to succeed William Burnet in 1730. Served as governor until his dismissal in 1741, and as governor of New Jersey from 1747 until his death. Was instrumental in the building of Princeton College, but declined to have the first building, now Nassau Hall, named after him. Died in Elizabethtown, New Jersey, in 1759.

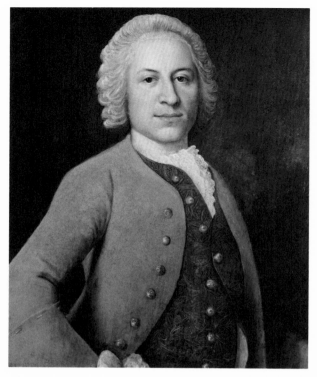

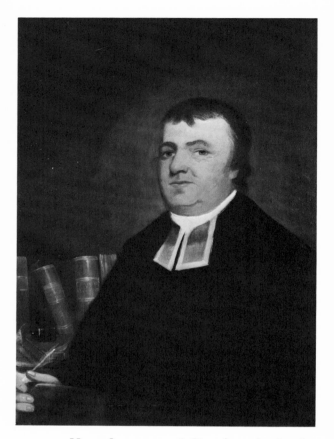

ARTIST: Franz Lippoldt, London, 1729. Formerly signed: "F. Liopoldt pinxit Anno 1729."

DESCRIPTION: Oil on canvas, 75.5 x 64.6 cm. Half-length view, turned slightly left, facing front. Curled wig, red coat and green brocade waistcoat, both with buttons, white stock with ruffle, white sleeve at wrist. A 1977 restoration removed extensive overpainting in which the wig was increased in size, the coat was painted dark blue with gold frogs, and the waistcoat yellow.

PROVENANCE: Unknown donor. In the Society's collections before 1838.

REFERENCES: *Sibley's Harvard Graduates*, 4:434–449; *NEHGR*, 4(1850):345; *DAB*, 1, pt. 2:143–144; *MHS Coll.*, 3rd ser., 7:287.

Jeremy Belknap

Born in Boston in 1744, son of Joseph and Sarah (Byles) Belknap. Graduated from Harvard in 1762, married Ruth Eliot in 1767. Served at the First Congregational Church of Dover, New Hampshire, from 1766 to 1786, and at the Church in Long Lane, later the Federal Street Church, Boston, from 1787 until his death. Author of several works including a three-volume *History of New Hampshire* and *American Biography*. Principal founder and first corresponding secretary of the Society. Fellow of the American Academy, and member of the American Philosophical Society. Died in Boston in 1798.

ARTIST: Henry Sargent, 1798. Signed on a book spine in the portrait: "Painted / By / H. Sargent / 1798." When the portrait was donated to the Society, there was some discussion of whether it had been painted during Belknap's lifetime since one of the books included by the artist, the second volume of the *American Biography*, was not published until after Belknap's death. Dr. George Ellis said "he well remembered the portrait, having often seen it hanging in one of the apartments in the house of the late John Belknap. He had always understood that the picture was in process of painting when Dr. Belknap died."

DESCRIPTION: Oil on canvas, 88.4 x 69.3 cm. Almost half-length view, facing slightly right. Short black hair, dark eyebrows, black robe, white stock and bands. Holds a quill pen and book. Among books in background is the second volume of *American Biography*.

PROVENANCE: Gift of Mrs. Jules Marcou, granddaughter of the sitter, 1866. It came to her from her aunt, Miss Elizabeth Belknap.

ARTIST: Henry Sargent, 1798. Either a preliminary sketch or a modified replica of the above.

DESCRIPTION: Oil on canvas, 64.8 x 54.8 cm. Head-and-shoulders view of the above without background detail.

PROVENANCE: Purchased for the Society by several members, 1799.

REFERENCES: *Sibley's Harvard Graduates*, 15:175–195; *Proc.*, 1st ser., 1(1791–1835):117, 120, 124, 9(1866–1867):2, 3, 189.

George Berkeley

Born in Kilkenny, Ireland, in 1684/5, son of William Berkeley. Graduated from Trinity College, Dublin, in 1704. Took Anglican orders and became dean of Derry in 1724. Married Anne Forster, daughter of John Forster, a chief justice of the common pleas in Ireland, in 1728. Came to America to seek backing for the founding of a college in Bermuda. Lived from 1729 to 1731 in Newport, Rhode Island, where two of his seven children were born. Returned to London where he stayed until he was consecrated bishop of Cloyne in Dublin in 1734. Lived at Cloyne for 18 years and continued his earlier philosophical writings. Died in Oxford, England, in 1753.

ARTIST: John Smibert, Newport, Rhode Island, 1730. Perhaps a copy of the one signed and dated by Smibert and owned by the Worcester Art Museum. The likeness strongly resembles that of Dean Berkeley in Smibert's "Bermuda Group" at Yale University.

DESCRIPTION: Oil on canvas, 75.7 x 63.4 cm. Head-and-shoulders view, facing one-quarter right. Gray curly wig to shoulders, black robe, white clerical bands. Dark background. (*See Color Plate 4*).

PROVENANCE: Perhaps the portrait commissioned by Henry Collins, a Newport merchant.

Given to the Society by Thomas Wetmore, probably in 1836.

REFERENCES: Foote, *Smibert*, 129–131; Smibert, *Notebook*, 3–5, 14n; *DNB*, 2:348–356; *Proc.*, 1st ser., 2(1835–1855):65.

William Worman Berry

Born in 1797. Entered the United States Navy as a midshipman in 1810. Aboard the frigate *Chesapeake* when she was captured by the British frigate *Shannon* off Boston Light on June 1, 1813, and taken to Halifax. In Washington, Berry wrote an official letter the next month describing the capture and treatment of the crew. A copy of the letter is owned by the Society. Promoted

to lieutenant in 1816. Married Caroline Manning of Portsmouth, New Hampshire, in 1819. Died in Washington, D.C., in 1824.

ARTIST: Unknown.

DESCRIPTION: Oil on canvas, 83.0 x 67.6 cm. Half-length view, turned one-quarter right. Tousled brown hair, blue eyes. Naval uniform of dark blue coat with double row of brass buttons, epaulet on left shoulder, buff trousers. Gold belt around waist, sword on left, hat under left arm.

PROVENANCE: Bequest of Miss Margaret Manning Salter, granddaughter of the sitter, 1931.

REFERENCES: Edward W. Callahan, ed., *List of the Navy of the United States and of the Marine Corps from 1775 to 1900* (New York, 1901), 55; *Proc.*, 64(1930–1932):404–405; *Columbian Centinel*, Nov. 27, 1819; *Evening Gazette* (Boston), July 31, 1824.

Gurdon Bill

Born in Groton, Connecticut, in 1784, son of Joshua and Abigail (Miner) Bill. Married Lucy Yerrington in 1821. Served in the War of 1812 on picket duty at Stonington, Connecticut, when the British fleet was cruising offshore. Owned considerable land in Groton, where he was a merchant, inn-keeper, and farmer. Represented Groton in the state legislature in 1828, and was

instrumental in the division of the old town of Groton in 1836, when one section was named Ledyard. Died in Ledyard in 1856.

ARTIST: Unknown.

DESCRIPTION: Oil on canvas, 69.1 x 56.1 cm. Head-and-shoulders view facing front. Brown hair parted on left, brown eyes. Stiff white shirt with high collar, black stock and coat. Light to dark gray background, back of red upholstered chair just visible.

PROVENANCE: The portrait was inherited by Miss Molly Beach of Pasadena, California, great-granddaughter of the sitter. From her it descended to her niece Judith M. Crawford and then to the latter's sister-in-law, Mrs. Seth Turner Crawford.

 Gift of Mrs. Crawford, 1976.

REFERENCES: Ledyard Bill, *History of the Bill Family* (New York, 1867), 167–168, 219–226; *Proc.*, 88(1976):144.

Daniel Boone

Born near Reading, Pennsylvania, in 1734, son of Squire and Sarah (Morgan) Boone. Of Quaker stock he had little education but was of great native intelligence. Married Rebeccah Bryan in 1756. Hunter, surveyor, Indian fighter, he led the first division of settlers to Kentucky in 1775, was made lieutenant-colonel of Fayette County, and served in the early Kentucky legislature. After losing his land holdings, he moved to Missouri in 1798 or 1799. Held the post of magistrate of the district from 1800 until it was ceded to the United States in 1804. Died in St. Charles County, Missouri, in 1820.

ARTIST: Chester Harding, 1820. Inscribed on back of canvas: "Daniel Boone / First Settler of Kentucky / Original by Chester Harding / 1821." Several copies by Harding from this original exist in various collections including the J. B. Speed Art Museum, Louisville, Kentucky, the Missouri Historical Society, the Filson Club, Louisville, and in private collections.

DESCRIPTION: Oil on canvas, 56.0 x 43.2 cm. Head-and-shoulders view, facing slightly right, eyes front, curly gray-white hair, blue eyes. Brown coat, white shirt with stiff turned-down collar. Unfinished dark oval background. (*See Color Plate 5*).

PROVENANCE: Oil sketch from life taken at Boone's home in Missouri. George Tyler Bigelow probably obtained it directly from the artist.

 Gift of Mr. Bigelow, 1861.

REFERENCES: Lipton, *A Truthful Likeness*, 55–59, 138–139; *DAB*, 1, pt. 2:441–443; *Proc.*, 1st ser., 5(1860–1862):197.

Mrs. Leonard Vassall Borland (Sarah Lloyd)

Born in 1762, daughter of Dr. James and Sarah (Comrin) Lloyd of Boston. Married Leonard Vassall Borland in 1785 and had six children. He was a Boston merchant, who, in 1787, sold his grandfather's home in Braintree (that part now Quincy), to John Adams. It is the oldest portion of the Adams Mansion, now a National Park Service museum. He died on board the ship *John Jay* returning from Batavia to Boston in 1801. She died in Boston, in 1839.

ARTIST: Gilbert Stuart, about 1818.

DESCRIPTION: Oil on panel, 68.6 x 53.8 cm. Head-and-shoulders view, facing left. Light brown hair in curls under a turban held by a comb. Light brown eyes, fair complexion. Black dress with lacy ruffles and brooch at v-neck, red cashmere shawl around shoulders. Gray background with column.

PROVENANCE: Inherited by the sitter's daughter, Augusta Elizabeth Borland (1795–1861), wife of William Parkinson Greene of Boston, and later of Norwich, Con-

necticut. It was inherited by her daughter, Anna Lloyd Greene (1829–1900), wife of John Jeffries of Boston, and then to her son, William Augustus Jeffries of Milton.

Bequest to the Society by Mrs. George L. Batchelder (Katharine Abbott), a great-great-granddaughter of the sitter's son John Borland, 1977.

REFERENCES: Park, *Stuart*, 1:166; *New-York Historical Society Collections*, 2(1927–1928):889, 895; *Proc.*, 70(1950–1953):29.

James Bowdoin

Born in Boston in 1726, son of James and Hannah (Pordage) Bowdoin. Graduated in 1745 from Harvard, where he was later an overseer and benefactor. Married Elizabeth Erving in 1748. First president of the Massachusetts Bank (now the Bank of Boston), member of the General Court for various terms over 35 years beginning in 1753. First president of the American Academy of Arts and Sciences from 1780 until his death. Governor of Massachusetts from 1785 to 1787. His last official appointment was to the Massachusetts convention that approved the Federal Constitution in 1788. Owned extensive lands in Maine as well as Boston. Bowdoin College in Brunswick, Maine, chartered in 1794, was named in his honor. Died in Boston in 1790.

ARTIST: Unknown. Copy of a miniature by John Singleton Copley, which was owned by Mrs. Robert Charles Winthrop in 1915. A second copy of the miniature by Edmund C. Tarbell hangs in the State House in Boston.

DESCRIPTION: Oil on canvas, 76.2 x 63.8 cm. Head-and-shoulders view, face in right profile. White wig clubbed in back. Brown coat and waistcoat, white stock.

PROVENANCE: Belonged to Robert Charles Winthrop. Inherited by his granddaughter, Clara Bowdoin Winthrop.

From the estate of Miss Clara Bowdoin Winthrop, 1969.

REFERENCES: *Sibley's Harvard Graduates*, 11:514–549; *DAB*, 11:498–501; *American Portraits, 1620–1825*, 44–45.

Ward Nicholas Boylston

Born Ward Hallowell in Boston in 1749, son of Benjamin and Mary (Boylston) Hallowell. Changed his name in 1770 at the request of his uncle Nicholas Boylston, whose estate he inherited the next year. Married twice: Ann Molineaux, who died in 1779, and to Alicia Darrow of Yarmouth, England, in 1807. Left on a tour of Europe and the Middle East in 1773. Joined his Loyalist uncle Thomas Boylston, who had re-established his Boston merchant house in London at the outbreak of the

Revolution. Returned to Boston in 1800, settled at Princeton in the summers and spent winters at Roxbury. Benefactor of Harvard College, and founder of the Boylston Fund for medical dissertation there. Died in Roxbury in 1828.

REFERENCES: Park, *Stuart*, 1:172, 173; *Harvard Portraits*, 26; *History of the Town of Princeton, Massachusetts* (Princeton, 1915), 1:278–279.

Royal Brewster

Born in Hamden, Connecticut, in 1770, son of Dr. John and Mary (Durkee) Brewster and brother of the artist. Married Dorcas Coffin in Buxton, Maine, in 1795. Became a physician like his father, settled in Buxton where he practiced for 40 years. Died in Buxton in 1835.

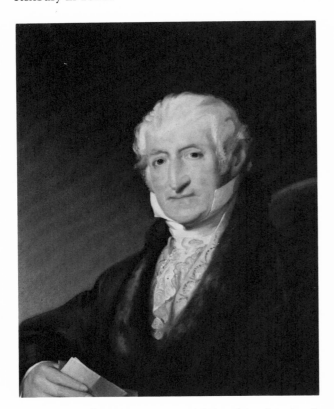

ARTIST: Gilbert Stuart, 1825. Painted at the sitter's home in Princeton in 1825 for $200. Stuart painted a similar portrait which the sitter gave in 1825 to the Boylston Medical Society, which in turn presented it to Harvard College in 1936. Another portrait of Boylston by Stuart is at the Museum of Fine Arts, Boston.

DESCRIPTION: Oil on canvas, 68.7 x 55.8 cm. Head-and-shoulders view, facing front. White hair and side whisker. Brown dressing gown with fur collar, yellow waistcoat, high white collar and jabot, papers held in right hand.

PROVENANCE: Inherited by the sitter's widow, the painting passed at her death in 1843 to a grandson, Dr. Ward Nicholas Boylston (1815–1870) of Princeton. At his death it became the joint property of his brother and sister, and in 1887 passed to the survivor of them, Louisa Catherine Adams Boylston (1827–1895), wife of Edwin J. Nightingale of Providence, Rhode Island. It was inherited by her nephew and niece, Ward N. Boylston, Jr., and Miss Barbara H. Boylston (later Mrs. Beane).

From the estate of Mrs. Barbara Boylston Beane, 1976.

ARTIST: John Brewster, Jr., about 1795.

DESCRIPTION: Oil on canvas, 68.8 x 56.0 cm. Head-and-shoulders view, facing front. Dark hair and eyebrows, brown eyes. Double-breasted black coat, high white collar with white stock. Right arm resting on back of chair; left hand holding a book with fingers between pages. Gray background.

PROVENANCE: Probably descended to Cyrus Woodman (1814–1889), whose mother was a sister-in-law of the sitter, and whose step-mother was the sitter's daughter.

Gift of Woodman's daughter, Miss Mary Woodman (1842–1928), 1920.

REFERENCE: *Connecticut Historical Society Bulletin*, 25(1960):97–103.

Sally Brown

Known as "Mammy Sally Brown," servant of Colonel William Heth of Curles, Virginia, to whose estate she belonged. Died in 1842.

ARTIST: Robert Matthew Sully. On back of canvas: "This portrait (to perpetuate the memory of an old and faithful servant) was painted by R. M. Sully and presented by him to Margaret Lorton / Richmond / March 29, 1842."

DESCRIPTION: Oil on canvas, 76.4 x 63.9 cm. Half-length view, facing front. Dark eyes, frowning expression, light brown skin. Frill white cap tied under chin, brown dress, blue apron, hands folded in lap. (*See Color Plate 6*).

PROVENANCE: Gift of John P. Reynolds, Jr., 1901.

REFERENCE: *Proc.*, 2nd ser., 16(1902):146.

Sebastian Cabot

Born probably in Bristol, England, in 1474, son of John Cabot, a merchant and Venetian navigator. Went on a voyage of discovery for the English with his father and two brothers in 1497 during which they found Cape Breton and Nova Scotia. Between 1512 and 1548 he

was in the service of Spain as a navigator and cartographer. In 1551 the Company of Merchant Adventurers was founded in London, with Cabot as governor for life, to search for new trade routes to Cathay and the east through a northeast passage. In seeking these routes the White Sea was discovered and a profitable trade with Russia opened. Died in England in 1557.

ARTIST: John Gadsby Chapman, 1838. Inscribed, upper left: "EFFIGIES * SEBASTIANI CABOTI * ANGLI.FILII * JOHANIS CABOTI * VENETI * MILITIS * AURATI * PRIMI * INVENTORIS * TERRAE * NOVAE * SUB * HENRICO.VII * ANGLIAE * REGE"; in upper right: "SPES . MEA . IN . DEO . EST." Copy of an original portrait purchased in England for £500 by Richard Biddle of Pittsburgh, Pennsylvania, who allowed Chapman to copy it for the Society for $150. The original was destroyed in an 1840 fire. A copy by Cephas Giovanni Thompson from the same original is owned by the New-York Historical Society.

DESCRIPTION: Oil on canvas, 92.1 x 73.7 cm. Three-quarter length standing view, facing front. White hair and beard. Black hat, black cloak with brown fur collar. Long gold chain around his neck reaches his waist. A globe of the world stands on his right.

PROVENANCE: Gift of Thomas L. Winthrop, 1838.

REFERENCES: *DNB*, 3:619–623; *Proc.*, 1st ser., 2(1835–1855): 101, 111, 8(1864–1865):91–96; Richard Biddle, *A Memoir of Sebastian Cabot* (Philadelphia, 1831), 523.

John Callahan

Born in Cork, Ireland, in 1745, son of John and Eleanor (Clifford) Callahan. Married Lucretia Greene* of Boston in 1774. Ran away to sea at the age of 10 and came to America. Employed as a ship captain by John Hancock and other Bostonians. Master of numerous vessels including the ship *Lucretia*, named after his wife. John and Abigail Adams and Thomas Hutchinson were among his distinguished passengers. Died in Demerara (now Suriname) in 1806.

ARTIST: Ralph Earl, 1785. Inscribed on upper stretcher: "By Earl 1785. aged 40 when this was taken Father Died in [Demerara?] 1806 aged 62."

DESCRIPTION: Oil on ticking, 71.9 x 61.2 cm. Head-and-shoulders view, facing front, eyes looking left. Gray swept-back hair clubbed in back. Blue coat and gray waistcoat, both with brass buttons, white shirt with jabot and sleeve edged with ruffle. Seated in a chair with wooden arms. Fragment of a larger group portrait. Another fragment in a private collection includes Capt. Callahan's hand and the remainder of his sleeve. He

presents a ball to his two young daughters whose hands are playfully intertwined with his own. Fragment including the mother has been lost. (*See Color Plate 7*).

PROVENANCE: Probably descended to the sitter's daughter, Mrs. Benjamin Winslow (Abigail Amory Callahan). Owned in 1903 by Mrs. Benjamin P. Winslow of Jamaica Plain.

Gift of Miss Anne R. Winslow of New York City, 1968.

REFERENCES: Nina F. Little, *Paintings by New England Provincial Artists 1775–1800* (Boston, 1976), 98; *Proc.*, 80(1968):142.

Mrs. John Callahan (*Lucretia Greene*)

Born in Boston in 1748, daughter of Benjamin and Mary (Chandler) Greene. Married Capt. John Callahan* in 1774. Made many voyages with him, and as a result their 7 children were born in different parts of the world. A digest of letters she wrote to her sister Sally in Boston from 1776 to 1778 is in the Society's collections. Died in 1824.

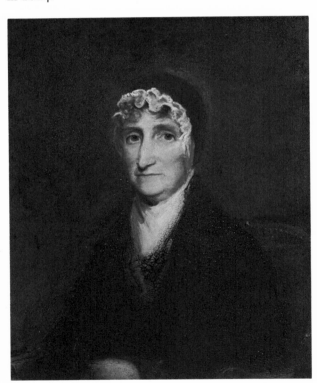

ARTIST: Unknown.

DESCRIPTION: Oil on panel, 72.1 x 60.2 cm. Seated half-length view facing front. Black bonnet with white ruffle around face, blue eyes. Black dress with white scarf

within v-neckline. Right arm resting on arm of upholstered chair.

PROVENANCE: Same as for Capt. John Callahan (q.v.).

REFERENCES: Louise Brownell Clarke, *The Greenes of Rhode Island* (New York, 1903), 1:257–258; *Proc.*, 80(1968):142.

James G. Carney

Born in Boston in 1804, son of Daniel and Sarah (Bell) Carney. Married Clarissa Willett in Boston in 1828 and that same year moved to Lowell where he became a leading citizen. Engaged in banking all his life, was the first president of the Bank of Mutual Redemption in Boston from 1858 to 1863; treasurer for 17 years of the Lowell Bank; and treasurer of the Lowell Institution for Savings from its chartering in 1829 until his death. Active in many civic activities including the Lowell Dispensary, Howard Benevolent Society, and the Lowell Cemetery Association. Created fund to award the "Carney Medals" to the 6 best scholars in the local high school. Died in Lowell in 1869.

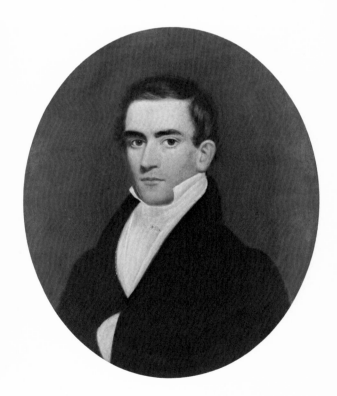

ARTIST: Charles Osgood, about 1840.

DESCRIPTION: Oil on panel, 66.3 x 53.7 cm. Head-and-shoulders view, facing front. Brown hair parted on

left, black eyebrows, brown eyes. Black coat with high collar, white waistcoat, high white shirt collar and stock, right hand thrust into coat opening. Gray-brown background.

PROVENANCE: Gift of Dr. Sidney H. Carney, Jr., grandson of the sitter, probably 1932.

REFERENCES: Sydney H. Carney, Jr., *Descendants of Mark Carney* (New York, 1904), 84–96; *Proc.*, 65(1932–1936):1, 2.

Charles Carroll

Born in Annapolis, Maryland, in 1737, son of Charles and Elizabeth (Brooke) Carroll. Married Mary Darnall, his cousin, in 1768. Member of Maryland Committee of Correspondence and Safety, delegate to the Continental Congress from 1776 to 1778, signer of the Declaration of Independence in 1776, United States senator from Maryland from 1789 to 1792. Active in business and land development, member of the Chesapeake & Ohio Canal Company, organized in 1823, and on the first board of directors of the Baltimore & Ohio Railroad. Died in Baltimore in 1832.

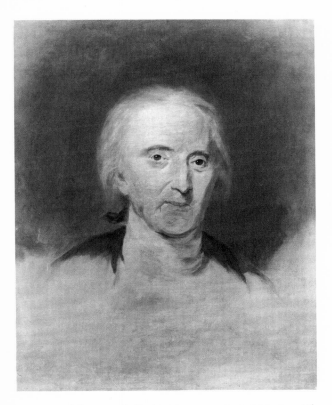

ARTIST: Thomas Sully, Baltimore, 1826. This is a life study painted between May 22 and May 25, 1826. There is a similar, although more idealized life study,

painted by Sully around the same time, in the collection of the Fine Arts Museum of San Francisco. Later paintings by Sully, related to these life studies, are at the Gilcrease Institute in Tulsa, Oklahoma, the Maryland State House, Walters Art Gallery, Yale University Art Gallery, and in a private collection.

DESCRIPTION: Oil on canvas, 61.0 x 51.0 cm. Head, eyes front. Gray hair clubbed in back, black coat, white stock. Dark background.

PROVENANCE: Given by the artist to Thomas Swann, governor of Maryland. Purchased at auction by George B. Chase.
　　Gift of Mr. Chase, 1886.

REFERENCES: *DAB*, 2, pt. 1:522–523; Monroe H. Fabian, *Mr. Sully, Portrait Painter* (Washington, D.C., 1983), 38; Records of the American Paintings Department, The Fine Arts Museum of San Francisco; *Proc.*, 2(1885–1886):261; Ann C. Van Devanter, *"Anywhere So Long As There Be Freedom"* (Baltimore, 1975), 162–171.

Charles Chauncy

Born in Boston in 1705, son of Charles and Sarah (Walley) Chauncy. Graduated from Harvard in 1721, a great-grandson and namesake of the second president of the college. Married 3 times: in 1728 to Elizabeth Hirst, who died in 1738; in 1738/9 to Elizabeth (Phillips) Townsend, who died in 1757; and in 1760 to Mary Stoddard. Minister of the First Church in Boston from 1727 until his death. One of the forerunners of Unitarianism, he was deeply involved in the religious controversies of the day. Died in Boston in 1787.

ARTIST: Unknown, possibly —— McKay, 1786. A similar portrait, for which the provenance is unknown, is owned by Harvard College. Both resemble the work of the painter of Hannah Bush (1767–1807), whose portrait is owned by the American Antiquarian Society, Worcester, and is signed twice: once as "MacKay" and once as "M'Kay, 1791."

DESCRIPTION: Oil on canvas, 79.4 x 72.2 cm. Half-length view, facing slightly left. Large white wig, double chin, black clerical robe, white bands. Seated, left hand on knee, large book resting upright on chair arm held by right hand. Drapery and back of upholstered armchair in background. (*See Color Plate 8*).

PROVENANCE: Painted for Joseph Woodward who presented it to the Society in 1833. On loan to the First Church, Boston, since 1964.

REFERENCES: *Sibley's Harvard Graduates*, 6:439–460; *DAB*, 2, pt. 2:42–43; *Harvard Portraits*, 39–41; *American Portraits, 1620–1825*, 1:77.

Rufus Choate

Born in Ipswich in 1799, son of David and Miriam (Foster) Choate. Graduated from Dartmouth in 1819. Married Helen Olcott of Hanover, New Hampshire, in 1825. Brilliant lawyer and orator; organizer of the Whig party in Massachusetts with Daniel Webster, Caleb Cushing, and Edward Everett. Completed Webster's term in the United States Senate from 1841 to 1845. Elected to membership in the Society in 1835. Died in Halifax, Nova Scotia, in 1859.

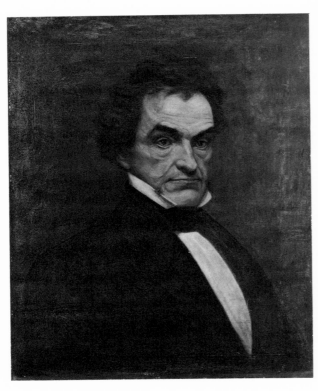

ARTIST: William Matthew Prior, about 1845. On upper stretcher: "Rufus Choate by Prior."

DESCRIPTION: Oil on canvas, 68.8 x 56.2 cm. Head-and-shoulders view, facing slightly left. Black tousled hair, wrinkled forehead, black eyebrows. Black coat, white shirt with high white collar and black tie. Dark background.

PROVENANCE: Gift of George C. Lord, 1872

REFERENCES: *Proc.*, 1st ser., 2(1835–1855):12, 4(1858–1860): 365–372; *DAB*, 2, pt. 2:86–90.

John Clarke

Born in Portsmouth, New Hampshire, in 1755, son of John and Sarah (Pickering) Clarke. Graduated from Harvard in 1774. Married Esther Orne of Salem in 1780. Became an associate of Charles Chauncy* at the First Church in Boston in 1778. At Chauncy's death in 1787 he became minister and served in that position until his death. A founder of the American Academy of Arts and Sciences and a trustee of the Humane Society, he was one of the original planners for the Boston Library. Elected to membership in the Society in 1796. Died in Boston in 1798.

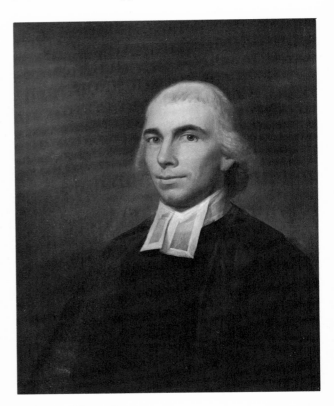

ARTIST: Henry Sargent.

DESCRIPTION: Oil on canvas, 66.7 x 52.8 cm. Head-and-shoulders view, facing slightly right, eyes front. Powdered hair, black clerical robe, neckbands and white stock. Dark background shading to light brown around head.

PROVENANCE: Painted for Joseph Barrell of Charlestown, who, shortly before his death, gave it to his son John Clarke Barrell. The latter conditionally gave it to John Clarke Derby. The latter's mother deposited it with the Society in 1834 on the condition that it be surrendered to either Barrell or Derby on request.

Given to the Society in 1879 in the name of John Clarke Derby at the direction of his sisters, Miss Eleanor Derby and Miss Harriet B. Derby. On loan to the First Church, Boston, since 1964.

REFERENCES: *Proc.*, 1st ser., 1(1791–1835):482, 17(1879–1880): 120; Arthur B. Ellis, *History of the First Church in Boston, 1630–1880* (Boston, 1881), 208–214.

David Cobb

Born in Attleborough in 1748, son of Thomas and Lydia (Leonard) Cobb. Brother-in-law of Robert Treat Paine.* Graduated from Harvard in 1766. Married Eleanor Bradish of Cambridge in 1766. Practiced medicine in Taunton, served as a distinguished general in the Revolution, was a founder of the Society of Cincinnati. Served as a representative in Congress from 1793 to 1795, as chief justice of the Court of Common Pleas in Hancock County, Maine, and as lieutenant governor of Massachusetts and president of the state senate. Active as a land speculator in Maine, his papers are in the Society's collections. Died in Boston in 1830.

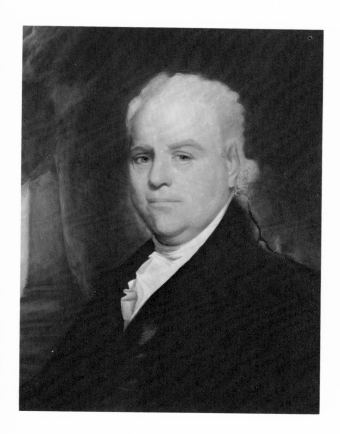

ARTIST: Chester Harding, after the original painted by Gilbert Stuart about 1820. The original portrait was owned by McKim Daingerfield of New York City in 1972.

DESCRIPTION: Oil on panel, 71.0 x 55.8 cm. Head-and-shoulders view, turned slightly right. Blue-gray eyes, gray hair. Black high-collared coat, white stock and ruffled shirtfront. Brown pillar at right, orange-brown drapery in background.

PROVENANCE: Gift of Robert Treat Paine of Brookline (1803–1885), great-nephew of the sitter, 1883.

REFERENCES: Park, *Stuart*, 1:222–223; *Sibley's Harvard Graduates*, 16:337–351; *DAB*, 4, pt. 1:239–240; *Proc.*, 1st ser., 20(1882–1883):189–190.

Isaac Collins

Born in Gloucester in 1756, son of John and Abigail (Tyler) Collins. Married Abigail Willis in Boston in 1785. Served in the army during the Revolution from 1776 to 1777 and entered naval service as a midshipman in 1778. As a master's mate he served on two vessels captured by the British. Imprisoned in England's Mill Prison in 1780, he and 4 others escaped in 1781. Settled in Gloucester in 1804. Died in Gloucester in 1834.

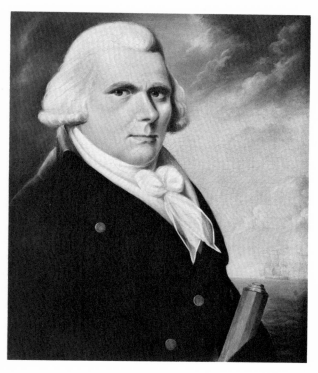

ARTIST: John Brewster, 1796. Signed, lower left: "JB 1796." Label on middle stretcher reads: "Portrait of Capt. Isaac Collins / Naval Officer in the Revolution / And Pensioner of the U.S. till he died / Painted in the year 1790 / . . . Presented to the Historical Society / by Nathaniel Willis, aged 82 / a nephew of the Captain."

DESCRIPTION: Oil on canvas, 61.1 x 50.8 cm. Head-and-shoulders view, facing left, eyes front. White wig with narrow curl at bottom, blue naval coat with brass buttons, white waistcoat and stock tied with a bow. A telescope rests on left arm. Clouds and blue sky with a ship in right background.

PROVENANCE: Gift of Nathaniel Willis, nephew of the sitter, 1862.

REFERENCES: *NEHGR*, 19(1865):212; *Proc.*, 1st ser., 6(1862–1863):20–21, 50(1916–1917):98; *Boston Marriages, 1759–1809* (Boston, 1903), 74.

Christopher Columbus

Born probably in Genoa, Italy, about 1451, son of Domenico Columbo and Suzanna Fontanarossa. Married Felipa Moniz de Perestrello about 1478 in Portugal. She died about 1484. Beatrice Enriquez was the mother of his second son. Mariner and explorer, he discovered America in 1492. Spanish monarchs designated him "admiral of the ocean sea" and viceroy and governor of the islands and mainlands in the Indies. Died in Valladolid, Spain, in 1506.

I

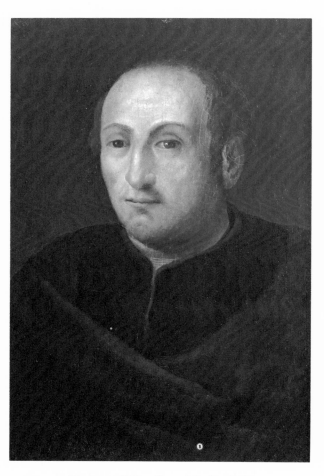

ARTIST: Giuseppe Calendi, 1788. Copied from a portrait in the Gioviana Collection of the Gallery of the Uffizi, Florence, Italy.

DESCRIPTION: Oil on canvas, 61.2 x 47.2 cm. Head-and-shoulders view, facing almost full front. Short hair, brown eyes, dark brown collarless coat under a green cloak. Brownish background.

PROVENANCE: While in Paris in the autumn of 1787, Thomas Jefferson requested Philip Mazzei to arrange for copies of the portraits of Columbus, Vespucci, Magellan, and Cortez, then thought to be hanging in Florence. Mazzei located them in the collection of the Grand Duke of Tuscany and arranged for copies at a price of one and a half guineas apiece. Jefferson received the copies in Paris in early January 1789, and they were part of his baggage when he returned to the United States that autumn. After his death, all four portraits were among those sold at Chester Harding's Boston gallery in 1833. The portrait of Columbus is the only one which can be traced with any certainty. It was purchased by Israel Thorndike for $20, and he presented it to the Society in 1835, along with the Wright portrait of Washington (q.v.) from the same sale.

II

ARTIST: Unknown. An idealized 19th-century likeness.

DESCRIPTION: Oil on canvas, 61.1 x 50.9 cm. Head-and-shoulders view in left profile. Black hair under black beret with medal or button affixed. White shirt under tan waistcoat, red coat with fur collar.

PROVENANCE: According to family tradition, the portrait was given to William Hickling Prescott by Queen Isabella II of Spain. The portrait presumably was inherited by Mrs. James Lawrence (Elizabeth Prescott), a daughter of the historian, and eventually by her grandson Harold Peabody.

From the estate of Mrs. Harold Peabody (Marian Lawrence), 1974.

REFERENCES: Jefferson, *Papers*, 12:245, 14:440, 467–468, 15:xxxv–xxxvi; *Proc.*, 1st ser., 2(1835–1855):23, 25, 83(1971):19, 86(1974):126.

George Combe

Born in Edinburgh, Scotland, in 1788, son of George and Marion (Newton) Combe. Married in 1833 Cecilia Siddons, daughter of the well-known actress, Mrs. Sarah Siddons. Had a distinguished career as a teacher and phrenologist, and lectured in America on phrenology from 1838 to 1840. A colleague of Johann Spurzheim,* he was author of treatises in philosophy and phrenology including *Constitution of Man*. Died in Farnham, England, in 1858.

ARTIST: Sir Daniel Macnee, 1836. Inscribed on back: "Geor. Combe -/ Dan Macnee. pinxit / Sept. 1836."

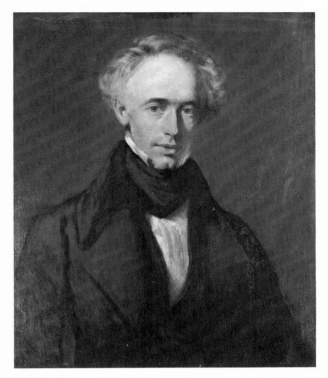

DESCRIPTION: Oil on canvas, 76.3 x 63.5 cm. Head-and-shoulders view, facing almost front. Brownish gray tousled hair, light brown eyes. White shirt with black stock, black coat. Reddish gray background.

PROVENANCE: Owned by Nahum Capen at his death in 1886. Inherited by his daughter, Mrs. Shelton Barry (Elizabeth Sprague Capen).
Gift of Mrs. Barry, 1915.

REFERENCES: *DNB*, 4:883–885; *Proc.*, 49(1915–1916):59.

Samuel Cooper

Born in Boston in 1725, son of Rev. William Cooper* and Judith (Sewall) Cooper, and a grandson of Samuel Sewall.* Graduated from Harvard in 1743. Married Judith Bulfinch in 1746. Succeeded his father as minister of the Brattle Street Church in Boston, where he served from 1745 until his death. An active and influential patriot, it was to Cooper that Benjamin Franklin sent the stolen letters of Governor Thomas Hutchinson. Like his father, elected president of Harvard (in 1774) but declined the position. A founder of the American Academy of Arts and Sciences, and its first vice president in 1780. Died in 1783.

I

ARTIST: Attributed to John Singleton Copley.

DESCRIPTION: Oil on canvas, 47.2 x 37.2 cm. Head-and-shoulders view, facing front. Full gray wig curled on bottom, brown eyes, smiling. Black clerical robes, white bands. Dark background.

PROVENANCE: Gift of Chandler Robbins, 1836.

II

ARTIST: Attributed to John Singleton Copley.

DESCRIPTION: Oil on canvas, 76.5 x 63.5 cm. Same pose as I, but eyes are more blue than brown and bands have a wider hem.

PROVENANCE: Bequest of Rev. Samuel Kirkland Lothrop, minister of the Brattle Street Church and a member of the Society, 1886. (*See Color Plate 9*).

NOTE: There are several versions of this portrait. The one owned by Harvard has a provenance from Dr. Cooper himself to Harvard's donor in 1849, Thomas Curtis Clarke. A replica, now owned by the Ralph Waldo Emerson House, Concord, has a label on the canvas signed by Emerson stating "This portrait was given by the Brattle Square Church to my grandfather, William Emerson of the First Church. It has always hung here on the stairs." Another version belongs to Williams College. There is no agreement as to which version of this likeness is the original. Prown in his *Copley* treats the Williams College version as the original, but does not mention the Harvard portrait; Parker and Wheeler in their *Copley* consider the Emerson House version as the original and the Harvard portrait as a copy.

REFERENCES: *Sibley's Harvard Graduates*, 11:192–213; Prown, *Copley*, 1:212; Parker and Wheeler, *Copley*, 61–63; *Harvard Portraits*, 45; *Proc.*, 1st ser., 2(1835–1855):52, 2d ser., 3(1886–1887):57, 276, 284.

William Cooper

Born in Boston in 1694, son of Thomas and Mehitable (Minot) Cooper. Graduated from Harvard in 1712. Married twice, to Judith Sewall, daughter of Judge Samuel Sewall,* in 1720, and to Mary Foye in 1742. Father of Rev. Samuel Cooper* and William Cooper, Boston's town clerk during the Revolution. A colleague of Benjamin Colman at the Brattle Square Church in Boston from 1715 until his death. Elected president of Harvard College in 1737 but declined the position. Died in Boston in 1743.

ARTIST: John Smibert, 1743. Handwritten label on back of frame: "The Revd Mr. William Cooper / of Boston in New England Aet 50 1743 / J Smibert Pinx - P. Pelham fecit an engraving of this is in the possession of A. S. Manson Esq."

DESCRIPTION: Oil on canvas, 76.5 x 63.5 cm. Head-and-shoulders view, facing front. Curly gray wig, brown

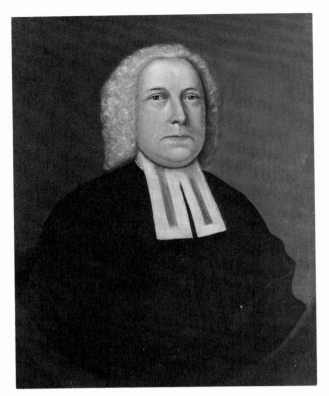

eyes, round double chin. Black clerical robes, white bands. Gray background.

PROVENANCE: The unidentified portrait hung in the Society's gallery for many years, deposited by an unknown person. In 1880 it was identified as William Cooper and found to have been the property of Capt. William E. Perkins, a descendant.

Gift of William Perkins, 1880.

REFERENCES: Foote, *Smibert*, 146–147; Smibert, *Notebook*, 98, 117; *Sibley's Harvard Graduates*, 5:624–634; Andrew Oliver, "Peter Pelham (c.1697–1751)," in *Publications of the Colonial Society of Massachusetts*, 46(1973):152–155; *Proc.*, 1st ser., 17(1880–1881):328, 51(1917–1918):167.

Hernando Cortez

Born in Medellin, Estremadura, Spain, in 1485. In 1518 chosen to lead an expedition to Mexico. Began negotiations with the Aztecs but eventually captured the capital city, subjugated the Indian emperor Montezuma, and destroyed the power of the Aztecs. As captain general, Cortez extended the conquest sending out his lieutenants over Mexico and Central America. Died in Castilleja de la Cuesta, near Seville, Spain, in 1547.

ARTIST: Unknown.

DESCRIPTION: Oil on canvas, 55.0 x 44.7 cm. Half-length view, almost full front. Head turned half-way right. Beard and mustache. Wears a velvet cap with feather and dark coat. Left hand on hip, right in front with outstretched fingers. Monochrome.

PROVENANCE: A label on the back of the painting states: This "Picture of Cortez came from Europe with one of the Huguenot families that settled in New England, after the revocation of the Edict of Nantes. Bequeathed to the late John Foster, D.D., of Brighton. It is presented to the Massachusetts Historical Society by his widow, April 29, 1830."

Gift of Mrs. Foster, 1830.

REFERENCES: William H. Prescott, *History of the Conquest of Mexico*, 3 vols. (Philadelphia, 1873), 1:23off.; *Proc.*, 1st ser., 1(1791–1835):446, 4(1858–1860):108; *MHS Coll.*, 3rd ser., 3:405.

Edward Cummings

Born in Colebrook, New Hampshire, in 1861, son of Edward Norris and Lucretia Frances (Merrill) Cummings. Graduated from Harvard in 1883; and from Harvard Divinity School in 1885. Married Rebecca Haswell Clarke* in 1891. A Unitarian, he was minister of the South Congregational Society of Boston from 1900 until it merged with the First Church in 1925, and a colleague there of Edward Everett Hale. Prominent in the World Peace Foundation. Died in an automobile accident near Ossipee, New Hampshire, in 1926.

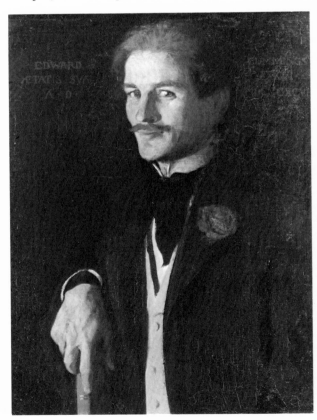

ARTIST: Charles Sydney Hopkinson, 1897. Signed, lower right: "Hopkinson"; in block letters flanking the subject's head: "EDWARD CUMMINGS / AETATIS SUAE XXXVI / A.D. MDCCCXCVII."

DESCRIPTION: Oil on canvas, 63.5 x 50.9 cm. Half-length view, turned one-half right, eyes front. Brown hair and mustache. High-collared white shirt, black tie, buff waistcoat under black coat, red carnation in buttonhole. Right hand resting on chair. Dark background.

PROVENANCE: Gift of Edward Estlin Cummings, son of the sitter, 1954.

REFERENCES: *Harvard College Class of 1883, Fiftieth Anniversary Report* (Cambridge, Mass., 1933), 84–86; *Proc.*, 71(1953–1957):455; "Edward Cummings, The Father of the Poet," by Richard S. Kennedy, *Bulletin of the New York Public Library*, 70(1966):437–439.

Mrs. Edward Cummings (Rebecca Haswell Clarke)

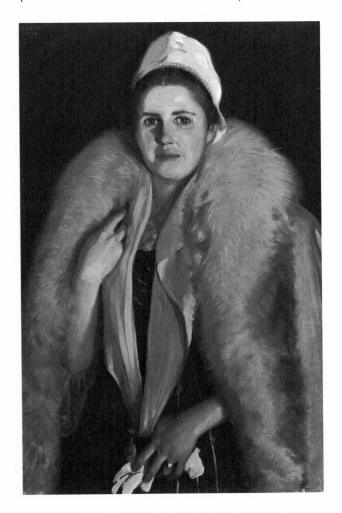

Born Rebecca Haswell Hanson, daughter of Mary Lewist Clarke and John A. Hanson in 1859. Took her mother's maiden name when the marriage of her parents was annulled in 1873. Married Rev. Edward Cummings* in Roxbury in 1891. They lived in Cambridge and New Hampshire and were parents of poet e.e. cummings.* Died in Northfield, Minnesota, in 1947.

ARTIST: Charles Sydney Hopkinson, 1898. Inscribed, upper left: "1898 / Hopkinson."

DESCRIPTION: Oil on canvas, 90.4 x 59.4 cm. Three-quarters length view, facing front. Brown hair and eyes. Close fitting light blue hat, light blue and navy dress, tan coat with fur collar, broad gold wedding ring on left hand, holding a glove. Dark background.

PROVENANCE: Gift of Edward Estlin Cummings, son of the sitter, 1954.

REFERENCES: *Proc.*, 71(1953–1957):455; Cummings Papers, MHS; *Boston Herald*, Jan. 16, 1947, 11.

Edward Estlin Cummings (e.e.cummings)

Born in Cambridge in 1894, son of Rev. Edward Cummings* and Rebecca (Clarke) Cummings.* Graduated from Harvard in 1915. Married three times: to Elaine Orr, in 1927 to Anne Barton, and in 1933 to Marion Morehouse.* Studied painting in Paris, but is best known as e.e.cummings, the poet with a trademark disregard

of capitalization and punctuation. His first book, *The Enormous Room*, was based on a 3-month internment in a German detention camp during the First World War. Numerous other works of poetry and prose made him one of the country's leading literary figures. Lived in New York City and spent summers at a family home on Silver Lake, New Hampshire. Appointed Charles Eliot Norton professor of poetry at Harvard in 1952, elected to the American Academy of Arts and Letters in 1953. Died in North Conway, New Hampshire, in 1962.

ARTIST: Charles Sydney Hopkinson, 1896. Signed, lower left: "Hopkinson / June 1896."

DESCRIPTION: Oil on canvas, 81.4 x 79.6 cm. Full-length view of a small boy, facing front. Blonde hair with a light brown ribbon, blue eyes. White dress, brown shoes trimmed with blue. Holds a brown rubber ball in right hand. Green background of grass and leaves.

PROVENANCE: From the estate of Mrs. Edward Estlin Cummings, 1969.

REFERENCES: *Selected Letters of E.E. Cummings*, ed. by F. W. Dupee and George Stade (New York, 1969); *Proc.*, 82(1970):155.

Mrs. Edward Estlin Cummings (Marion Morehouse)

Born in South Bend, Indiana, in 1906. Married as his third wife Edward Estlin (e.e.) Cummings* in 1933. Became an actress in New York and appeared in several stage roles but soon turned to modeling. Described by Edward Steichen as "the greatest fashion model I ever shot," in his 1963 *A Life in Photography*. A photographer herself, she published a volume entitled *Adventures in Values* (1962) with captions by her husband. Died in New York City, in 1969.

ARTIST: William James, in New Hampshire, probably 1952/1953. Signed, lower left: "William James."

DESCRIPTION: Oil on canvas, 51.2 x 40.6 cm. Head facing front. Brown hair plastered to head, somber face, red lips. Rose colored v-neck dress with turned-over collar. Stark white background.

PROVENANCE: From the estate of Mrs. Edward Estlin Cummings, 1969.

REFERENCES: *New York Times*, May 19, 1969, 47; *Proc.*, 82(1970):155.

George William Curtis

Born in Providence, Rhode Island, in 1824, son of George and Mary Elizabeth (Burrill) Curtis. Graduated from Brown University in 1853. Married Anna Shaw in 1856. Associated briefly with the *New York Tribune* and *Putnam's Monthly* magazine; editor of *Harper's* from 1863 until his death. Through his writings and speeches, advocated political and social reforms and was among the first to fight for the enfranchisement of women. Elected to membership in the Society in 1875. Died on Staten Island, New York, in 1892.

ARTIST: Caroline Amelia Cranch. The artist was the daughter of the sitter's friend Christopher Pearse Cranch.

DESCRIPTION: Oil on academy board, 33.5 x 27.7 cm. Head-and-shoulders view, turned left, head in left profile. Gray hair and sideburns, pince-nez glasses. Turned-down collar on white shirt, black coat and tie. Reading a book. Dark background. There is a sketch of a young girl on the reverse side.

PROVENANCE: Probably given with the Cranch Papers in 1941.

REFERENCES: Lenora Cranch Scott, *The Life and Letters of Christopher Pearse Cranch* (Boston, 1917); *NEHGR*, 47(1893):228; *Proc.*, 2d ser., 8(1892–1894):1; *DAB*, 2, pt. 1:614–616.

Mrs. George Davie
(Mary Mirick?)

Born about 1635, probably the daughter of John Mirick of Charlestown. The Rev. William Bentley of Salem wrote in his diary, Sept. 28, 1798: "She had three husbands by whom she had 9 children. 45 Grand children. 215 Great Grand Children. 800 Great Grand children's Children. At 104 years she could do a good Day's work at Shelling Corn. At 110 years she sat at her spinning wheel. By notice on the canvas 1962, probably 1662, that might be the year of her arrival, for the settlement on the Kennebec at Wiscasset Point, was in 1662, under one George Davie, whose children write Davis. . . . In 1680 they were driven away, & in 1730 began again, but on Sheepscott River." After his death she returned to Charlestown and later moved to Newton. Died in Newton at the age of about 117 in 1752.

ARTIST: Attributed to Nathaniel Smibert, about 1750. "The portrait is said to have been painted in response to a request made by Governor Belcher to Judge Paul Dudley, after a visit to Mrs. Davie near the end of her life, that he would arrange to have her painted" by "Smibert."

DESCRIPTION: Oil on canvas, 33.1 x 23.5 cm. Head. Wrinkled old face tied in a kerchief with a white tuft of hair showing underneath.

PROVENANCE: On Sept. 28, 1798, Bentley noted that, "I was favoured from Madame Skinner of Marblehead with a likeness of Mary Davis."

Gift of Rev. William Bentley, a member of the Society, 1801.

REFERENCES: *The Diary of William Bentley, D.D.* (Salem, Mass., 1907), 2:283–284; Foote, *Smibert*, 266–267.

John Davis

Born in Plymouth in 1761, son of Thomas and Mercy (Hedge) Davis. Graduated from Harvard in 1781. Married Ellen Watson in 1786. Elected 3 times to Massachusetts House of Representatives, and in 1795 to the State Senate from which he resigned to become comptroller of the treasury of the United States from 1795 to 1796. Appointed United States Attorney for the District of Massachusetts in 1801, a position he held until 1841. A member of the American Academy of Arts and Sciences, the American Philosophical Society, a treasurer and member of the board of overseers at Harvard. Elected to membership in the Society in 1791 and served as its third president from 1818 to 1835. Died in Boston in 1847.

ARTIST: Joseph Greenleaf Cole, 1836.

DESCRIPTION: Oil on canvas, 87.4 x 73.4 cm. Half-length view, facing front. White hair, brown eyes. White stock with ruffle under black coat with shawl collar. Left hand rests on upright book. Seated in red upholstered chair. Dark background.

PROVENANCE: Gift of Thomas Lindall Winthrop, 1836.

REFERENCES: *DAB*, 5, pt. 1:132–133; *MHS Coll.*, 3rd ser., 10:186–203; *Proc.*, 1st ser., 2(1835–1855):29.

Samuel Worthington Dewey

Born in Falmouth in 1807, son of Samuel M. and Mercy Dewey. Went to sea at the age of 13 and eventually became first mate of the ship *Topaz*. Best known for his daring exploit of July 2, 1834, when he sawed off the top of the much-protested figurehead of Andrew Jackson on the ship *Constitution*. The figurehead, fastened to the ship's bow earlier in the year by order of the Jackson administration's Navy department, created much opposition in Massachusetts. Later engaged in the South American shipping trade as a broker with offices in New York. Retired from that business in 1845 and "turned his attention to mineralogy and incidentally to political matters." Died in Philadelphia in 1899.

ARTIST: Henry Peters Gray, about 1840–1845. Label affixed to back by the donor: "Painted by Henry Peters Gray 1840 or 1845, the first president of the Academy of Design of New York; so I am told by his daughter Miss Florence de Noyon Gray in 1931 in her eighty-first year."

DESCRIPTION: Oil on canvas, 75.7 x 63.8 cm. Head-and-shoulders view, facing front. Light brown hair, brown eyes. White shirt and black high-collared vest. Olive-brown background.

PROVENANCE: Written on the stretcher: "Painted for Mrs. George Clarke, Late of N.Y."
Gift of Guy Waring, 1931.

REFERENCES: *Proc.*, 64(1930–1932):404; Oliver B. Brown, *Vital Records of Falmouth, Massachusetts to the year 1850* (Warwick, R.I., 1976), 35; *Boston Evening Transcript*, June 12, 1899.

George Dexter

Born in Fulton, Ohio, in 1838, son of Edmund and Mary Ann (Dellinger) Dexter. Graduated from Harvard in 1858 and from Harvard Law School in 1860. Married Lucy Waterston Deane in 1868. A scholar, historian, and writer, he traveled extensively and contributed to worthy causes and institutions. Elected to membership in the Society in 1877, where he followed his father-in-law, Charles Deane, as recording secretary. Frequent contributor of papers at Society meetings, many are published in the *Proceedings*. Died in Santa Barbara, California, in 1883.

ARTIST: Otto Grundmann, 1887. Drawn from a photograph taken in 1865. Signed, lower left: "Otto Grundmann - / 1887."

DESCRIPTION: Crayon and charcoal, 71.3 x 55.9 cm. Head-and-shoulders view, facing slightly left. Curly hair, sideburns, mustache and beard. White shirt, striped tie, with buttoned vest and coat. Light background.

PROVENANCE: Given in accordance with the wish of Lucy Waterston Dexter.
Bequest of Mary Deane Dexter, daughter of the sitter, 1951.

REFERENCES: *Proc.*, 2d ser., 1(1884–1885):327–334, 4(1887–1889):54, 70(1950–1953):338.

Eunice Diman

Born in Salem in 1752, daughter of Rev. James and Mary (Orne) Diman. Married Thomas Mason, Jr., in 1774. As a widow, she married, as his second wife, Capt.

Jonathan Haraden, a distinguished naval commander and privateer in the American Revolution, in 1782. Died in Salem in 1796.

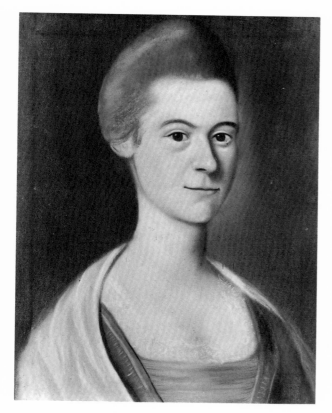

ARTIST: Benjamin Blyth, about 1774.

DESCRIPTION: Pastel on paper, 51.0 x 41.5 cm. Head-and-shoulders view. Brown hair and eyes. Low-cut, square-necked blue dress trimmed with white lace, light tan shawl over shoulders. Gray background.

PROVENANCE: Gift of Mrs. Irving W. Bailey (Helen Diman Harwood), 1972.

REFERENCES: *Vital Records of Salem, Massachusetts*, 6 vols. (Salem, Mass., 1916–1925), 3:297, 5:310; Walter Muir Whitehill, *Portraits in the Peabody Museum* (Salem, Mass., 1939), 57; *Proc.*, 84(1972):134, 139.

Mrs. Nathaniel Dowse (Margaret Temple)

Born in Concord in 1724, daughter of Robert and Mehitable (Nelson) Temple and sister of Sir John Temple.* Married Nathaniel Dowse, a sea captain of Charlestown, in 1746. Had five children including Mary who married Samuel Nicholson.* They removed to Concord in 1759. Died in 1771.

ARTIST: Joseph Blackburn, about 1757.

DESCRIPTION: Oil on canvas, 129.7 x 104.6 cm. Three-quarter length view, facing front, head turned slightly right. Dark brown hair, brown eyes. Low-cut greenish blue dress, trimmed with wide white lace at neck and undersleeves. Seated, right hand in lap holds spray of pink flowers. Dark landscape background. (*See Color Plate 10*).

PROVENANCE: Gift of Miss Clara Bowdoin Winthrop, whose grandfather, Robert C. Winthrop, was the great-nephew of the sitter, 1934.

REFERENCES: *Proc.*, 1st ser., 16(1878):391, 58(1924–1925):147, 65(1932–1936):268; Dows, *Dowse Family*, 25.

Thomas Dowse

Born in Charlestown in 1772, son of Eleazer and Mehitable (Brentnall) Dowse. A leather dresser by trade, he was an avid book collector, reader, and philanthropist. He said of Walter Scott, in reference to their common physical disability, "Lameness drove us both to books, him to making them and me to reading them." Gave his fine library to the Society and became one of its greatest benefactors. Died unmarried in Cambridge in 1856.

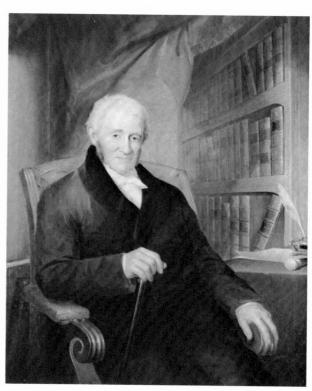

ARTIST: Moses Wight, 1856. Signed, lower right: "M. Wight Pinxt 1856." The Boston Athenaeum has a slightly different version of this portrait which Wight copied from the Society's portrait.

DESCRIPTION: Oil on canvas, 127.2 x 101.7 cm. Three-quarters length view, facing front. Gray hair, darker sideburns, gray-blue eyes. White shirt with ruffle and tie under brown coat with velvet collar. Right hand resting on cane. Seated in an upholstered armchair, table with green cover to left. Red drapery and shelf of books in background.

PROVENANCE: On August 5, 1856, in accepting the donation of the private library of Mr. Dowse, the Society also resolved that it would "respectfully and earnestly ask the favor of Mr. Dowse, that he will allow his portrait to be taken for the Society, to be hung for ever in the room which shall be appropriated to his Library." Edward Everett took on the task of approaching Dowse. "I recommended to him strongly the highly promising youthful artist, Mr. Wight, for whom I had had the pleasure, a few years ago, of procuring an opportunity to paint the portrait of the illustrious Humboldt.* Mr. Dowse consented with the hesitation inspired by his characteristic diffidence and humility; and the result does the highest credit to Mr. Wight's artistic skill and taste." Within a few months, Dowse died.

Commissioned by the Society, 1856.

REFERENCES: Dows, *Dowse Family*, 36–37; Jonathan P. Harding, *The Boston Athenaeum Collection* (Boston, 1984), 64–65; *Proc.*, 1st ser., 3(1855–1858):108–110, 115–122, 71(1953–1957):167–178.

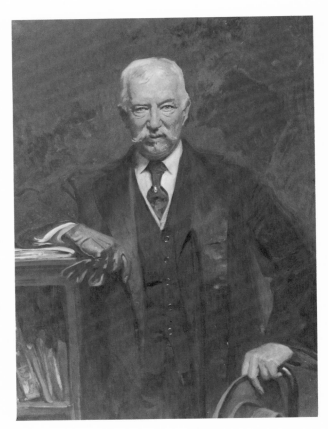

stickpin, black vest and coat under overcoat, brown gloves, gray hat held in left hand. Standing, right elbow resting on shelf which holds books and papers. Greenish brown background.

PROVENANCE: Gift of the sitter, 1926.

REFERENCES: Dows, *Dowse Family*, 184, 279; *Proc.*, 60(1926–1927):88, 62(1928–1929):67–84.

William Bradford Homer Dowse

Born in Sherborn in 1852, son of Edmund and Elizabeth (Bowditch) Dowse, grand-nephew of Thomas Dowse.* Graduated from Harvard in 1873 and from Harvard Law School in 1875. Married Fanny Lee Reed in 1883. Bought the patent for a "snap fastener" about 1882 and organized the United States Fastener Company. Gave up his law practice in 1898 and became president of his father-in-law's silver manufacturing company. Active in many historical and patriotic organizations, a member of the Society from 1918. Died in Boston in 1928.

ARTIST: Hermann Hanatschek, 1925. Signed, upper right: "H. Hanatschek / 1925."

DESCRIPTION: Oil on canvas, 114.4 x 83.8 cm. Three-quarters length view, facing front. White hair, mustache and goatee, gray eyes. White shirt, black tie with

Anne Dudley

Born in Roxbury in 1684, daughter of Gov. Joseph Dudley* and Rebecca (Tyng) Dudley.* Despite long-standing political feuds between their fathers and grandfathers, married John Winthrop, F.R.S.,* in 1707. Moved to New London, Connecticut, where she raised seven surviving children and managed the family properties after her husband left for England in 1726. He died in England in 1747, and in 1750 she married Jeremiah Miller, a prominent citizen of New London. Died in New London in 1776.

ARTIST: Unknown. Copy of a portrait also by an unknown artist. Copy commissioned by Robert C. Winthrop, Jr., 1872, after the original then owned by Grenville Lindall Winthrop of New York.

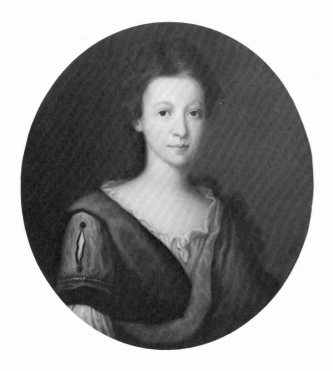

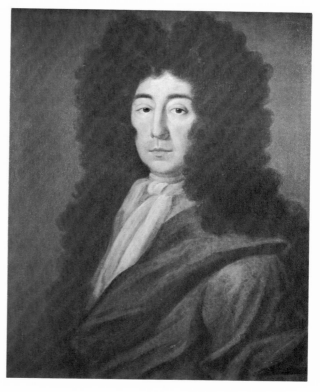

DESCRIPTION: Oil on canvas, 76.0 x 63.0 cm. Half-length view, facing front. Brown wavy hair with curls over left shoulder, dark brown eyes. Brown dress with slit short sleeve, white chemisette. Background in two shades of brown.

PROVENANCE: Gift of Miss Clara Bowdoin Winthrop, 1934.

REFERENCES: Mayo, *Winthrop Family*, 121, 132, 136; Winthrop Papers, MHS; *Proc.*, 65(1932–1936):268.

Joseph Dudley

Born in Roxbury in 1647, son of Gov. Thomas and Catherine (Dighton) (Hackburn) Dudley. Graduated from Harvard in 1665. Married Rebecca Tyng* in 1668. One of two commissioners to England from the United Colonies from 1677 to 1681. After the revocation of the old charter in 1685 was appointed president of the Council, and governor of New Hampshire, Massachusetts, and the King's Province until the arrival of Edmund Andros. Served in the Council of Governor Andros from 1686 to 1689 when the governor was overthrown. Dudley was arrested and imprisoned for 10 months until the king ordered him released and taken to England. Spent several years in England during which time he was deputy governor of the Isle of Wight. Was captain general and governor in chief of Massachusetts Bay Colony from 1702 to 1715. Died in Roxbury in 1720.

ARTIST: Unknown, painted in England, probably between 1682 and 1686. A similar portrait by an unidentified artist, possibly a copy of the Society's painting, is at Harvard University.

DESCRIPTION: Oil on canvas, 76.1 x 63.3 cm. Head-and-shoulders view, facing slightly left. Long flowing wig, long white cravat tied around neck, rust-brown coat. Brown background.

PROVENANCE: Gift of Henry A. S. D. Dudley, a descendant of the sitter, 1870.

ARTIST: Unknown, painted in England, probably about 1701.

DESCRIPTION: Oil on canvas, 76.3 x 63.9 cm. Similar pose to I, but cravat is more loosely tied and right hand appears at bottom.

PROVENANCE: Formerly in the New London collection of the Winthrop family portraits. Later owned by a descendant Robert Charles Winthrop, and inherited by his granddaughter, Clara Bowdoin Winthrop.
 Gift of Miss Clara Bowdoin Winthrop, 1934.

REFERENCES: *DAB*, 3, pt.1:481–483; Catalogue of American Portraits, NPG; *Proc.*, 1st ser., 11(1869–1870):201, 252, 2d ser., 2 (1885–1886):195–196, 58(1924–1925):146, 65(1932–1936):268.

Mrs. Joseph Dudley
(Rebecca Tyng)

Born in Boston in 1651, daughter of Edward and Mary (Sears) Tyng. Married Gov. Joseph Dudley* in 1668 and had 13 children including Anne Dudley.* "That which She was eminent for above many, was her Humility, Meekness and Poverty of Spirit. She was a most Affectionate and Faithful Wife, a Kind, Careful and Tender Mother, and an Excellent Christian, high Esteemed, Respected and Beloved in her Life; Lamented and Honour'd at the Death." Died in Roxbury in 1722.

Henry Edes

Born in Boston in 1778, son of Edward and Elizabeth (Edes) Edes. Graduated from Harvard in 1799. Married Catharine Cravath May* in Boston in 1805. Studied law and practiced in Boston for a time. In 1826 earned a divinity degree from Harvard and became minister of the First Congregational Society of Providence, Rhode Island, a position he held from 1805 to 1832. Served as a trustee of Brown University from 1809 to 1813. Returned to Massachusetts and lived for some years with his children in Dorchester. Died in Worcester in 1851.

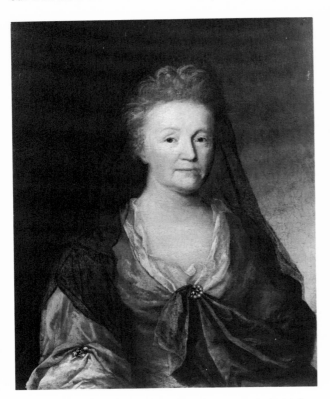

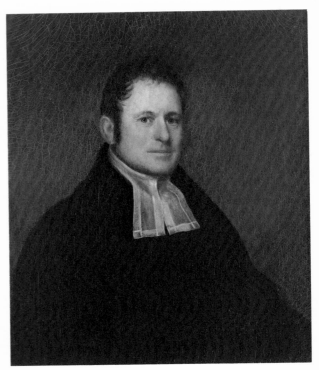

ARTIST: Unknown. Probably painted in England between 1682 and 1686. There is a similar portrait by an unidentified artist at Harvard University.

DESCRIPTION: Oil on canvas, 76.6 x 63.8 cm. Head-and-shoulders view, facing front. Brown hair covered with black lace shawl, low-cut red dress with white chemisette showing at neck and wrist. Jewels at neck and sleeve. Brown shaded background.

PROVENANCE: Gift of Henry A. S. D. Dudley, a descendant of the sitter, 1870.

REFERENCES: *NEHGR*, 9(1855):172, 10(1856):130; *Boston News-Letter*, Oct. 1, 1722; Catalogue of American Portraits, NPG; *Proc.*, 11(1869–1870):201, 252.

ARTIST: Unknown.

DESCRIPTION: Oil on canvas, 73.1 x 62.1 cm. Head-and-shoulders view, facing front. Dark hair and sideburns, blue-gray eyes, black robes, white clerical bands. Gray background.

PROVENANCE: Gift of Edward L. Edes, 1959.

REFERENCES: Edes Family Papers, MHS; *Proc.*, 72(1957–1960): 475.

Mrs. Henry Edes
(Catharine Cravath May)

Born in Boston in 1782, daughter of John and Abigail (May) May. Married Henry Edes* in Boston in 1805.

Lived most of her married life in Providence, Rhode Island, where her two sons were educated. Late in life traveled extensively in this country and in Europe. Died in Boston in 1856.

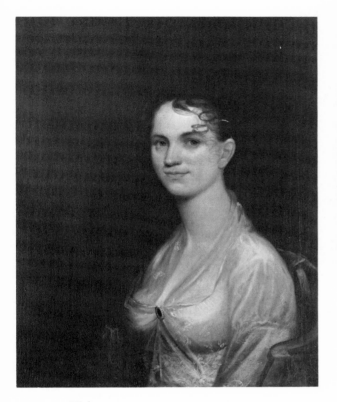

ARTIST: Unknown.

DESCRIPTION: Oil on canvas, 74.2 x 60.8 cm. Head-and-shoulders view turned slightly right, facing front. Brown hair, curls on forehead under round braid. Low-cut, light gray figured dress with pearl brooch. Seated in wooden armchair with a red shawl visible over back. Dark background.

PROVENANCE: Gift of Edward L. Edes, 1959.

REFERENCES: Edes Family Papers, MHS; *Proc.*, 72(1957–1960): 475; *NEHGR*, 10(1856):291, 27(1873):15, 32(1878):123.

John Eliot

Born in Boston in 1754, son of Andrew and Elizabeth (Langdon) Eliot. Graduated from Harvard in 1772. Married Ann Treadwell of Portsmouth, New Hampshire, in 1784. Pastor of the New North Church in Boston from 1779 until his death. One of the founders of the Society, its librarian and cabinet keeper, editor of several volumes of its *Collections*, and author of the *New England Biographical Dictionary*. Died in Boston in 1813.

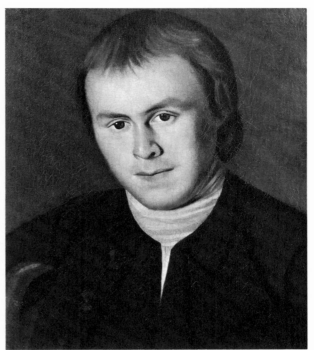

ARTIST: Samuel King, 1779. Inscribed on back of canvas: "Rev. John Eliot / 1754–1813 / Painted By / Samuel King / In 1779."

DESCRIPTION: Oil on canvas, 46.3 x 41.2 cm. Head-and-shoulders view, facing front. Brown hair, brown eyes. White neckcloth under dark brown waistcoat and coat with large buttons.

PROVENANCE: John F. Eliot to Charles Deane of the Society, Boston, Dec. 8, 1865: "I have had in my possession, for many years, a portrait of Rev. John Eliot, D.D., one of the original members of the Massachusetts Historical Society. Where it came from, or by whom painted, is not known. I remember it more than fifty years ago, hanging in the parlor of Captain Nathaniel Goodwin, of this city (who married a sister of Dr. E.); and at his death it fell into my hands, and has so remained to the present time. My personal recollection of Dr. Eliot is very slight, but I should say that there is a strong resemblance; yet I have always understood that his friends were never satisfied with it as a likeness. . . . The Doctor himself was never pleased with it."

Gift of John F. Eliot, 1865.

REFERENCES: *MHS Coll.*, 2d ser., 1:211–229; *Proc.*, 8(1864–1865):481–482, 61(1927–1928):104.

George Edward Ellis

Born in Boston in 1814, son of David and Sarah (Rogers) Ellis. Graduated from Harvard in 1833 and from Har-

vard Divinity School in 1836. Twice married: in 1840 to Elizabeth Bruce Eager, who died in 1842, and to Lucretia Goddard Gould in 1859. Pastor of the Harvard Unitarian Church in Charlestown from 1840 to 1869. First professor of systematic theology at the Harvard Divinity School from 1857 to 1863, established the Free Ministry at Harvard and was influential in the building of the Harvard Chapel. A Harvard overseer from 1850 to 1879. Elected to membership in the Society in 1841, he was vice president from 1877 to 1885 and president from 1885 until his death. Died in Boston in 1894.

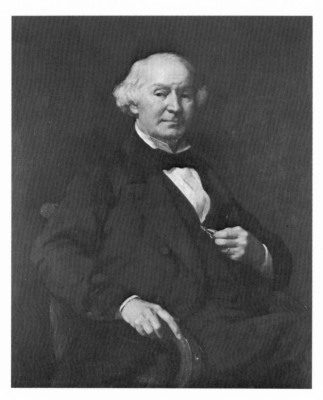

ARTIST: Frederic Porter Vinton, June 1880. Signed, lower left: "Fred'c P. Vinton 1880."

DESCRIPTION: Oil on canvas, 106.9 x 86.7 cm. Three-quarter length view, turned slightly left, eyes front. White wavy hair back from forehead. Wing collar on stiff white shirt, black tie and suit. Seated, fingering watch fob with left hand, right resting on wooden arm of chair. Dark background.

PROVENANCE: Bequest of the sitter, 1895.

REFERENCES: *DAB*, 6, pt. 2:103–104; *Proc.*, 2d ser., 10(1895–1896):207–255, 292.

John Endecott

Born in Devonshire, England, about 1589, son of Thomas and Alice (Westlake?) Endecott. Came to Naumkeag (now Salem) with his wife, Ann (Gower), in 1628 as an incorporator of the Massachusetts Bay Colony and was in charge until John Winthrop arrived in 1630. Married Elizabeth Gibson as his second wife in 1630, and she was the mother of his two sons. Served as assistant to Governor Winthrop and was governor himself four times between 1644 and 1664. Died in Boston in 1665.

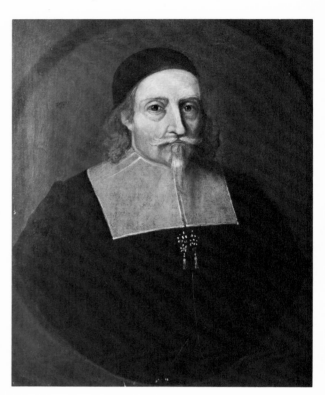

ARTIST: John Smibert, 1739. Copied from the original, painted in 1665 in Boston by an unknown artist and owned by William Crowninshield Endicott of Danvers in 1935. Two other copies of the original are owned by the American Antiquarian Society, another by the Essex Institute, and there may be as many 19 others.

DESCRIPTION: Oil on canvas, 76.1 x 64.1 cm. Head-and-shoulders view, facing front. Wavy gray hair hanging to shoulders, white mustache and goatee. Black cap and robe, broad white collar with straight lower edge and two tassels below. Black oval painted around figure on gray background. No right hand holding glove or column and drapery in background, which were said to have been in the original portrait.

PROVENANCE: Gift of Francis Calley Gray, a member of the Society, 1836.

REFERENCES: Smibert, *Notebook*, 95, 114; L. Dresser, *XVIIth Century Painting in New England* (Worcester, Mass., 1935), 76–79; *DAB*, 6, pt. 2: 155–157; *EIHC*, 71(1935):70.

38

William Crowninshield Endicott

Born in Salem in 1860, son of William Crowninshield and Ellen (Peabody) Endicott. Graduated from Harvard in 1883, studied at Harvard Law School and in a law office in Salem. Admitted to the bar in 1886. Practiced law in Boston and Washington. Married Marie Louise Thoron of New York in 1889. Supportive of many historical institutions and museums in Boston and Salem. Elected a member of the Society in 1915, became its 12th president in 1927, a position he held until his death. In 1930 read a paper before the Society on his ancestor John Endecott* and John Winthrop.* Died in Boston in 1936.

ARTIST: John Singer Sargent, London, 1907. Signed, upper left: "John S. Sargent," upper right: "1907."

DESCRIPTION: Oil on canvas, 142.0 x 86.9 cm. Three-quarter length view, facing front. Brown eyes, fringe of dark hair, graying mustache and van dyke beard. White wing collar, black tie with pearl stickpin, black waistcoat under long black coat. Standing, right arm resting on marble pillared table, classical bust on small pedestal in left background. (*See Color Plate 11*).

PROVENANCE: Gift of Mrs. Endicott, widow of the sitter, 1950.

REFERENCES: *Proc.*, 66(1936–1941):423–426, 69(1947–1950): 494.

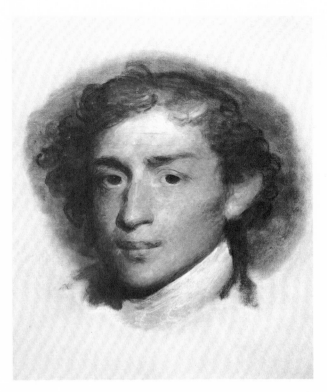

reddish brown hair, pink tone to cheeks, white neck cloth. Light background.

PROVENANCE: From the estate of Thomas Dowse, 1856.

II

Edward Everett

Born in Dorchester in 1794, son of Oliver and Lucy (Hill) Everett. Graduated from Harvard in 1811 and from Harvard Divinity School in 1814. Unitarian minister of the Brattle Street Church from 1814 to 1815, and then named a professor at Harvard. Elected to membership in the Society in 1820 at the age of 26. Married Charlotte Gray Brooks in 1822. An outstanding teacher and brilliant orator. Served five terms in Congress from 1825 to 1835, four terms as governor of Massachusetts from 1836 to 1839, four years as ambassador to the Court of St. James from 1841 to 1845, three years as president of Harvard from 1846 to 1849, briefly as secretary of state in 1853 and as a United States senator in 1853 and 1854. Died in Boston in 1865.

I

ARTIST: Gilbert Stuart, 1820. There is a similar portrait by Stuart at Harvard University in which the background and figure were completed by a different artist.

DESCRIPTION: Oil on canvas, 76.1 x 63.9 cm. Unfinished sketch of head turned right, eyes front. Unruly

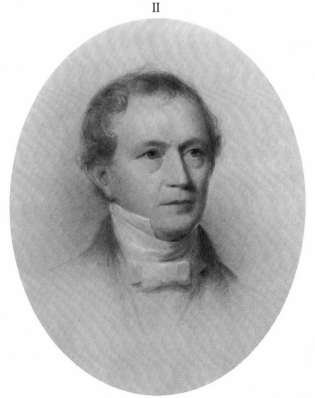

ARTIST: Richard Morrell Staigg.

DESCRIPTION: Crayon and chalk, 57.4 x 48.1 cm. Oval. Head turned slightly left. White standing collar, stock and white bow tie, collar of dark coat just visible. Light background.

PROVENANCE: Gift of Mrs. Kingsmill Marrs, 1924.

REFERENCES: *DAB*, 3, pt. 2:223–226; Park, *Stuart*, 316; Catalogue of American Portraits, NPG; *Proc.*, 1st ser., 3(1855–1858):169, 2d ser., 18(1903–1904):91–117, 58(1924–1925):2.

Mary Ann Faneuil

Born in New Rochelle, New York, in 1715, daughter of Huguenot refugees Benjamin and Anne (Bureau) Faneuil. Lived in Boston with her unmarried brother, merchant Peter Faneuil,* until his death in 1743. Married John Jones of Roxbury shortly thereafter. Died in Boston in 1790.

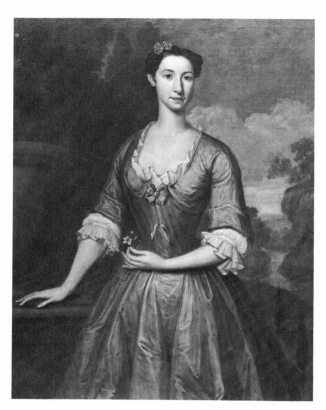

ARTIST: John Smibert, 1739. Smibert recorded in his *Notebook* painting "Ms. Marey A. Funnell" in August 1739. The next entry is "Mr. Pr. Funnell."

DESCRIPTION: Oil on canvas, 127.4 x 101.8 cm. Three-quarter length view. Dark hair, decorated with two flowers, brown eyes. Low-cut brown dress with ruf-

fled chemisette. Standing, right hand resting on table on which there stands a pottery urn. Left hand holds a flower at waist. Clouds, trees and river in left background.

PROVENANCE: Presumably descended to the sitter's son Edward Jones, and then to his son Charles Faneuil Jones, who was father of the donor, Mary Ann Jones.
Gift of Miss Jones, 1906.

REFERENCES: *Proc.*, 2d ser., 20(1906–1907):409–410; Smibert, *Notebook*, 96.

Peter Faneuil

Born in New Rochelle, New York, in 1700, son of Huguenot refugees Benjamin and Anne (Bureau) Faneuil, and brother of Mary Ann Faneuil.* Came at a young age to Boston, where he prospered as a merchant. Contributed toward the erection of King's Chapel and in 1740 provided for the building of Faneuil Hall, a public meeting place for the city, designed by John Smibert. Died unmarried in Boston in 1743.

ARTIST: John Smibert, about 1739. A very similar portrait of Faneuil by Smibert is in the Corcoran Gallery in Washington, D.C. A half-length portrait almost certainly of Peter Faneuil was owned by Michael H. Hardy of Auburn Hills, Michigan, in 1986.

NOTE: In his *Notebook* Smibert mentioned several portraits of members of the Faneuil family. In June 1739 he painted "Mrs. B. Funnell," probably the mother of Peter and Mary Ann. "Ms. Marey A. Funnell" was painted in August at a cost of 12 guineas. A half-length portrait of "Mr. Pr. Funnell" was painted for the same price the next month. In March 1740 half-length copies of "Mr. Funnell" and "Mrs. Funnell" were made. A full-length portrait of Peter Faneuil painted for 32 guineas in March 1743 may have been the one commissioned by the town of Boston to hang in Faneuil Hall. A fire in 1761 damaged that painting so severely that it could not be rehung. However, Henry Sargent probably used it as the basis for his 1807 commission, which now hangs in the Hall. By 1744 the price of a half-length portrait had risen to 16 guineas. Smibert painted "Mr. Bn. Funnell" in February of that year and a copy of "Mr. Peter Funnell" was made in August after his death.

DESCRIPTION: Oil on canvas, 127.5 x 103.0 cm. Three-quarter length view turned one third right. Long curly gray wig and queue, brown eyes. White shirt with ruffles, brown velvet waistcoat and coat with many buttons. Standing, right hand resting on a table, left outstretched. Clouds, ship, and seascape in left background. (*See Color Plate 12*).

PROVENANCE: Gift of Charles Faneuil Jones and Eliza Jones, grandchildren of Mary Ann Faneuil, 1835.

REFERENCES: Foote, *Smibert*, 151–152; Smibert, *Notebook*, 98; Catalogue of American Portraits, NPG; *Proc.*, 2d ser., 20(1906–1907):409–410; *DAB*, 3, pt. 2:262–263.

Worthington Chauncey Ford

Born in Brooklyn, New York, in 1858, son of Gordon Lester and Emily Ellsworth (Fowler) Ford and a great-grandson of Noah Webster. Married Bettina Fellmore Quin in 1899. Educated at the Brooklyn Polytechnic Institute and Columbia University, he worked as an editorial writer for the *New York Herald*, for several government bureaus, and for the Boston Public Library before becoming chief of the Division of Manuscripts of the Library of Congress. Elected to membership in the Society in 1900 and in 1909 was appointed its editor. During his tenure he produced or supervised the publication of some 49 volumes, including the two-volume edition of William Bradford's *History of Plymouth Plantation, 1620–1647* (1912) and *The Education of Henry Adams: An Autobiography* (1918). After his retirement in 1928, he edited two volumes of the *Letters of Henry Adams* and went to France as director of the European Mission of the Library of Congress, for which he secured facsimiles of documents in European archives and librar-

ies relating to American history. At the time of the German occupation, he fled to Portugal whence he secured passage to New York. Died at sea on the return home in 1941.

ARTIST: Hermann Hanatschek, 1927. Signed, upper right: "H Hanatschek / 1927."

DESCRIPTION: Oil on canvas, 45.8 x 38.5 cm. Head-and-shoulders view, facing right. Fringe of gray hair and mustache, blue eyes. Turned-over white collar, dark tie and coat, gray background.

PROVENANCE: Gift of Mrs. Emily E. F. Lowes, the sitter's daughter, 1980.

REFERENCES: *Proc.* 69(1947–1950):407–411, 92(1980):183.

Joshua Gee

Born in Boston in 1698, son of Joshua and Elizabeth (Thacher) Gee. Graduated from Harvard in 1717. Married three times: in 1722 to Sarah Rogers, who died in 1730; in 1734 to Anna (Gerrish) Appleton,* who died in 1736; and in 1739/40 to Sarah Gardner. Served as librarian at Harvard in 1721 and 1722, during which time he produced the first printed catalogue of the library, which was published in 1723. One of two known

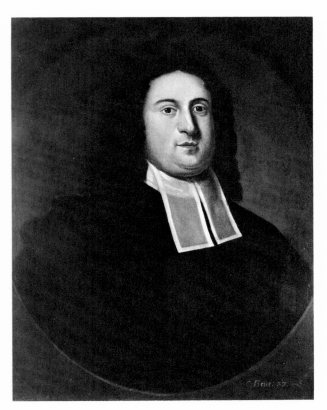

and complete copies is owned by the Society. In 1723 became pastor of the Second Church, also known as the Old North Church, where he was a colleague of Cotton Mather until the latter's death in 1728. Was a member of the Harvard Board of Overseers through his position at the church. Died in Boston in 1748.

ARTIST: John Smibert, 1733. Inscribed, lower right: "Ætat:33." A similar portrait was owned in 1949 by a Miss Neilson of Boston and displayed at Widener Library at Harvard.

DESCRIPTION: Oil on canvas, 77.3 x 65.0 cm. Head-and-shoulders view, facing front. Dark curly wig, brown eyes, ruddy complexion. Black robes with white clerical bands. Light brown background with dark brown spandrels.

PROVENANCE: A portrait is mentioned in the inventory of the Rev. Mr. Gee in 1748.

From Rev. Chandler Robbins, also a minister of the Second Church and a member of the Society, 1849.

REFERENCES: Foote, *Smibert*, 156; Smibert, *Notebook*, 91, 110; *Proceedings of the AAS*, 42(1932):221; *Sibley's Harvard Graduates*, 6:175–183; *Proc.*, 1st ser., 2(1835–1855):430.

Mrs. Joshua Gee (Anna Gerrish)

Born in Boston in 1700, daughter of John and Sarah (Hobbes) Gerrish. Married in 1719 Samuel Appleton,

a Boston merchant, and had four children. He died in 1728. Married Rev. Joshua Gee* as his second wife in 1734 and had two children. Died one evening having "eat[en] her dinner as well as usual, soon after which she fell into a fainting fit" in Boston in 1736.

ARTIST: John Smibert, 1734. Companion portrait to that of Joshua Gee.

DESCRIPTION: Oil on canvas, 77.3 x 65.0 cm. Head-and-shoulders view. Brown hair with long curl over right shoulder, brown eyes. Low-cut dark dress with white ruffle at neckline, brown shawl over right arm and behind left shoulder. Dark brown background with light brown spandrels.

PROVENANCE: Same as for Joshua Gee (q.v.).

REFERENCES: Foote, *Smibert*, 167; Smibert, *Notebook*, 92, 110; *NEHGR*, 67(1915):106–109.

Mrs. Elbridge Gerry (Ann Thompson)

Born in New York City about 1766, daughter of Charles and Hannah (Harrison) Thompson. Educated in Europe and considered by some to be the "most beautiful woman in the United States." Married Elbridge Gerry in 1786, when she was 20 and he 41. The next year he purchased Elmwood, a confiscated Tory estate in Cam-

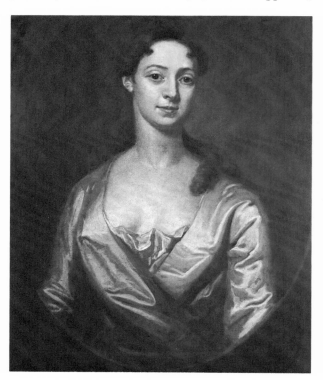

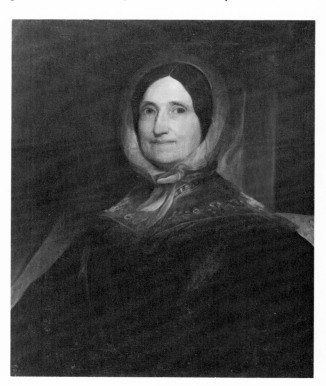

bridge, and there they raised nine children. He died in 1814 while vice president of the United States. She was the last surviving widow of a signer of the Declaration of Independence. Died in New Haven, Connecticut, in 1849.

ARTIST: Dominico Canova. Attribution made by Emily Louisa Gerry, the sitter's youngest daughter.

DESCRIPTION: Oil on canvas, 76.0 x 63.4 cm. Head-and-shoulders view. Black hair parted in middle, gray eyes. Gray bonnet tied with satin ribbons, broad lace collar on dark dress. Seated on red brocade upholstered chair. Red drapery in a very dark background.

PROVENANCE: Probably descended through the sitter's daughter, Mrs. David S. Townsend (Eliza Gerry). Their son George James Townsend, who died in 1894, was the father of Mrs. Eliza Gerry Birdsall of Albany, New York. The portrait came through her daughter-in-law, Mrs. George James Townsend Birdsall (Mabel Van Norden).

Bequest of Mrs. Birdsall, 1982.

REFERENCES: Elbridge Gerry Papers, MHS; George Athan Billias, *Elbridge Gerry: Founding Father and Republican Statesman* (New York, 1976), 147, 243, 403–404, n.28.

Christopher Gore

Born in Boston in 1758, son of John and Frances (Pinckney) Gore. Graduated from Harvard in 1776. Married Rebecca Payne of Boston in 1783. A commissioner for the adjustment of claims under the John Jay Treaty in London from 1796 to 1804, governor of Massachusetts from 1809 to 1810, and U.S. senator from 1814 to 1817. Overseer, fellow, and benefactor of Harvard. Elected a member of the Society in 1798, served as its president from 1806 to 1818. Died in Waltham in 1829.

ARTIST: John Trumbull, probably London, about 1800.

DESCRIPTION: Oil on panel, 73.7 x 60.8 cm. Head-and-shoulders view turned slightly right, facing front. Gray curly hair, broad forehead, dark eyes. White stock and tie under dark coat. Seated, holding a small book in right hand, left hand resting in front of it. Red drapery in background with column at right.

PROVENANCE: The six known portraits of Gore by Trumbull are somewhat confused in terms of provenance. A 1793 portrait is in the possession of a collateral descendant, Mrs. John M. Elliot; and a later portrait (about 1819) was destroyed by fire in 1948. While in London about 1800 Trumbull painted two portraits of Gore (one now in the Trumbull Collection, Yale University),

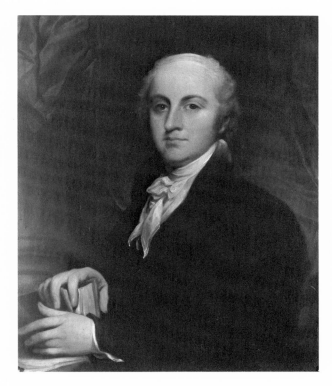

sity), along with a companion portrait of Mrs. Gore (now in the possession of Mrs. John M. Elliot), both on panels. In 1810, another portrait of Gore was painted, and it is this one which was given to Harvard in 1834 by William Payne, brother of Mrs. Gore. A later copy by Trumbull of the 1810 portrait is now at Gore Place, Waltham. Also in 1834, Harvard requested that Trumbull paint a portrait of Gore to hang in its newly endowed Gore Library. Therefore, Trumbull requested the loan of one of the 1800 portraits, already at Yale, for the purpose of making a copy. Apparently the transaction with Harvard was never completed. In 1844 after the artist's death, his executor, Yale professor Benjamin Silliman, located a portrait (identical to the 1800 pose at Yale), which had been crated for some seven or eight years. Silliman then offered the newly located portrait to Harvard, but President Josiah Quincy declined on the assumption that it was a copy of the 1810 portrait already hanging at Harvard. It was then offered to I. P. Davis, who inaccurately reported that: "Colonel Trumbull painted two portraits of Mr. Gore while in London,—one for Mr. Gore and the other for himself. The former is in Harvard University; the latter is now in Boston, for sale, at the price of one hundred dollars." A subscription was taken up and the portrait was purchased for the Society. The Society's portrait is thought to be one of the 1800 paintings, which was returned to the artist after the sitter's death. Apparently the copy requested by Harvard in 1834 was never executed. In 1858 the Corporation of Harvard College requested permission to copy

43

the Society's portrait. This likewise seems not to have been completed since the only portrait of Gore at Harvard is the 1834 Payne donation.

Purchased for the Society with $95 in subscriptions from 14 Boston gentlemen, 1844.

REFERENCES: Theodore Sizer, *The Works of Colonel John Trumbull*, rev. ed. (New Haven, 1967), 34; *MHS Coll.*, 3d ser., 3:191–209; Charles A. Hammond and Stephen A. Wilbur, *"Gay and Graceful Style": A Catalogue of Objects Associated with Christopher & Rebecca Gore* (Waltham, Mass., 1982), 14–19; *Proc.*, 1st ser., 2(1835–1855):296, 312, 4(1858–1860):108–109.

Ellis Gray

Born in Boston in 1715, son of Edward and Hannah (Ellis) Gray. Graduated from Harvard in 1734. Married Sarah Tyler of Boston in 1739. Called in 1737 to be a colleague of Rev. William Welsteed* at the New Brick Church, Boston, a post he held until his sudden death from apoplexy. As a Congregational minister, he served as chaplain to the House of Representatives and as an overseer at Harvard. Died in Boston in 1753.

I

ARTIST: Joseph Badger, about 1750. There are four or five known copies. In 1918 Lawrence Park wrote: "This is inferior to the others both in technique and color, a fact which leads me to think that it is the original portrait from life and that the others are replicas painted at a somewhat later date." Rev. William Bentley gave one, painted about 1758, to the American Antiquarian Society. A second, half-length copy also painted about 1758, went to the Museum of Fine Arts, Boston, in 1958 from Mrs. Robert S. Russell, a descendant of the sitter. A third half-length copy painted about 1758, was owned by another descendant of the sitter, Mrs. Russell Montague (Harriet Anne Cary) of White Sulphur Springs, West Virginia, in 1918. A three-quarter length portrait, of which only the head is a copy, was owned by Mrs. Edward C. Storrow (Caroline Mackay Richardson) of Readville in 1918.

DESCRIPTION: Oil on canvas, 76.5 x 62.7 cm. Head-and-shoulders view. Dark eyes front, curly black hair hanging down to shoulders. Black coat with buttons, white clerical bands, black silk gown across left arm. Painted in oval on dark background.

PROVENANCE: From Rev. Chandler Robbins.

II

ARTIST: Joseph Badger, about 1758.

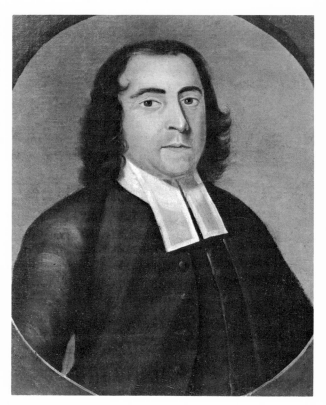

DESCRIPTION: Oil on canvas, 38.6 x 30.2 cm. Similar to I except that the background is light.

PROVENANCE: Gift of George Gilman Davis of Needham, 1944.

REFERENCES: *Sibley's Harvard Graduates*, 9:400–404; *Proc.* 49(1915–1916):259–261, 51(1917–1918):173–174, 68(1944–1947):485; *American Portraits, 1620–1825*, 1:175–176.

Mrs. John Gray (Mary Otis)

Born in West Barnstable about 1730, daughter of James and Mary (Allyne) Otis. Sister of James Otis, Jr., patriot, politician and orator, and of Mercy Otis Warren, patriot historian and dramatist. Married in 1761 John Gray of Boston, a collector of customs before the Revolution and owner of ropewalks. Died in 1763.

ARTIST: John Singleton Copley, about 1763 or earlier. Copley painted a portrait of John Gray in 1766.

DESCRIPTION: Oil on canvas, 128.2 x 101.7 cm. Three-quarter length view. Dark hair swept back and adorned with pearls, dark eyes. Low-cut blue dress trimmed with lace, pearls and a lavender bow, shawl over left shoulder. Standing, dark background with blue drapery on left. (*See Color Plate 13*).

Alexander Viets Griswold

Born in Simsbury, Connecticut, in 1766, son of Elisha and Eunice (Viets) Griswold. Married twice: in 1785 to Elizabeth Mitchelson, who died in 1817; and to Mrs. Amelia Smith about 1827. Ordained in the Anglican Church in 1795. Became rector of St. Michael's Church, Bristol, Rhode Island, in 1804 and served until 1830 when he moved to Salem to become rector of St. Peter's Church. In 1810 he was elected the first bishop of the Eastern Diocese, which included all the New England states except Connecticut. In 1835 he turned all his energies toward strengthening and expanding the Episcopal church through his role as bishop. Elected presiding bishop of the United States in 1838. Died in Boston in 1843.

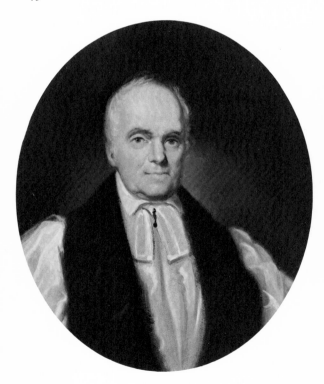

ARTIST: Unknown. Similar to the portrait by H. Inman reproduced in *Memoir of the Life of the Rt. Rev. Alexander Viets Griswold, D.D.*, by John S. Stone (Northampton, Mass., 1854). A similar portrait is owned by the Episcopal Diocese of Massachusetts.

DESCRIPTION: Oil on linen, 22.7 x 17.0 cm. Head-and-shoulders view. Natural white hair, light brown eyes. Turned-over white collar and stock, clerical bands, white surplice under black stole. Painted in an oval, brown background shading light to dark.

PROVENANCE: Gift of William Henry Whitmore, a member of the Society, 1870.

REFERENCES: *DAB*, 4, pt. 2:7–8; *Proceedings*, 1st ser., 11(1869–1870):388.

Courtenay Guild

Born in Roxbury in 1863, son of Curtis Guild* and Sarah Crocker (Cobb) Guild, and brother of Curtis Guild, Jr.* Graduated from Harvard in 1866. In 1907 joined his brother Curtis in the firm of Guild & Company, publishers of *The Commercial Bulletin of Boston* and founders of the Anchor Linotype Printing Company. After his brother's death in 1915 became editor and owner of the newspaper, and president and treasurer of the printing company. Director of many charitable, temperance, religious, and business organizations. Died unmarried in Boston in 1946.

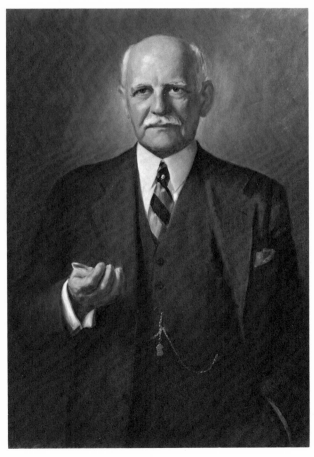

ARTIST: Wilbur Fiske Noyes, 1942. Signed, lower left: "Wilbur Fiske Noyes 1942."

DESCRIPTION: Oil on canvas, 91.4 x 66.2 cm. Half-length view, facing front. Fringe of white hair and mustache. Stiff turned-down collar and cuffs on white shirt, striped tie with stickpin, brown suit, gold watch and chain across vest. Left hand in pocket, right hand holding eyeglasses. Gray background shading light to dark.

PROVENANCE: Bequest of Sarah Louisa Guild, sister of the sitter, 1949.

REFERENCES: *Harvard Class of 1886, 50th Anniversary Report* (Boston, 1936), 204–206; *Proc.*, 69(1947–1950):471, 477.

Curtis Guild

Born in Boston in 1827, son of Curtis and Charlotte Louisa (Hodges) Guild. Married Sarah Crocker Cobb, granddaughter of Gen. David Cobb,* in 1858. Father of Curtis Guild, Jr.,* and Courtenay Guild.* Journalist with several Boston newspapers and contributor to various magazines. Founded in 1859 the eminently successful *Boston Commercial Bulletin*, which published tabulated stock quotations, reports of markets, and general banking news. A founder of the Bostonian Society in 1881 and its president until 1907. Died in Boston in 1911.

ARTIST: Jean Paul Selinger, 1897. Signed, upper right: "J. P. Selinger/ 1897." A replica of this portrait by the same artist is at the Bostonian Society, Boston.

DESCRIPTION: Oil on canvas, 132.1 x 101.7 cm. Full-length view. White hair, mustache and beard. White shirt, long black coat with wide lapels and vest, gray trousers. Seated in high-backed chair, right hand resting on arm, left on a table piled with books. Gray background shading light to dark.

PROVENANCE: Bequest of Sarah Louisa Guild, daughter of the sitter, 1949.

REFERENCES: *DAB*, 4, pt. 2: 40–41; Catalogue of American Portraits, NPG; *Proc.*, 69(1947– 1950):471, 477.

Curtis Guild, Jr.

Born in Boston in 1860, son of Curtis Guild* and Sarah Crocker (Cobb) Guild, and brother of Courtenay Guild.* Graduated from Harvard in 1881. Married Charlotte Howe Johnson in 1892. Served in the Army during the Spanish-American War, becoming the inspector-general of the Department of Havana. Worked on the *Boston Commercial Bulletin*, the financial newspaper founded by his father, became editor and sole owner in 1902. Active in the Republican party, he was elected lieutenant-governor of Massachusetts in 1902 and governor in 1905, serving until 1909. Served as

ambassador to Russia from 1911 to 1913. Elected to membership in the Society in 1910. Died in Boston in 1915.

ARTIST: August Benziger, about 1914. Signed, lower left: "A. Benziger."

DESCRIPTION: Oil on canvas, 100.2 x 82.5 cm. Half-length view turned half left, facing front. Thinning gray hair and mustache, blue eyes. Wing collar, blue tie with stick pin, black coat. Seated, hands clasped, ring on little finger of left hand. Gray background shading light to dark.

PROVENANCE: Bequest of Sarah Louisa Guild, sister of the sitter, 1949.

REFERENCES: *DAB*, 4, pt. 2:41–42; Marieli and Rita Benziger, *August Benziger, Portrait Painter* (Glendale, Calif., 1958), 427–428; *Proc.*, 50(1916–1917):308–312, 69(1947–1950):471, 477.

James Gunnison

Born in Dorchester in 1827, son of Elihu and Rhoda (Foss) Gunnison. Married Sarah Jane Robinson in 1849. Member of the Independent Fusiliers of Boston, a military organization, from 1854. Moved to Scarborough, Maine, in the 1860s and died there in 1868.

ARTIST: Davenport (the elder), 1856. Signed, lower right: "Davenport / 1856 / Boston."

DESCRIPTION: Watercolor on paper, 44.3 x 32.6 cm. Full-length figure in uniform. Black mustache and beard, eyeglasses. Wearing black shako, red tunic, black belt and trousers, very long sword. Standing on hill, landscape and one building in light background.

PROVENANCE: Gift of Mrs. Arthur Warren (Abbie Nutter Gunnison), daughter of the sitter, 1930.

REFERENCES: *A Genealogy of the Descendants of Hugh Gunnison of Boston, Mass.*, by George W. Gunnison (Boston, 1880), 149–150; *Proc.*, 64(1930–1932):2.

John Hancock

Born in Braintree in 1737, son of Rev. John and Mary (Hawke) (Thaxter) Hancock. Graduated from Harvard in 1754. Married Dorothy Quincy in Fairfield, Connecticut, in 1775. Treasurer of Harvard College, 1773 to 1777. An indifferent merchant and zealous politician, he was elected to the Massachusetts General Court in 1766 and was a leader of a Boston committee of patriots. President of the Provincial Congress from 1774 to 1777, a delegate to the Continental Congress, a signer of the Declaration of Independence, he was the first governor of the Commonwealth of Massachusetts in 1780, a position he held off and on for nine terms. Died in Boston in 1793.

ARTIST: John Singleton Copley, about 1770–1772.

DESCRIPTION: Oil on canvas, 76.3 x 63.7 cm. Head-and-shoulders view. Brown eyes, gray shadow of a beard. Short white wig, white stock, blue coat and waistcoat trimmed with gold lace and buttons. Dark background. (*See Color Plate 14*).

PROVENANCE: Bequest of Henry Lee Shattuck, who had received it from his father, Dr. Frederick C. Shattuck, 1971.

REFERENCES: *Sibley's Harvard Graduates*, 13:416–446; Prown, *Copley*, 217, pl. 300; *DAB*, 4, pt. 2:218–219; *Proc.*, 3(1855–1858):308–309, 83(1971):191.

William Henry Harrison

Born in Charles City County, Virginia, in 1773, son of Benjamin and Elizabeth (Bassett) Harrison. Attended

Hampden-Sydney College; studied medicine briefly with Benjamin Rush. Married Anna Symmes in 1795. Long in active army service in the Indian wars in Illinois, Indiana, and Ohio, where in a battle on Tippecanoe Creek he earned the nickname used in his 1840 presidential campaign slogan, "Tippecanoe and Tyler too." Served as governor of Indiana, congressman and senator from Ohio, and minister to Colombia. Elected ninth president of the United States in 1840. Died of pneumonia after one month in office, in Washington, D.C., in 1841.

ARTIST: Albert Gallatin Hoit, 1840. This is a copy by Hoit of his original taken from life in Cincinnati in 1840. The original hangs in the National Portrait Gallery in Washington, D.C.

DESCRIPTION: Oil on canvas, 91.3 x 73.3 cm. Half-length figure turned slightly left, facing front. Dark graying hair, turned-down collar on white shirt under black tie and coat with wide lapels. Seated in red upholstered chair, left elbow resting on arm, left hand holding rolled up papers. Table to left holds book and papers. Red drapery in dark background.

PROVENANCE: Gift of Albert Fearing of Hingham, 1868.

REFERENCES: *DAB*, 4, pt. 2:348–352; *Proc.*, 1st ser., 10(1867–1869):135; Patricia L. Heard, *With Faithfulness and Quiet Dignity: Albert Gallatin Hoit (1809–1856)* (Concord, N.H., 1984).

Robert Haswell

Born in 1768, the son of William Haswell, the collector of customs at Nantasket. Deported to Nova Scotia with his family as Loyalists during the Revolution but later returned to Boston. Married Mary Cordis in 1798. Sailed on the *Columbia* on its two voyages to the northwest coast. The one in 1787 was extended to a three-year trip around the world, the first circumnavigation by a ship under the American flag. His logs of the two voyages are published in the Society's *Collections* (vol. 79). Later served as master aboard the *Adventure*, the *Hannah*, and the *John Jay* on trading voyages. Joined the United States Navy as a lieutenant in 1799 serving until 1801. Set out from Boston for China in August 1801 commanding the trading ship *Louisa*, which was lost at sea.

ARTIST: Attributed to James Sharples. Inscribed on wood back: "J. S. Clarke."

DESCRIPTION: Pastel on paper, 24.1 x 19.0 cm. Head-and-shoulders view, facing front. Unruly dark hair, blue eyes. White shirt and tie under royal blue naval uniform coat. Shaded gray background.

PROVENANCE: Gift of Mrs. E. E. Cummings, whose mother-in-law, Mrs. Edward Cummings (Rebecca Haswell Clarke), was a descendant of the sitter, 1963.

REFERENCES: *Proc.*, 65(1932–1936):592–600, 75(1963):129, 136.

PROVENANCE: Gift of Mrs. Arthur Amory Codman (Mary Belknap), great-granddaughter of the sitter, 1921.

REFERENCES: *Sibley's Harvard Graduates*, 12:382–392; *Proc.*, 54(1920–1921):290.

Samuel Haven

Born in Framingham in 1727, son of Joseph and Mehitable (Haven) Haven. Graduated from Harvard in 1749. Married twice: to Mehitable Appleton in 1753, and to Margaret (Marshall) Marshall in 1778. His large family of 17 children, including Thomas Haven,* may have accounted for his being "famous for his poverty." Fourth minister of the Second, or South, Congregational Church in Portsmouth, New Hampshire. Received honorary degrees from Dartmouth and Edinburgh, was chaplain to the New Hampshire House of Representatives for many years and an ardent Son of Liberty. Died in Portsmouth, New Hampshire, in 1806.

Thomas Haven

Born in Portsmouth, New Hampshire, in 1783, son of Rev. Samuel Haven* and Margaret (Marshall) Haven. Married three times: to Eliza Hall of Portsmouth, by whom he had two children; second, to Mehitable Jane Livermore*; and to Ann Furness of Philadelphia. Merchant in Portsmouth, Boston, and Philadelphia. A proprietor of King's Chapel, Boston, in 1834. Died in Philadelphia in 1867.

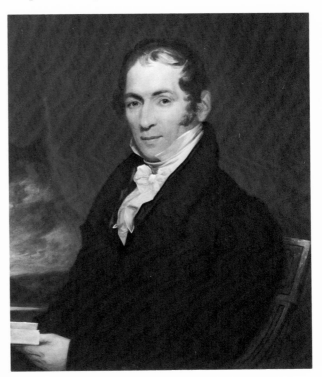

ARTIST: Unknown. Canvas has a Philadelphia maker's label.

DESCRIPTION: Oil on canvas, 76.6 x 63.6 cm. Half-length figure, face turned slightly front. Dark curly hair. Black high-collared coat and vest, white standing collar with a white bow tie. Holds a letter in his left hand. Seated. Brownish red curtain in back, sky and clouds in lower left background.

PROVENANCE: Gift of Mrs. Arthur Amory Codman (Mary Belknap), granddaughter of the sitter, 1921.

REFERENCES: Thwing, *Livermore Family*, 259; *Proc.*, 54(1920–1921):290.

ARTIST: Attributed to Joseph Steward, about 1794. A similar portrait was advertised for sale in *Antiques* (February 1981).

DESCRIPTION: Oil on canvas, 78.3 x 65.2 cm. Half-length view facing front. Long flowing wig, black clerical robes over coat with 2 buttons on right cuff, white bands. Holds book in right hand with first finger between pages. Shelf of books in right background, red drapery over window at left with a landscape view.

Mrs. Thomas Haven
(Mehitable Jane Livermore)

Born in Portsmouth, New Hampshire, in 1792, daughter of Edward St. Loe and Mehitable (Harris) Livermore. Married, as his second wife, Thomas Haven,* in 1815, and had twelve children. Died in Boston in 1837.

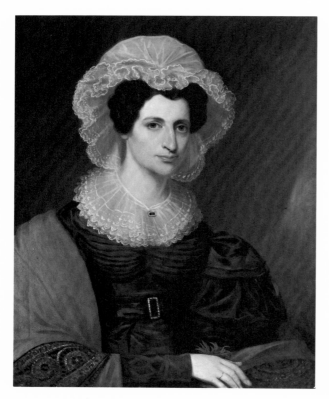

ARTIST: Unknown.

DESCRIPTION: Oil on canvas, 76.2 x 63.5 cm. Half-length figure. Wears a large white ruffled cap over her dark hair matching the ruffled collar with a brooch at the neck, a black dress with long puffed sleeves. The belt at the high waist has a jeweled buckle. A crimson shawl covers parts of both arms. Seated with drapery in the background.

PROVENANCE: Gift of Mrs. Arthur Amory Codman (Mary Belknap), granddaughter of the sitter, 1921.

REFERENCES: Thwing, *Livermore Family*, 259; *Proc.*, 54(1920–1921):290.

William Hayley

Born in 1656. Commenced at All Soul's College, Oxford, in 1676. Married the daughter of Sir Thomas Mears. Was chaplain to Sir William Trumbull, ambassador to Constantinople, and succeeded Rev. John Scott as rector of St. Giles's in the Fields, London, in 1695. Also chaplain in ordinary to King William III and installed dean of Chichester in 1699. Died in London in 1715.

ARTIST: Attributed to Sir Godfrey Kneller.

DESCRIPTION: Oil on canvas, 71.8 x 61.8 cm. Oval. Head-and-shoulders view, facing front. Long black curly wig, brown eyes, double chin. Black clerical gown with white bands. Arms and crest appear in the upper left corner. Very dark background.

PROVENANCE: Acquired many years before 1862 when the subject was identified by Dr. John Appleton, the Society's librarian, through the coat-of-arms. The arms and crest are those of Hayley, granted in 1701, impaled with the armorial bearings of Mears.

REFERENCES: *Proc.*, 1st ser., 6(1862–1863):18, 22.

Stephen Higginson

Born in Salem in 1743, son of Stephen and Elizabeth (Cabot) Higginson. Married three times: to Susan Cleveland, a second cousin from Connecticut, in 1764; to Elizabeth Perkins of Boston in 1789; and to her sister

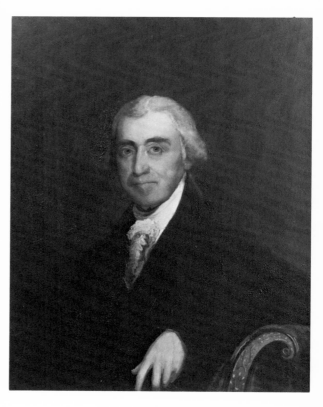

Sarah Perkins in 1792. Merchant and sea captain, he was one of the American shipmasters called upon to testify before Parliament on American colonial matters in 1775. Served in the Continental Congress. A prominent Federalist, he helped organize and equip the navy during the administration of Thomas Jefferson. Died in Brookline in 1828.

ARTIST: Gilbert Stuart Newton, after the original by Gilbert Stuart, which was owned by George Higginson of Lenox in 1938.

DESCRIPTION: Oil on panel, 85.4 x 68.8 cm. Head-and-shoulders view facing front. Gray hair parted in middle, gray eyes. White neck-cloth with ruffle, high-collared back coat. Seated with left arm resting on arm of sofa upholstered in red material. Dark gray background.

PROVENANCE: The portrait once belonged to Waldo Higginson, a grandson of the sitter. It descended to his nephew, the donor.
Gift of Edward Higginson of Fall River, 1908.

REFERENCES: Thomas W. Higginson, *Life and Times of Stephen Higginson* (Cambridge, Mass., 1907); *DAB*, 5, pt. 1: 15–16; *Proc.*, 42(1908–1909):15–16, 251.

George Stillman Hillard

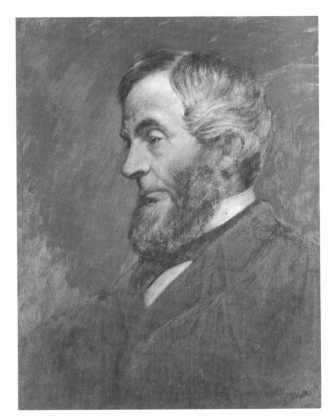

Born in Machias, Maine, in 1808, son of John and Sarah (Stillman) Hillard. Graduated from Harvard with first honors in 1828. Married Susan Tracy Howe of Northampton in 1835. Lawyer, orator, author, editor. Served as member of the Massachusetts House of Representatives and Senate. Was United States district attorney for Massachusetts from 1866 to 1871, and trustee of the Boston Public Library. Elected a member of the Society in 1843. Died in Brookline in 1879.

ARTIST: William Willard, 1878. Said to have been painted in Sturbridge from a photograph.

DESCRIPTION: Oil on panel, 59.4 x 46.5 cm. Head-and-shoulders profile, facing left. Graying dark hair and full beard, stiff collar on white shirt with black tie and coat. Gray background.

PROVENANCE: Acquired for the Society by the trustees of the Sanders Fund, 1879.

REFERENCES: *Proc.*, 1st ser., 17(1879–1880):165, 19(1881–1882):339–345; *DAB*, 5, pt. 1:49–50.

Abiel Holmes

Born in Woodstock, Connecticut, in 1763, son of David and Temperance (Bishop) Holmes. Graduated from Yale in 1783. Married twice: in 1790 to Mary Stiles, who died in 1795, daughter of Yale President Ezra Stiles; and

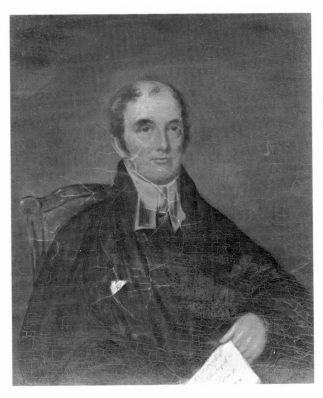

to Sarah Wendell of Boston in 1801. One of the children of this second marriage was Oliver Wendell Holmes, poet and essayist. Congregational clergyman, pastor of the First Church in Cambridge, and author of *American Annals* (1805). Elected to membership in the Society in 1798; served as its corresponding secretary from 1813 to 1833. Died in Cambridge in 1837.

ARTIST: Unknown.

DESCRIPTION: Oil on linen, 26.7 x 21.6 cm. Head-and-shoulders view, facing front. Thinning dark hair and sideburns. Black high-collared coat, white stock and clerical bands. Seated in red upholstered chair. Holds paper in left hand. Dark background.

PROVENANCE: Gift of Usher Parsons, son-in-law of the sitter, 1861.

REFERENCES: *DAB*, 5, pt. 1:160–161; *Proc.*, 1st ser., 5(1860–1862):195; *MHS Coll.*, 3d ser., 7:270–282.

Samuel Hopkins

Born in Waterbury, Connecticut, in 1721, son of Timothy and Mary (Judd) Hopkins. Graduated from Yale in 1741. Studied theology with Jonathan Edwards. Married twice: to Joanna Ingersoll of Housatonic, Connecticut, in 1748; and to Elizabeth Webb of Newport, Rhode Island, in 1794. Pastor of the Congregational Church of Great Barrington from 1743 to 1769 and of

the First Congregational Church in Newport, Rhode Island, from 1770 until his death. A strong opponent of slavery, his conservative religious philosophy, known as "Hopkinsianism," had considerable influence on New England thought. Died in Newport, Rhode Island, in 1803.

ARTIST: Attributed to Joseph Badger, about 1755.

DESCRIPTION: Oil on canvas, 60.0 x 52.4 cm. Head-and-shoulders view, facing front. Wearing his study dress of a peaked red hat framing face, white stock under tunic and black coat. Blue background at right shading to dark gray at left.

PROVENANCE: "While this interesting old portrait was in a public gallery at Hartford, it was examined by a gentleman, who disliked the subject of it so intensely, that he thrust his cane through the canvas, near the head of the figure, and made a rupture. . . . He gave as a reason for thus defacing the picture, that Dr. Hopkins believed in the damnation of infants."

Gift of Samuel Hopkins of New York, a descendant of the sitter, 1928.

REFERENCES: *DAB*, 5, pt. 1:217–218; *Proc.*, 2d ser., 3(1886–1887):42.

Friedrich Heinrich Alexander Von Humboldt

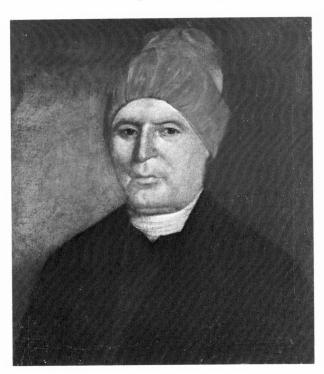

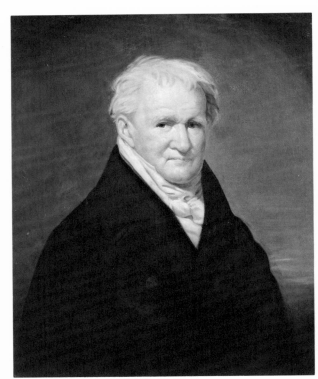

Born in Berlin, Prussia, in 1769. Man of science, extensive world traveler. Spent several years on a scientific expedition in the Americas in the early 19th century. Wrote a five-volume work on his scientific observations and inquiries entitled *Cosmos*, begun at the age of 74. Elected to membership in the Society in 1817. Died in Berlin in 1859.

ARTIST: Moses B. Russell. After the original painted in Berlin in 1852 by Moses Wight.

DESCRIPTION: Oil on canvas, 75.2 x 63.8 cm. Head-and-shoulders view. Thinning white hair, brown eyes, rosy cheeks. White stand-up collar with neckcloth, high-collared black coat with big buttons. Brown-gray background, light streaks at left.

PROVENANCE: Gift of several members of the Society, 1879.

REFERENCES: *Proc.*, 1st ser., 4(1858–1860):312–321, 17(1879–1880):229.

Joshua Huntington

Born in Norwich, Connecticut, in 1786, son of Jedediah and Ann (Moore) Huntington. Graduated from Yale in

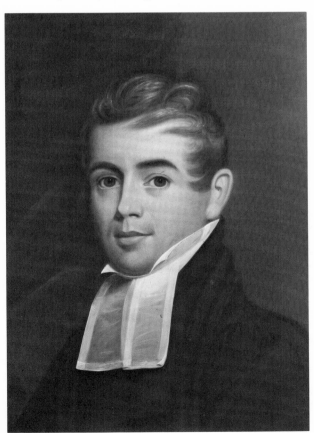

1804, studied theology, and began preaching at New London, Connecticut, in 1806. Married Susan Mansfield in 1809. Came to Old South Church in Boston as associate pastor in 1808, became pastor three years later, and remained until his death. Died at Groton in 1819.

ARTIST: Unknown. A similar portrait, also by an unidentified artist, is at the Yale University Art Gallery.

DESCRIPTION: Oil on panel, 56.0 x 43.3 cm. Head-and-shoulders view facing front. Curly light brown hair, deep blue eyes. High-collared clerical robes over high stiff white collar with white bands. Reddish drapery to right in a brown background.

PROVENANCE: Gift of the heirs of John C. Phillips, 1915.

REFERENCES: Sprague, *Annals of the American Pulpit*, 2:501–503; *Proc.*, 48(1914–1915):495.

Thomas Hutchinson

Born in Boston in 1711, son of Thomas and Sarah (Foster) Hutchinson, great-great-grandson of Anne Hutchinson. Graduated from Harvard in 1727. Married Margaret Sanford in 1734. Merchant and historian, he served as provincial assemblyman, speaker of the Massachusetts House of Representatives, councillor, lieutenant governor, chief justice, and the last colonial governor of Massachusetts. A conservative and loyalist, he left for

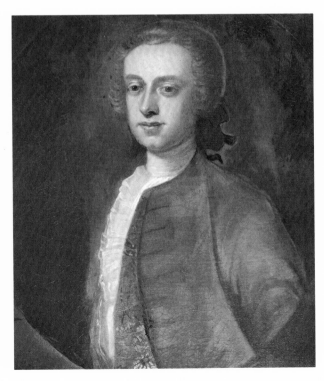

England in 1774 as one of the most hated men in Massachusetts. Died in exile in England in 1780.

I

ARTIST: Edward Truman, 1741. Inscribed, lower left: "Edward Truman, pinx. 1741." This is believed to be the only existing life portrait.

DESCRIPTION: Oil on canvas, 71.9 x 60.2 cm. Half-length view turned one-quarter right, eyes front. Brown hair clubbed with black ribbon. White stock on ruffled white shirt, collarless brown coat over embroidered waistcoat. Painted oval in dark background.

PROVENANCE: The portrait once belonged to Jonathan Mayhew, grandfather of the donor. Gift of Peter Wainwright, Jr., 1835.

II

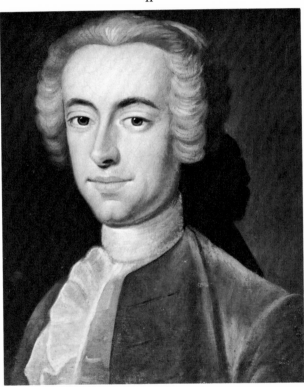

ARTIST: Unknown. Formerly attributed to John Singleton Copley, but probably a copy of I by an unknown artist. A copy of this portrait for a Hutchinson relative in England was authorized by the Society in 1829.

DESCRIPTION: Oil on canvas, 44.3 x 35.4 cm. Head-and-shoulders view similar to above.

PROVENANCE: Received in exchange for some shells in the Society's collection, 1796.

REFERENCES: *Sibley's Harvard Graduates*, 8:149–214; Prown, *Copley*, 1:220; *Proc.*, 1st ser., 1(1791–1835):101, 417, 2(1835–1855):17.

Jonathan Jackson

Born in Boston in 1743, son of Edward and Dorothy (Quincy) Jackson.* Graduated from Harvard in 1761. Married twice: to Sarah Barnard of Salem in 1767; and in 1772 to Hannah Tracy, daughter of Patrick Tracy* and Hannah (Gookin) Tracy.* Engaged in commerce in Newburyport and in privateering during the Revolution. A member of the Constitutional Convention in 1779 and of the Continental Congress for four months in 1782, a marshal of the Federal Court of the first district of Washington. Treasurer of Massachusetts in 1802 and of Harvard in 1807. First president of the Boston Bank, now the Bank of Boston, from 1803 until his death in Boston in 1810.

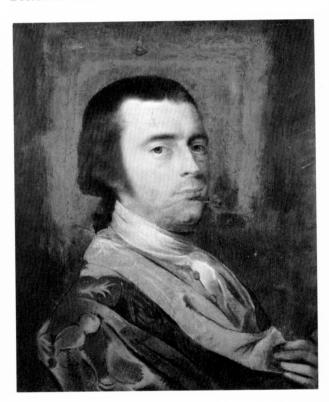

ARTIST: John Singleton Copley, about 1768.

DESCRIPTION: Pastel on paper, 58.7 x 48.7 cm. Head-and-shoulders view turned one-half right, eyes front. Black hair clubbed in back, gray-blue eyes. White stock on white shirt with ruffle. Buff waistcoat, blue-figured coat with buff lapels. Left hand fingering lapel, brown background.

PROVENANCE: In 1873, the portrait belonged to Mrs. Oliver Wendell Holmes (Amelia Lee Jackson), granddaughter of the sitter. It descended to her grandson, Edward Jackson Holmes, whose widow gave it to the Society.

Gift of Mrs. Edward Jackson Holmes (Mary Stacy Beaman), 1958.

REFERENCES: *Sibley's Harvard Graduates*, 15:56–67; Prown, *Copley*, 1:220–221; *Proc.*, 1st ser., 1(1791–1835):417, 72(1957–1960):436.

John Jekyll and daughter

Born in England, probably in Wiltshire, about 1673, son of Rev. Thomas and Elizabeth Jekyll. Married twice: to Hannah Clark of New Jersey, who died in 1725, mother of two daughters and five sons; and to Christian (Codner) Cummins, widow of Archibald Cummins, in 1726/7. A warden of King's Chapel, Boston, justice of the peace of Suffolk and Middlesex counties, and royal collector of customs for the port of Boston, with distinct local rather than regional authority, from 1707 until his death. His son John succeeded him in the customs post. "He was a very free and hospitable Gentleman, and who discharged his Trusts to good acceptance, and his Death is very much lamented." Died in Boston in 1732.

The daughter is either Hannah Jekyll, who was sent home to her brothers in England upon the death of their father, or Mary Jekyll who married Col. Richard Saltonstall of Haverhill in 1738/9 but died childless in Boston in 1739/40.

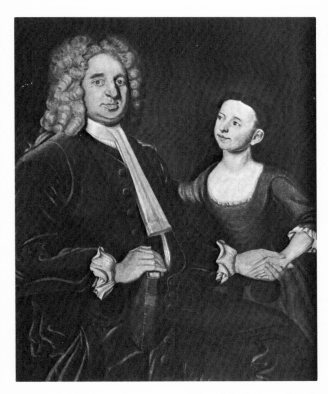

ARTIST: John Smibert, 1730. Listed in his notebook as: "Mr. Jekell and Daughter."

DESCRIPTION: Oil on canvas, 111.1 x 90.4 cm. Three-quarter length view, facing front. Man with long flowing curly wig, untied white neckcloth on shirt with ruffled cuffs, brown collarless coat with large buttons over brown waistcoat. Seated with "Book of Rates" standing on his lap steadied by right hand. Holds left hand of a daughter with his left hand. She has dark hair pulled back and parted in the middle, wears a red dress with low-cut square neckline trimmed with white ruffle at neck and sleeves. Stands beside her father's chair with right hand on his shoulder. Dark background.

PROVENANCE: Gift of Mrs. F. P. Webber of Boston, 1872.

REFERENCES: Smibert, *Notebook*, 88; *Proc.*, 1st ser., 12(1871–1873):264; *DNB*, 10:727; *Boston Weekly News-Letter*, Jan. 4, 1733; *MHS Coll.*, 80:78.

William Jenks

Born in Newton in 1778, son of Samuel and Mary (Haynes) Jenks. Graduated from Harvard in 1797. Mar-

ried Betsey Russell in 1797. Congregational clergyman in Bath, Maine, and later in Boston where he opened the first free chapels for seamen. Professor at Bowdoin College; originator of the American Oriental Society, founded in 1842; member of the American Antiquarian Society and the New England Historic Genealogical Society. Author of the six-volume comprehensive *Commentary on the Holy Bible*. Elected to membership in the Society in 1821 and served as its librarian from 1823 to 1832. Died in Boston in 1866.

ARTIST: Unknown, possibly Henry Willard.

DESCRIPTION: Oil on canvas, 152.7 x 96.5 cm. Full-length view, facing slightly right. Receding white hair, blue eyes with spectacles. White stock on white shirt, black suit with knee breeches and black silk stockings under black clerical robe. Seated in upholstered armchair, left arm resting on an ornate table. Red drapery in background.

PROVENANCE: Gift of Mrs. Francis M. Jencks of Baltimore, Maryland, 1953.

REFERENCES: *Proc.*, 1st ser., 10(1867–1869):106–112, 71(1953–1957):440; *DAB*, 10, pt.2:54.

Joshua Johnson

Born in Calvert County, Maryland, in 1742, son of Thomas and Dorcas (Sedgwick) Johnson. A merchant,

he lived for many years in England and France and undertook various missions for the state of Maryland and for Congress. Married Catherine Nuth or Young.* Was first United States consul in London from 1790 to 1797. After his business ventures abroad failed he returned to America. Died in Frederick, Maryland, in 1802.

ARTIST: Unknown, London, 1796. There is a similar portrait hanging in the National Gallery of Art, Washington, D.C.

DESCRIPTION: Oil on canvas, 76.1 x 63.3 cm. Half-length view turned half right. White hair, possibly a wig, brown eyes, white stock with lacy ruffle attached to shirt front. Buff waistcoat under high-collared brown coat. Seated in an upholstered chair, left hand rests on a table holding papers. A box of writing utensils with a bell sits on the same table. Brown drapery in background with a faint view at right of canvas.

PROVENANCE: This and the companion portrait of Mrs. Johnson were bequeathed to Charles Francis Adams II (1835–1915) in 1903 by Robert C. Buckman, only child of Carolina Virginia Marylanda Buckman, third daughter of the sitters. Mr. Adams was the great-grandson of the sitters.

Gift of James Barr Ames, whose wife Mary Ogden Adams was a granddaughter of Charles Francis Adams II, 1970.

REFERENCES: *Proc.*, 82(1970):155; *Diary and Autobiography of John Adams*, L. H. Butterfield, ed. (Cambridge, Mass., 1962), 2:300.

Mrs. Joshua Johnson (Catherine Nuth or Young)

Born about 1757, probably in London, England. Married Joshua Johnson.* They were the parents of 8 children including Louisa Catherine, who married John Quincy Adams* in 1797 and another daughter with the patriotic name of Carolina Virginia Marylanda. An ambitious woman, aggressive hostess, and a merchant in her own right. Died in Washington, D.C., in 1811.

ARTIST: Unknown, London, 1796. A similar portrait hangs in the National Gallery of Art, Washington, D.C.

DESCRIPTION: Oil on canvas, 76.1 x 63.3 cm. Half-length view, facing slightly left. Curls piled high on head and interwoven with a scarf. Gray dress with long sleeves. Seated in green upholstered chair with left elbow resting on a table. Red drapery in background.

PROVENANCE: Same as for the companion portrait of Joshua Johnson (q.v.).

REFERENCES: *Joshua Johnson's Letterbook, 1771–1774*, Jacob M. Price, ed. (London, 1979), ix n, xxii, xxiii n; *Proc.*, 82(1970):155; Andrew Oliver, *Portraits of John Quincy Adams and His Wife* (Cambridge, Mass., 1970), 23–24; Joan R. Challinor, "The Miseducation of Louisa Catherine Johnson," *Proc.*, 98(1986):21–48.

John Joy, Jr.

Born in Boston in 1751, son of John and Sarah (Homer) Joy. His father, a Loyalist, took the family to England in 1776. Several of them remained, but John, Jr., returned to Boston after the peace of 1783. Married Abigail Greene of Boston in 1777, had three children, all of whom died unmarried. A landowner and apothecary, he carried the title of "doctor." Died in Boston in 1813.

ARTIST: Joseph Badger, about 1758.

DESCRIPTION: Oil on canvas, 102.3 x 78.5 cm. Full-length figure about seven years old. Dark hair curling over ears, dark eyes. White shirt, ruffled collar and cuffs. Long blue waistcoat under long gray coat with stockings, black shoes with silver buckles. Black hat held under left arm. Dog in foreground. Landscape background with large tree at left, hills and trees to right. (*See Color Plate 15*).

PROVENANCE: The portrait was owned by Mrs. Charles Henry Joy of Boston, whose husband was a great nephew of the sitter, in 1917 and 1936. It was inherited by her son, the donor.

Gift of Benjamin Joy (1882–1968), 1953.

REFERENCES: *Proc.*, 51(1917–1918):178, 71(1953–1957):440.

Johann Kupetsky

Born in Hungary in 1667. An artist who settled in Vienna as court painter to the royal family of Austria, painted Tsar Peter the Great, and whose work hangs in many European museums. Died in Nuremberg in 1740.

ARTIST: Self-portrait. A similar portrait, which includes a likeness of Kupetsky's son, is in the National Museum of Brunswick, Germany.

DESCRIPTION: Oil on panel, 31.5 x 24.0 cm. Three-quarter length view turned right, eyes front. Dark hair and eyes, pince nez. Wears a white shirt and striped overshirt under a brown coat with a striped sash. Seated, right hand rests on arm of chair, left akimbo at hip. Dark brown drapery fills almost the entire light background.

PROVENANCE: Given to Henry Wheaton, father of the donor, by the U.S. consul in Bamberg, Bavaria, in 1845 as a portrait of Benjamin Franklin.

Gift, with the same identification, of Miss Martha B. Wheaton, 1869.

REFERENCES: Bénézit, *Dictionnaire*, 5:330; *Proc.*, 1st ser., 11 (1869–1870):150, 152.

Marie Jean Paul Roch Yves Gilbert Motier, marquis de Lafayette

Born in Auvergne, France, in 1757, son of Gilbert, marquis de Lafayette, and Marie Louise Julie de la Rivière, both of notable French families. In 1774 married Marie Adrienne Françoise de Noailles. Entered the King's Musketeers in 1771, promoted to captain in 1774, withdrew from active service in 1776. Commissioned a major general by the Continental Congress in 1777. A longtime friend of George Washington, he commanded troops in Virginia during the American Revolution and helped procure for the Americans the assistance of French general Comte de Rochambeau. Took part in the French Revolution of July 1830 which established Louis Philippe as a constitutional monarch. Elected to membership in the Society in 1824. Died in Paris in 1834.

I

ARTIST: Joseph Boze, Paris, 1790.

DESCRIPTION: Oil on canvas, 92.1 x 72.6 cm. Half-length view, facing front. Short, curly, powdered wig tied in queue, brown eyes. White stock, white shirt with ruffles under white waistcoat with brass buttons. Dark blue uniform coat trimmed with red and white. Gold epaulets, sword, closed gloved right hand at waist. Clouds and hills in background. (*See Color Plate 16*).

PROVENANCE: Commissioned by Thomas Jefferson through his agent William Short. On April 6, 1790, Jefferson wrote: "My pictures of American worthies will be absolutely incomplete till I get the M. de la fayette's. Tell him this, and that he must permit you to have it drawn for me." In his letter of Nov. 7, Short reported that "The Marquis de la fayettes picture is begun and will be sent to Havre as soon as finished." And on Dec. 23, "I have advice also that the Mis. de la fayette's picture is finished and I have directed it to be sent also to Havre. The price is 16 guineas for the painting, 3 for the gilt frame; and 12.lt [Livres Tournois] for box and packing. The painter is Boze, who I think has taken by far the best likenesses of the Marquis." In 1835 the portrait was offered at the sale of Jefferson's paintings at the Chester Harding Gallery in Boston.

Gift of Mrs. John W. Davis, 1835.

II

ARTIST: Henry Cheever Pratt, Boston, 1825. Signed "H. C. Pratt, pinxt. 1825."

DESCRIPTION: Oil on panel, 69.9 x 55.5 cm. Head-and-shoulders view, facing right. Short dark hair, dark eyes. Standing high white collar on shirt with ruffle, stock, black coat. Column at right in brownish background.

PROVENANCE: Gift of Society members, 1925.

REFERENCES: Jefferson, *Papers*, 16:318, 18:32, 356; *Proc.*, 1st ser., 1(1791–1835):376, 377n; 2(1835–1855):16; 4(1858–1860):108; 58(1924–1925):377; *DAB*, 5, pt. 2:535–539; *Boston Transcript*, July 18, 1833; *Jefferson and the Arts: An Extended View*, ed. William Howard Adams (Washington, D.C., 1976), 119.

Edwin Lamson

Born in Salem in 1811, son of Samuel and Sarah (Sleuman) Lamson. Married Mary Swift* in 1846. Entered the commission business as a merchant on Commercial Wharf, Boston, and was a partner in the firm of Twombly & Lamson. Spent several years in Europe with his family after his retirement in 1868. Deacon of Park Street Church, Boston, for many years. Died in Winchester in 1876.

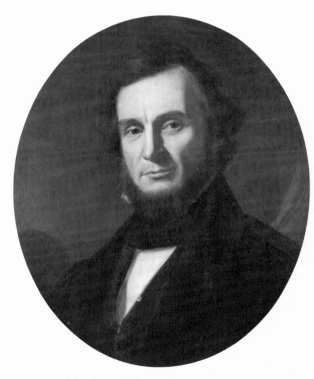

ARTIST: Matthew Wilson, about 1858.

DESCRIPTION: Oil on canvas, 61.5 x 50.5 cm. Oval. Head-and-shoulders view, facing front. Dark hair and beard, cleft between eyes, slight smile. Black stock with high shirt collar and white shirt. Brown waistcoat under patterned black, high-collared coat. Dark background.

PROVENANCE: Gift of Walton F. Dater, a relative by marriage of the sitter's son, Gardner Swift Lamson, 1969.

REFERENCES: *Proc.*, 81(1969):243; William J. Lamson, *Descendants of William Lamson of Ipswich, Mass.* (New York, 1917), 151; Lamson Papers, MHS.

Mrs. Edwin Lamson (Mary Swift)

Born in Philadelphia, Pennsylvania, in 1822, daughter of Dr. Paul and Dorcas (Gardner) Swift of Philadelphia and Nantucket. Married Edwin Lamson* in 1846, and they had four children including Gardner Swift Lamson.* One of the first students at the "first normal school in America" at Lexington (now Framingham State College) in 1839–1840. A teacher at the Perkins Institution for the Blind in Boston. Wrote a biography of one of her students, Laura Bridgman, the first blind deaf-mute to be educated. Acknowledged as an inspiration by Helen Keller, a later student at the school. One of the early organizers of the Young Women's Christian Association in Boston and an active worker there for many years. Died in Cambridge in 1909.

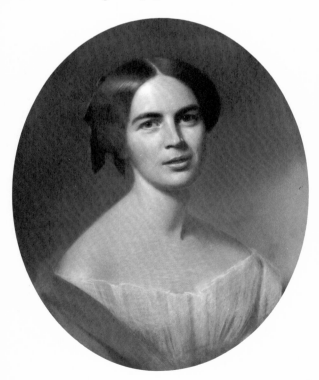

ARTIST: Matthew Wilson, about 1858.

DESCRIPTION: Pastel on paper, 60.1 x 51.0 cm. Oval. Head-and-shoulders view, facing front. Dark hair parted in middle with brown ribbon in back. Slight smile. Off-the-shoulder muslin dress or waist with bright green shawl. Light background.

PROVENANCE: Same as for Edwin Lamson (q.v.).

REFERENCES: *The First State Normal School in America: The Journals of Cyrus Pierce and Mary Swift* (Cambridge, Mass., 1926), xxxi–xxxii; *Proc.*, 81(1969):243.

Gardner Swift Lamson

Born in Boston in 1855, son of Edwin Lamson* and Mary (Swift) Lamson.* Graduated from Harvard in 1877. Married Mary Roberts Dater of Brooklyn, New York, in 1882. Spent a few years in business before he became a professional singer and voice teacher in Boston. In 1894 went to head the vocal department of the University of Michigan Music School at Ann Arbor. Spent ten years in Germany studying and singing. Returned to the United States in 1910, and taught singing in New York City for many years. Died in New York City in 1940.

ARTIST: Matthew Wilson, about 1858.

DESCRIPTION: Pastel on paper, 55.2 x 45.5 cm. Oval. Head-and-shoulders view, facing front. Blond hair, blue

eyes. Off-the-shoulder white shortsleeved shirt trimmed with rick-rack. Gray background.

PROVENANCE: Gift of Walton F. Dater, a relative by marriage of the sitter, in 1969.

REFERENCES: *Harvard Class of 1877, 40th Anniversary Report* (Cambridge, Mass., 1917), 143–145; *Proc.*, 81(1969):243.

Mrs. Ezekiel Lewis (Jane Clark)

Born in England about 1723, daughter of Jonathan and Mary (Phillips) Clark. Came to Boston with her parents in her early youth and in 1741 married Ezekiel Lewis, a Boston merchant and a 1735 graduate of Harvard. Died about 1753, leaving four children.

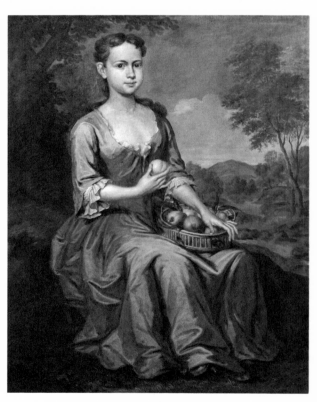

ARTIST: Attributed to John Smibert, 1743. A "Mrs. Lewis" is listed in his notebook in 1743, although the sitter in this portrait appears to be younger than 20. Previously attributed to William Hogarth, London, 1739.

DESCRIPTION: Oil on canvas, 128.0 x 103.4 cm. Full-length view, turned slightly left, eyes front. Dark wavy hair, pulled back, brown eyes. Low-cut, square-necked mauve dress over chemisette ruffled at neck and elbows. Seated, holding a basket of apples. Landscape background.

PROVENANCE: Said to have been brought to Groton by the sitter's son, Jonathan Clark Lewis.
Gift of Miss Susan Minns, 1916.

REFERENCES: James Thomas Flexner, *First Flowers of Our Wilderness* (Cambridge, Mass., 1947), 128, 353; Foote, *Smibert*, 144–145; Thwing Catalogue; *Sibley's Harvard Graduates*, 9:550–551; Smibert, *Notebook*, 98.

Benjamin Lincoln

Born in Hingham in 1733, son of Benjamin and Elizabeth (Thaxter) (Norton) Lincoln. Married Mary Cushing of Pembroke in 1756. A farmer in Hingham, he was a major general during the American Revolution, fought in the Yorktown campaign, and served as secretary of war from 1781 to 1783. Led Massachusetts troops to suppress Shays's Rebellion in 1787. Was a member of the constitutional convention in 1788, collector for the Port of Boston from 1789 to 1809, and a federal commissioner to negotiate Indian treaties. Elected to membership in the Society in 1798. Died in Hingham in 1810.

ARTIST: Henry Sargent, 1806. Signed, lower right: "Painted by Henry Sargent." A similar portrait is at the Pennsylvania Academy of Fine Arts. The Society authorized a copy by F. A. Durivage for the Boston Custom-House in 1854.

DESCRIPTION: Oil on canvas, 153.5 x 129.8 cm. Three-quarter length view, head turned slightly left. Fringe of white hair, bushy eyebrows, blue eyes. White stock, dark blue uniform coat over buff waistcoat and with a red sash through epaulet on right shoulder. Sword at left side, holds black cocked hat in left hand. Right hand holds a letter and rests on a cannon. There are tiny military figures in right background. Blue background shades to dark at top.

PROVENANCE: Commissioned by a number of General Lincoln's friends "entertaining sentiments of high respect for his eminent private virtues, and grateful recollection of his important civil and military services during our Revolutionary War with Great Britain." For $300 two copies were ordered, one for Mrs. Lincoln and the other for the Society.

Gift from 26 Boston men, 1807.

REFERENCES: *DAB*, 6, pt.1:259–261; *Sibley's Harvard Graduates*, 12:416–438; Catalogue of American portraits, NPG; *Proc.*, 1st ser., 1(1791–1835):119, 192, 2(1835–1855):592.

George Livermore

Born in Cambridge in 1809, son of Nathaniel and Elizabeth (Gleason) Livermore. Married Elizabeth Cunningham Odiorne in 1839. An insatiable reader and discriminating bibliophile, he stayed out of college because of poor health and worked as a wool and leather merchant, which financed his book collection. Member of the American Antiquarian Society and the American Academy of Arts and Sciences, trustee and vice president of the Boston Athenaeum, elected to the Society in 1849. Died in Cambridge in 1865.

ARTIST: James Carroll Beckwith, 1904. Signed on back: "Portrait of / George Livermore / Painted from Photograph / by Carroll Beckwith / 1904."

DESCRIPTION: Oil on canvas, 61.0 x 50.9 cm. Head-and-shoulders view, turned one-quarter left, eyes front. Deep-set dark eyes, receding hair. High-standing white collar with black stock and tie, black coat and vest. Dark background.

PROVENANCE: Purchased through the Society's general fund, 1905.

REFERENCES: *Proc.*, 1st ser., 10(1867–1869):415–469, 2d ser., 19(1905):83–86.

Mrs. John Livingston
(Mary Winthrop)

Born in the 1670s, only daughter of Fitz-John Winthrop* and Elizabeth Tongue, whose legal marriage has never been verified. Married John Livingston about 1701. He was a member of a prominent Albany, New York, family, and lived with the Winthrops in New London, Connecticut, during much of his New England schooling. Resided at Mohegan, a few miles north of New London. Died, childless, in 1713.

ARTIST: Attributed to Samuel Stillman Osgood, 1872. Copy of a portrait by an unknown artist, 1701. Original is at Harvard University.

DESCRIPTION: Oil on canvas, 75.6 x 62.3 cm. Oval. Head-and-shoulders view turned slightly left. Brown wavy hair hanging over left shoulder, brown eyes. Low-cut brown dress over ruffled chemisette. Bit of brown fur over right arm. Dark background.

PROVENANCE: Commissioned by Robert Charles Winthrop, Jr., 1872. Inherited by his daughter, the donor.

Gift of Miss Clara Bowdoin Winthrop, 1934.

REFERENCES: Mayo, *Winthrop Family*, 94–96; *Proc.*, 58(1924–1925):147, 65(1932–1936):268.

Elizabeth Davis Locke

Born in 1814, daughter of Joseph Locke and Mary (Ingersoll) (Foster) Locke* of Hingham and Boston, younger sister of Frances Sargent Locke,* who married the artist, Samuel Stillman Osgood. Married Henry Francis Harrington in 1838 and had five children. An 1834 Harvard graduate, he was a Unitarian minister at Providence, Rhode Island, Albany, New York, and at Lawrence and Cambridge before becoming superintendent of schools at New Bedford. Died in 1878.

ARTIST: Samuel Stillman Osgood, about 1830.

DESCRIPTION: Oil on canvas, 77.0 x 64.0 cm. Head-and-shoulders view, facing slightly right. Long dark wavy hair, brown eyes. Round-necked rose dress trimmed with white. Deeper rosy jacket trimmed with gold braid. Dark background.

PROVENANCE: Purchased at auction from Charles A. Locke for ten dollars by Miss Helen I. Tetlow, granddaughter of the sitter.

Bequest of Miss Tetlow, 1976.

REFERENCES: Locke, *Book of the Lockes*, 139, 259; Thomas Cushing, *Memorials of the Class of 1834 of Harvard College* (Boston, 1884), 75–76; *Proc.*, 88(1976):150, 157.

Frances Sargent Locke

Born in Boston in 1811, daughter of Joseph Locke and Mary (Ingersoll) (Foster) Locke* of Boston and Hingham. Married Samuel Stillman Osgood, the artist, in 1835, a year after he painted her portrait. Began writing when she was very young and contributed to the *Juvenile Miscellany* at the age of 14. Soon after her marriage, they went to London, where she moved in the major literary circles and continued to publish her poetry. Returned to the United States in 1839 and settled in New York, where she developed a close friendship with Edgar Allan Poe. Continued to write stories and poetry. Died in New York City in 1850.

ARTIST: Samuel Stillman Osgood, about 1834. Another portrait of the same sitter by the same artist, dated about 1835, is at the New-York Historical Society.

DESCRIPTION: Oil on canvas, 69.0 x 55.7 cm. Oval. Head-and-shoulders view, head tilted slightly left. Dark hair parted in the middle, brown eyes. Off-the-shoulder white dress. Gray background.

PROVENANCE: Bequest of Miss Helen I. Tetlow, a descendant of the sitter, 1976.

REFERENCES: *Notable American Women, 1607–1950*, 2:653–655; *New-York Historical Society Portraits*, 2:590; *Proc.*, 88(1976):150, 157.

62

Mrs. Joseph Locke (Mary Ingersoll)

Born in Gloucester in 1770, daughter of David Ingersoll. Went by the name of "Polly." Married shipmaster Benjamin Foster in 1789. Foster died about 1795, and in 1800 she married Joseph Locke, widower of her sister Martha. Mother of 2 Foster children, including Anna Maria (Mrs. Thomas Wells*), and 7 Locke children, including Martha Ingersoll Locke,* Frances Sargent Locke,* and Elizabeth Davis Locke.* Died in Lawrence in 1849.

ARTIST: Samuel Stillman Osgood.

DESCRIPTION: Oil on panel, 69.4 x 56.9 cm. Head-and-shoulders view facing front. Dark hair under lacy frilled bonnet, brown eyes. Black dress with wide white collar. Dark gray background.

PROVENANCE: From the estate of Miss Helen I. Tetlow, 1976.

REFERENCES: Notes by Miss Helen I. Tetlow, MHS; Foster, *Colonel Joseph Foster*, 167–168; Locke, *Book of the Lockes*, 139; *Proc.*, 88(1976):150, 157.

Martha Ingersoll Locke

Born in 1803, daughter of Joseph Locke and Mary (Ingersoll) Locke.* Named for her mother's sister, who was also her father's first wife.

ARTIST: Samuel Stillman Osgood.

DESCRIPTION: Oil on canvas, 77.0 x 64.3 cm. Oval. Head-and-shoulders view. Brown hair parted in the middle, curls over ears, coiled high on back of head. Slight smile. Off-the-shoulder filmy dress. Plain dark to light background.

PROVENANCE: From the estate of Miss Helen I. Tetlow through Mrs. Thomas E. Jansen, Jr., 1980.

REFERENCES: Locke, *Book of the Lockes*, 139.

Arthur Lord

Born in Port Washington, Wisconsin, in 1850, son of William Henry and Persis (Kendall) Lord. Graduated from Harvard in 1872. Married Sarah Shippen in 1878. Practiced law in Plymouth and Boston. Served two terms in the Massachusetts House of Representatives and for one term was chairman of the judiciary committee. Elected president of the Massachusetts Bar Association in 1917. Moved to Plymouth in 1874 and became a

trustee and president of the Pilgrim Society and an avid student of Pilgrim history. Elected to membership in the Society in 1882, he served as treasurer, vice-president, and president. Died in Boston in 1925.

ARTIST: Hermann Hanatschek, 1924. Signed, upper right: "1924 H. Hanatschek." A copy was made for the Pilgrim Society in 1925.

DESCRIPTION: Oil on canvas, 114.6 x 83.8 cm. Three-quarter length view turned almost left. Gray hair, mustache and beard, blue eyes with pince nez. White shirt, black tie and coat, gray trousers. Seated, right hand on chair arm, left holding papers. Green-gray background.

PROVENANCE: Commissioned by the Society, 1924.

REFERENCES: MHS Council Minutes, Nov. 12, 1925; *Proc.*, 58(1924–1925):87, 61(1927–1928):196–211.

Benjamin Loring

Born in Hingham in 1775, son of Joseph and Ruth (James) Loring. A highly successful Boston stationer in business with his twin brother, Josiah. Like his brother he never married. Well known for his philanthropy, he

made donations to the Society in 1803 and 1853. Died in Boston in 1859.

ARTIST: Ethan Allen Greenwood, 1813. Signed, lower left: "Greenwood / Pinx / 1813." In November 1816 Greenwood painted a portrait of Josiah Loring in Boston.

DESCRIPTION: Oil on panel, 66.3 x 49.8 cm. Head-and-shoulders view, turned slightly right, facing front. Dark curly hair and sideburns. White stock and ruffled shirt, white tie, black high-collared coat. Seated. Dark gray background.

PROVENANCE: Gift of Benjamin Loring Young, a relative of the sitter and member of the Society, 1960.

REFERENCES: Crawford, *Famous Families*, 2:268; *History of the Town of Hingham, Massachusetts*, 3 vols. (Hingham, Mass., 1893), 3:35; *Proceedings of the AAS*, 56(1946):140, 141, 147; *Proc.*, 1st ser., 1(1791–1835):154, 2(1835–1855):508, 72(1957–1960):483.

Ellis Gray Loring

Born in Boston in 1803, son of James Tyng and Relief (Faxon) (Cookson) Loring. A member of the class of 1823 at Harvard, elected to Phi Beta Kappa, but dis-

missed just before graduation for resisting college discipline. Lawyer and anti-slavery advocate, perhaps the first lawyer to train a black youth for the bar. Married Louisa Gilman* in 1827. Their home was a center for antislavery workers and fugitive slaves. Died in Boston in 1858.

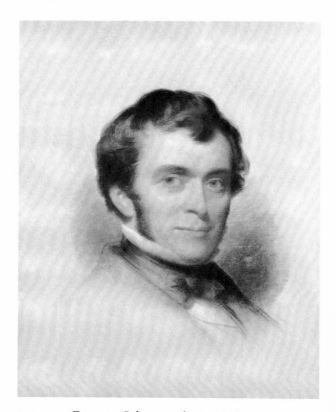

ARTIST: Eastman Johnson, about 1848.

DESCRIPTION: Charcoal and white chalk on paper, 64.5 x 54.0 cm. Facing front, turned slightly left. Dark curly hair and sideburns. High white stiff collar and black tie. Light background with some shading in back of head.

PROVENANCE: In 1885 the portrait was owned by Mrs. Otto Dresel (Anna Loring), only daughter of the sitter. Inherited by her daughter, Miss Louisa Loring Dresel.

Gift of Miss Dresel, 1951.

REFERENCES: *DAB*, 6, pt. 1:416; Crawford, *Famous Families*, 2:275; *Proc.*, 70(1950–1953):337.

Mrs. Ellis Gray Loring (Louisa Gilman)

Born in Gloucester in 1797, daughter of Frederick and Abigail Hillier (Somes) Gilman. Married Ellis Gray Lor-

ing* in 1827. Shared his dedication to the antislavery movement and opened their home in Brookline to antislavery workers and fugitive slaves. Died in Boston in 1868.

I

ARTIST: William Page, about 1844–1849. Signed, lower right: "W. Page."

DESCRIPTION: Watercolor sketch for portrait II, 16.4 x 15.9 cm. Oval. Half-length view facing front. Dark hair parted in middle with ringlets at sides with a bun at back and tied with a blue ribbon. White dress with black brooch on wide lace collar. Seated in red chair. Unfinished background.

PROVENANCE: From the estate of Miss Louisa Loring Dresel, granddaughter of the sitter, 1958.

II

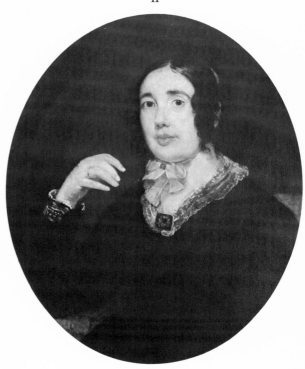

ARTIST: William Page.

DESCRIPTION: Oil on canvas, 76.6 x 63.9 cm. Half-length view. Dark hair parted in middle pulled back and tied with a ribbon under chin, dark brown eyes. Black dress with lace collar and cuffs, black brooch decorated with a bird and fruit. Seated in red chair, dark background.

PROVENANCE: Gift of Miss Louisa Loring Dresel, granddaughter of the sitter, 1951.

REFERENCES: Arthur Gilman, *The Gilman Family* (Albany, N.Y., 1869), 99, 149; *Proc.*, 70(1950–1953):337, 72(1957–1960):436.

John Low

Born about 1768, son of John Low of Lyman, Maine. Married Rachel Francis* of Beverly in 1792. Merchant, trader, and shipowner in the firm of Bourne & Low. An early settler of Kennebunk, Maine, he was a captain in the local militia and deacon of the church. The Embargo and the War of 1812 devastated the economy of the region, and his company along with many others did not recover. "He was a man of unswerving integrity, governing his life by Christian principles, and always ready to give his help in every good work." Died in 1833.

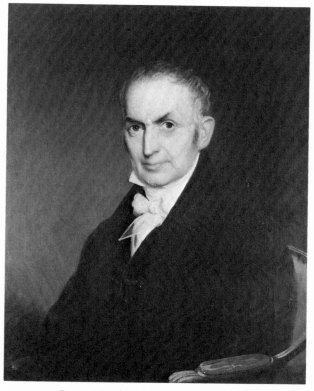

ARTIST: James Frothingham.

DESCRIPTION: Oil on canvas, 76.5 x 63.5 cm. Half-length view facing front. Gray-white hair and short sideburns, dark eyes. Stiff high white collar and tie, black high-collared coat. Seated in red upholstered chair. Dark background.

PROVENANCE: Gift of Francis H. Bigelow, 1932.

REFERENCES: Bourne, *History of Wells and Kennebunk*, 643, 695, 760–761; *Proc.*, 44(1921–1922):172, 64(1930–1932):434.

Mrs. John Low (Rachel Frances)

Born in Beverly in 1770, daughter of Ebenezer and Judith (Wood) Francis. Married John Low* of Wells, Maine, in 1792. Died childless in 1851.

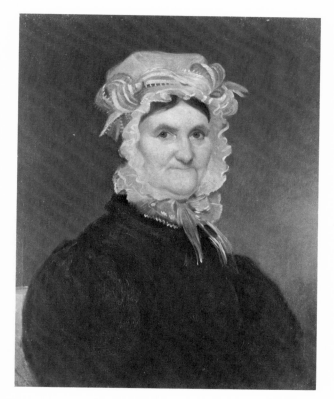

ARTIST: James Frothingham.

DESCRIPTION: Oil on canvas, 76.5 x 63.5 cm. Head-and-shoulders view, facing front. Frilly lace bonnet tied under chin, lace collar on black dress. Seated in upholstered chair in red. Gray background.

PROVENANCE: Same as for John Low (q.v.).

REFERENCES: Bourne, *History of Wells and Kennebunk*, 760–761; *Vital Records of Beverly, Massachusetts, to 1850*, 2 vols. (Topsfield, Mass., 1907), 1:143, 2:126; *Proc.*, 64(1930–1932):434.

Abbott Lawrence Lowell

Born in Boston in 1856, son of Augustus and Katharine Bigelow (Lawrence) Lowell, brother of poet Amy Lowell. Graduated from Harvard in 1877 and from Harvard Law School in 1880. Married in 1879 Anna Parker Lowell, sister of Francis Cabot Lowell, his early law partner. Professor of government at Harvard, member of the Corporation of the Massachusetts Institute of Technology, sole trustee of the Lowell Institute, president of Harvard University from 1909 to 1933. His presidency was marked by the creation of the Harvard House Plan, modeled after the colleges at Oxford and Cambridge, and by the expansion of the Graduate School of Business Administration, which he had helped to establish. Elected to membership in the Society in 1890. Died in Boston in 1943.

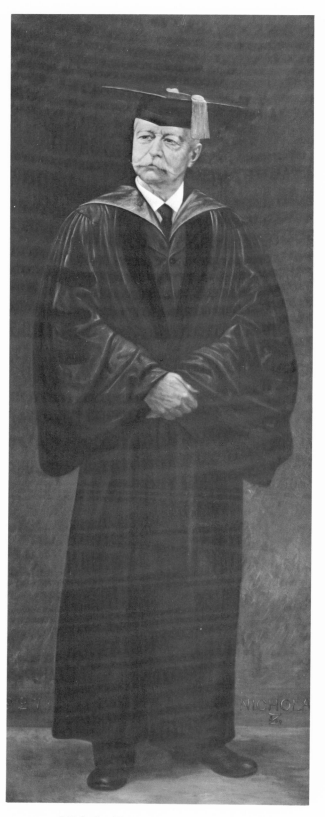

Charles Lowell

Born in Boston in 1782, son of John and Rebecca (Russel) (Tyng) Lowell. Graduated from Harvard in 1800 and studied theology in Edinburgh, Scotland. Married Harriet Spence of Portsmouth, New Hampshire, in 1806. The youngest of their six children was James Russell Lowell, the poet. In 1806 became the fourth pastor of the West Church, Boston, where he served until his death. Elected to membership in the Society, 1815. Was recording secretary and corresponding secretary for more than 30 years. Died in Cambridge in 1861.

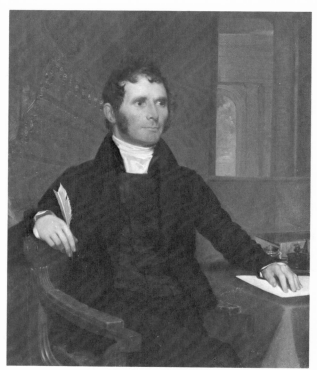

ARTIST: Chester Harding, ca. 1833. A copy by Marie Danforth Page is at the Boston Public Library. Another by an unknown artist is at the Unitarian Universalist Association, Boston.

ARTIST: Nicholas Zengo, 1927. Inscribed, lower left: "1927," lower right: "Nicholas / Zengo."

DESCRIPTION: Oil on canvas, 112.0 x 94.5 cm. Three-quarter length figure, facing slightly left. Dark curly hair and sideburns. White stock under high-collared black coat, black trousers. Seated in an armchair, holding white quill pen of the Society in right hand, left rests on a table. Red drapery in left background. Window in right background reveals a loggia with a view of sky beyond.

PROVENANCE: Acquired before 1885. Source unknown.

REFERENCES: Crawford, *Famous Families*, 1:112–116; Lipton, *A Truthful Likeness*, 167; *Proc.*, 1st ser., 5(1860–1862):146, 147, 427–440.

Jean Paul Mascarene

Born in France in 1684 of Huguenot parents, Jean and Margaret (de Salavy) Mascarene. Educated in Geneva. Became a naturalized citizen of England in 1706; came to Boston in 1709. Married Elizabeth Perry of Boston. Served in the military in New England, Nova Scotia, and Newfoundland, aided the governors of Massachusetts and New Hampshire in negotiating the Indian treaty of 1725–1726. Served as lieutenant governor and acting governor of Nova Scotia from 1740 to 1749, and became a major general in 1758. Died in Boston in 1760.

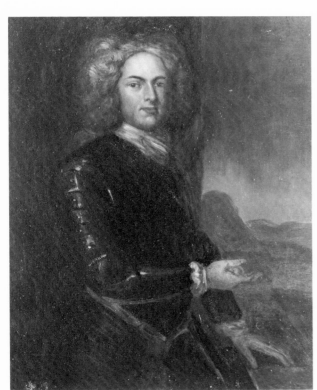

ARTIST: William Henry Whitmore, 1871. Copied from the 1729 original by John Smibert. Inscribed at bottom: "Lt Govr Mascarene / of Nova Scotia. / Original at / Halifax / Copied Feb. 1871." The original, which was later owned by Mrs. Paul Mascarene Hamlin, is now in the Los Angeles County Museum of Art.

DESCRIPTION: Oil on canvas, 43.0 x 35.2 cm. Three-quarter length view, facing front. Full gray curled wig. Dressed in armor, white neckcloth, narrow wrist ruffles, red sash at waist. Standing, left hand rests on a table, right hand points to a window looking out on a landscape view. Dark background.

PROVENANCE: Gift of the artist, a member of the Society and an amateur painter, 1871.

REFERENCES: *DNB*, 36:406–407; Smibert, *Notebook*, 88; *Proc.*, 1st ser., 12(1871–1873):53.

Jonathan Mason

Born in Boston in 1725, son of Benjamin and Elizabeth (Scollay) Mason. Married Miriam Clark in 1747 and had 4 children. A brazier by trade, became a prosperous merchant and served as a Boston town selectman from 1769 to 1771. Deacon of the Old South Church from 1770 until his death. Active as a Son of Liberty during the Revolution. Died in 1798.

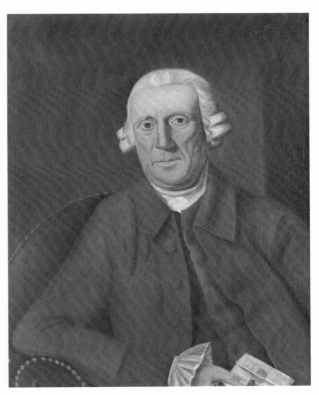

ARTIST: Jonathan Mason, 1822. Copied from the 1783 original by John Johnston. Inscribed on back: "copied from the original / painted 1783 by Johnson / Mr. Mason /Aetat 60 years by / his grandson J. Mason / in / 1822."

DESCRIPTION: Oil on canvas, 75.7 x 63.2 cm. Head-and-shoulders view, facing front. White wig tightly curled in two rolls. White stock, white ruffles at wrists, brown coat with turned-down collar and buttons over brown waistcoat. Seated with right elbow resting on chair arm. Part of his right hand shows holding a white paper with red seal. Plain, very dark background.

PROVENANCE: Gift of Jonathan Phillips, before 1835.

REFERENCES: DAB, 6:370; Thwing Catalogue; Proc., 2(1885–1886):5.

Increase Mather

Born in Dorchester in 1639, son of Richard and Katharine (Holt) Mather. Graduated from Harvard in 1656; received his M.A. from Trinity College in Dublin, Ireland, in 1658. Married twice—to Maria Cotton, his stepsister, in 1662, and to Ann (Lake) Cotton, his nephew's widow, in 1714. A Puritan clergyman, author, and politician, he was pastor of the Old North Church, acting president and rector of Harvard from 1685 to 1701, and an agent for Massachusetts in negotiating the colonial charter of 1690. Died in Boston in 1723.

ARTIST: John van der Spriett, London, 1688. Inscribed, lower center: "Joh Vander / Sprjtt 1688," and upper left on the edge of the shelf: "AEtatis suae 49 1688." There is a copy at the American Antiquarian Society in Worcester. In 1931 a copy was authorized for Leverett House, Harvard College. It now hangs in Mather House.

DESCRIPTION: Oil on canvas, 124.6 x 104.1 cm. Three-quarter length view. Long dark curly hair. Long black cassock buttoned down front with white clerical bands. Seated in an armchair, holds a large volume open with right hand, points to a page with left. Bookshelves and a black curtain in background. (See Color Plate 17).

PROVENANCE: Gift of Mrs. Joseph Crocker (Hannah Mather), a great-granddaughter of the sitter, 1798.

REFERENCES: DAB, 6, pt. 2:390–394; Kenneth Murdock, The Portraits of Increase Mather (Cleveland, 1924), 37–38, 41; MHS Council Records, 5:11, 12 Feb. 1931; Proc., 1st ser., 1(1791–1835):116, 10(1867–1869):47, 2d ser., 8(1892–1894):143–151, 45(1912):556.

Samuel Foster McCleary

Born in Boston in 1780, son of Samuel and Mary (Luckis) McCleary. Married Jane Walter, who died a few months after their marriage, in 1819. Married her sister Maria Lynde Walter in 1821, and they were the parents of Samuel Foster McCleary II.* A lawyer, he was clerk of the State Senate from 1815 until 1822, when he was elected first city clerk of Boston, a position he held until 1851 when he resigned because of ill health. Died in Boston in 1855.

ARTIST: Unknown.

DESCRIPTION: Oil on canvas, 76.0 x 63.2 cm. Oval. Head-and-shoulders view, facing right. Receding dark hair and sideburns. White stock and shirt ruffle under high-collared black coat. Dark gray background.

PROVENANCE: Gift of Miss Helen C. McCleary, granddaughter of the sitter, 1921.

REFERENCES: Proc., 2d ser., 15(1901–1902):255–256, 258; 54 (1920–1921):193.

Samuel Foster McCleary II

Born in Boston in 1822, son of Samuel Foster McCleary* and Maria Lynde (Walter) McCleary. Graduated from Harvard in 1841, and from Harvard Law School; admitted to the bar in 1844. Married Emily Thurston Barnard of Nantucket in 1855. Left the law in 1852 to succeed his father as city clerk of Boston, a position he held for 31 years until a partisan city council failed to re-elect him in 1883. Elected to membership in the Society in 1886, and served as cabinet-keeper. His papers are in the Society's collections. Died in Brookline in 1901.

I

ARTIST: Attributed to James Frothingham, about 1830.

DESCRIPTION: Oil on panel, 28.0 x 22.5 cm. Half-length view of an 8-year-old boy. Light brown curly hair. Wide white ruffled collar on brown coat. Plain dark background.

PROVENANCE: Gift of Miss Helen C. McCleary, daughter of the sitter, 1934.

II

ARTIST: Edward L. Custer, 1875. Signed, middle right: "E. Custer 1875."

DESCRIPTION: Oil on canvas, 68.6 x 56.0 cm. Head-and-shoulders view, facing front. Receding dark hair,

graying beard. Starched shirt with black bow tie under black coat and waistcoat. Gray background.

PROVENANCE: Gift of Miss Helen C. McCleary, daughter of the sitter, 1921.

REFERENCES: *Proc.*, 2d ser., 15(1901–1902):255–263, 54(1920–1921):193.

Mrs. William Minns (Sarah King)

Born in 1737, daughter of Henry and Sarah (Milton) King. Married William Minns, a Boston landowner and merchant, in 1756. Loyalists during the Revolution, she and her family left with the British troops evacuating Boston in 1776, and fled to Halifax, Nova Scotia. Later the same year they went to Newport, Rhode Island, then occupied by the British. When Newport was also evacuated by the British in 1779, the family probably went to New York City and again to Halifax. After the war they returned to Boston. Died a widow in Boston in 1819.

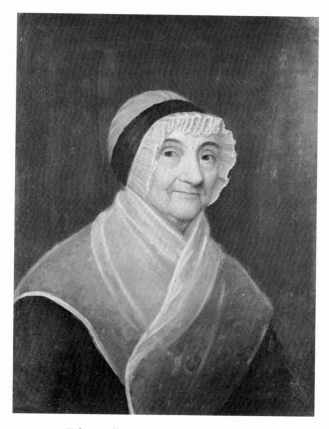

ARTIST: Ethan Allen Greenwood, 1818.

DESCRIPTION: Oil on panel, 72.0 x 54.4 cm. Head-and-shoulders view, turned slightly left. An elderly woman in a white lawn cap with a broad black ribbon band and a pleated white ruffle framing the face. A wide white fichu is draped around her neck covering her dark brown dress. Plain brown background.

PROVENANCE: Gift of Miss Susan Minns, great-granddaughter of the sitter, 1916.

REFERENCES: *Genealogical Histories of Minns and Allied Families*, ed. Ruth Lawrence (New York, 1925), 3, 5, 7; *Proc.*, 49(1915–1916):287.

Nicholas Mitchell

Born in Hull in 1817, son of John and Hannah (Barestead) Mitchell. Married Henrietta Swett Lovell in Hull in 1837 and had 7 children there. Was a farmer and fisherman in his native town. Died in Hull in 1872.

ARTIST: Unknown.

DESCRIPTION: Oil on canvas, 63.8 x 48.4 cm. Half-length view, facing front and smiling. Short light brown hair parted on left. Stiff turned-down white collar, flowing black tie, black coat and waistcoat. Dark gray background.

PROVENANCE: Gift of Miss Barbara Mitchell of Hingham, 1976.

REFERENCES: *Hull Vital Records to 1850* (Boston, 1911), 53; *Proc.*, 88(1976):157.

Samuel Nicholson

Born in Maryland in 1743, son of Joseph and Hannah (Smith) (Scott) Nicholson. Married Mary Dowse, daughter of Nathaniel and Margaret (Temple) Dowse* of Charlestown in 1780. A naval officer in the Revolution and a commissioned captain in the Continental navy in 1776, he commanded the cutter *Dolphin* and the frigate *Deane*. Superintended construction of the *Constitution* and was its first commander. Served as superintendent of the Charlestown navy yard after 1801. Died in Charlestown in 1811.

ARTIST: Attributed to Christian Gullager.

DESCRIPTION: Oil on canvas, 85.1 x 68.5 cm. Half-length view, turned half left, facing front. Short graying brown hair, large double chin. White shirt ruffle and ruffled cuffs under buff waistcoat with many buttons and high-collared black coat. A medal hangs on left side of coat. Dark drapery in right background, view of seascape at left.

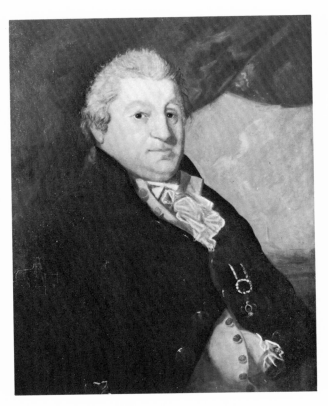

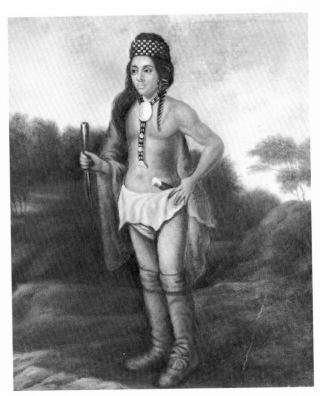

PROVENANCE: Estate of Mrs. David Greene Haskins, Jr., 1949. Nicholson's commissions as captain of the *Dolphin*, signed by John Hancock, of the *Constitution*, signed by George Washington, came to the Society at the same time.

REFERENCES: *DAB*, 7, pt. 1:506–507; *Proc.*, 69(1947–1950):473.

Ninigret II

Son of the Sachem Ninigret I of the Niantics (later called the Narragansetts), and succeeded his step-sister Wuenquesh as sachem about 1686. English influence in the area resulted in a loss of Ninigret's power, and he sold much of the Narragansetts' lands to the settlers including a 135,000 acre tract in 1709. Retained an eight-square-mile reservation covering most of present-day Charlestown, Rhode Island. Died in 1723.

ARTIST: Charles Osgood, 1837–1838. Copy of an original by an unknown artist, then in the possession of the New York branch of the Winthrop family and now at the Rhode Island School of Design. Long thought to represent the elder Ninigret and to have been painted in 1647 after the sachem saved the life of Gov. John Winthrop, Jr. Now considered to represent the son and to have been painted about 1681.

DESCRIPTION: Oil on canvas, 89.3 x 73.6 cm. Full-length figure, facing slightly right. Long dark hair, under embroidered cap, oval medallions at throat, orange breech cloth, large scarf or blanket over right arm, high moccasins. Standing, staff in right hand. Landscape background.

PROVENANCE: Commissioned by Robert Charles Winthrop. Later inherited by his granddaughter, Miss Clara Bowdoin Winthrop.
Gift of Miss Winthrop, 1934.

REFERENCES: Osgood, Record Book; *Rhode Island History*, 36 (1977):42–53, 37(1978):70–72; *Proc.*, 65(1932–1936):268.

Mrs. Daniel Oliver
(Elizabeth Belcher)

Born in 1678, daughter of Andrew and Sarah (Gilbert) Belcher and sister of the first Gov. Jonathan Belcher. Married Daniel Oliver in 1696. They had 5 children including Andrew Oliver, later lieutenant governor of Massachusetts. Elizabeth Oliver* was their granddaughter. Died in Boston in 1735.

ARTIST: John Smibert, after 1732. Not listed in Smibert's notebook.

70

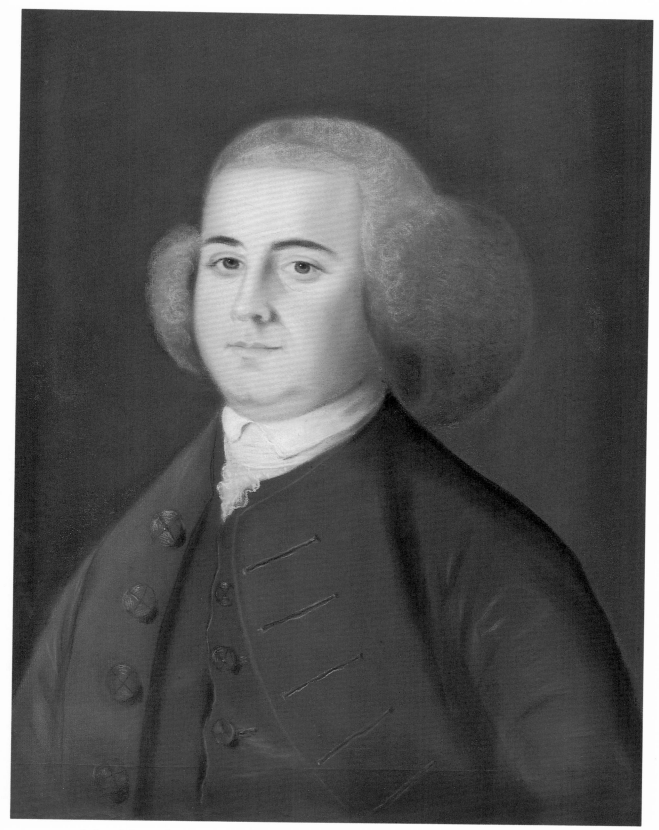

PLATE 1 John Adams by Benjamin Blyth, probably 1766

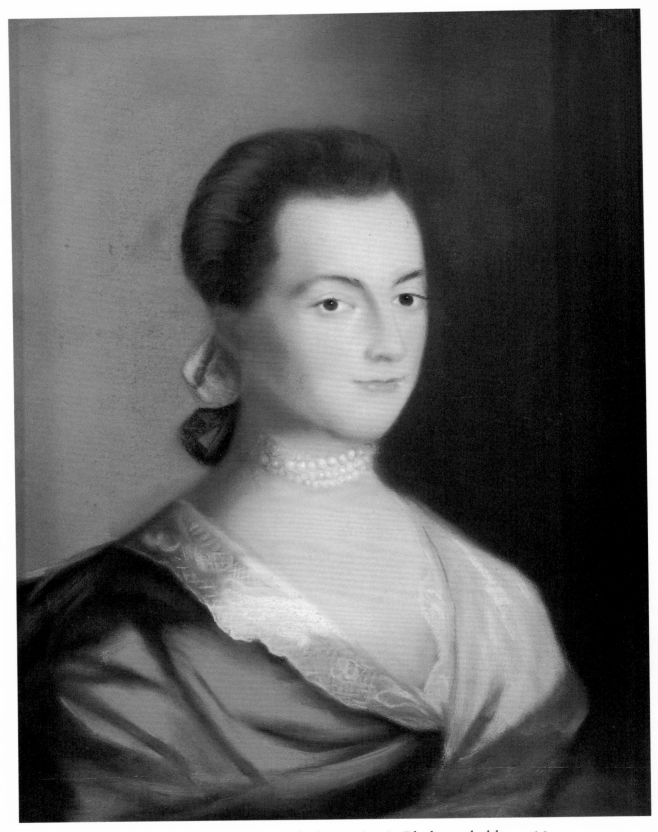

PLATE 2 Mrs. John Adams (Abigail Smith) by Benjamin Blyth, probably 1766

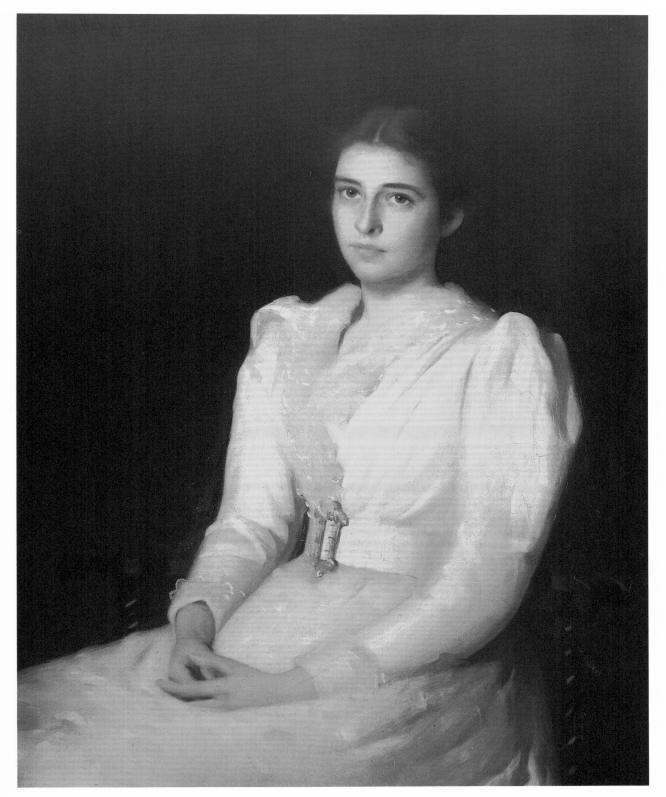

PLATE 3 Alice Bacon by Frank Weston Benson, 1891

PLATE 4 George Berkeley by John Smibert, 1730

PLATE 5 Daniel Boone by Chester Harding, 1820

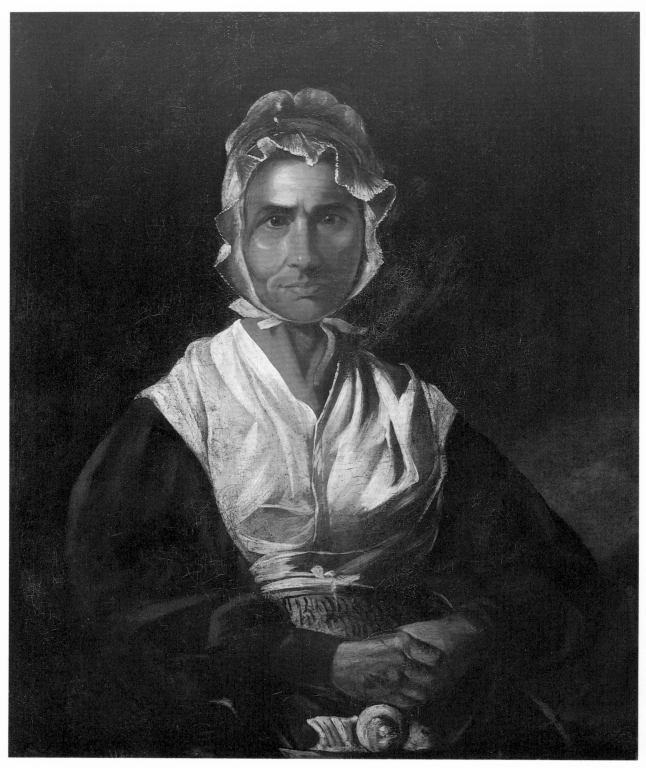

PLATE 6 Sally Brown by Robert Matthew Sully

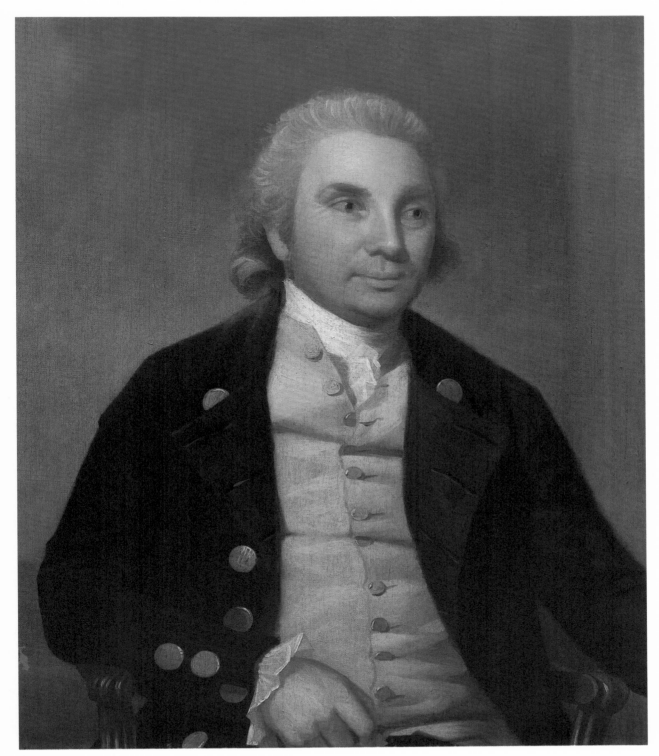

PLATE 7 John Callahan by Ralph Earl, 1785

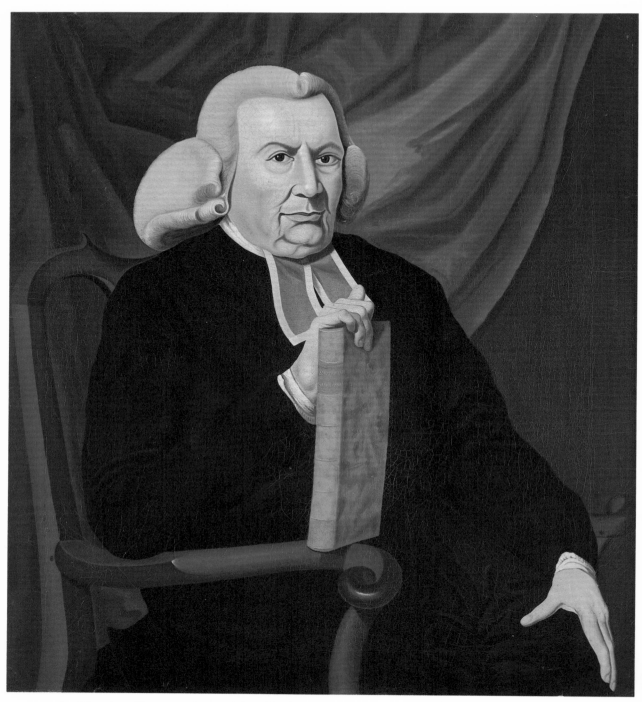

PLATE 8 Charles Chauncy by unidentified artist, 1786

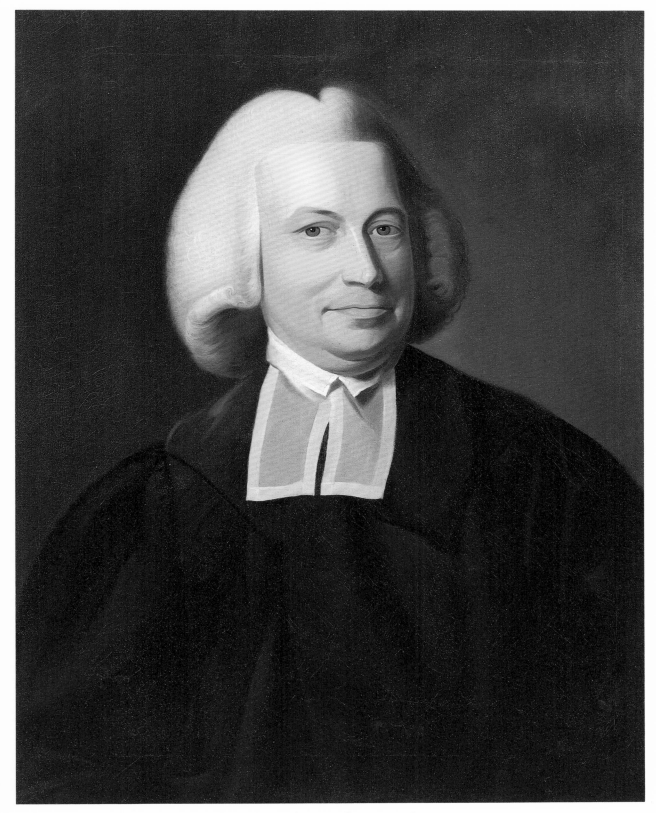

PLATE 9 Samuel Cooper attributed to John Singleton Copley

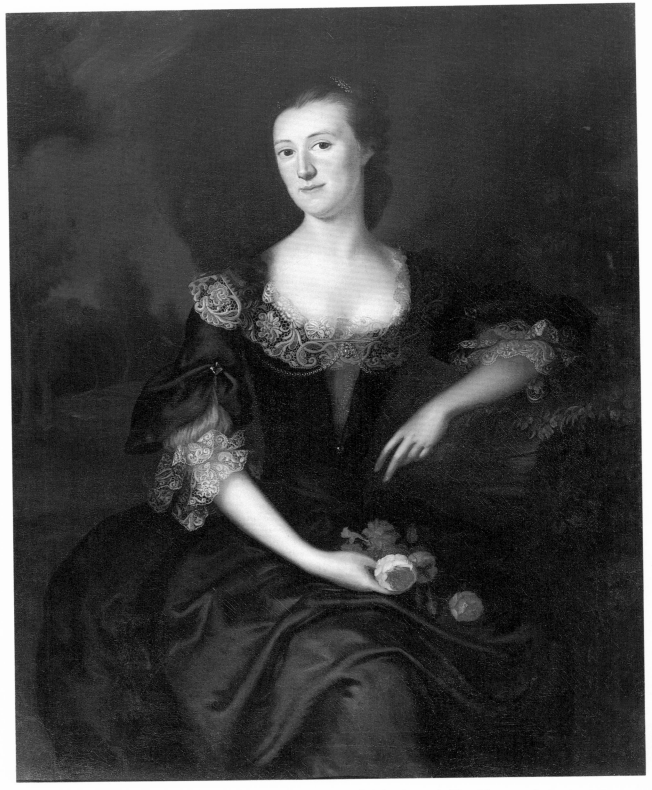

PLATE 10 Mrs. Nathaniel Dowse (Margaret Temple) by Joseph Blackburn, about 1757

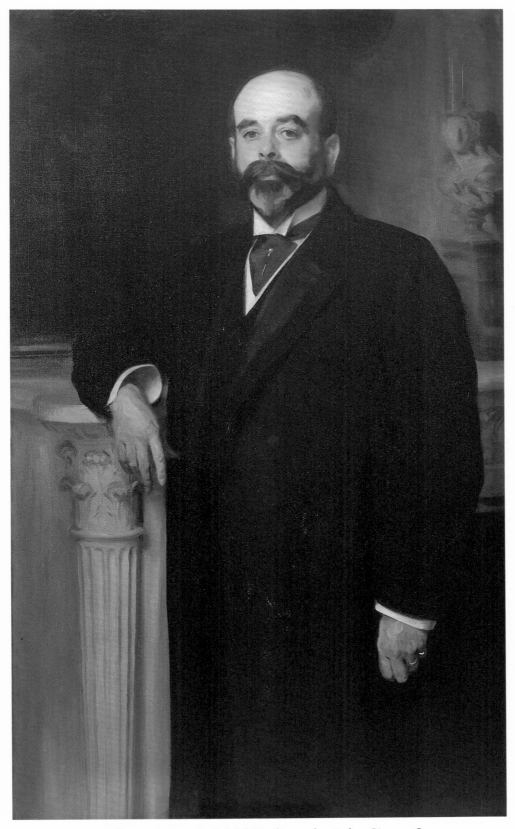

PLATE 11 William Crowninshield Endicott by John Singer Sargent, 1907

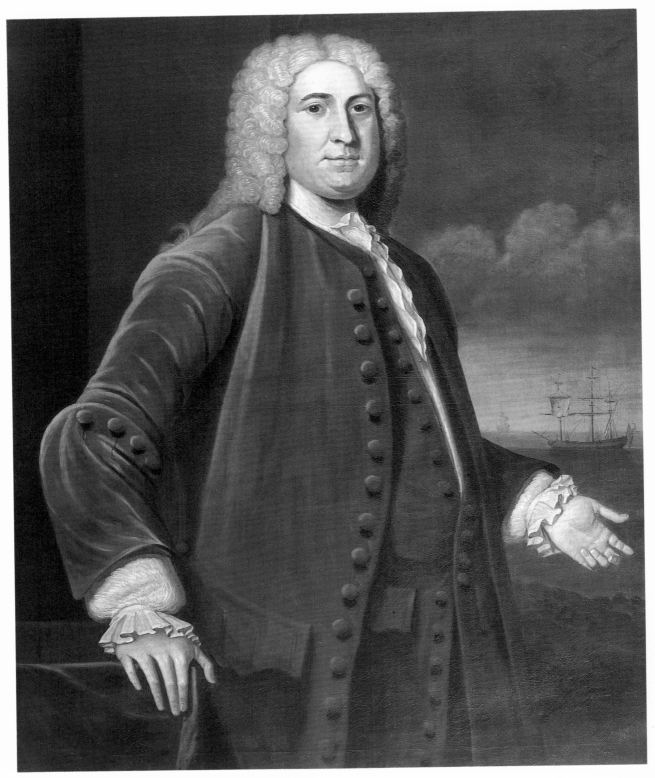

PLATE 12 Peter Faneuil by John Smibert, about 1739

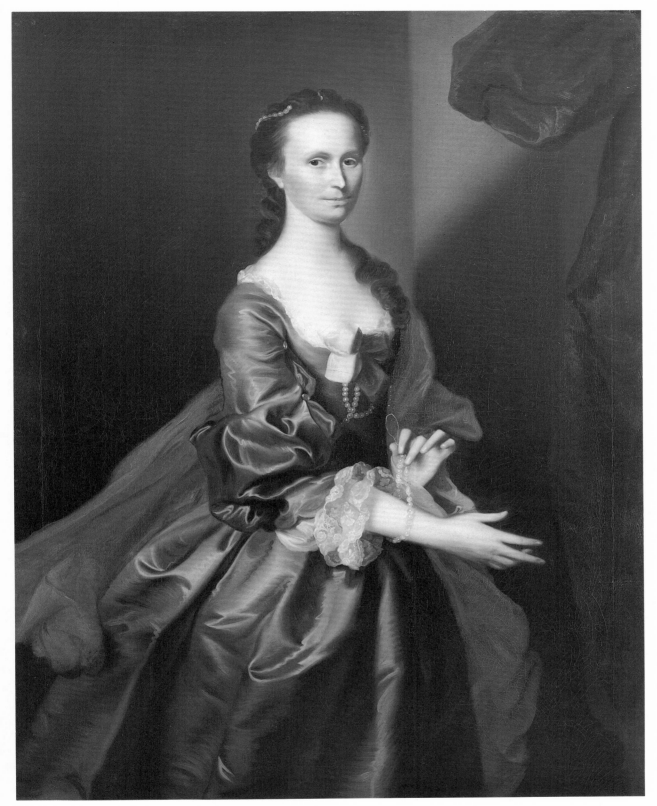

PLATE 13 Mrs. John Gray (Mary Otis) by John Singleton Copley, about 1763

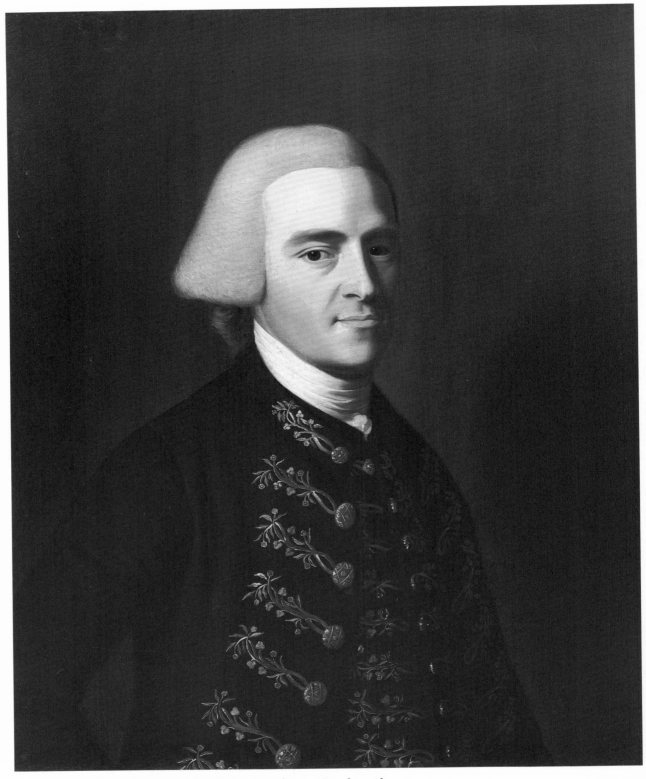

PLATE 14 John Hancock by John Singleton Copley, about 1770–1772

PLATE 15 John Joy, Jr., by Joseph Badger, about 1758

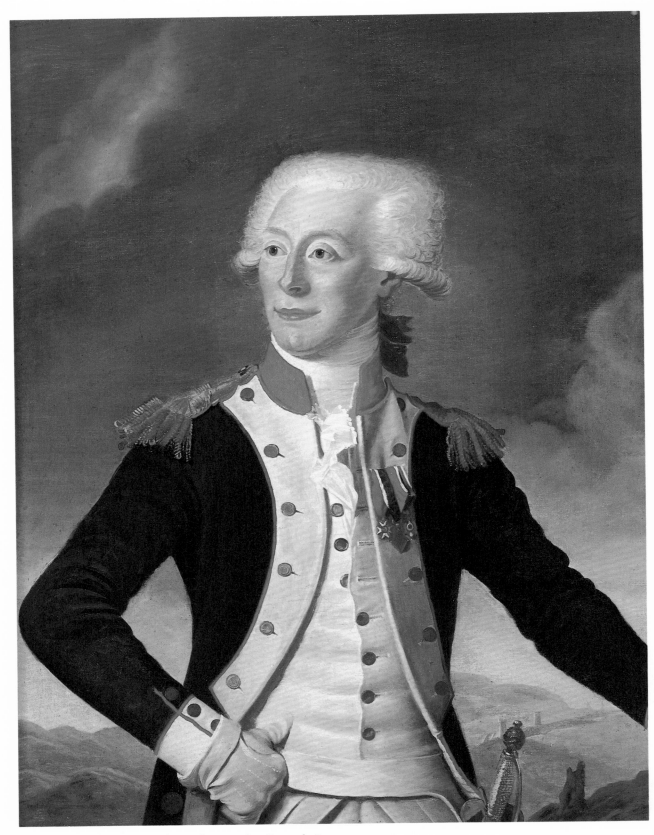

PLATE 16 Marquis de Lafayette by Joseph Boze, 1790

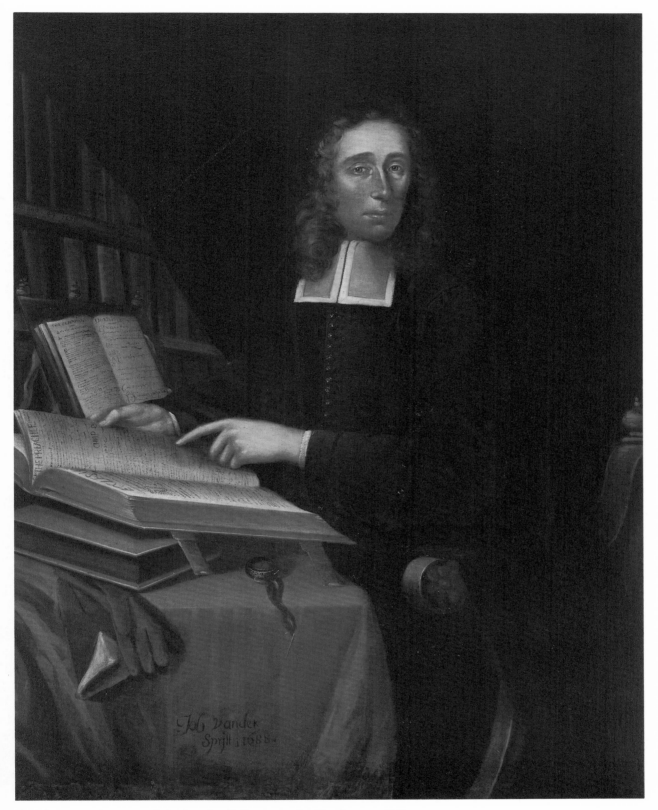

PLATE 17 Increase Mather by John van der Spriett, 1688

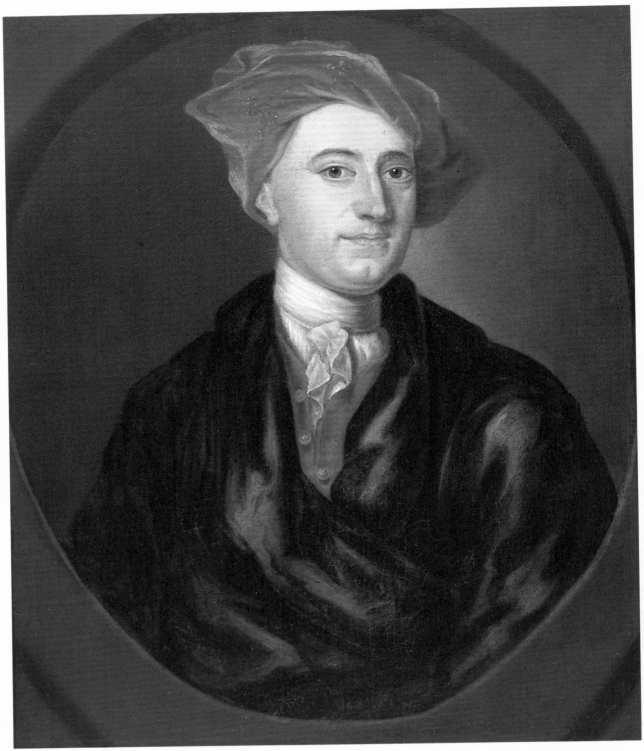

PLATE 18 Benjamin Pollard by Joseph Blackburn, 1755

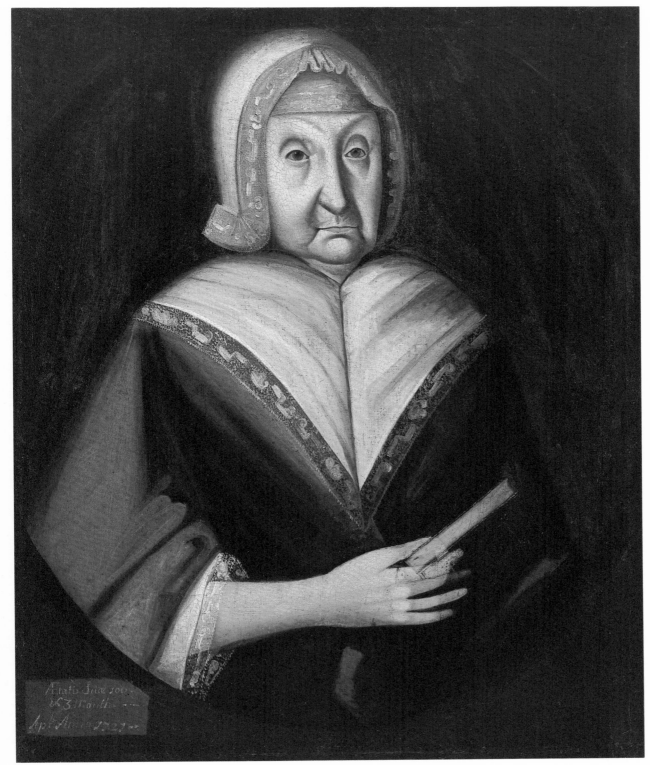

PLATE 19 Mrs. William Pollard (Anne Dison?) by unidentified artist, 1721

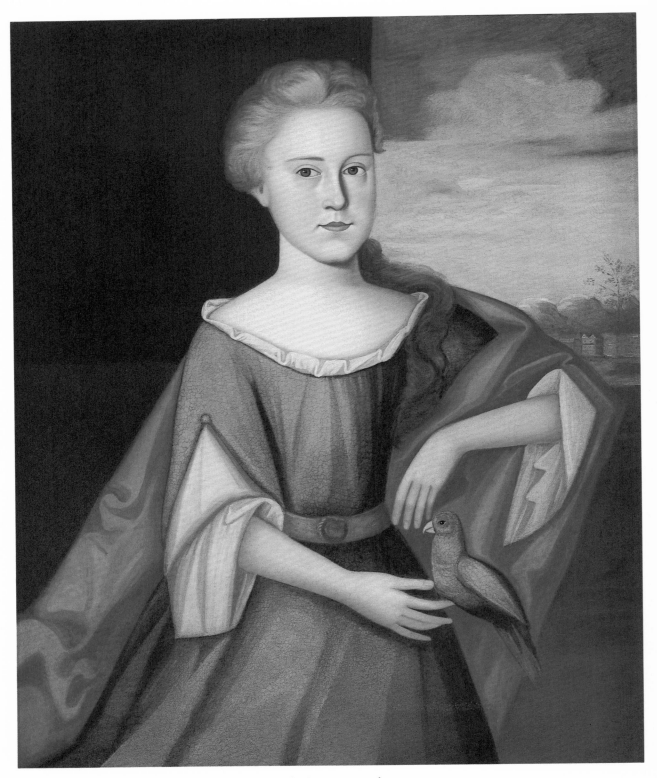

PLATE 20 Dorothy Quincy by unidentified artist, early 1720s

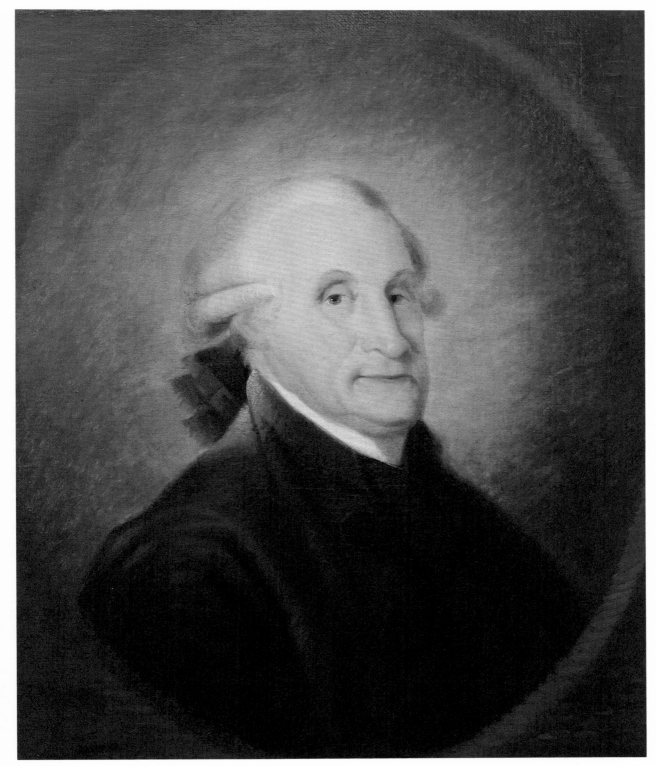

PLATE 21 George Washington by Christian Gullager, 1789

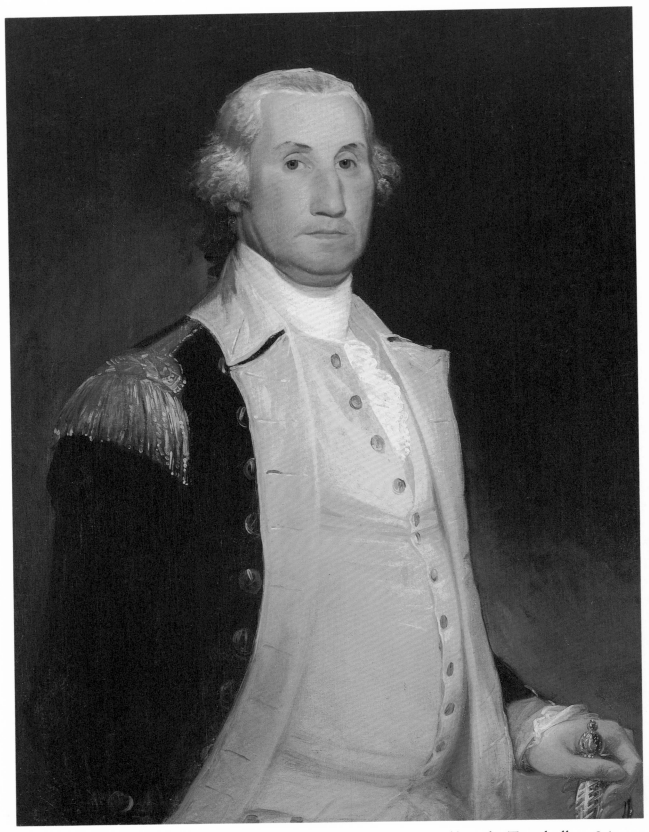

PLATE 22 George Washington by Joseph Wright, 1784, completed by John Trumbull, 1786

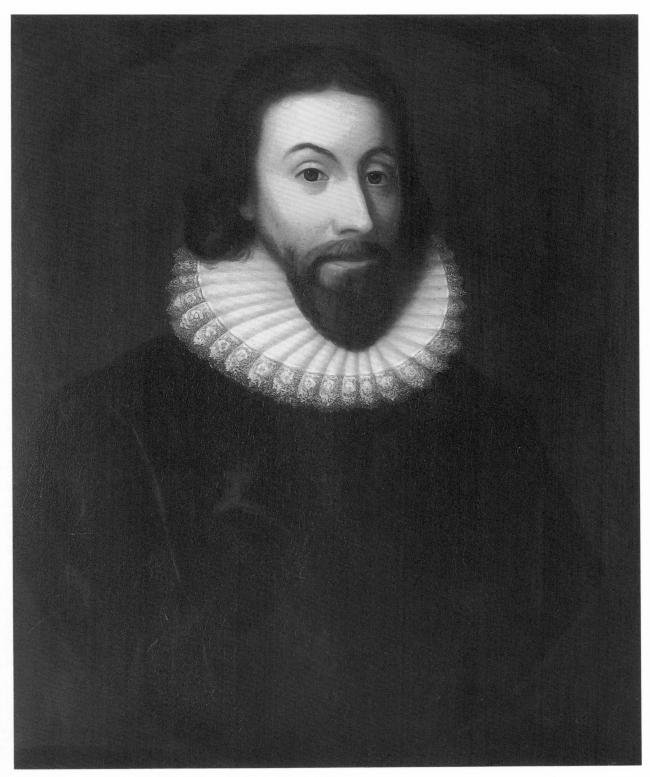

PLATE 23 John Winthrop by Charles Osgood, 1834

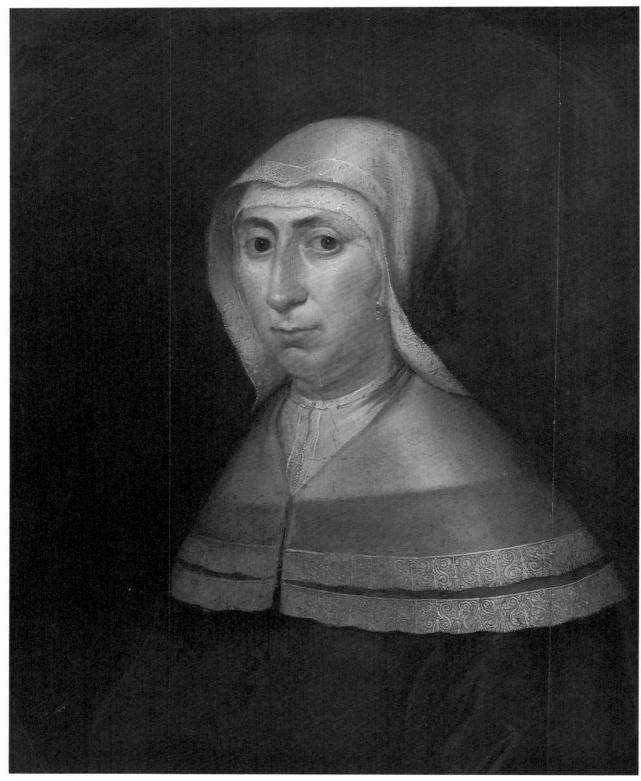

PLATE 24 Mrs. Winthrop by unidentified artist

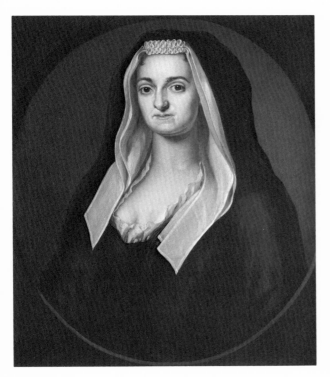

DESCRIPTION: Oil on canvas, 76.3 x 63.9 cm. Head-and-shoulders view, facing front. Brown eyes, pink cheeks, wearing widow's weeds with underlying white trimmings. Gray background in oval.

PROVENANCE: Owned by Hon. Andrew Oliver, Jr. (1731–1799), and inherited by his son, Dr. B. Lynde Oliver of Salem (1760–1835). The portrait was valued in his estate inventory at $2 and went to his nephew, B. Lynde Oliver (1788–1843). After his death, the portrait passed to his sister Sarah Pynchon Oliver, who sold it in 1844 to her nephew, Rev. Andrew Oliver. Upon his death in 1898 it was inherited by his son William H. P. Oliver. It was among the family paintings given jointly to William's three sons in 1950, and divided among the three in 1958. This portrait went to Peter Oliver, and was inherited at his death by his two daughters, Mrs. Starr Oliver Lawrence and Mrs. Prudence Oliver Harper.

Gift of Mrs. Lawrence and Mrs. Harper, 1985.

REFERENCES: Oliver, *Faces of a Family*, xv–xvi, 4; *Proc.*, 97(1985):170.

Elizabeth Oliver

Born in 1739, daughter of Andrew Oliver, lieutenant governor of Massachusetts, and Mary Sanford, his second wife. Granddaughter of Mrs. Daniel Oliver.* Married as his second wife, Boston merchant Edward Lyde, her second cousin, in 1772. Loyalists, they removed to Halifax and then to England during the Revolution. Afterwards they settled in New York City. Died in New York City in 1820.

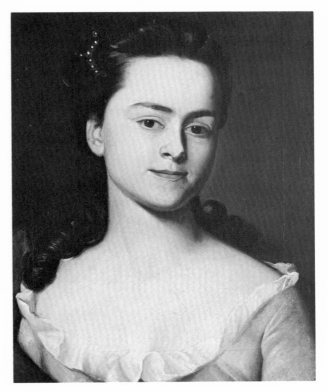

ARTIST: John Singleton Copley, about 1758.

DESCRIPTION: Oil on canvas, 44.4 x 36.8 cm. Head-and-shoulders view, facing front. Dark hair in long curls, dark eyes. Off-the-shoulder, round-necked dress trimmed with white ruffle. Plain dark background.

PROVENANCE: Owned in 1873 by Mrs. Charles Ellis (Elizabeth Ann Byles) of Burlington, New Jersey, a granddaughter of the sitter.

Purchased from the estate of Grace Lyde Gordon, a great-granddaughter of the sitter, 1920.

REFERENCES: Oliver, *Faces of a Family*, 13; Prown, *Copley*, 1:224; *Proc.*, 54(1920–1921):4–5.

George Lyman Paine, Jr.

Born in New York City in 1901, son of George Lyman and Clara Adelaide (May) Paine. Graduated from Harvard in 1922, studied architecture in the United States and in Europe. Twice married—to Ruth Forbes in 1926 and to Frances Drake in 1939. Worked in New York until 1952 when he moved to Los Angeles. Concern for

the ordinary worker moved him to join the communist movement and the Civil Liberties Union and co-edit *Correspondence*, a paper devoted to the working class. Died in 1978.

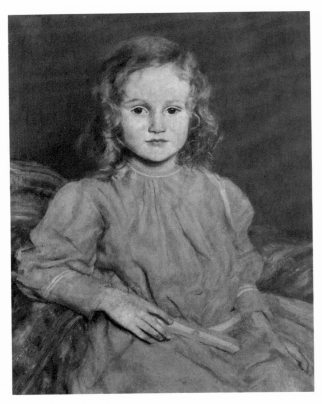

ARTIST: Margarita Pumpelly Smyth, 1905.

DESCRIPTION: Oil on canvas, 62.2 cm. x 50.1 cm. Three-quarter length view of a boy of 4 years. Long curly blond hair, brown eyes. Long-sleeved blue dress trimmed with white. Seated with right hand in lap. Plain gray background.

PROVENANCE: Gift of Mrs. George Lyman Paine, Sr., step-mother of the sitter, 1971.

REFERENCES: *Harvard Class of 1922: Fiftieth Anniversary Report* (Cambridge, Mass., 1972), 386–387; *Proc.*, 83(1971):185.

Robert Treat Paine

Born in Boston in 1731, son of Thomas and Eunice (Treat) Paine. Graduated from Harvard in 1749. Married Sally Cobb, sister of Gen. David Cobb,* in 1770. After employment variously as a teacher, sea captain, merchant, army chaplain, and whaler, he studied law

and was admitted to the bar in 1757. Prosecuting attorney in the Boston Massacre trials; delegate to the Continental Congress; signer of the Declaration of Independence; and first Massachusetts attorney general. Became a state supreme court justice, 1790. Retired from the bench in 1804. Died in Boston in 1814.

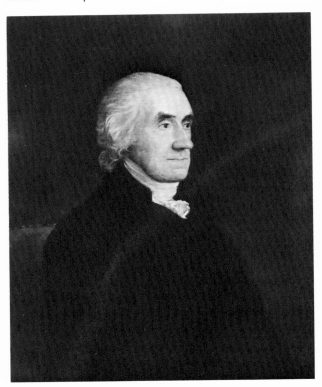

ARTIST: Edward Savage, completed by John Coles, Jr. In Nov. 1821 it was described by the sitter's daughter: "I think it a likeness. The head & face are pretty nearly finished. But the shoulders & breast only the outlines." In 1823 John Coles completed the portrait for $25.

DESCRIPTION: Oil on canvas, 74.3 x 61.7 cm. Half-length view, turned one-third left. White hair, high forehead, prominent pointed nose. White stock and ruffle, black coat and waistcoat. Plain dark background.

PROVENANCE: It was purchased in 1822 for $50, by Miss Mary Paine, daughter of the sitter, from Savage, through Ethan A. Greenwood. A newsclipping in the Paine Collection dated June 15, 1842, states that Robert Treat Paine, Charles C. Paine, and James H. Paine, offered the painting to the City of Boston to hang in Faneuil Hall. Apparently the offer was never accepted, as the painting remained in the family until given to the Society. Eventually owned by Mary Paine's great nephew, Gen. Charles Jackson Paine, and given to the Society by his daughters and the widows of his sons.

Gift of Mrs. Llewellyn Howland (Georgina Paine), Mrs. Frederick Winsor (Mary Anna Lee Paine), Mrs.

John Bryant Paine (Louise Rue Frazer), and Mrs. Frank Cabot Paine (Virginia Low), 1954.

REFERENCES: *Sibley's Harvard Graduates*, 12:462–482; Paine Papers, MHS.

Mrs. Robert Treat Paine
(Lydia Williams Lyman)

Born in Boston in 1837, daughter of George Williams and Anne (Pratt) Lyman. Married Boston lawyer Robert Treat Paine (1835–1910) at King's Chapel in Boston in 1862, but later joined Trinity Church, where her husband's close friend and college classmate Phillips Brooks was minister. A vigorous woman, she founded the Trinity Employment Society and served on the boards of many humane societies. Died in 1897.

ARTIST: Jessie Noa, 1897. Signed, lower right: "Jessie Noa / 1897."

DESCRIPTION: Aquarelle on paper, 81.0 x 55.7 cm. Head-and-shoulders view, facing front. Elaborately waved brown hair, blue eyes, slight smile. High-collared black dress with puff sleeves, brooch at neck, 2 white flowers pinned on left side. Light blue background with faint tones.

PROVENANCE: Gift of Mrs. George Lyman Paine, Sr., daughter-in-law of the sitter, 1971.

REFERENCES: *Paine Ancestry*, Sarah Cushing Paine, comp., Charles Henry Pope, ed. (Boston, 1920), 280, 316; *Proc.*, 83(1971):185.

Charles Paxton

Born in Boston in 1708, son of Wentworth and Faith (Gillman) Paxton. A customs officer by the age of 25, he became surveyor of customs in 1760 and a commissioner of customs in 1767. Strictly enforced the writs of assistance despite their unpopularity. When Gov. Thomas Hutchinson's house was sacked in August 1765, Paxton is said to have used a barrel of punch to bribe the mob to stop the attack. Seized one of John Hancock's vessels for smuggling wine, was hanged in effigy on the Liberty Tree, fled to England in 1776. Died in England in 1788.

ARTIST: Attributed to Edward Truman, 1734. Another portrait, signed "J. Cornish 1751" (probably John Cornish of Oxford, England) is owned by the American Antiquarian Society in Worcester.

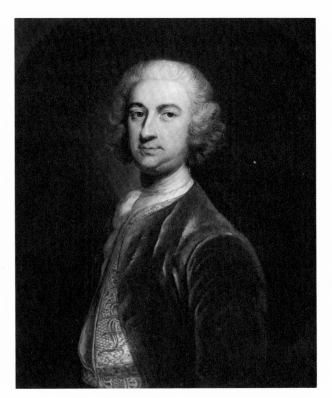

DESCRIPTION: Oil on canvas, 76.5 x 62.6 cm. Half-length view, turned half right, facing front. Gray wig tied at back with black ribbon, blue eyes. White stock on white shirt under figured waistcoat and gray velvet collarless coat. Oval in dark background.

PROVENANCE: Owned by Rev. Jonathan Mayhew, and later inherited by his grandson, the donor.
 Gift of Peter Wainwright, Jr., 1835.

REFERENCES: Thwing Catalogue; *Proceedings of the AAS*, 19(1908–1909):208, 33(1923):245; Hiller B. Zobel, *The Boston Massacre* (New York, 1970), 50, 55, 65; *Proc.*, 56(1922–1923):343–352, 94(1982):15–36.

Andrew Preston Peabody

Born in Beverly in 1811, son of Andrew and Mary (Rantoul) Peabody. Graduated from Harvard in 1826 as the second youngest person to have received a degree there. Married Catherine Whipple Roberts of Portsmouth, New Hampshire, in 1836. Studied at the Divinity School in Cambridge, ordained at the South Parish in Portsmouth, New Hampshire in 1833 and pastor there for 27 years. Editor and proprietor of the *North American Review* from 1853 to 1863 and a prolific writer. From 1860 to 1881 Plummer Professor of Christian Morals and preacher to the university at Harvard, where

he was required to conduct daily prayers, preach two sermons on Sunday, and act as pastor to the whole student body. Elected to membership in the Society in 1858. Died in Cambridge in 1893.

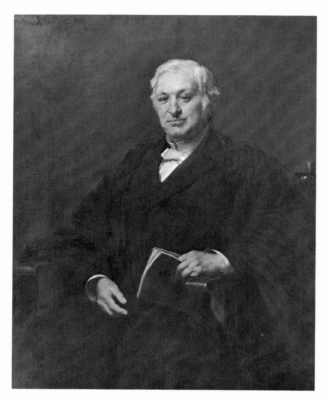

ARTIST: Frederic Porter Vinton, 1887. Signed, upper left: "Frederic P. Vinton 1887." A similar portrait by Vinton is at Harvard University.

DESCRIPTION: Oil on canvas, 128.5 x 103.4 cm. Three-quarter length view, facing front. Short white hair and sideburns. Stiff standing white collar on shirt with white bow tie. Black coat under black academic robes. Seated, holding book in left hand. Plain dark background.

PROVENANCE: Gift of Mrs. John Langdon Sibley, 1887.

REFERENCES: *DAB*, 7, pt. 2:334–335; Catalogue of American Portraits, NPG; *Proc.*, 2d ser., 3(1886–1887):276, 11(1896–1897):25–46.

William Pepperrell

Born in Kittery Point, Maine, in 1696, son of William and Margery (Bray) Pepperrell. Married Mary Hirst, granddaughter of Samuel Sewall,* in 1723. Went into business with his father, a prosperous merchant, invested in real estate, and became one of the wealthiest men in the colony. President of the Massachusetts Governor's Council for many years, served as chief justice of Massachusetts, and was head of the Maine militia. Commanded the American forces in the expedition that captured Louisbourg, the French fortress on Cape Breton, in 1745. Received a baronetcy in 1746, the first native American to be so honored. Died in Kittery, Maine, in 1759.

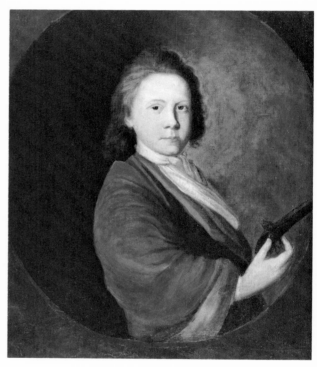

ARTIST: Attributed to the "Savage limner," about 1710–1712.

DESCRIPTION: Oil on canvas, 76.6 x 63.7 cm. Head-and-shoulders view, turned half left, facing front. Shoulder-length brown hair, brown eyes. Loose white cravat under gray coat edged with brown. Holds pistol in right hand. Painted in an oval on a brown background.

PROVENANCE: Given by Miss Harriet Hirst Sparhawk, great-granddaughter of the sitter, to Benjamin Pollard Winslow. Inherited by his son Erving Winslow and then by the latter's daughter, the donor.
Gift of Miss Anne R. Winslow, 1971.

NOTE: The *Proceedings* in 1878 included the Pepperrell portrait on a list of portraits by John Smibert, misidentifying it as Andrew Pepperrell (1725/6–1757), as did the *Essex Institute Historical Collections* in 1894. *Sibley's Harvard Graduates* (vol. 16) published the portrait as representing the second Sir William Pepperrell (1746–1816).

REFERENCES: *DAB*, 7, pt. 2:456–457; "The Pepperrell Portraits," by Cecil Hampden Cutts Howard, *EIHC*, 31(1894):54–65; *Proc.*, 1st ser., 16(1878):398, 83(1971):200.

Wendell Phillips

Born in Boston in 1811, son of John and Sarah (Walley) Phillips. Graduated from Harvard in 1831 and from Harvard Law School. Married Ann Terry Greene in 1837. A lawyer and skillful orator, he was prominent in the antislavery movement and active in many other popular reform movements, including the labor cause. Author of *The Labor Question*, published in 1884. Died in Boston in 1884.

I

ARTIST: Charles V. Bond, 1849. May be the earliest known portrait of Phillips.

DESCRIPTION: Oil on canvas, 92.6 x 74.8 cm. Half-length view, facing front. Receding, short dark hair, brown eyes. High stiff collar, black stock and tie, black coat. Seated in an armchair, left arm and hand resting on chair's arm. Plain dark background.

PROVENANCE: Gift of Mrs. Susan B. Hall of New York, 1912.

II

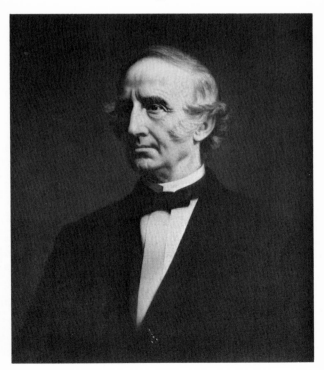

ARTIST: Unknown.

DESCRIPTION: Oil on canvas, 76.2 x 63.7 cm. Head-and-shoulders view, facing slightly right. Gray curly hair, stiff white shirt, black bow tie and coat. Plain dark background.

PROVENANCE: Bequest of Oliver Wendell Holmes, 1936.

III

ARTIST: Daniel Fansel(?). Signed, lower right: "Daniel [Fansel?]."

DESCRIPTION: Oil on canvas, 61.3 x 45.8 cm. Head-and-shoulders view in left profile. Short curly gray hair. White stock, black bow tie, black waistcoat and coat. Dark background.

PROVENANCE: Gift of Jacob Reiss, 1955.

REFERENCES: *DAB*, 7, pt. 2:546–547; *Proc.*, 45(1911–1912):415, 65(1932–1936):535.

Timothy Pickering

Born in Salem in 1745, son of Timothy and Mary (Wingate) Pickering. Graduated from Harvard in 1763; admitted to the bar in 1768. Married Rebecca White in

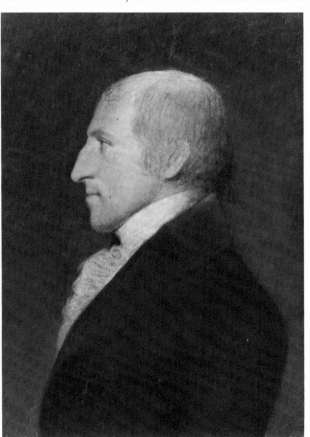

1776. A fervent Federalist, merchant, and farmer, he served as an officer in the Continental Army; postmaster general, secretary of war, secretary of state under George Washington; and member of John Adams's cabinet. A man of wide-ranging abilities and interests including a musical aptitude, he negotiated treaties with the Indians and helped establish the American navy. Joined the Society as a corresponding member from Philadelphia in 1798. Died in Salem in 1829.

ARTIST: James Sharples, or James and Ellen Sharples, about 1800.

DESCRIPTION: Pastel on paper, 25.5 x 20.2 cm. Head-and-shoulders view in left profile. Short gray hair, pointed nose. White stock and ruffle under high-collared black coat. Blue-gray background.

PROVENANCE: Estate of Miss Clara Bowdoin Winthrop, 1969.

REFERENCES: Knox, *Sharples*, 97; *DAB*, 7, pt. 2:565–568; *Sibley's Harvard Graduates*, 15:448–473; *Proc.*, 1st ser., 1(1791–1835):110.

Stephen Snow Pierce

Born in Boston in 1897, son of Jesse Harding and Ella (Rourke) Pierce. Graduated from Harvard in absentia in 1919 while serving in the United States Army, and from the Harvard School of Business Administration in 1926.

Married Hope Hamilton in 1928. Worked as a statistical expert for the United Fruit Company, the Commercial Brewing Company, the General Capital Corporation of Boston and the Watertown Arsenal. Died in Boston in 1973.

ARTIST: Raymond Perry Rogers Neilson, 1913. Signed upper right corner: "Raymond P. R. Neilson 1913."

DESCRIPTION: Oil on canvas, 80.6 x 64.9 cm. Half-length view, facing front. Brown hair and mustache. Turned-down stiff white collar on blue shirt, red tie under black coat. Seated, right arm resting on arm of chair. Holding gloves in clasped hands. Blue-gray background.

PROVENANCE: Gift of Rodman A. Heeren, 1969.

REFERENCES: *Harvard Class of 1919, Fiftieth Anniversary Report* (Cambridge, Mass., 1969); *Boston Globe*, April 24, 1973; *Proc.*, 81(1969):241.

Robert Pike

Born in 1685, son of John and Sarah (Moody) Pike of Dover, New Hampshire, and grandson of Maj. Robert Pike (1616–1670) of Salisbury, whose portrait this was long thought to be. Married Elizabeth Atkinson in 1711. Practiced medicine in Portsmouth, New Hampshire. Died in Portsmouth in 1731.

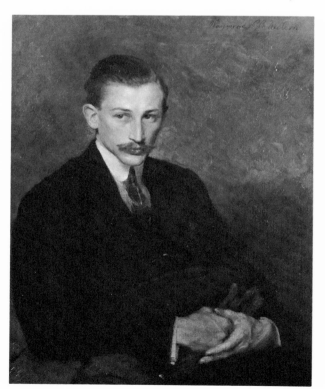

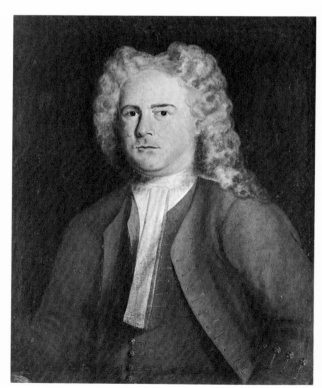

ARTIST: Unknown.

DESCRIPTION: Oil on canvas, 76.2 x 63.9 cm. Half-length view, facing front. Long curled white wig, parted in middle. White shirt with loose jabot trimmed with lace, brown waistcoat and matching collarless coat. Plain dark background.

PROVENANCE: Probably inherited by the sitter's only son, Robert Pike, and upon his death in 1737 by his uncle Theodore Atkinson.

Gift of Mrs. William King Atkinson, 1836.

REFERENCES: *Genealogical Records of Portsmouth* (1903), 1:14, 3:77; Bolton, *Portraits of the Founders*, 3:881–883; *Proc.*, 1st ser., 2(1835–1855):55.

Pocahontas

Born in Virginia in 1595, daughter of Powhatan, powerful chief of the Powhatan confederacy. Capt. John Smith credited her with saving his life in 1608, an oft-repeated episode in American history. Captured by the English and held hostage at Jamestown in 1613. Converted to Christianity and was baptized as "Rebecca." Married John Rolfe, an English settler, in 1614. In 1616 they went to England, where she was entertained by the bishop of London, received by the king and queen, and accorded all respects due to a princess. Died suddenly at Gravesend, England, where she is buried, in 1617.

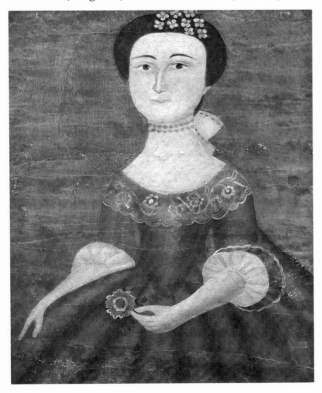

ARTIST: Mary Woodbury of Beverly. She painted the idealized depiction at a Boston finishing school in the 1730s.

DESCRIPTION: Oil on paper mounted on canvas, 38.5 x 32.0 cm. Stylized representation. Half-length, doll-like figure. Dark hair and eyes. Low round neckline on dark dress trimmed with lace and ruffles. Holding a stiff flower in left hand.

PROVENANCE: The artist married Dr. Benjamin Jones of Beverly, and the portrait presumably was inherited by their daughter Lydia, who married Rev. Thomas Lancaster of Scarborough, Maine. Their daughter, Mrs. Samuel Tompson (Mary Lancaster), was the mother of Mrs. Storer Libby (Dorothy Lancaster Tompson).

Gift of the grandchildren of Dorothy Lancaster Libby, 1931.

REFERENCES: *DAB*, 8, pt. 1:18–19; Josephine S. Ware, *The Lancaster Genealogy* (Rutland, Vt., 1934), 18, 33; *Proc.*, 64(1930–1932): 346.

Benjamin Pollard

Born in Boston in 1696, son of Jonathan and Mary (Winslow) Pollard and grandson of Mrs. William (Anne) Pollard.* Married Margaret Winslow in 1746. A prominent merchant, colonel in the local militia, and a member of the Ancient and Honorable Artillery Company, he was a founder of the First Corps of Cadets in 1741. Succeeded his uncle Edward Winslow as sheriff of Suffolk County in 1743 and served until his own death. Died in Boston in 1756.

ARTIST: Joseph Blackburn, 1755. The Society authorized a copy of the Pollard portrait for the First Corps of Cadets in 1876. It was painted by William Churchill and is now in the Corps's museum in Boston. Another version of this same portrait, differing only in the color of the cap and waistcoat was in the Winslow family until it was sold at Sotheby Parke Bernet in the 1950s. It was owned by James St. L. O'Toole in 1986. Blackburn painted a companion portrait of Mrs. Pollard, which was in the Winslow family in 1878 and is now in the Yale University Art Gallery.

DESCRIPTION: Oil on canvas, 75.9 x 63.8 cm. Head-and-shoulders view, head slightly left. Brown eyes. Wears a rose-colored velvet cap, white neckcloth and small white ruffle under a rose-colored waistcoat, and a loose robe or dressing gown of dark bluish green. Plain dark background painted in an oval. (*See Color Plate 18*).

PROVENANCE: Gift of Isaac Winslow, 1834.

REFERENCES: Roberts, *Ancient and Honorable Artillery Company*, 1:424; Thwing Catalogue; *Proceedings of the AAS*, 2d ser., 32(1922):312, 46(1936):24–25; MHS Council Records, vol. 1, 1876 Dec. 11; *Proc.*, 1st ser., 1 (1791–1835):498, 16(1878):390, 391.

REFERENCES: Joseph W. Porter, *A Genealogy of the Descendants of Richard Porter [and] . . . of John Porter* (Bangor, Me., 1878), 252; *Boston Town Records*, 1796–1813 (Boston, 1905), 44, 297; *NEHGR*, 140(1986):237; *Proc.*, 81(1969):244.

Mrs. William Pollard (Anne Dison?)

Born in Saffron Walden, Essex, England, in 1621. Came to Massachusetts in 1630 with John Winthrop's fleet and was said to have been the first to set foot on Boston soil. Married William Pollard, a Boston innkeeper, about 1643, and after his death continued to "sell drink" until 1710. Had 12 children and at her death left 130 descendants including grandson Benjamin Pollard.* Lived to the age of 104 and was the last survivor of the Winthrop fleet. Died in Boston in 1725.

ARTIST: Unknown. 1721. Inscribed, lower left: "Aetatis Suae 100 / & 3 months. / Apr. Anno 1721."

DESCRIPTION: Oil on canvas, 71.5 x 60.5 cm. Half-length view. White cap trimmed with lace, brown dress also trimmed with lace, large white collar. The book in the sitter's hand is a later overpainting, as x-rays indicated that the hand originally held a pipe. Plain dark background. (*See Color Plate 19*).

PROVENANCE: Gift of Isaac Winslow, 1834.

REFERENCES: Maurice J. Pollard, *The History of the Pollard Family of America* (Dover, N.H., 1960), 47–50; Thwing Catalogue; *MHS Coll.*, 3d ser., 7:291; *Proc.*, 1(1791–1835):498.

William Porter

Born in Braintree in 1743, son of Dr. Jonathan and Hannah (Hayden) Porter. Married Mary Lamb in 1781. A distiller by trade, he served as a selectman of the town of Boston from 1798 to 1811. The Society owns a memorandum book in which he noted town activities during these years. Died in Boston in 1813.

ARTIST: Attributed to Edward Savage.

DESCRIPTION: Oil on canvas, 76.5 x 64.1 cm. Head-and-shoulders view, turned slightly right, facing front. Short dark hair, mole on right cheek. White shirt, tie and ruffle under dark patterned waistcoat and high-collared coat. Plain gray background.

PROVENANCE: Gift of Aimee and Rosamond Lamb, 1969.

Thomas Pownall

Born in Lincolnshire, England, in 1722, son of William and Sarah (Burniston) Pownall. Received a bachelor's degree from Trinity College, Cambridge, in 1743. Twice married—in 1765 to Harriet (Churchill) Fawkener, and in 1784 to Hannah (Kennett) Astell. Served as a lieutenant governor and later governor of New Jersey from 1755 to 1759, and governor of the Massachusetts Bay Colony from 1757 to 1759. In 1760 returned to England where he served in Parliament for some years. Author of *The Administration of the Colonies* (1764) and other works on a wide range of subjects. Died in Bath, England, in 1805.

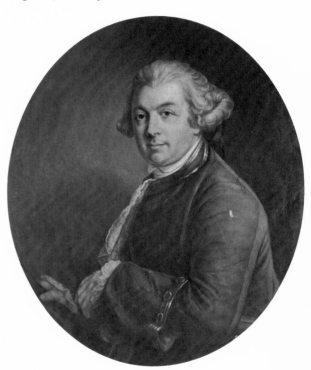

ARTIST: Henry Cheever Pratt, 1861. Based on a 1777 engraving by Richard Earlom of a portrait by Francis Cotes. Signed on back of canvas: "H. C. Pratt / pinxit - 1861 - / after a portrait by / Cotes." A similar portrait by Pratt based on the same engraving and also painted in 1861 is owned by the Maine State Museum at Augusta, Maine.

DESCRIPTION: Oil on canvas, 91.5 x 73.9 cm. Oval. Half-length view, turned half right, facing front. Short

graying hair starting in a wedge on the forehead and clubbed with a black ribbon. White shirt with ruffles under maroon coat trimmed with gold braid and buttons. Seated, left arm resting on chair arm. Holding black hat in right hand. Plain gray background.

PROVENANCE: Gift of Lucius Manlius Sargent, who commissioned it for the Society, 1861.

REFERENCES: *DAB*, 15, pt. 1:161–163; Catalogue of American Portraits, NPG; *Proc.*, 1st ser., 5(1860–1862):235–237.

Thomas Prentice

Born in Cambridge in 1702, son of Thomas and Mary (Batson) Prentice. Graduated from Harvard in 1726, received his A.M. in 1729. Married 3 times—to Irene Emery of Wells, Maine, in 1729, to Rebecca Austin in 1746, and to Mary (Hovey) Burman of York, Maine, in 1749. Became minister in Arundel, Maine, later the First Congregational Parish of Kennebunkport, in 1730, and minister of the First Church in Charlestown in 1739, a position he held until the town was burned in 1775. Retired to Cambridge. Died in Cambridge in 1782.

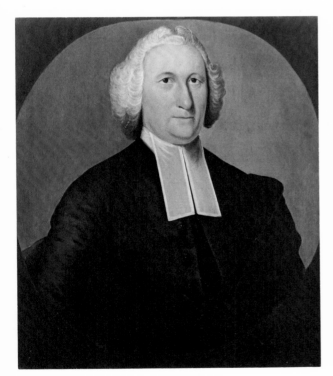

ARTIST: Attributed to Joseph Badger, 1755.

DESCRIPTION: Oil on canvas, 75.5 x 62.4 cm. Head-and-shoulders view, facing front. Short, white curled wig, brown eyes. White clerical band on white stock under black collarless coat and cloak. Painted in a gray oval. Dark background.

PROVENANCE: Gift of Edward Prentiss Freeman, great-grandson of the sitter, 1930.

REFERENCES: *Sibley's Harvard Graduates*, 8:81–89; *Proc.*, 64 (1930–1932):2.

William Hickling Prescott

Born in Salem in 1796, son of William and Catherine Greene (Hickling) Prescott. Graduated from Harvard in 1814. Married Susan Amory of Boston in 1820. An eminent author and historian, among his publications were *History of the Reign of Ferdinand and Isabella the Catholic* (1837), *Conquest of Mexico* (1843), *Conquest of Peru* (1847), and an unfinished multi-volume work on Philip II. An eye injury in college which caused partial blindness bothered him throughout his life. Elected a member of the Society in 1838. Died in Boston in 1859.

I

ARTIST: Joseph Alexander Ames, 1844.

DESCRIPTION: Oil on canvas mounted on masonite, 59.2 x 48.3 cm. Oval. Half-length view, facing front. Gray-white hair parted on left, sharp pointed nose. High white collar, black bow tie, stickpin in shirt front, black coat and waistcoat. Seated in red upholstered chair, right hand holding glasses. Column and landscape in left background.

PROVENANCE: The portrait presumably was inherited by Mrs. James Lawrence (Elizabeth Prescott), a daughter of the historian, and eventually by her grandson Harold Peabody.

Gift of Mrs. Harold Peabody (Marian Lawrence), 1974.

II

ARTIST: Unknown, about 1815.

DESCRIPTION: Oil on canvas, 69.4 x 55.3 cm. Oval. Head-and-shoulders view, facing front. Short dark hair parted on left, brown eyes. White shirt with turned-down collar, black tie and coat. Plain, dark gray background.

PROVENANCE: Once owned by Clark Prescott Bissett, a descendant. He was the legal guardian of Mrs. E. McCormick Clark and gave her the portrait when he moved to LaJolla, California.

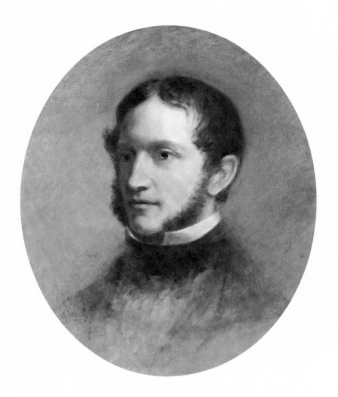

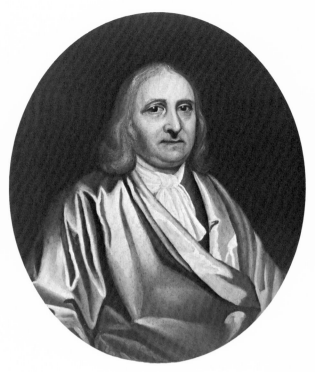

Gift of Mrs. Clark of Seattle, Washington, 1980.

REFERENCES: *The Correspondence of William Hickling Prescott, 1833–1847*, Roger Wolcott, ed. (Boston, 1925), ix–xxi; *William Hickling Prescott: A Biography*, by C. Harvey Gardiner (Austin, Texas, 1969), 213; *Proc.*, 1st ser., 2(1835–1855):112, 82(1970):145, 92(1980):171.

PROVENANCE: Owned by a Rev. Robbins when it was exhibited at the Boston Athenaeum in 1864.

Purchased from Mrs. Karen J. Robbins, whose husband was a Prince descendant, 1985.

REFERENCES: Thomas Weston, *History of the Town of Middleboro, Massachusetts* (Boston, 1906), 227, 228; *Publications of the Colonial Society*, 19(1918):332.

Samuel Prince

Born in Boston in 1649, son of John and Margaret Prince. Married twice: in 1674 to Martha Barstow who died in 1684, and to Mercy Hinckley* who was mother of his son, Rev. Thomas Prince.* Practiced law in Rochester and Sandwich and represented both towns in the General Court. A man of ability and influence, he was a justice of the peace for King George I. In 1723 he moved to Middleborough, the first lawyer ever to live there. Died in Middleborough in 1728.

ARTIST: Unknown, possibly Peter Pelham, early 18th century.

DESCRIPTION: Grisaille on panel, 33.5 x 35.9 cm. Painted in the style of a mezzotint. Half-length view, facing front. Shoulder-length gray hair parted in middle. White knotted tie under gray silk coat. Painted in a dark oval on a dark background.

Mrs. Samuel Prince
(Mercy Hinckley)

Born in 1662/3, daughter of Thomas Hinckley, governor of Massachusetts, and his second wife, Mary (Smith) (Glover) Hinckley of Barnstable. Married as his second wife Samuel Prince.* Mother of 10 children, among them Rev. Thomas Prince.* Died in Middleborough in 1736.

ARTIST: Unknown, possibly Peter Pelham.

DESCRIPTION: Grisaille on panel, 32.9 x 25.9 cm. Head-and-shoulders view, facing front. Face framed in loose white cap or scarf under a black scarf. Broad white collar on black dress. Painted in a dark oval in a dark background.

REFERENCES: *Sibley's Harvard Graduates*, 5:341–368; *Proc.*, 1st ser., 1(1791–1835):448.

PROVENANCE: Same as for Samuel Prince (q.v.).

REFERENCES: Savage, *Genealogical Dictionary*, 2:425; *Publications of the Colonial Society*, 19(1918):332.

Thomas Prince

Born in Sandwich in 1687, son of Samuel Prince* and Mercy (Hinckley) Prince.* Graduated from Harvard in 1707. Married Deborah Denny in 1719. Served as associate minister, with Joseph Sewall, and later as minister at the Old South Church in Boston from 1718 until his death. Historian and theologian, he was a supporter of the evangelist George Whitefield and author of *A Chronological History of New England*. Died in Boston in 1758.

ARTIST: Unknown. After the 1750 original by John Greenwood, which was not located in 1937. There is another copy at the New Old South Church.

DESCRIPTION: Oil on canvas, 75.2 x 62.4 cm. Head-and-shoulders view, facing front. Long gray curled, brown eyes. White stock and clerical bands under black gown. Painted in an oval in a gray background.

PROVENANCE: Gift of Jonathan Phillips, 1831.

Dorothy Quincy

Born in Braintree in 1708/9, daughter of Edmund and Dorothy (Flynt) Quincy. Married in 1732 Edward Jackson, a Harvard graduate and Boston merchant. At the time she was described as "an agreeable young Gentlewoman, with a handsome Estate." Left a widow in 1757 with two children, Jonathan Jackson* and Mary who married Oliver Wendell. Died in 1762.

ARTIST: Unknown, early 1720s.

DESCRIPTION: Oil on canvas, 76.3 x 63.8 cm. Three-quarter length view, facing front. Light brown hair falling in a curl over left shoulder, brown eyes. Low-necked green dress with white ruffle and white undersleeves, red belt and shawl. Standing. Holds a parrot on right hand. Landscape in right background. (*See Color Plate 20*).

PROVENANCE: Inherited by the sitter's daughter, Mrs. Oliver Wendell (Mary Jackson), and hung in the Cambridge home of Oliver Wendell which he shared with his daughter, Mrs. Abiel Holmes, and her family. It was there that Wendell's grandson Oliver Wendell Holmes described the portrait: "It was a young girl in antique

costume, which made her look at first sight almost like a grown woman. The frame was old, massive, carved, gilded——the canvas had been stabbed by a sword-thrust——the British officer had aimed at the right eye and just missed it." Holmes used the painting as a subject for the poem "Dorothy Q.: A Family Portrait." The hole in the canvas has since been repaired.

Bequest of Oliver Wendell Holmes, Jr., 1936.

REFERENCES: *Sibley's Harvard Graduates*, 8:62; Eleanor M. Tilton, *Amiable Autocrat: A Biography of Dr. Oliver Wendell Holmes* (New York, 1947), 5–6.

John Williams Quincy

Born in New York City in 1868, son of William Williams and Lucretia Deming (Perkins) Quincy. Educated by private tutors, he made a voyage around Cape Horn in 1883–1884. Traveled extensively in Europe; because of delicate health he later lived a leisurely and retiring life in Litchfield, Connecticut, and New York.

ARTIST: Sarah Whitman, 1892.

DESCRIPTION: Oil on canvas, 56.5 x 49.0 cm. Head-and-shoulders view. Dark hair and mustache, brown eyes. White collar, black tie with stickpin underneath dark coat trimmed with brown around collar and a brown frog button. Family crest in upper left corner. Shaded background.

PROVENANCE: Bequest of Miss Mary Perkins Quincy, sister of the sitter, 1922.

REFERENCES: Mary Perkins Quincy Papers, MHS; *Descendants of Edmund Quincy, 1602–1637*, H. Hobart Holly, comp. (Quincy, Mass., 1977), 20–21; *Proc.*, 56(1922):4.

Josiah Quincy

Born in Braintree (now Quincy) in 1772, son of Josiah and Abigail (Phillips) Quincy. Graduated from Harvard in 1790. Married Eliza Susan Morton of New York City in 1797, and was father of Anna Cabot Lowell Quincy, who married Robert Cassie Waterston.* Served as a congressman from 1805 to 1813, as a Massachusetts state senator from 1813 to 1820, five terms as mayor of Boston, and as president of Harvard University from 1829 to 1845. Elected a member of the Society in 1796. Died in Boston in 1864.

ARTIST: Moses Wight, 1858.

DESCRIPTION: Oil on canvas, 86.8 x 63.6 cm. Head-and-shoulders view, head turned slightly right. Receding white hair. High white collar and white bow tie under black waistcoat and coat. Dark gray background.

PROVENANCE: Gift of Harvard College class of 1829, which commissioned it for the Society, 1858.

REFERENCES: *DAB*, 8, pt. 1:309–311; *Proc.*, 1st ser., 9(1866–1867):83–156, 3(1855–1858):329–331.

Samuel Miller Quincy

Born in Boston in 1832, son of Josiah and Mary Jane (Miller) Quincy, and grandson of Harvard President Josiah Quincy.* Graduated from Harvard in 1832. Served in the Civil War as a captain in the Second Massachusetts Infantry, was wounded and taken prisoner in 1862. Later commanded black infantry regiments in New Orleans and served as acting mayor there. Awarded the brevet rank of brigadier general in 1866 for "gallant services." Served in the Massachusetts House of Representatives, as alderman of Boston, and as first clerk and treasurer of the Bostonian Society. Died in Keene, New Hampshire, in 1887.

ARTIST: Unknown.

DESCRIPTION: Watercolor, 22.5 x 20.5 cm. Full-length view in left profile. Gray hair and large beard,

sideburns and mustache. Dressed in Civil War Union Army uniform, high boots. Seated, right arm resting on a table, hand holding white gloves, sword at left side.

PROVENANCE: Gift of Mark Anthony DeWolfe Howe, whose wife was a niece of the sitter, 1954.

REFERENCES: Grace Williamson Edes, *Annals of the Harvard Class of 1852* (Cambridge, Mass., 1922), 143–150; *Proceedings of the Bostonian Society at the Special Meeting, May 24, 1887, 7–27.*

Paul Revere

Born in Boston in 1735, son of Paul Revere (changed name from Apollos Rivoire) and Deborah (Hichborn) Revere. Married twice: to Sarah Orne in 1757; to Rachel Walker* in 1773. Patriot, master silversmith, and engraver, he was a principal participant in the Boston Tea Party, and familiar as the official courier for the Massachusetts Provincial Assembly to Congress before he made his famous ride to Lexington in 1775. Designed and printed the first issue of Continental money; was a member of the Committee of Correspondence. As a founder he supplied copper work for the U.S.S. *Constitution* and sheet copper for the steam ferry *Robert Fulton.* Died in Boston in 1818.

ARTIST: Chester Harding, ca. 1823. Copy of the original by Gilbert Stuart, commissioned by Joseph Warren Revere, son of the sitter, in 1813 and now in the Museum of Fine Arts, Boston.

DESCRIPTION: Oil on canvas, 72.1 x 58.3 cm. Head-and-shoulders view, turned slightly left. Thinning white hair, brown eyes, double chin. White stock under white waistcoat and high-collared black coat. Plain dark background.

PROVENANCE: Owned by Mrs. Nathaniel Thayer (Pauline Revere), a great-granddaughter of the sitter, in 1926.

Gift of Paul Revere, Jr., a descendant of the sitter, 1973.

REFERENCES: *DAB*, 8, pt. 1:514–515; Lipton, *A Truthful Likeness,* 177; *Proc.,* 85(1973):145.

Mrs. Paul Revere (Rachel Walker)

Born in Boston in 1745, daughter of Richard and Rachel (Carlile) Walker. Married Paul Revere in 1773 as his second wife and was mother of 8 of his 16 children. Died in Boston in 1815.

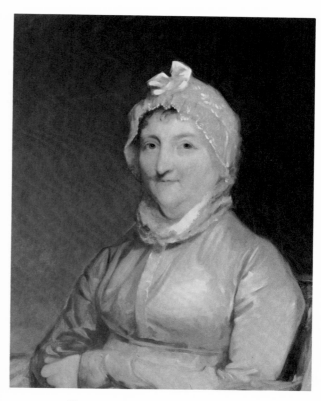

ARTIST: Chester Harding, about 1823. Copy of the original by Gilbert Stuart, commissioned in 1813 by

Joseph Warren Revere, son of the sitter, and now at the Museum of Fine Arts, Boston.

DESCRIPTION: Oil on canvas, 72.1 x 58.3 cm. Half-length view, facing front. Dark curls on forehead under lace cap, double chin, slight smile. Gray dress with white ruffle over collar at high neck. Seated in red upholstered chair, left arm resting on arm. Plain, dark gray background.

PROVENANCE: Same as for Paul Revere (q.v.).

REFERENCES: Crawford, *Famous Families*, 2:355; *Proc.*, 85(1973):145; Esther Forbes, *Paul Revere and the World he lived in* (Boston, 1942), 177; Lipton, *A Truthful Likeness*, 177.

historical works. Held honorary degrees from Western Reserve, Harvard, and Oxford. Elected to membership in the Society in 1893, and served as a vice-president. Died in Brookline in 1927.

ARTIST: John Singer Sargent, 1920. Signed, bottom edge: "John S. Sargent 1920."

DESCRIPTION: Charcoal on paper, 61.0 x 46.0 cm. Head-and-shoulders view, facing front. Graying hair, beard, and mustache. Black bow tie, white shirt under dark waistcoat and coat. Very dark background.

PROVENANCE: Gift of Mrs. Daniel Pomeroy Rhodes, daughter-in-law of the sitter, 1951.

REFERENCES: *DAB*, 8, pt.1:531–533; *Proc.*, 2d ser., 18(1903–1904):289, 60(1926–1927):122–128, 70(1950–1953):324.

James Ford Rhodes

Born in Cleveland, Ohio, in 1848, son of Daniel Pomeroy and Sophia Lord (Russell) Rhodes. Studied at the University of the City of New York, 1865–1866, and at the University of Chicago, 1867. Married Ann Card in 1872. Retired from a highly successful business career in 1885 and later moved to Boston where he published the 6-volume *History of the United States from the Compromise of 1850* and several other major

Katherine Roberts

Born in England in 1660, daughter of Nicholas Roberts* and Elizabeth (Baker) Roberts.* "When your sister Katherines was drawn wee littell thought the curtaine would have been soe soon drawne ovr that yet being intended for you hath sent it you that you may see by the shadow what a likly sweet babe it was to live." Died in England in 1675.

ARTIST: Percival DeLuce. Copy of an original by an unknown artist painted in England about 1675. Original owned by the heirs of Mrs. James W. Gerard (Eliza Sumner), New York.

DESCRIPTION: Oil on canvas, 71.7 x 59.0 cm. Three-quarter length view. Light brown curls under embroidered cap. Dark dress with embroidered front and side panels, white undersleeves, coral necklace and bracelets. Standing, with her right hand offers a piece of cake to a spaniel dog. Plain, very dark background.

PROVENANCE: Same as for Mrs. Baker (q.v.).

REFERENCES: Shrimpton Papers, MHS; *Proc.*, 61(1927–1928): 129.

Nicholas Roberts

Born in England. Married in 1645 Elizabeth Baker, daughter of Mrs. Baker.* He was a merchant, iron-monger, and citizen of London, and served on the London Common Council. Sent the group of family portraits to his daughter and son-in-law in Boston in 1675 as described in the note under Mrs. Baker. Died in England in 1676.

ARTIST: Unknown, but the same artist who painted Mrs. Baker and Mrs. Nicholas Roberts. Painted in England about 1671.

DESCRIPTION: Oil on canvas, 75.7 x 63.3 cm. Half-length view, turned slightly left, facing front. Long, brown wavy hair, thin mustache, dark eyes. White embroidered collar and undersleeves, dark velvet coat. Right hand holding a cane. Plain dark background.

PROVENANCE: Sent by the sitter in 1675 to his daughter, Elizabeth (Roberts) Shrimpton, in Boston. Inherited by Elizabeth (Richardson) Shrimpton, who was a grand-daughter of the sitter as well as niece, daughter-in-law and later stepdaughter-in-law of Elizabeth (Roberts) Shrimpton. Elizabeth (Richardson) Shrimpton and her second husband, David Stoddard, were the grandparents of Mrs. Increase Sumner (Elizabeth Hyslop), mother of the donor.

This portrait was identified as Simeon Stoddard by William H. Sumner, the donor, in his *History of East Boston*, opp. p. 225. It is clearly by the same artist who painted those identified as Mrs. Baker and Mrs. Nicholas Roberts.

Bequest of William H. Sumner, 1872.

REFERENCES: J. R. Woodhead, *The Rulers of London, 1660–1689* (London, 1969), 139. *NEHGR*, 9(1855):303; Shrimpton Collection, MHS; *Proc.*, 1st ser., 12(1871–1873):298.

Mrs. Nicholas Roberts (Elizabeth Baker)

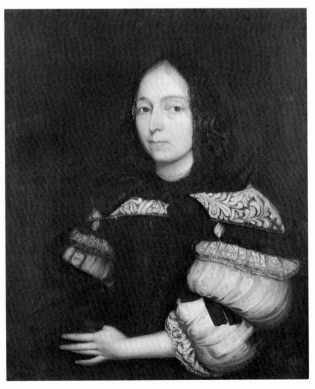

Born in England, daughter of Mrs. Baker.* Married Nicholas Roberts* in London in 1645. Their children included Elizabeth, who married Samuel Shrimpton,* and Katherine Roberts.* Made her will in London in 1700 and presumably died shortly thereafter.

ARTIST: Unknown, but the same artist who painted Mrs. Baker and Nicholas Roberts. Painted in England about 1674.

DESCRIPTION: Oil on canvas, 75.7 x 63.3 cm. Half-length view, facing front. Brown eyes. Black shawl over head, tied in front, necklace. Wide, embroidered white collar on black dress, white undersleeves tied with black ribbons. Plain, very dark background.

PROVENANCE: Same as for Nicholas Roberts (q.v.). This portrait was identified as Elizabeth (Roberts) Shrimpton by William H. Sumner, the donor, in his *History of East Boston*, opp. p. 220.

REFERENCES: *NEHGR*, 8(1854):128r, 9(1855):303; Shrimpton Papers, MHS; *Proc.*, 1st ser., 12(1871–1873):298.

Codman of Boston in 1832. In his youth went to the Orient as a supercargo. Moved to Boston in 1800 and became a successful merchant and ship owner. About 1830 went to Russia and established a mercantile house and from thence moved to London where he established a branch house in 1837. Returned to Boston in 1842. "Well known as an eminent merchant, and as an active promoter of philanthropic and religious enterprises." Died in Boston in 1869.

ARTIST: Unknown.

DESCRIPTION: Oil on panel, 37.3 x 29.6 cm. Half-length view, facing front. Receding wavy white hair, bushy white eyebrows. Stiff white shirt with stand-up collar, black bow tie under black waistcoat and coat. Wears black gloves and holds a paper in left hand. Plain dark background.

PROVENANCE: Bequest of Dr. William Ropes May (1874–1935), 1938.

REFERENCES: Perley, *History of Salem*, 1:345; *EIHC*, 7(1865):253; *Proc.*, 2d ser., 14(1900–1901):229–232.

William Ropes

Born in Salem in 1784, son of Samuel and Sarah (Cheever) Ropes. Married twice: in 1811 to Martha Reed of Marblehead who died in 1830; to Mary Anne

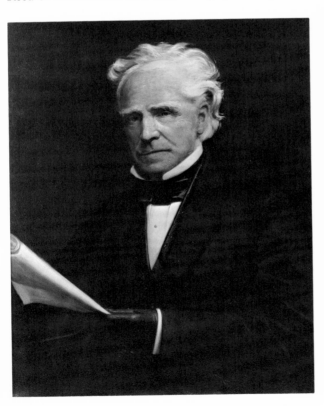

Jean Jacques Rousseau

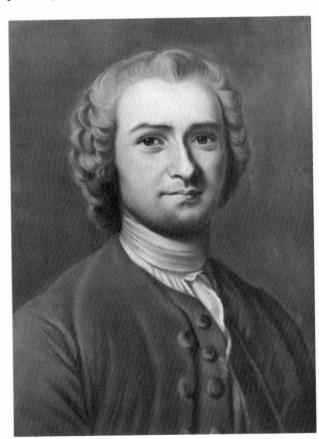

Born in Geneva, Switzerland, in 1712, son of a watch-maker. Largely self-taught, he was a brilliant and widely influential philosopher, author, political theorist, and composer. Among his works are the *Social Contract*, *Emile*, and his *Confessions*. Died at Ermenonville, France, near Paris, in 1778.

ARTIST: Abby Wheaton Little, 1846. Sebastien Cornu, the owner of the original by Maurice Quentin de Latour, allowed her to copy it on the condition that no other copy would be made.

DESCRIPTION: Pastel, 49.5 x 39.5 cm. Head-and-shoulders view, facing front. Curled gray wig, dark eyebrows, brown eyes. White stock and ruffle on shirt under gray-brown waistcoat and collarless coat. Dark gray background.

PROVENANCE: Gift of the artist, 1881.

REFERENCES: *Proc.*, 1st ser., 19(1881–1882):53–54.

Charles Russell

Born in Charlestown in 1739, son of James and Catharine (Graves) Russell. Graduated from Harvard in 1757. Married Elizabeth Vassall, daughter of Henry Vassall* and Penelope (Royall) Vassall.* Their daughter

Penelope became the third wife of Theodore Sedgwick.* Practiced medicine in Charlestown and Lincoln and studied abroad in London and Aberdeen. Appointed register of the Vice-Admiralty Court in 1771. Volunteered to care for the wounded after the Battle of Bunker Hill. A loyalist, he sought asylum in Antigua in 1774 and was proscribed by the act of October 16, 1778. Died in Antigua in 1780.

ARTIST: John Singleton Copley.

DESCRIPTION: Oil on canvas, 28.1 x 24.0 cm. Fragment. Head only on irregular canvas. Dark hair and eyebrows, brown eyes, pink cheeks. High, white turned-over collar under gray collarless coat. Plain, very dark background.

PROVENANCE: According to a story told in the family of the donor, the portrait was owned by Miss Sarah Russell, sister of the sitter, until her death in 1819. It was to go to Mrs. Penelope Sedgwick, the eldest daughter of the sitter, but an unmarried sister, Katharine Russell, was so disappointed at not receiving the portrait herself that "when alone in the room with the picture, she cut out the head with a pair of scissors, and concealed it in her pocket. . . . She always carried the head cut from the portrait with her in her pocket. Shortly before her death in 1847 she sent for her cousin Mrs. Warren Dutton (Elizabeth Lowell) confessed to her what she had done, and gave her the head." Mrs. Dutton left the painting fragment to her granddaughter Mrs. George M. Barnard (Ellen Russell). She left it to her daughter Sarah Barnard, who in turn bequeathed it to the donor.

Gift of Miss Mary Curtis, 1943.

REFERENCES: Letter from the donor, MHS; *Sibley's Harvard Graduates*, 14:202–204; *Proc.*, 6(1941–1944):650.

Leverett Saltonstall

Born in Haverhill in 1783, son of Nathaniel and Anna (White) Saltonstall. Prepared for college at Phillips Exeter Academy, and graduated from Harvard in 1802. Studied law in Salem in the office of William Prescott. Admitted to the Essex County bar in 1805. Practiced law briefly in Haverhill, returned to Salem in 1806. Married Mary Elizabeth Sanders in 1811. A brilliant and persuasive orator, he was an influential member of the General Court of Massachusetts for many years; first elected to the House of Representatives in 1813 and to the Senate (of which he was president in 1831) in 1817. Elected to membership in the Society in 1816, became a Harvard overseer in 1835 and served as first mayor of the city of Salem in 1836, 1837, and 1838. Elected

Massachusetts representative to Congress from Essex County in 1838 to fill a vacant seat, reelected in 1840, withdrew in 1843 and returned to the Massachusetts General Court in 1844. His papers are published in the Society's *Collections*. Died in Salem in 1845.

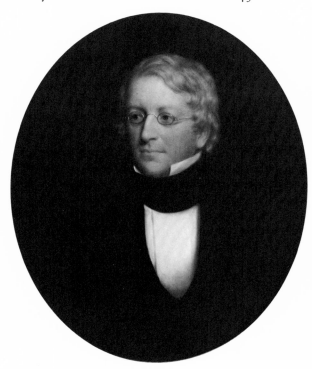

ARTIST: Chester Harding, about 1836.

DESCRIPTION: Oil on canvas, 74.0 x 61.0 cm. Oval. Head-and-shoulders view. Short blond curly hair, light brown eyes, steel-rimmed eyeglasses. Stiff shirt with high-standing collar, black stock, high-collared black coat. Very dark plain background.

PROVENANCE: Presumably inherited by the sitter's daughter, Mrs. John Francis Tuckerman (Lucy Sanders Saltonstall); and then by her daughter Mrs. William P. Parker (Mary Saltonstall Tuckerman); and then by her son Francis Tuckerman Parker.
 Purchased from the estate of Mrs. Francis Tuckerman Parker (Hildred Elizabeth Kavanagh), 1985.

REFERENCES: *The Papers of Leverett Saltonstall, 1816–1845*, ed. Robert E. Moody (Boston, 1978), 1:xi–lix; *MHS Coll.*, 3d ser., 9:117–119.

Richard Saltonstall

Born in Halifax, England, in 1586, son of Samuel and Ann (Ramsden) Saltonstall. Studied at Clare College, Cambridge. Married three times: in 1609 to Grace Kaye, who was the mother of his six children and died in 1625;

to Elizabeth West in 1631/2; and to Martha (Cammock) Wilsford in 1640. A landowner and merchant, knighted by King James I in 1618, he came to New England with John Winthrop in 1630 and assisted in the founding of the Massachusetts Bay Colony. Helped to settle Watertown, where his son Samuel became a permanent resident. Returned to England in 1631 but maintained a strong and influential interest in the colonies for most of his life. Died in Cragford, Kent, England, in 1661.

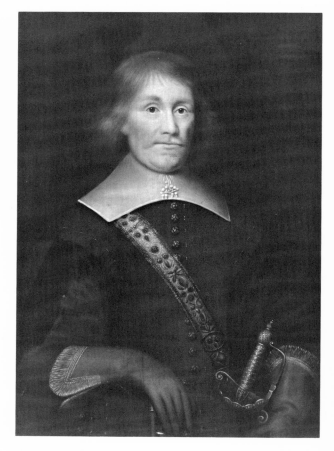

ARTIST: Charles Osgood, 1858. Copy of the original painted in Holland in 1644, formerly attributed to Rembrandt and more recently to Abraham deVries. It is now at the Peabody Museum, Salem. Osgood made 4 other copies including one for Harvard College and one for Mrs. N. Saltonstall, then the owner of the original.

DESCRIPTION: Oil on canvas, 84.0 x 59.1 cm. Half-length view. Light brown hair, brown eyes. Flat white collar, brown coat. Gold-green belt from right shoulder to waist holding sword. Seated, wearing light brown glove on left hand, right arm resting on chair arm. Dark background.

PROVENANCE: Commissioned by Charles Sanders for the Society. Presented on his behalf by his nephew Leverett Saltonstall, Jr. (1825–1895), 1858.

REFERENCES: *The Saltonstall Papers, 1607–1815*, Robert E. Moody, ed. (Boston, 1972), 1:3–24; Osgood, *Record Book*; *Proc.*, 1st ser., 4(1858–1860):2–3.

Franklin Benjamin Sanborn

Born in Hampton Falls, New Hampshire, in 1831, son of Aaron and Lydia (Leavitt) Sanborn. Graduated from Harvard in 1855. Married twice: in 1854 to Ariana Walker, who died a few days later; and to his cousin Louise Augusta Leavitt in 1862. Opened a school in 1855 in Concord, where he lived most of his life. A prolific author, he wrote extensively on the sages of Concord. Active in the abolitionist movement, he was a friend and supporter of John Brown. A correspondent of the *Springfield Republican* from 1856 to 1914 and resident editor from 1868 to 1872 and resident editor of the *Boston Commonwealth* from 1863 to 1867. Gov. John Albion Andrew in 1863 appointed him secretary of the state board of charities, the first office of its kind in the country. Elected to membership in the Society in 1903. Spent his later winters in Westfield, New Jersey, with his youngest son. Died in Westfield, New Jersey, in 1917.

ARTIST: Cloyd L. Boykin. Signed, lower right: "Cloyd L. Boykin."

DESCRIPTION: Pastel and graphite on paper, 57.2 x 47.1 cm. Head-and-shoulders view in right profile. Gray hat, short gray hair, mustache and goatee. Turned-down white collar with flowing bow tie under gray tweed jacket. Mottled gray background.

PROVENANCE: Purchased by the Society in 1919.

REFERENCES: *DAB*, 8, pt.2:326–327; *Proc.*, 51(1917–1918):307–311.

Lucius Manlius Sargent

Born in Boston in 1786, son of Daniel and Mary (Turner) Sargent, brother of painter Henry Sargent. Attended Harvard with the class of 1808; admitted to the bar in 1815 but never practiced law. Married twice: in 1816 to Mary Binney of Philadelphia, Pennsylvania, who died in 1824; and to Sarah Cutler Dunn of Boston in 1825. A poet and author, he was active in the temperance movement. Published *Dealings with the Dead. . .*, a collection of his newspaper pieces from the *Boston Transcript*, and a book of *Temperance Tales*. Elected to the New England Historic Genealogical Society in 1850 and to this Society in 1856. Died in Roxbury in 1867.

ARTIST: Henry Cheever Pratt, about 1856.

DESCRIPTION: 15.5 x 20.3 cm. Head-and-shoulders view, turned slightly left. Gray hair and sideburns. High, stiff white collar, black stock under black waistcoat and high-collared coat. Seated. Plain dark background.

PROVENANCE: Gift of John Johnson Pratt, 1886.

REFERENCES: Emma Worcester Sargent and Charles Sprague Sargent, *Epes Sargent of Gloucester and His Descendants* (Boston, 1923), 194–197; *Proc.*, 2d ser., 3(1886–1887):283, 309–312.

James Savage

Born in Boston in 1784, son of Habijah and Elizabeth (Tudor) Savage and grandson of John Tudor.* Graduated from Harvard in 1803; admitted to the bar in 1807. Married Elizabeth Otis (Stillman) Lincoln in 1823. Served several terms in the Massachusetts legislature, founded "The Provident Institution for Savings in the town of Boston" in 1816. Compiled *The Genealogical Dictionary of the First Settlers of New England*, and edited an authoritative edition of the *Journal* of Gov. John Winthrop. Was a member of the Harvard board of overseers and a founder of the Boston Athenaeum. Elected to membership in the Society in 1813; served in several capacities including as its fifth president. Died in Boston in 1873.

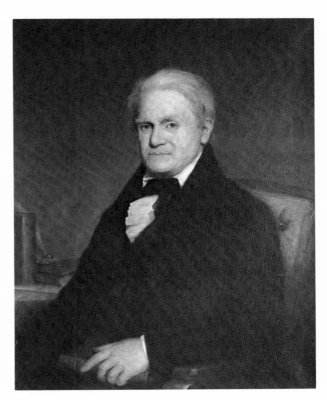

ARTIST: Moses Wight, about 1850–1855.

DESCRIPTION: Oil on canvas, 91.5 x 73.7 cm. Half-length view, turned slightly right, facing front. White hair, blue eyes, white shirt with ruffle and broad black tie under high-collared black coat. Seated in brown upholstered chair, left hand rests on volume of Winthrop's *History of New England*. Table at right holds books and writing materials. Plain gray background.

PROVENANCE: Unknown. In the Society's collections by 1855.

REFERENCES: *Proc.*, 1st ser., 2(1835–1855):v, 16(1878):117–153.

Margaret Savage

Born in Boston in 1698, daughter of Thomas and Margaret (Lynde) Savage and sister of Thomas Savage, Jr.* At age 15 married merchant John Alford, a wealthy and prominent Bostonian. Died in Boston in 1785.

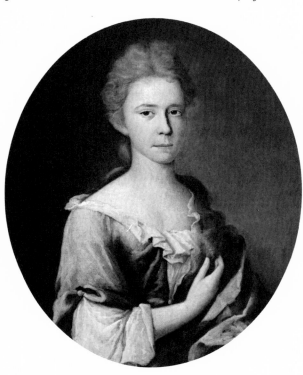

ARTIST: Attributed to the "Savage limner," about 1710–1713.

DESCRIPTION: Oil on canvas, 76.5 x 63.7 cm. Oval. Head-and-shoulders view, facing front. Long hair parted in middle and ending in curl over left shoulder, brown eyes. Low-cut blue-gray dress with ruffles at neck edge and by sleeves. Right hand is held across body. Dark background.

PROVENANCE: Descended in the Winslow family to Erving Winslow of Boston, who owned it in 1913. From him it passed to Harriet Patterson Winslow, then to Mrs. Charles Edward Amory Winslow of New Haven, Connecticut, and finally to her daughter, the donor.

Gift of Miss Anne R. Winslow of New York City, 1971.

REFERENCES: Park, *Major Thomas Savage and His Descendants*, 16; *NEHGR*, 67(1913):211; *Connecticut Historical Society Bulletin*, 23(1958):104–110, 116, 123.

Thomas Savage, Jr.

Born in Boston in 1703, son of Thomas and Margaret (Lynde) Savage, and brother of Margaret Savage.* Died in 1713.

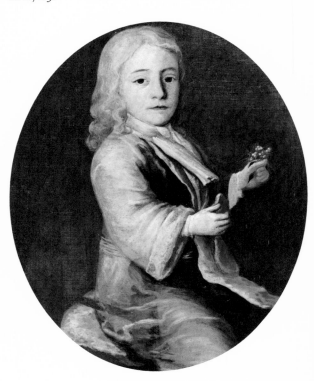

ARTIST: Attributed to the "Savage limner," about 1710–1713. Inscription on back of portrait: "Thomas Savage / son of Col. Thomas born about 1700 / Died quite young leaving 2 Sisters / Margaret married Alfred / Elizabeth married Joshua Winslow / Great grand-mother of Isaac Winslow's / children / This is the brother of my grandmother / Isaac Winslow."

DESCRIPTION: Oil on canvas, 76.5 x 63.7 cm. Oval. Three-quarter length view, turned half left, facing front. Shoulder-length, curly blond hair, brown eyes. Loose white tie, blue coat or suit trimmed with fur on front

and sleeves. Holds flowers in left hand. Dark brown background.

PROVENANCE: Same as for Margaret Savage (q.v.).

REFERENCES: Park, *Major Thomas Savage and His Descendants*, 16; *NEHGR*, 67(1913):211; *Connecticut Historical Society Bulletin*, 23(1958):104–110, 123.

David Sears

Born in Boston in 1787, son of David and Anne (Winthrop) Sears, and grandson of John Still Winthrop.* Graduated from Harvard in 1807. Married Miriam Mason of Boston in 1809 and had 10 children. Active in Massachusetts politics, traveled widely, and summered at Nahant and Newport. Inherited the estate of his father, a wealthy Boston merchant, and became known for his philanthropy among numerous Boston institutions, including this Society, to which he was elected in 1848. Died in Boston in 1871.

ARTIST: Henry Cheever Pratt, 1858.

DESCRIPTION: Oil on canvas, 122.5 x 91.5 cm. Three-quarter-length view, facing front. Curly gray hair and sideburns. Stiff, high white collar with broad black bow tie. Black double-breasted coat, waistcoat and trousers, garnet watch fob hangs from waistcoat pocket. Standing in front of upholstered chair, red drapery in right background. Left hand rests on piled books on a table covered with a red cloth. Dark background at left.

PROVENANCE: Gift of Robert C. Winthrop, 1873.

REFERENCES: *Proc.*, 1st ser., 13(1873–1875):100, 2d ser., 2(1885–1886):405–429.

Jacob Sebor

Born in Middletown, Connecticut, in 1755, son of Jacob and Jane (Woodbury) Sebor. Married Elizabeth Winthrop* in 1786. Moved to New York City about 1791 to continue a business started by his brother. After 1805 his name disappears from the New York City directory, and presumably he retired to Middletown at that time. Active as a merchant in the China and India trades. Died in Middletown, Connecticut, in 1847.

ARTIST: Unknown.

DESCRIPTION: Oil on panel, 38.1 x 29.6 cm. Termed a "kit-cat" portrait because of its small size. Half-length view turned slightly left, facing front. Receding white hair, white shirt and tie under black coat. Seated in brown upholstered armchair holding spectacles in left hand. Light background fading to dark at left.

PROVENANCE: Probably inherited by the sitter's daughter, Mrs. Henry Louis deKoven (Margaret Yates Sebor)(1790–1874); by her daughter, Mrs. Elijah Kent Hubbard (Elizabeth Sebor deKoven) (1813–1896); by her son Elijah Kent Hubbard (1835–1915); and finally by his daughter, the donor.

Gift of Mrs. Carl Stillman (Anna Jones Dyer Hubbard), 1959.

REFERENCES: *The Descendants of Jacob Sebor, 1709–1793, of Middletown, Connecticut*, by Helen Beach (n.p., 1923), 8; *Proc.*, 72(1957–1960):462.

Mrs. Jacob Sebor (Elizabeth Winthrop)

Born in New London, Connecticut, in 1766, daughter of John Still Winthrop* and his second wife, Elizabeth (Shirreff) (Hay) Winthrop. Married Jacob Sebor* in 1786, and had 11 children. Died in Middletown, Connecticut, in 1847.

ARTIST: Unknown.

DESCRIPTION: Oil on panel, 38.1 x 29.6 cm. Termed a "kit-cat" portrait because of its small size. Half-length view, turned half right, facing front. Tightly curled dark hair under frilly white bonnet. High collared dark dress with ruffle at neck. Seated in red upholstered chair holding pair of small spectacles in right hand. Plain dark background.

PROVENANCE: Same as for Jacob Sebor (q.v.).

REFERENCES: Mayo, *Winthrop Family*, 163; *Proc.*, 72(1957–1960):462.

Theodore Sedgwick

Born in West Hartford, Connecticut, in 1746, son of Benjamin and Ann (Thompson) Sedgwick. Graduated from Yale in 1765. Admitted to the bar in 1766. Married three times: in 1768 to Eliza Mason, who died childless in 1771; in 1774 to Pamela Dwight, whose 10 children included Catharine Maria Sedgwick; and in 1808 to Penelope Russell, daughter of Dr. Charles Russell.* A politician and a leading lawyer in western Massachusetts. In a celebrated case he successfully defended and helped free Elizabeth Freeman ("Mumbet"), a negro slave, whose portrait miniature, painted by one of Sedgwick's daughters, is owned by the Society. Served as a member of the Continental Congress, as United States congressman and senator, and was appointed for life to the Massachusetts supreme judicial court in 1802. Died in Boston in 1813.

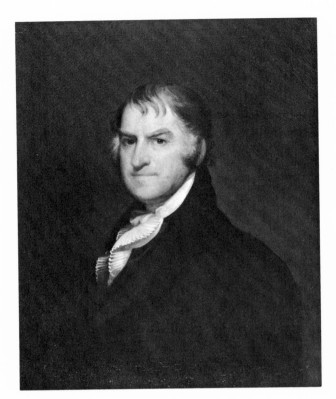

ARTIST: Ezra Ames, after the original painted about 1808 by Gilbert Stuart, now at the Museum of Fine Arts, Boston. Other copies of the same original are at Harvard University and the Historical Society of Pennsylvania.

DESCRIPTION: Oil on canvas, 79.0 x 63.5 cm. Head-and-shoulders view, facing front. Thinning dark hair and sideburns, brown eyes. White shirt with ruffle under high-collared black coat and waistcoat. Plain dark background.

PROVENANCE: Presumably the portrait of "Judge Sedgwick" listed in the artist's estate inventory in 1836 among a group of ten portraits at an "average—each 10.00." Listed in the 1842 catalogue of portraits for sale from the estate was "Hon. Theodore Sedgwick, from Stuart." Presented to the Old South Association, Boston, by Mrs. Maria Weston Chapman about 1880.

Gift of the Old South Association, 1981.

REFERENCES: *DAB*, 8, pt.2:549–550; Theodore Bolton and Irwin F. Cortelyou, *Ezra Ames of Albany* (New York, 1955), 268, 269; Catalogue of American Portraits, NPG; *Proc.*, 93(1981):142.

Samuel Sewall

Born in Horton, Hampshire, England, in 1652, where his parents, Henry and Jane (Dummer) Sewall of New-

bury, were in temporary residence. Graduated from Harvard in 1671. Married three times: in 1674 to Hannah Hull, from whom he acquired great wealth, and with whom he had 14 children including Judith who married Rev. William Cooper*; in 1714 to Abigail Melyen; and in 1722 to Mary Gibbs. Minister, merchant, and magistrate. Active in the Salem witchcraft trials in 1692, the only judge involved to publicly admit his error in sentencing 19 people to death. Served as chief justice of the Massachusetts Supreme Court from 1718 to 1728. His famous diary covered the years from 1674 to 1729, except for a gap from 1677 to 1685. Died in Boston in 1730.

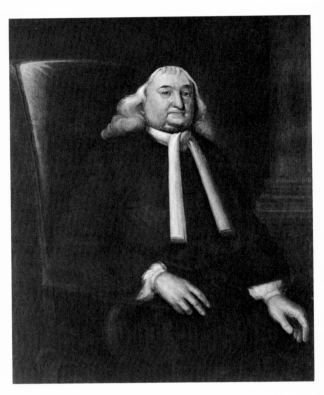

ARTIST: Nathaniel Emmons, 1728. Formerly attributed to John Smibert. There is a similar half-length portrait by Smibert at the Museum of Fine Arts, Boston.

DESCRIPTION: Oil on canvas, 125.3 x 102.3 cm. Three-quarters length view, facing front. Long, flowing white hair under black cap, brown eyes, prominent double chin. White cravat wrapped once under long black robe. Seated in green upholstered armchair, hand resting on his knees. Background with column at left.

PROVENANCE: Bequest of Miss Henrietta B. Ridgway, a descendant of the sitter, 1901.

REFERENCES: *Sibley's Harvard Graduates*, 2:345–364; Foote, *Smibert*, 189–190; Catalogue of American Portraits, NPG; *Proc.*, 2d ser., 15(1901–1902):324.

Lemuel Shaw

Born in Barnstable in 1781, son of Oakes and Susanna (Hayward) Shaw. Graduated from Harvard in 1800. Married twice: to Elizabeth Knapp in 1818, and Hope Savage in 1827. Admitted to the bar in Massachusetts and New Hampshire in 1804. Practiced law in Boston, served in the Massachusetts legislature, and was chief justice of the Massachusetts supreme court from 1830 to 1860. Elected to membership in the Society in 1831. Died in Boston in 1861.

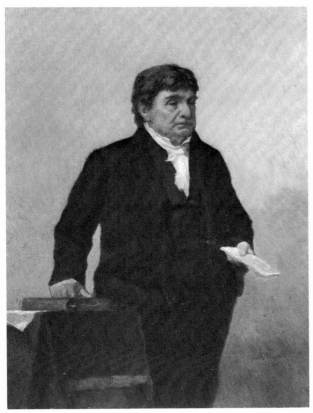

ARTIST: William Morris Hunt, 1859. Signed, lower right: "WM Hunt / 1859." Inscription on reverse: "Portrait of Lemuel Shaw, aged 78 / Chief Justice of Massachusetts / painted for Horace Gray, Jr. / by W. M. Hunt / Newport, R.I. / 1859."

This is a small finished painting done in preparation for the larger, final painting, now in the collection of the Essex Bar Association, Salem.

DESCRIPTION: Oil on panel, 32.1 x 24.3 cm. Three-quarters length view. Dark hair, white shirt with ruffle, white tie under black waistcoat and black suit. Standing, right hand resting on book and table to right, left hand holding papers. Plain light background.

PROVENANCE: Bequest of Justice Horace Gray, Jr., 1902.

REFERENCES: *DAB*, 9, pt. 1:42; Museum of Fine Arts, Boston, *William Morris Hunt: A Memorial Exhibition* (Boston, 1979), 38–39; Helen M. Knowlton, *The Art-Life of William Morris Hunt* (Boston, 1900), 33–36; *Proc.*, 1st ser., 10(1867–1869):50–79.

Samuel Shrimpton

Born in 1643, son of Henry and Elinor Shrimpton of Boston. Married in London in 1669 Elizabeth Roberts, daughter of Nicholas Roberts* and Elizabeth (Baker) Roberts.* Had large land holdings in Boston including Noddle's Island which he purchased in 1670. A councillor of the province of Massachusetts Bay, member of the Ancient and Honorable Artillery Company, on the council of safety, and head of the Suffolk regiment from which he was known as Colonel Shrimpton. Died in Boston in 1698.

ARTIST: Unknown, probably painted in England.

DESCRIPTION: Oil on canvas, 76.2 x 63.2 cm. Head-and-shoulders view, facing front. Long brown hair, lace jabot, brownish robe, blue shawl. In the left background there is a tiny male figure seated behind a table piled with books. Painted in a black oval on a brown background.

93

PROVENANCE: See note on Mrs. Baker* for background of the painting. Inherited through the sitter's daughter-in-law, Elizabeth (Richardson) Shrimpton, and her second husband, David Stoddard. Their granddaughter, Mrs. Increase Sumner (Elizabeth Hyslop), was the mother of the donor.

Bequest of William H. Sumner, 1872.

REFERENCES: Shrimpton Collection, MHS; Sumner, *History of East Boston*, 187–219; *Proc.*, 1st ser., 12(1871–1873):289.

DESCRIPTION: Oil on canvas, 76.3 x 63.9 cm. Head-and-shoulders view, facing front. White curly wig, brown eyes, round face. White clerical bands, black robe. Dark background. Brown spandrels in lower corners of canvas.

PROVENANCE: Gift of Mrs. Susan Parker and Mrs. Lucretia Lyman, 1836.

REFERENCES: *Sibley's Harvard Graduates*, 5:396–403; Foote, *Smibert*, 223; *Proc.*, 1st ser., 2(1835–1855):55.

William Shurtleff

Born in Plymouth in 1689, son of William and Suzannah (Lothrop) Shurtleff. Graduated from Harvard in 1707. Married Mary Atkinson* in 1718. A minister sympathetic to New Light views, he was ordained in New Castle, New Hampshire, in 1712 and served there until dismissed in 1731/2. Installed at the Old South Church of Portsmouth, New Hampshire, one month later and remained there until his death in 1747.

ARTIST: Unknown. Formerly attributed to John Smibert, but probably earlier. A copy was painted in 1879 by Mrs. L. A. Bradbury for the South Church in Portsmouth, New Hampshire.

Mrs. William Shurtleff (Mary Atkinson)

Born in New Castle, New Hampshire, in 1695, daughter of Theodore and Mary Atkinson. Married Rev. William Shurtleff* in 1718. Called a "great trial" to her husband for her whimsical ways. Lived at New Castle until 1732 and thereafter at Portsmouth, New Hampshire. When she was widowed, her brother Theodore Atkinson sent some funds from London to set "Sister Shurtleff into Some Little business." Died in 1760.

ARTIST: Unknown.

DESCRIPTION: Oil on canvas, 76.3 x 63.9 cm. Half-length view, facing slightly left. Light brown curly hair

ending in a long curl over right shoulder. Low-cut brown dress with white ruffle at neck and white undersleeves. Shawl draped over right arm. Very dark background.

PROVENANCE: Gift of Mrs. William King Atkinson, 1836.

REFERENCES: *Sibley's Harvard Graduates*, 5:396–403; *NEHGR*, 7(1853):115; *Proc.*, 1st ser., 2(1835–1855):55.

John Langdon Sibley

Born in Union, Maine, in 1804, son of Jonathan and Persis (Morse) Sibley. Graduated from Harvard in 1825, and Harvard Divinity School in 1828. Served as minister in Stow from 1828 to 1833 and as assistant librarian and librarian of Harvard for 35 years. Author of the first three volumes of *Biographical Sketches of Graduates of Harvard University*, covering the years 1642 to 1689. Elected to membership in the Society in 1846. Married Charlotte Augusta Langdon Cook in 1866. Died in 1885.

ARTIST: Frederic Porter Vinton, 1894. Signed, lower left: "Frederic P. Vinton." Replica of a portrait painted by Vinton for Phillips Exeter Academy in 1879.

DESCRIPTION: Oil on canvas, 101.3 x 81.2 cm. Head-and-shoulders view, facing front. Bushy white hair, sideburns, beard and mustache. White shirt under black waistcoat and coat. Seated at a wide table in an upholstered high-backed chair, holding spectacles in right hand. An inkwell, quill pen and paper are by his left hand and a copy of *Sibley's Harvard Graduates* by right elbow. Dark brown background.

PROVENANCE: Gift of Mrs. John Langdon Sibley, widow of the sitter, 1901.

REFERENCES: *Proc.*, 2d ser., 2(1885–1886):487–507.

Edmund Farwell Slafter

Born in Norwich, Vermont, in 1816, son of Sylvester and Mary Armstrong (Johnson) Slafter. Graduated from Dartmouth in 1840; studied at Andover Theological Seminary. Married Mary Ann Hazen of Boston in 1849. Ordained an Episcopal clergyman at Trinity Church, Boston, in 1844, he was registrar and acting librarian for the Massachusetts diocese, superintendent of the American Bible Society, and president of the Prince Society. Active member of many other organizations including this Society, to which he was elected in 1881. Died in North Hampton, New Hampshire, in 1906.

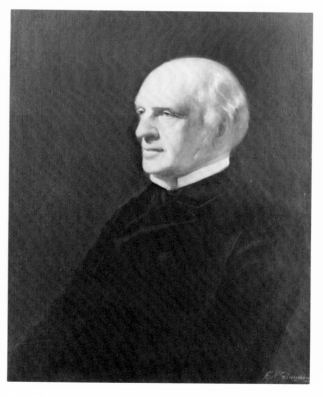

ARTIST: Freeman W. Simmons. Signed, lower right: "F. W. Simmons."

DESCRIPTION: Oil on canvas, 76.5 x 61.5 cm. Half-length view, facing right. Receding white hair, stiff standing white collar, black tie under double-breasted black coat. Plain dark background.

PROVENANCE: Bequest of the sitter, 1906.

This portrait has been on loan to the Episcopal Diocesan Library, Boston, since 1939.

REFERENCES: MHS Council Records, 6:15, April 1939; *Proc.*, 2d ser., 20(1906–1907):534, 591–596.

Charles Card Smith

Born in Boston in 1827, son of George and Harriet (Card) Smith. Married Georgianna Whittemore in 1853. A regular contributor to numerous publications including the *North American Review*. Elected a member of the Society in 1867; served 18 years as editor, 1889–1907; 30 years as treasurer, 1877–1907; and 34 years as a Council member, 1868–1870, 1875–1907. Died in Boston in 1918.

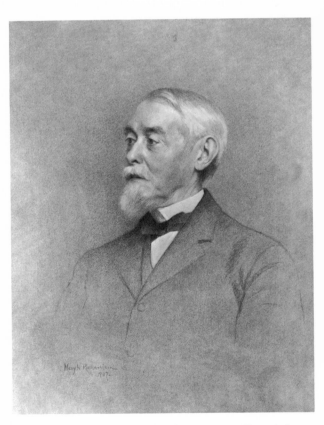

ARTIST: Mary Neal Richardson, 1907. Signed, lower left: "Mary N. Richardson, 1907."

96

DESCRIPTION: Charcoal on paper, 72.0 x 55.0 cm. Head-and-shoulders view facing slightly right. Thinning white hair, mustache and beard. Stiff white shirt with turned-over collar and black bow tie under dark vest and coat. Plain background.

PROVENANCE: Commissioned by the Society, 1907.

REFERENCES: *Proc.*, 41(1907–1908):428, 51(1917–1918):345–352.

Johann Gaspar Spurzheim

Born in Longuich, near Trèves, Prussia, in 1776. Educated at the University of Trèves and studied medicine in Vienna, Austria. A student of brain physiology and co-founder of the science of phrenology with his teacher Dr. Franz Gall. Lectured on his theories for many years in France and England. Came to the United States to lecture in 1832 and was enthusiastically received but died within four months. Died in Boston in 1832.

I

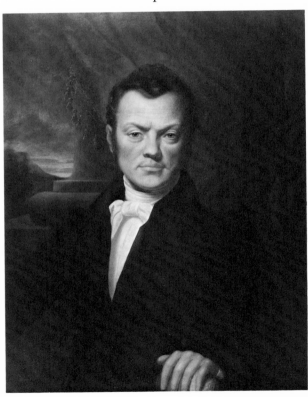

ARTIST: Cephas Giovanni Thompson, 1833.

DESCRIPTION: Oil on canvas, 91.8 x 73.2 cm. Head and shoulder view, facing front. Dark hair and sideburns. White stock, shirt and bow tie under high-collared black coat and waistcoat. Left hand rests on a skull at his left.

Red curtain with brown fringe hangs behind the sitter, gray column to the right with a landscape view beyond.

PROVENANCE: Owned by Nahum Capen and inherited by his daughter, the donor. Gift of Mrs. Shelton Barry, 1915.

II

ARTIST: Unknown. A similar portrait, painted by Alvin Fisher, is at Harvard University.

DESCRIPTION: Oil on canvas, 91.2 x 71.8 cm. Half-length view turned slightly right. Dark hair and sideburns. White standing collar, white stock and bow tie under black waistcoat and high-collared coat. Holds a small marble bust with left hand and points to its skull with his right forefinger. Plain brown background.

PROVENANCE: Painted for Dr. John Flint, a personal friend of the sitter. Inherited by his daughters, the donors. Gift of Charlotte Louise Flint and Elizabeth Henshaw Flint, 1921.

REFERENCES: Francis S. Drake, *Dictionary of American Biography* (Boston, 1872), 858; Catalogue of American Portraits, NPG; *Proc.*, 49(1915–1916):59, 55(1921–1922):5.

Andrew Leete Stone

Born in Oxford, Connecticut, in 1815, son of Dr. Noah and Rosalind (Marvin) Stone. Graduated from Yale in 1837 and taught the deaf and dumb in New York City while attending Union Theological Seminary. Married Matilda Bertody Fisher in 1842. Ordained as a Congregational minister in Middletown, Connecticut, in 1844. Served as pastor at Park Street Church in Boston from 1849 to 1866, and at the First Congregational Church in San Francisco, California, from 1866 until his retirement in 1881. Died in San Francisco, California, in 1892.

ARTIST: Helen Sewall Gilbert.

DESCRIPTION: Crayon and charcoal on paper, 54.3 x 46.0 cm. Head-and-shoulders view, facing front. Receding dark wavy hair, stiff turned-over white collar, black tie under black coat and vest. Black stud in shirt front. Plain light background.

PROVENANCE: Gift of Ada A. Gilbert, sister of the artist, 1920.

REFERENCES: William L. Stone, *The Family of John Stone* (Albany, N.Y., 1888), 38, 40, 123–125; *Obituary Record of Graduates of Yale University* (New Haven, Conn., 1892), 93–94; *Proc.*, 53(1919–1920):185.

Mrs. Tristram Storer (Harriet Gookin)

Born in 1795, daughter of Daniel and Abigail (Dearborn) Gookin of North Hampton, New Hampshire, and Saco, Maine. Married Captain Tristram Storer of Saco, Maine, and later of Boston. Died in Scarborough, Maine, in 1880.

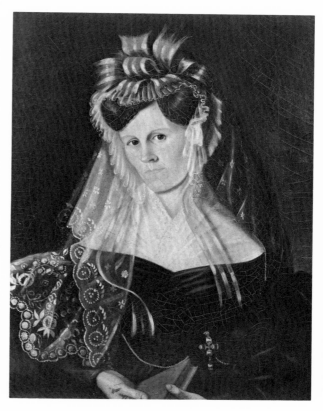

ARTIST: Unknown, about 1830 or 1840.

DESCRIPTION: Oil on canvas, 86.5 x 65.5 cm. Half-length view, facing front. Dark brown hair braided at edge under blue ribbons and lace scarf. Low-cut black dress with long puffed sleeves and white lace fichu at neck. A pin at her left waist is attached to a gold chain encircling her shoulders. Holds a red-bound book in both hands. Dark background.

PROVENANCE: Bequest of Harriet Storer Fisk, great-granddaughter of the sitter, 1932.

REFERENCES: Malcolm Storer, *Annals of the Storer & Ayrault Families* (Boston, 1927), 73; *Proc.*, 64(1930–1932):422; *NEHGR*, 1(1847):165, 8(1854):322.

Joseph Story

Born in Marblehead in 1779, son of Elisha and Mehitable (Pedrick) Story. Graduated from Harvard in 1798; began law practice in Salem in 1801. Twice married — to Mary Lynde Oliver in 1804 and Sarah Waldo Wetmore in 1808. Served several terms in the Massachusetts legislature and filled a vacancy in the United States Congress in 1808–1809. Appointed an associate justice of the United States Supreme Court in 1811 and served until 1845. Upon his appointment to the Dane professorship of law at Harvard in 1829, he developed a lifelong interest in the law school as a legal training ground to replace the former apprentice system. Elected to membership in the Society in 1816. Died in Cambridge in 1845.

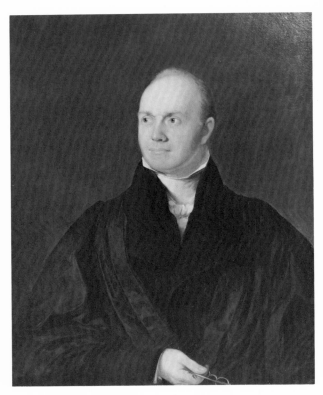

ARTIST: Chester Harding, about 1828.

DESCRIPTION: Oil on canvas, 92.0 x 72.5 cm. Head-and-shoulders view, facing slightly right. Receding blond hair, blue eyes. High stiff collar, white stock, and tie under high-collared black coat and black judicial robe. Dark background.

PROVENANCE: Gift of Benjamin Joy, 1951.

REFERENCES: *DAB*, 9, pt. 2:102–108; Gerald T. Dunne, *Justice Joseph Story* (New York, 1970), 425–429; Lipton, *A Truthful Likeness*, 182; *Proc.*, 1st ser., 10(1867–1869):176–205, 70(1950–1953):347.

Caleb Strong

Born in Northampton in 1745, son of Caleb and Phebe (Lyman) Strong. Graduated from Harvard in 1764; admitted to the bar in 1772. Married Sarah Hooker in 1777. Was on the drafting committee at the Massachusetts constitutional convention in 1779, represented Massachusetts at the federal convention in 1787, served in the United States Senate from 1789 to 1796, and was governor of Massachusetts from 1800 to 1808 and from 1812 to 1816. Elected to membership in the Society in 1800. Died in Northampton in 1819.

I

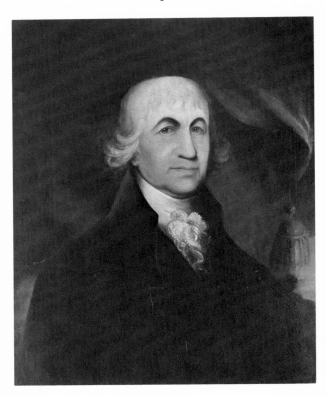

ARTIST: James B. Marston, 1807.

DESCRIPTION: Oil on canvas, 78.1 x 62.4 cm. Head-and-shoulder view, facing front. Curling white hair, blue eyes, stock with jabot under high-collared back coat and waistcoat. Seated. Reddish drapery with tassel at left with landscape view beyond. Dark left background.

PROVENANCE: Gift of N. Davies Cotton, 1851.

II

ARTIST: Chester Harding, about 1822, after the Gilbert Stuart original painted in 1813.

DESCRIPTION: Oil on panel, 70.9 x 55.1 cm. Head-and-shoulders view, facing front. Curling gray hair, deep-set blue eyes. White stock with ruffle under high-collared

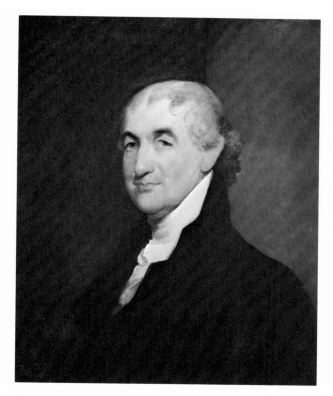

PROVENANCE: Gift of Robert Sturgis Potter of New York City, whose grandmother, Mrs. James Potter (Elizabeth Perkins Sturgis), was a niece of the sitter, 1980.

REFERENCES: *Edward Sturgis of Yarmouth, Massachusetts, 1613–1695, and His Descendants*, ed. Roger Faxton Sturgis (Boston, 1914), 51–52; *Proc.*, 92(1980):183.

James Sullivan

Born in Berwick, Maine, in 1744, son of John and Margery (Browne) Sullivan. Twice married: to Mehitable Odiorne in 1768 and to Martha Langdon in 1786. Studied law with his brother John Sullivan, who later became governor of New Hampshire. Practiced law in Maine and then in Massachusetts. Served as a justice on the Massachusetts superior court from 1776 to 1782, was a member of the Continental Congress, attorney-general of Massachusetts, and governor of Massachusetts, from 1807 to 1808. First president of the Society from 1791 to 1806. Died in 1808.

black coat and waistcoat. Plain brown right background, gray left background.

PROVENANCE: Gift of Joseph Lyman, 1865.

REFERENCES: *Sibley's Harvard Graduates*, 16:94–110; *DAB*, 9, pt.2:144–146; Lipton, *A Truthful Likeness*, 182; *Proc.*, 1st ser., 8(1864–1865):476.

Henry Parkman Sturgis

Born in Boston in 1806, son of Nathaniel Russell and Susan (Parkman) Sturgis. Married twice: to Mary Georgianna Howard, an Englishwoman, in 1835, and Elizabeth Orne Paine, his first cousin, in 1851. A merchant, like his father, he founded the house of Russell & Sturgis in Manila. Returned to Boston after the death of his first wife in 1850. Served as president of the Somerset Club from 1860 to 1868. Died in Boston in 1869.

ARTIST: James Sullivan Lincoln, 1860s.

DESCRIPTION: Oil on canvas, 92.4 x 73.2 cm. Half-length view, facing front. White hair parted on right, sideburns and mustache. High, stiff white collar and tie under black coat and overcoat with opened clasp at collar. Seated with right arm resting on a table. Plain dark background.

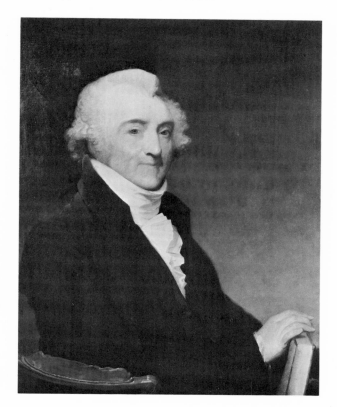

ARTIST: Gilbert Stuart, 1807. A replica by Stuart is at the Museum of Fine Arts, Boston. A copy made in 1899 by Ernest L. Ipsen for the Commonwealth of Massachu-

setts hangs in the State House, Boston. Another copy, by Clayton B. Moulton for Vernon Munroe, was authorized by the Society in 1936.

DESCRIPTION: Oil on panel, 83.8 x 67.3 cm. Half-length view, facing right. Curled gray-white hair in a queue, brown eyes, slight smile. High white neckcloth and ruffle under high-collared black coat seated in a red upholstered armchair. Holding a book upright on his knee with his right hand. Plain gray background.

PROVENANCE: Inherited by the sitter's son Richard Sullivan (1779–1861) and then by his son Richard (1820–1908).
Bequest of Richard Sullivan, 1908.

REFERENCES: Park, *Stuart*, 2:726–727; *DAB*, 9, pt. 2:190–191; Catalogue of American Portraits, NPG; *MHS Coll.*, 2d ser., 1:252–254; MHS Council Records, 5:174, Oct. 1936; *Proc.*, 42(1908–1909):15, 16.

Charles Sumner

Born in Boston in 1811, son of Charles Pinckney and Relief (Jacob) Sumner. Graduated from Harvard in 1830 and in 1834 from Harvard Law School, where he was a student of Justice Joseph Story.* Served in the United States Senate from 1851 until his death. An advocate of international peace, a founder of the Republican party, and a bellicose crusader for emancipation. Suffered a vicious physical attack on the Senate floor at the hands of South Carolina Congressman Preston Brooks in 1856. Married Mrs. Alice (Mason) Hooper, a young widow, in 1866, but they separated within the year and later divorced. Elected to membership in the Society in 1873. Died in Washington, D.C., in 1874.

I

ARTIST: Darius Cobb, 1877; probably from the photograph by J. W. Black, Boston, 1874.

DESCRIPTION: Oil on canvas, 127.9 x 102.1 cm. Three-quarter length view facing front. Dark hair edged with gray. Turned-over white collar, black tie, stiff shirt front, white waistcoat under black coat, gray trousers, monocle hangs from waistcoat. Seated, holding cane in right hand. Plain dark background.

PROVENANCE: Gift of Mrs. Charles Sumner Bird, 1981.

II

ARTIST: Unknown, probably after a photograph, 1873.

DESCRIPTION: Oil on canvas, 50.8 x 40.9 cm. Head-and-shoulders view in left profile. Graying wavy hair, white sideburns. Stiff white collar, black bow tie, white shirt under black coat and waistcoat from which hangs a gold chain. Plain gray background.

PROVENANCE: Gift of Miss Elizabeth Cook, 1950.

REFERENCES: Edward L. Pierce, *Memoirs and Letters of Charles Sumner*, 7th ed. (Boston, 1893), 4:610; *DAB*, 9, pt. 2:208–214; *Proc.*, 69(1947–1950):492.

William Hyslop Sumner

Born in Roxbury in 1780, son of Increase and Elizabeth (Hyslop) Sumner. Graduated from Harvard in 1799; admitted to the bar in 1802. Served in the Massachusetts legislature from 1808 to 1819 and as adjutant-general in the Massachusetts quartermaster corps from 1818 to 1834. Developed family-owned Noddles Island pasture land into the settlement of East Boston. Elected a member of the Society in 1857, the year his *History of East Boston* was published. Died in Jamaica Plain in 1861.

ARTIST: Attributed to William F. Wilson, 1857.

DESCRIPTION: Oil on canvas, 91.6 x 73.2 cm. Oval. Half-length view, turned slightly right, facing front. Gray hair, white at temples, parted on left side. Stiff standing white collar, black bow tie, stickpin in white shirt under black coat and waistcoat. Seated in red upholstered

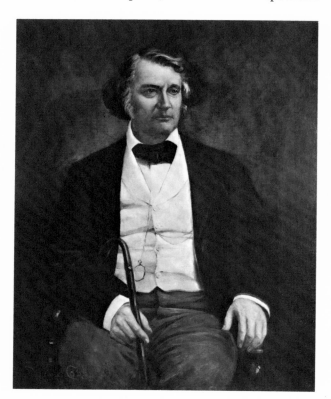

armchair, left arm resting on chair arm. Brown column in right background with landscape beyond. Plain dark background at left.

PROVENANCE: Bequest of the sitter. Presented by the executor, James W. Gerard, 1873.

REFERENCES: *Proc.*, 1st ser., 13(1873–1875):20, 18(1880–1881): 282–286.

Grenville Temple

Born in Boston in 1768, eldest son of John Temple* and Elizabeth (Bowdoin) Temple.* Married twice: in 1797 to Elizabeth (Watson) Russell, widow of Thomas Russell of Boston; and in 1812 to Maria Augusta Dorothea (Rumbold) Manners, an English widow. Succeeded his father in the claim as ninth baronet in 1798. Died in Florence, Italy, in 1829.

I

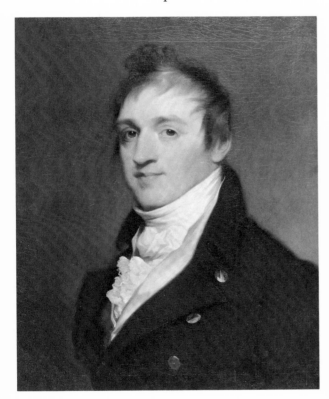

ARTIST: John Trumbull, about 1797.

DESCRIPTION: Oil on canvas, 63.7 x 51.5 cm. Head-and-shoulders view, turned slightly right, facing front. Curly light brown hair combed over forehead. White stock and ruffled shirt under yellow waistcoat and high-collared black coat with brass buttons. Plain brown background shading to light brown at right.

PROVENANCE: Gift of Miss Clara Bowdoin Winthrop, 1934.

II

ARTIST: Ellen Sharples, about 1820.

DESCRIPTION: Pastel on paper, 24.5 x 19.2 cm. Head-and-shoulders view, facing front. Short, gray powdered wig, dark eyes and eyebrows, dimple in chin. White stock and ruffled shirt under figured waistcoat and high-collared blue coat with velvet collar. Plain blue-gray background.

PROVENANCE: Estate of Miss Clara Bowdoin Winthrop, 1969.

REFERENCES: Prime, *Temple Family*, 60–61; Cokayne, *Complete Baronetage*, 1:86–87; Knox, *Sharples*, 97; *Proc.*, 65(1932–1936):268.

John Temple

Born on Noddle's Island in Boston in 1732, son of Robert and Mehetable (Nelson) Temple and brother of Mrs. Nathaniel Dowse.* Married Elizabeth Bowdoin* in 1767. Served in Boston as surveyor general of customs in the Northern District of America from 1761 to 1767; as a commissioner of revenue, 1767–1774; as lieutenant governor of New Hampshire from 1761 to 1774; and

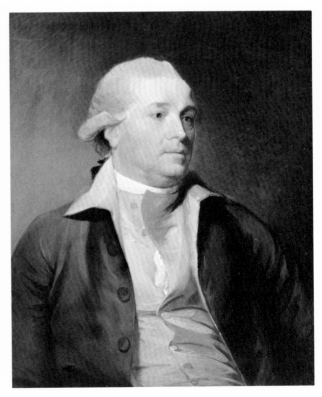

as first British consul general to the United States after the Revolution, 1786–1798. Claimed a British baronetcy in 1786. Died in New York City in 1798.

I

ARTIST: Gilbert Stuart, 1806. After the original by John Trumbull, 1784, now in the Canajoharie, New York, Library and Art Gallery.

DESCRIPTION: Oil on panel, 74.5 x 61.2 cm. Head-and-shoulders view, facing slightly right. Short, gray powdered wig tied in a queue, ruddy complexion. White neckcloth and ruffled shirt under a high buff waistcoat with brass buttons and a dark red coat faced with buff. Plain brown background shading to light brown below.

PROVENANCE: Gift of Miss Clara Bowdoin Winthrop, 1934.

II

ARTIST: James Sharples, about 1800.

DESCRIPTION: Pastel on paper, 24.5 x 19.2 cm. Head-and-shoulders view, turned half left, eyes front. Short, curly white wig, slight double chin. White ruffled shirt and black tie under white waistcoat and blue uniform, high-collared coat with brass buttons and epaulets. Right hand thrust into waistcoat. Plain blue-gray background.

PROVENANCE: Estate of Miss Clara Bowdoin Winthrop, 1969.

REFERENCES: Prime, *Temple Family*, 57–60; Cokayne, *Complete Baronetage*, 1:86; Mason, *Life and Works of Gilbert Stuart*, 266; Knox, *Sharples*, 97; Park, *Stuart*, 2:742–743; *Historical New Hampshire*, 30(1975):78–99; *Proc.*, 65(1932–1936):268.

Lady John Temple (Elizabeth Bowdoin)

Born in Boston in 1750, daughter of Gov. James Bowdoin* and Elizabeth (Erving) Bowdoin. Married Sir John Temple* in 1767 and had 5 children. From a wealthy and influential family, she brought a dowry of £1000 to her marriage and eventually inherited a third of her father's estate. Lived in New York after 1785. Died in Boston in 1809.

I

ARTIST: Jane Stuart, after the 1806 original by her father, Gilbert Stuart, which is in the Bowdoin College Museum of Art. John Trumbull painted an earlier portrait in which Lady Temple is wearing the same clothing.

DESCRIPTION: Oil on canvas, 73.8 x 60.3 cm. Head-and-shoulders view, turned slightly left, eyes front. Brown curls around face under a white turban tied with black ribbons. Slight smile, double chin. Low-cut, short-sleeved black dress with white yoke trimmed with ruffles at neck. Seated in a red upholstered chair. Plain dark background.

PROVENANCE: Owned by Robert C. Winthrop, Jr. Gift of Miss Clara Bowdoin Winthrop, 1934.

II

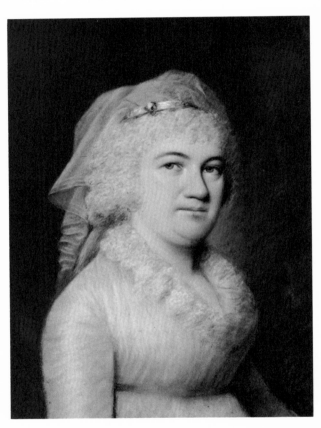

ARTIST: James Sharples, about 1800. A companion portrait to that of her husband (q.v.).

DESCRIPTION: Pastel on paper, 24.5 x 19.2 cm. Half-length view, turned almost half right, facing front. Curly white hair under lace held in lace by satin ribbon. White dress with ruffle around v-neck, blue belt at high waist. Blue-gray background.

PROVENANCE: Owned by Robert C. Winthrop, Jr. Estate of Miss Clara Bowdoin Winthrop, 1969.

REFERENCES: Gordon E. Kershaw, *James Bowdoin: Patriot and Man of the Enlightenment* (Brunswick, Me., 1976), 18–19; Knox, *Sharples*, 97; Park, *Stuart*, 2:743; Mason, *Life and Works of Gilbert Stuart*, 265–267; *Proc.*, 65(1932–1936):268.

John Thomas

Born in Marshfield in 1724, son of John and Lydia (Waterman) Thomas. Studied medicine with Dr. Simon Tufts of Medford. Married Hannah Thomas of Taunton in 1761. Practiced medicine in Kingston. Served as a lieutenant and surgeon in three military expeditions to Nova Scotia in the 1740s and 1750s. Appointed a general officer by the Provincial Congress of Massachusetts in February 1775, and in June the Continental Congress made him brigadier-general in command of troops in Roxbury. Under General Washington's orders, his troops occupied Dorchester Heights on the night of March 4–5, forcing the British evacuation of the city two weeks later. Sent, as a major-general, to Canada to command the Continental troops who had been repulsed in their December 1775 attack on Quebec. Died of smallpox at Chambly, Quebec, on his return home in 1776.

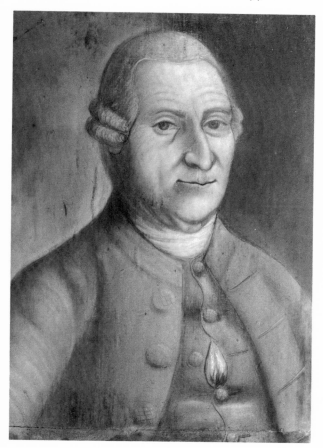

ARTIST: Benjamin Blyth, about 1775. Blyth's bill for the portrait (£4–4s.), frame, and glass (£1–16s.) are in the Society's collections.

DESCRIPTION: Pastel on paper adhered to panel, 56.5 x 43.3 cm. Head-and-shoulders view, facing front. Gray wig with narrow rolls above ears. White neckcloth under gray waistcoat and coat with buttons of the same material. Bluish gray background.

PROVENANCE: Gift of Sarah Williams and Joanna Williams, great-great-granddaughters of the sitter, 1923.

REFERENCES: *DAB*, 9, pt. 2:438–439; *Proc.*, 56(1922–1923):264, 71(1953–1957):73–74.

George Thompson

Born in Liverpool, England, in 1804, son of Henry Thompson. Married Anne Erskine in 1831. English anti-slavery advocate instrumental in forming branch associations of the American Anti-Slavery Society in 1834–1835. Denounced by President Andrew Jackson, he was forced to flee to England in 1835, but during the Civil War was given a public reception in the House of Representatives. Supported parliamentary reform in England. Died in Leeds, Yorkshire, England, in 1878.

ARTIST: Samuel Stillman Osgood, 1836 or 1837.

DESCRIPTION: Oil on canvas, 91.2 x 73.7 cm. Half-length view, full front, head turned slightly right. Short, curly brown hair and sideburns. White shirt, stock, and bow under black waistcoat and high-collared coat. Right hand rests on a table at right. Gray pillar in left background, landscape view at right.

PROVENANCE: Commissioned by Maria Weston Chapman for John Stacy Kimball, who purchased it and later gave it to the Anti-Slavery Society. Upon the dissolution of the Society, it was acquired by William Lloyd Garrison and descended to his son and grandson. It then passed to the donor, the daughter of the purchaser and first owner.

Gift of Mrs. James Baker Brown (Anne Kimball), 1915.

REFERENCES: *DNB*, 56:211; *Proc.*, 48(1914–1915):424–425.

Israel Thorndike

Born in Beverly in 1755, son of Andrew and Anna (Morgan) Thorndike. Married Anna Dodge of Salem in 1784. Went to sea as a privateer at a young age, entered a shipping firm with his brother-in-law in 1777, and was active in trade with China and the Orient. Elected to the Massachusetts legislature 13 times between 1788 and 1814. A man of considerable wealth, he was a donor to Harvard and the Society. Died in Boston in 1832.

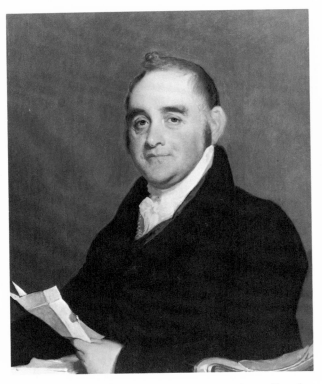

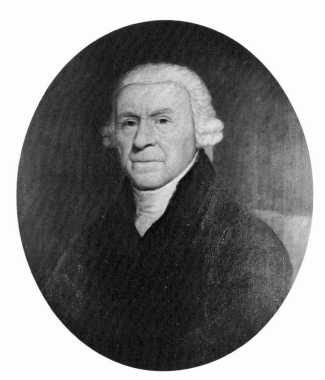

ARTIST: Gilbert Stuart, about 1820. A replica by Stuart, formerly owned by Augustus Thorndike, is at the Museum of Fine Arts, Boston. A copy painted by Bass Otis in 1854 was bequeathed to the Beverly Historical Society in 1903 by Edward Ingersoll Browne of Boston.

DESCRIPTION: Oil on panel, 81.2 x 64.3 cm. Half-length view facing front. Brown hair with curl on top graying sideburns. Slight smile, rosy cheeks, double chin. White neckcloth tied in a bow under black waistcoat and high-collared black coat. Seated in a red upholstered armchair, holding paper with a broken red seal in left hand. Plain dark background.

PROVENANCE: Owned in 1880 by Mrs. Robert C. Winthrop, Jr. (Elizabeth Mason), granddaughter of the sitter, who bequeathed it in 1924 to her daughter, Clara Bowdoin Winthrop.
 Gift of Miss Clara Bowdoin Winthrop, 1934.

REFERENCES: Park, *Stuart*, 2:750; *DAB*, 9, pt. 2:498–499; Catalogue of American Portraits, NPG; *Proc.*, 65(1932–1936):268.

John Tileston

Born in Boston in 1734, son of John and Rebecca (Fowle) Tileston. Married Lydia Coffin in 1760. Master for 57 years of Boston's North Writing School in Love Lane, renamed Tileston Street in his honor. Several of his pupils, among them Edward Everett,* became leaders in the Boston community. Died in 1826.

ARTIST: Ethan Allen Greenwood, 1818.

DESCRIPTION: Oil on panel, 71.1 x 59.9 cm. Oval. Head-and-shoulders view, facing front. White wig with double row of curls over ears. White stock under black waistcoat and high-collared black coat. Seated in red chair. Plain dark background.

PROVENANCE: Bequest of Henry H. Edes, 1935.

REFERENCES: Thwing Catalogue; *Proceedings of the AAS*, 56 (1946):150; D. C. Colesworthy, *John Tileston's School* (Boston, 1887), 33–48; *Proc.*, 4(1887–1889):193, 65(1932–1935):501.

Patrick Tracy

Born in Ireland, probably in County Wexford, in 1711. Came to Newbury as a young man. Married three times—Hannah Carter of Hampton, New Hampshire, in 1742; Hannah Gookin,* mother of his 3 surviving children, in 1749; and Mary, widow of Michael Dalton, in 1773. An experienced shipmaster and later owner of a fleet of ships, in 1763 he was among the petitioners to the General Court for the incorporation of Newburyport where he became a principal merchant and importer of foreign merchandise. A member of the committee of safety in 1774, he was a supporter of the provincial government during the Revolution. Died in Newburyport in 1789.

ARTIST: John Greenwood, between 1749 and 1752.

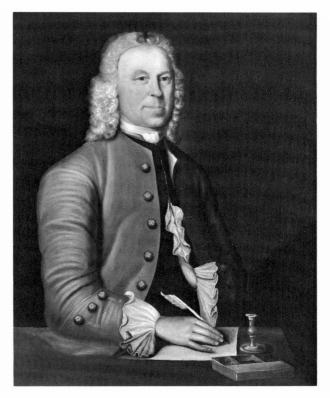

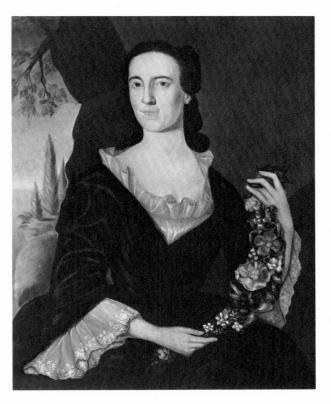

DESCRIPTION: Oil on canvas, 90.4 x 72.1 cm. Half-length view facing front. Long curly wig, slight smile. White ruffled shirt with large ruffled cuffs under black waistcoat and gray collarless coat with gray buttons. Seated in a black chair, left hand thrust into waistcoat, right hand holding a quill pen and resting on a piece of paper on a table. Plain dark gray background.

PROVENANCE: Presumably inherited by the sitter's daughter, Mrs. Jonathan Jackson (Hannah Tracy), and then by her daughter, Mrs. Henry Lee (Mary Jackson). Owned by the latter's son, Col. Henry Lee of Boston in 1878. Inherited by his daughter, Mrs. Frederick Cheever Shattuck (Elizabeth Perkins Lee) and then by her daughter, Mrs. Henry Bryant Bigelow (Elizabeth Perkins Shattuck), and finally by her daughter, Mrs. Lamar Soutter (Mary Cleveland Bigelow), the donor.
 Gift of Dr. and Mrs. Lamar Soutter of Concord, 1986.

REFERENCES: John T. Currier, *History of Newburyport, 1764–1909* (Newburyport, 1909), 2:216; Kenneth W. Porter, *The Jacksons and the Lees* (Cambridge, Mass., 1937), 1:259–260; Burroughs, *Greenwood*, 71; *Proc.*, 16(1878):474–475.

Mrs. Patrick Tracy
(Hannah Gookin)

Born in 1724, daughter of Nathaniel and Dorothy (Cotton) Gookin of Hampton, New Hampshire. Married

Patrick Tracy* of Newburyport as his second wife in 1749. Their two sons, Nathaniel and John, followed their father into the shipping business and founded the firm of Jackson, Tracy and Tracy in 1774 with Jonathan Jackson* who had married their sister Hannah. Died in 1756.

ARTIST: John Greenwood, between 1749 and 1752. Companion portrait to that of her husband (q.v.).

DESCRIPTION: Oil on canvas, 90.4 x 72.1 cm. Three-quarter length view, head turned slightly right. Long black hair curled at neck, pursed lips. Low-cut brown dress with ruffles at neck and lace. Seated. "She holds a wreath of flowers, which tradition says the artist was forced to substitute for a baby whose picture he did not succeed in drawing." Drapery at right pulled back to reveal landscape.

PROVENANCE: Same as for Patrick Tracy (q.v.).

REFERENCES: John T. Currier, *History of Newburyport, 1764–1909* (Newburyport, 1909), 2:216; Kenneth W. Porter, *The Jacksons and the Lees* (Cambridge, Mass., 1937), 1:259–260; Burroughs, *Greenwood*, 71; *Proc.*, 16(1878):475.

John Tudor

Born near Exeter, Devonshire, England, in 1709, son of William and Mary Tudor. Came to Boston with his

mother in 1715 after the death of his father. Married Jane Varney in 1732. A baker by trade and a church deacon, he kept a remarkable diary of events in Boston from 1732 to 1793. Owned by the Society, the diary was edited and published in 1896 by his descendant William Tudor. Died in Boston in 1795.

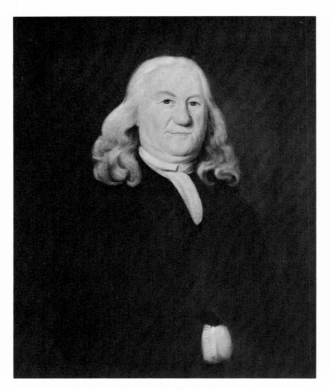

ARTIST: Attributed to Joseph Badger and to Joseph Steward.

DESCRIPTION: Oil on canvas, 76.2 x 63.2 cm. Half-length view, facing front. Long curling white hair, parted in the middle. Narrow, white, turned-over collar and ruffled cuff. Black waistcoat under collarless black coat with large buttons. Right hand thrust into waistcoat. Plain dark background.

PROVENANCE: In his 1792 will, the sitter bequeathed "to my grandson J. H. Tudor my picture in a large four square guilt frame drawn above forty years ago with the paper on the back of it." John Henry Tudor died without children in 1802, and the portrait presumably passed to his brother Frederic Tudor and then to his son, Frederic Tudor, Jr. The last named was the father of Mrs. Frederick Shepherd Converse (Emma Cecile Tudor), mother of the donor.
Gift of Mrs. Paul Codman Cabot (Virginia Converse), 1980.

REFERENCES: *Deacon Tudor's Diary*, William Tudor, ed. (Boston, 1896), v, 1, 109, XX, XXII; *Proc.*, 92(1980):171.

Henry Tufts

Born in Charlestown in 1822, son of Joseph Frothingham and Hannah (Whitney) Tufts, brother of James B. W. Tufts* and nephew of Nathan A. Tufts.* Lived in Charlestown and Medford. After his death in Manila, Tufts's father sent a stone there to mark his grave. Died in Manila, Philippine Islands, in 1847.

ARTIST: Unknown, about 1840.

DESCRIPTION: Oil on canvas, 76.3 x 64.3 cm. Half-length view turned slightly right facing front. Short dark hair. Turned-over stiff white collar, loosely tied black tie. Black waistcoat and coat. Standing with hands on a table covered with a red cloth. Column in right of plain gray-brown background.

PROVENANCE: Gift of Rhodes Robertson, 1970.

REFERENCES: Tufts Family Papers, MHS; Wyman, *Charlestown Genealogies*, 969; *Proc.*, 82(1970):145.

James Bradish Whitney Tufts

Born in 1817, son of Joseph Frothingham and Hannah (Whitney) Tufts. Brother of Henry Tufts* and nephew of Nathan Tufts.* Listed as a clerk in the 1842 Charlestown city directory. Died in Charlestown in 1844.

ARTIST: Unknown.

DESCRIPTION: Oil on canvas, 74.8 x 63.3 cm. Half-length view, facing front. Short black hair and sideburns. High white stiff collar and black bow tie under black waistcoat and coat. Seated with left arm resting on back of sofa. Plain brownish background.

PROVENANCE: Gift of Rhodes Robertson, 1963.

REFERENCES: Tufts Family Papers, MHS; Wyman, *Charlestown Genealogies*, 969; *Proc.*, 75(1903):123.

Nathan Adams Tufts

Born in Charlestown in 1799, son of Amos and Deborah (Frothingham) Tufts, and uncle of Henry Tufts* and James Bradish Whitney Tufts.* Married Mary Ann Lamson in New Hampshire in 1822. A manufacturer and merchant, he was a director of the Warren Institution for Savings and its president from 1850 to 1855. Died in Charlestown in 1873.

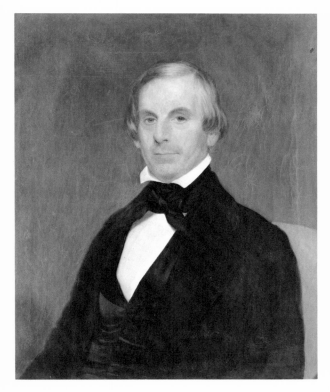

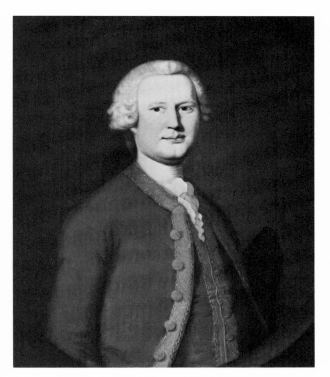

ARTIST: Unknown.

DESCRIPTION: Oil on canvas, 75.8 x 63.8 cm. Head-and-shoulders view facing front. Short graying hair. Stiff, high turned-over collar under wide black bow tie. Black waistcoat and coat. Seated in red upholstered armchair. Plain brownish background.

PROVENANCE: Gift of Rhodes Richardson, 1970.

REFERENCES: Tufts Family Papers, MHS; Wyman, *Charlestown Genealogies*, 969; *Proc.*, 82(1970):145.

Henry Vassall

Born in Jamaica in 1721, son of Leonard and Ruth (Gale) Vassall, a wealthy plantation family. Came to Boston and in 1741 purchased from his brother a mansion house in Cambridge. Married Penelope Royall* in 1742. Twice elected to the General Court, and in 1763 appointed lieutenant colonel of the First Regiment of Middlesex Militia. Active with business interests in his West Indies properties in Jamaica and Antigua but died insolvent in Cambridge in 1769.

ARTIST: Joseph Blackburn, 1757. Signed, lower left: "I. Blackburn Pinxit 1757." Copies of this and the companion portrait of Mrs. Vassall were made for James Russell Soley of New York City.

DESCRIPTION: Oil on canvas, 75.8 x 63.4 cm. Half-length view facing front. Short curled wig, white neckcloth and ruffled shirt under matching brown waistcoat and coat trimmed with gold braid. Hat under left arm. Plain, dark gray background.

PROVENANCE: This portrait and the companion portrait of Mrs. Vassall were inherited by the sitters' daughter, Mrs. Charles Russell (Elizabeth Vassall), and then by her daughter, Mrs. David Pearce (Rebecca Russell) of Boston. Her son, Charles Russell Pearce, took them to Baltimore about 1825. His daughter, Mrs. Prentiss (Elizabeth Vassall Pearce), gave them to her granddaughter Mrs. Oliver H. McCowen (Elizabeth Vassall Prentiss), who sold them in 1914 to Richard Henry Dana, 3d, of Cambridge.

Gift of Richard H. Dana, 3d, in trust for the Cambridge Historical Society, 1917.

REFERENCES: Cambridge Historical Society, *Proceedings* 10(1915): 5–85; Ayres, *Harvard Divided*, 120–121.

Mrs. Henry Vassall (Penelope Royall)

Born in Antigua in 1724, daughter of Isaac and Elizabeth (Eliot) Royall, both natives of Massachusetts. Returned to Boston with her family in 1737. Upon her father's death in 1739 inherited extensive holdings in Antigua, but these were later lost by her husband. Married Henry

Vassall* in 1742 and had one surviving daughter, Elizabeth, who married Charles Russell.* Her Cambridge home was confiscated as a Tory property during the Revolution and she fled to Antigua. Returned to Boston after the war but lived in near poverty. Died in Boston in 1800.

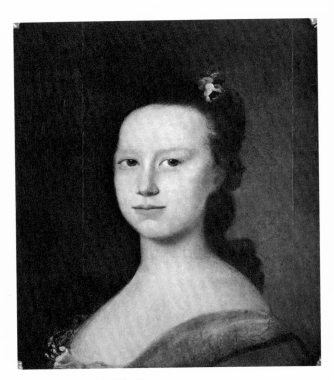

ARTIST: Joseph Blackburn, 1750s.

DESCRIPTION: Oil on canvas, 44.3 x 38.9 cm. Head-and-shoulders view, turned half right, facing front. Flowers in top left of long dark hair with curl down back. Low-cut dress with ruffle at neck.

PROVENANCE: Same as for Henry Vassall (q.v.).

REFERENCES: Cambridge Historical Society, *Proceedings* 10(1915): 5–85; Ayres, *Harvard Divided*, 120–121.

Amerigo Vespucci

Born in Florence, Italy, in 1454. An explorer and navigator, he charted the coast of South America for Portugal in 1501–1502 and discovered that it was a new continent and not part of Asia as Columbus believed. Developed a system for computing almost exact longitude during his explorations. His measurement of the earth's equatorial circumference was only 50 miles short of the actual distance. The name America, applied in his honor to South America, first appeared in 1507. Died in Seville, Spain, in 1512.

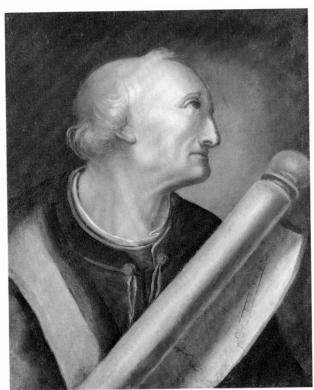

ARTIST: Attributed to Agnolo Bronzino. Copy of original by unknown artist which was bought from the Vespucci family by U.S. Consul C. Edwards Lester at Genoa and taken to New York sometime before 1858.

DESCRIPTION: Oil on canvas, 60.5 x 48.1 cm. Head-and-shoulders view in right profile. Receding curly gray hair. Narrow, round red collar and 2 matching buttons on a green coat with a lighter green sash over right shoulder. A partly unrolled map extends cross-wise from left shoulder over chest. Plain dark gray background shading to lighter gray toward left.

PROVENANCE: In the Society's collections by 1838. A portrait of Vespucci was among the Thomas Jefferson collection of paintings sold at Harding's Gallery, Boston, in 1833, but identification with this portrait has not been made.

REFERENCES: Frederick J. Pohl, *Amerigo Vespucci: Pilot Major* (New York, 1944); *Proc.*, 1st ser., 4(1858–1860):117–118; *MHS Coll*, 3d ser., 7:285.

Lynde Minshull Walter

Born in Shelburne, Nova Scotia, in 1799, son of Lynde and Ann (Minshull) Walter, and half-brother of Jane Walter and Maria Lynde Walter, who successively married Samuel Foster McCleary.* Graduated from Harvard in 1817. After college went to Brazil as a supercargo and

buyer in the merchant trade. Returned to Boston and began a journalistic career. Founder of *The Boston Evening Transcript* in 1830 and its editor until his death, when his sister, Cornelia Wells Walter, succeeded him. Elected to the state legislature in 1835. Died unmarried in 1842.

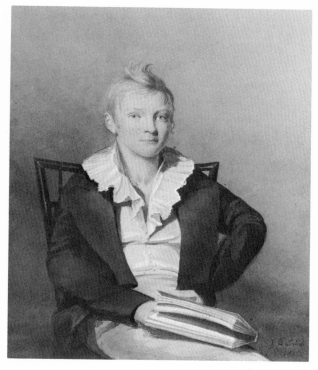

ARTIST: John Rubens Smith. Signed, lower right: "J. R. Smith 1813."

DESCRIPTION: Watercolor on paper, 18.1 x 15.1 cm. Three-quarter length view, facing front, a 14-year-old boy. Unruly light blond hair. White shirt with white pleated collar open at neck, dark coat and yellow trousers. Seated in a black wooden chair, right hand on hip, left holding book on lap with fingers inserted between the pages.

PROVENANCE: Gift of Miss Elise Bordman Richards, niece of the sitter, 1921.

REFERENCES: Joseph Edgar Chamberlin, *The Boston Transcript* (Boston, 1930), 7–62; *Proc.*, 54(1920–1921):290–291.

Mrs. Joseph Wanton
(Mary Winthrop)

Born in Boston in 1708, first child of John Winthrop, F.R.S.* and Anne (Dudley) Winthrop.* Married in 1729 Joseph Wanton, merchant, and later, after her death, last

colonial governor of Rhode Island. Died in Newport, Rhode Island, in 1767.

ARTIST: Unknown. Copy of the original by Robert Feke, painted about 1740, which is at Redwood Library, Newport.

DESCRIPTION: Oil on canvas, 75.8 x 63.6 cm. Half-length view, facing front. Long brown hair with a curl on left shoulder, brown eyes. Low-cut blue dress with lace at neck line, rose-colored shawl over shoulders. Plain dark background painted in an oval.

PROVENANCE: Gift of Miss Clara Bowdoin Winthrop, 1934.

REFERENCES: Mayo, *Winthrop Family*, 137; Henry Wilder Foote, *Robert Feke: Colonial Portrait Painter* (Cambridge, Mass., 1930), 56–58, 200–201; *Proc.*, 65(1932–1936):268.

Artemas Ward

Born in Shrewsbury in 1727, son of Nahum and Martha (How) Ward. Graduated from Harvard in 1748. Married Sarah Trowbridge of Groton in 1750. Colonel in the French and Indian Wars, member of the provincial council, general and the commander-in-chief of Massachusetts troops in 1775 until George Washington assumed command of the Continental Army. Chief justice of the Worcester county court of common pleas, member of the first and second Massachusetts provincial con-

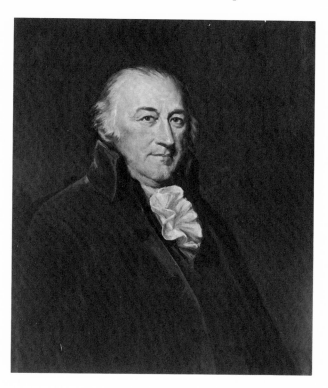

gresses and the Continental Congress, United States Congress, and the Massachusetts legislature. Died in Shrewsbury in 1800.

ARTIST: Albert Rosenthal, 1909, after the original by Charles Willson Peale. Signed on back: "Artemas Ward / Painted by Albert Rosenthal, 1909 / after the original by C. W. Peale, in / Independence Hall / (for Artemas Ward)." Another copy of the Peale portrait by Rosenthal was painted in 1916 and is at Fraunces Tavern, New York City.

DESCRIPTION: Oil on canvas, 76.4 x 63.9 cm. Head-and-shoulders view, facing front. Receding gray-white hair, brown eyes. White shirt with ruffle under brown waistcoat and high-collared brown coat with brown buttons. Plain dark brown background.

PROVENANCE: Gift of Artemas Ward, Jr., 1937.

REFERENCES: *Sibley's Harvard Graduates*, 12:326–348, *DAB*, 10, pt. 1:415–416; Catalogue of American Portraits, NPG; *Proc.*, 66(1936–1941):477.

Joseph Warren

Born in Roxbury in 1741, son of Joseph and Mary (Stevens) Warren. Graduated from Harvard in 1759. Married Elizabeth Horton in 1764. Studied medicine with Dr. James Lloyd and practiced in Boston. As a Freemason, he joined St. Andrew's Lodge, a newly organized group, which included many political agitators. A radi-

cal leader in activities leading to the Revolution, he delivered addresses commemorating the Boston Massacre in 1772 and 1775, and drafted the Suffolk Resolves. Elected to the Provincial Congress in 1774, he served as president *pro tem* and was chairman of the Provincial Committee of Safety. Commissioned second major-general in 1775, but served as a volunteer in the battle at Bunker Hill in which he was killed in 1775.

ARTIST: Edward Savage. A copy of the original painted by John Singleton Copley in 1765, owned by the Museum of Fine Arts, Boston.

DESCRIPTION: Oil on panel, 77.3 x 62.6 cm. Half-length view facing front. Short wig, slight smile. Turned-down collar on white shirt under dark collarless coat. Seated in red upholstered chair. Plain dark background.

PROVENANCE: Gift from members of the Society, 1925.

REFERENCES: *Sibley's Harvard Graduates*, 14:510–527; *DAB*, 10, pt. 1:482–483; *Proc.*, 58(1924–1925):377.

George Washington

Born in 1732 in Westmoreland County, Virginia, son of Augustine and Mary (Ball) Washington. Married Martha (Dandridge) Custis, a widow, in 1759. Worked as a surveyor in Virginia, served as a commander in the Virginia Regiment during the 1750s and was elected to the Virginia House of Burgesses in 1758. Commander-in-chief of the Continental Army during the Revolution from 1775 to 1783, and first president of the United States from 1789 to 1797. Retired to Mount Vernon, his Virginia estate. Died at Mount Vernon in 1799.

I

ARTIST: Christian Gullager, 1789. A life study painted at Portsmouth, N.H.

DESCRIPTION: Oil on canvas, 77.2 x 63.2 cm. Head-and-shoulders view, turned slightly right, eyes front. Powdered wig clubbed in back. White stock under buttoned waistcoat. Painted in an oval. Plain brown background, lighter shading around head. (*See Color Plate 21*).

PROVENANCE: Washington's diary for Nov. 3, 1789, records at Portsmouth, New Hampshire: "Sat two hours in the forenoon for a Mr. —, painter, of Boston, at the request of Mr. Brick [probably Samuel Breck, Esq.], of that place, who wrote Major Jackson that it was an earnest desire of many of the inhabitants of that town that he might be indulged." To raise money for the purchase, several Boston gentlemen organized a raffle, which was won by Daniel Sargent, Jr. He presented the portrait to Dr. Jeremy Belknap.

It was inherited by Belknap's daughter Elizabeth, who presented it to her nephew Edward Belknap of New York. The portrait was then inherited by his daughter, the donor.

Gift of Mrs. Arthur Codman, 1921.

II

ARTIST: Joseph Wright painted the head, face, and figure outline, 1784, Philadelphia, Pennsylvania; completed by John Trumbull, 1786. Copied from Wright's original life study, taken in the fall of 1783, now at the Historical Society of Pennsylvania.

DESCRIPTION: Oil on canvas, 94.5 x 77.8 cm. Half-length view, turned slightly right, facing front. Short powdered wig clubbed in back. White stock and short ruffle under buff waistcoat and navy uniform coat with buff collar and facings, epaulets, and brass buttons. Left hand holds the gold top of his sword or cane. Plain dark background. (*See Color Plate 22*).

PROVENANCE: Commissioned by Thomas Jefferson, who noted in a list of paintings at Monticello: "A Washington half length of full size or larger, an original taken by Wright (son of Mrs. Wright, famous for her works in wax), when Genl. Washington attended the meeting of the Cincinnati in Philadelphia May 1784. Passing then through that city on my way from Annapolis to Boston to embark for Europe I could only allow Wright time to finish the head and face and sketch the outlines of the body. These and the drapery were afterwards finished in Paris by Trumbull."

Sold in 1833 at the sale of Jefferson's paintings at Chester Harding's gallery in Boston, where it was purchased by Israel Thorndike, who purchased the portrait of Christopher Columbus* at the same time.

Gift of Israel Thorndike, 1835.

III

ARTIST: Mr. Vivian, 1874, England. Copy of a Charles Willson Peale original, 1779, one of several Peale painted that year. The original, intended for the Stadtholder of Holland in 1780, was captured by Capt. Keppel of the British Navy at the same time as Henry Laurens who was on his way to negotiate a treaty with the Dutch. Presented by the captor to his uncle, Admiral Lord Keppel, it remained in the collections of the Earl of Albemarle at Quidenham Park, Norfolk, until 1918 when Lord Albemarle presented it to the nation and it was hung in the residence of the prime minister at No. 10 Downing Street, London. It is generally referred to as the "Albemarle Washington."

DESCRIPTION: Oil on canvas, 244.9 x 154.9 cm. Full-length figure, facing front. Buff-and-navy blue uniform with black boots. Light blue decorative ribbon under coat over right shoulder, standing with crossed legs hold-ing hat in right hand, leaning on cannon with left. Landscape with figures in background and foreground.

PROVENANCE: Commissioned by Alexander Duncan of London as a gift to the Society.

Gift of Alexander Duncan, 1874.

IV

ARTIST: Unknown; copy after Charles Willson Peale. Inscribed: "Le General Washington, peint d'après nature in Philadelphie par N. Piehle en 1783."

DESCRIPTION: Oil on panel, 29.2 x 23.9 cm. Head-and-shoulders view, facing front. White wig tied in a queue. In uniform with epaulets. Landscape background painted in an oval encircled by the inscription.

PROVENANCE: Gift of Miss Sarah J. Eddy, 1890.

V

ARTIST: Unknown. Based on the 1796 Gilbert Stuart "Athenaeum Washington" with added clothes and background. The original is now jointly owned by the Museum of Fine Arts, Boston, and the National Portrait Gallery, Washington, D.C.

DESCRIPTION: Oil on canvas, 73.6 x 60.7 cm. Head-and-shoulders view, turned slightly left, facing front. White curly hair tied in a queue. White stock, lace jabot under waistcoat and high-collared black coat. Plain dark background.

PROVENANCE: Estate of Mrs. James Warren Sever, 1878.

VI

ARTIST: Attributed to John Vanderlyn.

DESCRIPTION: Oil on canvas, 171.5 x 147.7 cm. Full-length view. In uniform wearing tri-cornered hat and gloves. Astride a white horse, upraised sword in right hand, holding reins in left. Military figures and landscape in background.

PROVENANCE: Unknown; in the Society's collections by 1885.

REFERENCES: *DAB*, 19, pt. 1:509–527; *Proc.*, 1st ser., 2(1835–1855):25, 3(1855–1858):309–310, 5(1889–1890):419, 452, 13 (1873–1875):324–327, 16(1878):11, 54(1920–1921):289; John Hill Morgan and Mantle Fielding, *The Life Portraits of Washington and Their Replicas* (Philadelphia, 1931), 31, 77, 151–153; Marvin Sadik, *Christian Gullager, Portrait Painter to Federalist America* (Washington, D.C., 1976), 74–76; Monroe H. Fabian, *Joseph Wright: American Artist, 1756–1793* (Washington, D.C., 1985), 101–106; Gustavus A. Eisen, *Portraits of Washington* (New York, 1932), 1:136, 2:361–362.

Helen Ruthven Waterston

Born in Boston in 1841, only daughter of Robert Cassie Waterston* and Anna Cabot Lowell (Quincy) Waterston. Named after her aunt Helen Waterston, whose husband, Charles Deane, was a member of the Society as was her father. Among her journals owned by the Society is one describing her visit to England in 1856. She left school in Paris in 1857 to travel with her parents in Switzerland and Italy. Died in Naples, Italy, in 1858.

ARTIST: Alonzo Hartwell, 1856.

DESCRIPTION: Crayon on paper, 61.2 x 51.8 cm. Oval. Head-and-shoulders view, facing slightly left. Dark hair parted in middle, slight smile, dimple in chin. V-necked dress with lace collar. Plain, light background.

PROVENANCE: Probably the gift of Josiah P. Quincy, 1901.

REFERENCES: Waterston Papers, MHS; *Proc.*, 8(1892–1894):296.

Robert Cassie Waterston

Born in Kennebunk, Maine, in 1812, son of Robert and Hepsea (Lord) Waterston. Came to Boston with his family at age 4; studied at the Divinity School in Cambridge. Married in 1840 Anna Cabot Lowell Quincy, daughter of President Josiah Quincy* of Harvard. Their daughter was Helen Ruthven Waterston.* Served as a Unitarian minister in Boston and environs. A member of the Society for 34 years, he bequeathed to it his library with funds to care for it and three funds for printing and publishing. Died in 1893.

ARTIST: Rosamond L. Smith, 1901. After the original by Otto Grundmann, owned by the Unitarian Universalist Association.

DESCRIPTION: Oil on canvas, 91.2 x 76.1 cm. Half-length view. Head tipped slightly to right, facing front. Short dark hair parted on left side, double chin, black coat. Seated in upholstered armchair. Right hand thrust into coat, left holding book with forefinger between pages. Plain dark background.

PROVENANCE: Commissioned for the Society in 1901.

REFERENCES: *Proc.*, 2d ser., 8(1892–1894):172, 293–302.

Rufus Webb

Born in Windham, Connecticut, in 1768, son of Stephen and Content (Hewitt) Webb. A schoolmaster at the South Writing School in Boston, known for producing students with beautiful penmanship. Died unmarried in Boston in 1827.

ARTIST: Attributed to William M. S. Doyle, 1814.

DESCRIPTION: Pastel on paper, 69.2 x 59.7 cm. Head-and-shoulders view, turned half right. Dark unruly hair and sideburns. White stock and tan waistcoat showing above stock under buttoned black high-collared coat. Plain dark background.

PROVENANCE: Bequest of Grace W. Edes Stedman, 1935.

REFERENCES: Webb Family Papers, MHS; Unpublished checklist of Doyle's works by Dr. Arthur Kern, Providence, R.I.; *Proc.*, 65(1932–1936):501.

Daniel Webster

Born in Salisbury, New Hampshire, in 1782, son of Ebenezer and Abigail (Eastman) Webster. Graduated from Dartmouth in 1801. Twice married—to Grace Fletcher* in 1808 and to Caroline Le Roy in 1829. Renowned statesman and orator. Practiced law in Portsmouth, New Hampshire, from 1807 to 1816. Served as United States congressman from New Hampshire and later from Massachusetts; United States senator from Massachusetts for more than 20 years; and twice secretary of state. Elected a member of the Society in 1821. Died at Marshfield in 1852.

I

ARTIST: Joseph Alexander Ames, 1852.

DESCRIPTION: Oil on canvas, 76.8 x 63.6 cm. Head-and-shoulders view, turned half left, eyes front. Dark graying hair under wide-brimmed, tan felt hat. White, turned-over shirt collar, black tie, dark gray coat. Plain gray background shading to lighter around face.

PROVENANCE: Donor unknown.

ARTIST: Joseph Alexander Ames, probably 1852.

DESCRIPTION: Oil on canvas, 91.5 x 73.2 cm. Full-length figure, facing front. Represents Webster at his farm in Marshfield. Dark hair under wide-brimmed hat, white shirt with black bow tie. Calf-length olive coat, darker trousers, black boots. Standing with staff in left hand. Landscape background and foreground.

PROVENANCE: Owned by Charles H. Joy of Boston in 1886.
 Gift of Benjamin Joy, 1962.

III

ARTIST: Alvan Clark, 1846.

DESCRIPTION: Oil on panel, 25.1 x 19.9 cm. Head-and-shoulders view, turned slightly right. Receding short black hair, black bushy eyebrows. White shirt with high collar, black tie, white waistcoat, black double-breasted coat. Architecture in background.

PROVENANCE: Gift of Miss Martha C. Codman, 1914.

IV

ARTIST: Chester Harding, 1830. Three other portraits by Harding from the same life sitting are at Dartmouth College, Newark Museum, New Jersey, and the National Portrait Gallery, Washington, D.C.

DESCRIPTION: Oil on canvas, 76.2 x 63.5 cm. Head-and-shoulders view. Unruly, short dark hair and sideburns. High stiff collar and ruffle on white shirt, white tie. Black waistcoat under high-collared black coat. Plain dark background.

PROVENANCE: Gift of Mrs. C. Minot Weld, 1935.

V

ARTIST: Chester Harding, about 1830. A replica of the portrait by Harding at the Boston Athenaeum.

DESCRIPTION: Oil on canvas, 68.8 x 48.1 cm. Full-length figure facing front. Black suit with additional black knee-length coat on top. Standing in front of red upholstered chair with red drapery behind it. Right hand resting on a table with books on it. A small full-length statue stands in a recess on the right.

PROVENANCE: Bequest of John H. Eastburn, 1886.

VI

ARTIST: Unknown.

DESCRIPTION: Oil on canvas, 61.1 x 44.7 cm. Head-and-shoulders view, facing front. Determined look. Black suit with white waistcoat.

PROVENANCE: Said to have hung in the State House, Concord, New Hampshire, until replaced by a larger portrait. Purchased by the donor's father from a Boston art dealer.

Gift of Theodore Chase, 1970.

REFERENCES: *DAB*, 10, pt. 1:585–592; Lipton, *A Truthful Likeness*, 114–115, 185; *Proc.*, 1st ser., 2(1835–1855):529–531, 2(1885–1886):261–265, 48(1914–1915):167, 65(1932–1936):475, 74(1962):113, 121, 82(1970):164.

Mrs. Daniel Webster (Grace Fletcher)

Born in Hopkinton, New Hampshire, in 1781, daughter of Rev. Elijah and Rebecca (Chamberlain) Fletcher. Educated at Atkinson Academy in Atkinson, New Hampshire. Taught school at Boscawen and Salisbury, New Hampshire, before her marriage. Married Daniel Webster* in 1808 and was the mother of all his children. Died in New York City in 1828.

ARTIST: Chester Harding, 1827. Harding made replicas of it for other members of the family. One is now at Baker Library, Dartmouth College, and another is in the collection of a descendant of Julia Webster.

DESCRIPTION: Oil on canvas, 98.8 x 71.3 cm. Half-length view. Dark hair under large gray silk bonnet trimmed inside with lace and blue ribbons. Matching gray dress with wide collar and long sleeves. Red shawl over right arm. Seated in an upholstered armchair holding gloves in hand. Plain light gray background. The

costume depicted is the one the sitter wore at her husband's oration dedicating the Bunker Hill Monument in 1825.

PROVENANCE: The portrait was finished in December 1827, just before the Websters left for Washington, D.C. They stopped in New York, where Mrs. Webster became very ill. She died there on January 21, 1828. Webster wrote to her half-brother, James William Paige, in February regarding the painting, "I cannot tell you how I value it. It was a most fortunate thing, that we had it done." Given by Webster's daughter-in-law, Mrs. Fletcher Webster, to Mrs. Charles Joy of Boston.
 Gift of Benjamin Joy, 1953.

REFERENCES: Claude Moore Fuess, *Daniel Webster*, 2 vols. (Boston, 1930), 1:100–101; Lipton, *A Truthful Likeness*, 94; *Proc.*, 71(1953–1957):440.

Frederick Hedge Webster

Born in Boston in 1843, son of John Gerrish and Mary (Moulton) Webster. Commissioned in 1864 as a second lieutenant in the 54th Regiment, Massachusetts Volunteer Infantry, the black regiment of Colonel Robert Gould Shaw. Died of fever in a military hospital in Beaufort, South Carolina, in 1865.

ARTIST: Benjamin Curtis Porter.

DESCRIPTION: Oil on canvas, 75.9 x 63.9 cm. Half-length view, facing front. Short, dark hair parted on left, mustache, brown eyes. Union army uniform with epaulets, brass buttons and a wide belt. Plain cream background.

PROVENANCE: Gift of Miss Vida Woley, 1968.

REFERENCES: *NEHGR*, 40(1886):416; *Proc.*, 80(1968):147.

Redford Webster

Born in Boston in 1761, son of Grant and Hannah (Wainwright) Webster. Married Hannah White in 1787. Worked as a druggist until the death of his father-in-law, at which time he sold his business and became a man of leisure. Elected to membership in the Society in 1792 and served as cabinet keeper from 1810 until his death in 1833.

ARTIST: Chester Harding.

DESCRIPTION: Oil on canvas, 75.7 x 63.1 cm. Head-and-shoulders view. Receding white hair and sideburns. White stock and tie under black waistcoat and high-collared black coat. Seated in an armchair.

PROVENANCE: Gift of Mrs. John White Webster, 1851.

REFERENCES: *Sibley's Harvard Graduates*, 10:91–92; *Proc.*, 1st ser., 1(1791–1835):490–492, 2(1835–1855):469.

Arthur Wellesley, Duke of Wellington

Born in Ireland, probably in Dublin, in 1769, son of Garrett Wellesley, 1st earl of Mornington, and his wife Lady Anne Hill. Educated primarily in England. Married Catherine Sarah Dorothea Pakenham in 1806. Served in the British army in Holland and India, and was created Viscount Wellington in 1809 after leading allied forces of British, Spanish, and Portuguese to victories against the French at Oporto and Talavera. Created Duke of Wellington in 1814. After commanding troops in the defeat of Napoleon at Waterloo in 1815, he turned to politics and diplomacy. Died in London in 1852.

ARTIST: William Salter, about 1840. One of several portraits painted from life.

DESCRIPTION: Oil on canvas, 53.6 x 43.6 cm. Three-quarter length view, head turned slightly right. Short graying hair, curled sideburns, sharp pointed nose. Red uniform coat, black trousers, gold belt, and sash with many decorations. Black cape draped over left shoulder. Standing, holding hat in right hand, gloves in left, sword in crook of left arm. Red drapery in upper left of very dark background.

PROVENANCE: Bequest of John H. Eastburn, 1886.

REFERENCES: *DNB*, 20:1081–1115; *Proc.*, 2d ser., 2(1885–1886):261.

Mrs. Thomas Wells (Anna Maria Foster)

Born in Gloucester in 1795, daughter of Benjamin and Mary (Ingersoll) Foster.* Married Thomas Wells as his second wife in 1821. She and her husband were writers and poets of quiet distinction. Died in Boston in 1868.

ARTIST: Unknown.

DESCRIPTION: Oil on panel, 42.5 x 31.0 cm. Head-and-shoulders view, head lifted slightly right. Dark curly hair parted in the middle, pink cheeks, slight smile. White dress with puffed sleeves. Plain gray background.

PROVENANCE: Bequest of Miss Helen I. Tetlow, 1976.

REFERENCES: Foster, *Colonel Joseph Foster*, 379–400; *Proc.*, 88(1976):150.

William Welsteed

Baptized in Boston in 1696, son of William and Katherine (Long) Welsteed. Graduated from Harvard in 1716. Worked at Harvard as librarian, tutor, and teaching fellow from 1718 to 1728. Married in 1728 Sarah Hutchinson, sister of Thomas Hutchinson.* Ordained minister of the New Brick Church in Boston in 1728 and served there until his death in Boston in 1753.

ARTIST: Unknown. Once attributed to John Singleton Copley, who in 1753 at age 16 made a mezzotint engraving of Welsteed by modifying his stepfather Peter Pelham's engraving of William Cooper. There is no doubt that the Cooper and Welsteed prints were pulled from the same plate. This portrait is probably a copy of the mezzotint, but the style of the painting does not support attribution to Copley.

DESCRIPTION: Oil on panel, 76.7 x 63.8 cm. Head-and-shoulders view facing front. Gray curled wig, gray eyes. Clerical bands, black robe. Plain dark to light gray background. Painted in oval at bottom.

PROVENANCE: Gift of Chandler Robbins, 1836.

REFERENCES: *Sibley's Harvard Graduates*, 6:153–158; Parker and Wheeler, *Copley*, 237–238; *Proc.*, 1st ser., 2(1835–1855):52.

John Wentworth

Born in Portsmouth, New Hampshire, in 1671, son of Samuel and Mary (Benning) Wentworth. Married Sarah Hunking about 1695. A sea captain and merchant, he was a councillor appointed by Queen Anne from 1711 to 1712, and justice of the court of common pleas from 1713 to 1718. Became resident lieutenant-governor of New Hampshire in 1717, an office he held until his death in 1730.

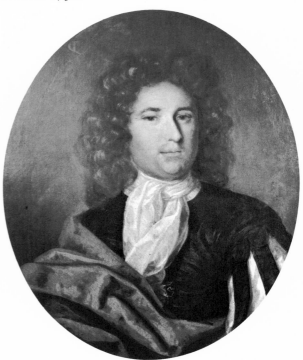

ARTIST: Unknown.

DESCRIPTION: Oil on canvas, 76.0 x 63.5 cm. Oval. Head-and-shoulders view. Long, dark curly hair. White neckcloth and tie, dark coat with slashed sleeve, red cape or shawl over right arm. Plain dark background.

PROVENANCE: Gift of Sir John Wentworth, governor of Nova Scotia, grandson of the sitter, 1798.

REFERENCES: John Wentworth, *The Wentworth Genealogy* (Boston, 1870), 1:67, 96–99; *Proc.*, 1st ser., 1(1791–1835):124.

Esther Wheelwright

Born in Wells, Maine, in 1696, daughter of John and Mary (Snell) Wheelwright. Captured in Wells and taken to Canada by the Abenaki Indians in 1703. In 1708, taken by the French to Quebec, where she was taken in by Governor Vaudreuil, who sent her with his daughter to school with the Ursulines. Took her vows as a nun in

1712 with the Ursuline Order in Quebec under the name of Sister Esther Marie Joseph de l'Enfant Jesu. In 1760 became the convent's first, and last, English mother superior. Died in Quebec in 1780.

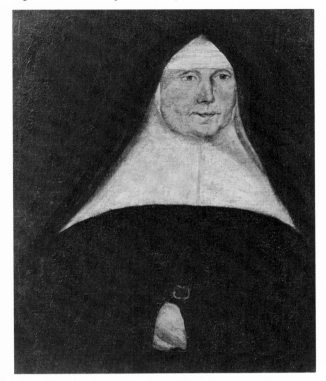

ARTIST: Unknown, probably 1763. In manuscript on back of canvas: "Esther Wheelwright / 1688. Property of M. E. Mitchell." A copy, taken from a photograph of the original, hangs in the museum of the convent in Quebec.

DESCRIPTION: Oil on canvas, 55.7 x 45.5 cm. Half-length view facing front. Dressed as a nun with white veil covering head and neck to shoulders under black habit. Part of right hand is showing. Plain, very dark background.

PROVENANCE: Sent back to New England with the sitter's nephew Joshua Moody, probably in 1763. It was handed down in the family with the name Esther from generation to generation. The last known family owner was Mrs. Esther Mitchell Morse.
Given to the Society by Charles D. Childs, 1968.

REFERENCES: "Thy Hand Shall Lead Me: The Story of Esther Wheelwright," an unpublished biography by Gerald M. Kelly, MHS; *Proc.*, 80(1968):142.

John Brooks Wheelwright

Born in Milton in 1897, son of Edmund March and Elizabeth (Brooks) Wheelwright. Educated at Harvard with the Class of 1920 and later as a special student at the Massachusetts Institute of Technology School of Architecture. As an architect, he designed alterations in houses on Beacon Hill and in Back Bay Boston. A writer of poetry, fiction, and literary criticism, he published three volumes of poetry and contributed to many periodicals. Joined the Socialist Party, became an active worker, for a time, was literary agent for the party in Massachusetts. Wrote for the Labor and Socialist monthly *Arise!* When the Socialist Party split in 1936 he became an active worker in the Socialists Workers' Party. Died unmarried in Boston in 1940.

ARTIST: Ivan Opffer, 1920. Signed, "Ivan Opffer / Cambridge 1920."

DESCRIPTION: Pen and pencil sketch, 27.8 x 21.6 cm. Head in left profile. Large nose, ears, and jutting chin. White background.

PROVENANCE: Gift of Mrs. S. Foster Damon, sister of the sitter, 1948.

REFERENCES: *Harvard Class of 1920: Fiftieth Anniversary Report* (Cambridge, Mass., 1970), 470; *Proc.*, 69(1947–1950):455.

Nathaniel Wheelwright

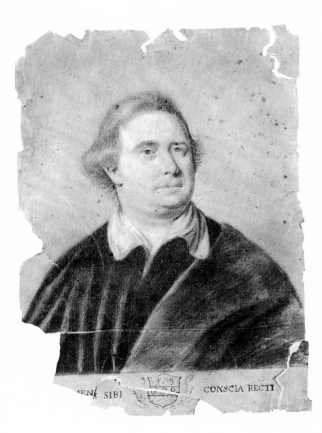

SIBI · · · CONSCIA RECTI

Born in 1721, son of John and Elizabeth (Greene) Wheelwright of Boston and Wells, Maine. Married Ann Apthorp in 1755. A merchant in Boston and London and a generous parishioner of King's Chapel. Went to Canada under a commission from Governor Shirley to try to redeem captives of the Indians in 1753; there he visited his aunt Esther Wheelwright,* whom Indians had captured as a girl. Declared bankruptcy in 1765 and fled to the West Indies. Died in the West Indies in 1766.

ARTIST: Attributed to John Singleton Copley.

DESCRIPTION: Oil on paper mounted on panel, 35.4 x 25.0 cm. Head-and-shoulders view, facing front, head turned slightly left. Short brown hair, double chin. Dark coat with light open collar over collarless white shirt. Gray cloak over left arm. Plain light brown background.

PROVENANCE: Unknown, given before 1960.

REFERENCES: Henry Wilder Foote, *Annals of King's Chapel* (Boston, 1896), 2:143, 168, 170; *The Bulletin of the Fort Ticonderoga Museum*, 10(1960):258–296.

Mrs. William Whitridge (Mary Cushing)

Born in Scituate in 1759, daughter of John and Deborah Cushing. Married William Whitridge, a distinguished

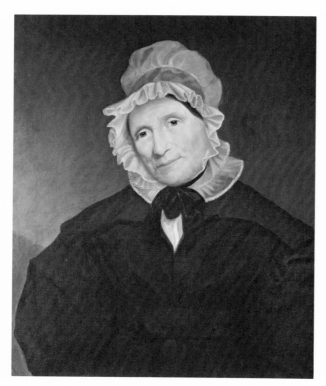

doctor of Tiverton, Rhode Island, in 1781. Among their many children was Dr. William Cushing Whitridge.* Died in 1846.

ARTIST: William Allen Wall, New Bedford.

DESCRIPTION: Oil on canvas, 76.3 x 63.2 cm. Head-and-shoulders view, facing front, head tipped slightly right. White ruffled bonnet tied with a black ribbon, brown hair, hazel eyes. Black cloak revealing a bit of white at neck. Dark object in right of plain gray background.

PROVENANCE: Gift of Mrs. Louis P. Dolbeare (Mary Cushing Niles), a descendant, 1980.

REFERENCES: *Scituate Vital Records* (Boston, 1909), 1:120, 2:93; *Proc.*, 92(1980):170.

William Cushing Whitridge

Born in Tiverton, Rhode Island, in 1784, son of William Whitridge and Mary (Cushing) Whitridge.* Studied briefly at Brown University; graduated from Union College in 1804. Learned medicine from his father, a distinguished physician, as was he and were two of his brothers. Married Olivia Cushing. Set up practice in New Bedford in 1822. A prominent member of the Massachusetts Medical Society. Died in New Bedford in 1857.

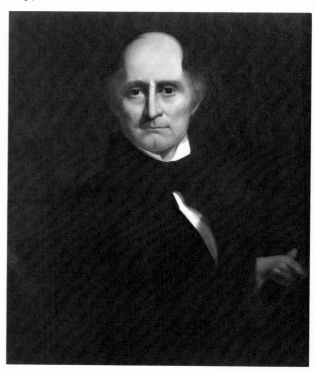

ARTIST: William Allen Wall, New Bedford.

DESCRIPTION: Oil on canvas, 76.6 x 64.2 cm. Head-and-shoulders view, facing front. Receding dark hair, graying at temples, brown eyes. Stiff, high-standing collar on white shirt. Black tie and high-collared black coat. Seated in red upholstered chair. Holding book in right hand, with finger between pages. Light shading to dark brown background.

PROVENANCE: Gift of William C. Whitridge, great-great-grandson of the sitter, 1981.

REFERENCES: Leonard B. Ellis, *History of New Bedford and its Vicinity 1602–1892* (Syracuse, N.Y., 1892), 668; *Vital Records of New Bedford, Massachusetts*, 2 vols. (Boston, 1932–1941), 1:517.

Daniel Brown Widdifield

Born in Boston in 1800. Trained as an optician. Married Harriet Hansell in 1825. Founded Widdifield & Company in Boston which had an excellent reputation for the quality of its optical and mathematical instruments. Died in Boston in 1862.

ARTIST: William Holbrook Beard.

DESCRIPTION: Oil on canvas, 76.2 x 63.7 cm. Head-and-shoulders view, facing slightly left. Curly brown hair, graying sideburns. High-standing, stiff collar on white shirt, black tie, black waistcoat, and coat. Plain dark gray background.

PROVENANCE: Gift of Mrs. Arthur M. Crain of Cranston, Illinois, 1916.

REFERENCES: *NEHGR*, 16(1862):379; *Proc.*, 50(1916–1917):1

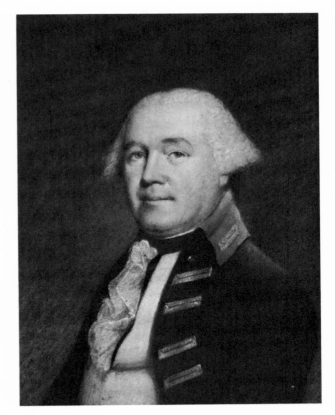

hair, slight smile. Wearing a military uniform with white ruffled shirt, white waistcoat, blue coat with red collar. Plain gray-blue background.

PROVENANCE: Estate of Miss Clara Bowdoin Winthrop, 1969.

REFERENCES: *DAB*, 10, pt. 2:222–226; Knox, *Sharples*, 97.

James Wilkinson

Born in Calvert County, Maryland, in 1757, son of Joseph Wilkinson. Married twice—to Anne Biddle who died in 1807, and in 1810 to Celestine Laveau Trudeau. Served as an army officer under Benedict Arnold, Horatio Gates, and George Washington. Involved in various intrigues, he was forced to resign his military appointments. Active in land and business speculation in Kentucky and Spanish Louisiana, but returned to the army in 1791. Appointed governor of the Louisiana Territory in 1805. A confederate of Aaron Burr, he narrowly escaped indictment by serving as chief witness at Burr's trial for treason. Died in Mexico City in 1825.

ARTIST: James Sharples, about 1795.

DESCRIPTION: Pastel on paper, 25.1 x 20.6 cm. Head-and-shoulders view, facing front. Curly, short, powdered

Joseph Willard

Born in Cambridge in 1798, youngest son of Joseph Willard, then president of Harvard College, and Mary (Sheafe) Willard. Graduated from Harvard in 1816, Harvard Law School in 1819. Married Susanna H. Lewis in 1830. Practiced law in Waltham, Lancaster, and later in Boston, where he was clerk of courts. Elected to membership in the Society in 1829; served as its librarian and recording and corresponding secretary. Died in Boston in 1865.

ARTIST: Lilla Cabot Perry, 1912, from a photograph taken in 1862 or 1863. Signed, upper right: "L. C. Perry."

DESCRIPTION: Oil on canvas, 93.0 x 68.8 cm. Three-quarter length view, turned slightly left. Short brown hair and beard. High-standing stiff collar on white shirt,

black tie. Black waistcoat, double-breasted black coat and matching trousers. Seated in an armchair with legs crossed. Plain, light gray background.

PROVENANCE: Gift of Miss Susanna Willard, daughter of the sitter, 1912.

REFERENCE: *Proc.*, 45(1911–1912):579–583.

William III

Born in The Hague, Netherlands, in 1650, son of Prince William II of Orange and his wife Princess Mary of Great Britain. Married his first cousin and jointly reigned with her as King William III and Queen Mary II of Great Britain following the Glorious Revolution of 1688. Among their gifts of religious libraries to colonial churches, that given to Kings' Chapel in Boston is on permanent loan to the Boston Athenaeum. Died in London in 1702.

ARTIST: Unknown.

DESCRIPTION: Oil on canvas, 72.9 x 59.1 cm. Head-and-shoulders view, facing front. Black hair, dark eyes and eyebrows. Wearing armor. Decorative chain over shoulders, decorations below right and at neck. Sword hilt at right, cloak or drapery at left. Very dark background.

PROVENANCE: Unknown, in the Society's collections before 1838. Previously listed as an unknown subject, the sitter was identified by John Appleton, assistant librarian, in 1862 through comparison with published portraits.

REFERENCES: *DNB*, 21:306–325; *Proc.*, 1st ser., 6(1862–1865): 331–332.

buttoned in front, and a red cloak appears from behind the right shoulder to the left arm. Painted in an oval. Plain, dark brown background.

PROVENANCE: Gift of Samuel Parker, 1848.

REFERENCES: Foote, *Smibert*, 109, 191; Smibert, *Notebook*, 88, 105.

Mary Williams

Born in Boston in 1707/8, daughter of Nathaniel and Anne (Bradstreet) Williams, both from prominent Boston families. Married John Smibert, the artist, who was 20 years her senior, in 1730. They had 9 children of whom only 3 survived their father. After his death in 1753, his widow carried on his "colour shop" for several years. Died after 1753.

ARTIST: John Smibert, 1729.

DESCRIPTION: Oil on canvas, 76.7 x 63.8 cm. Head-and-shoulders view, facing front. Dark brown hair pulled back from face, with a curl on right shoulder, brown eyes. Wearing dark green, low-cut dress with chemisette underneath. Dress is lined with red and un-

Stillman Willis

Born in Easton in 1786, son of Ephraim and Eunice (Egerton) Willis. Married Mahala Wood* in 1808. Lived in Boston and worked as a watchmaker and jeweller. Died in Boston in 1871.

ARTIST: Unknown, about 1860.

DESCRIPTION: Oil on canvas, 76.1 x 63.6 cm. Head-and-shoulders view, facing front. Light, short curly hair, wrinkled forehead. High, stiff collar on white shirt, black tie and coat. Seated in red upholstered chair. Plain dark background.

PROVENANCE: Gift of William Clifford French, 1920.

REFERENCES: *Some Willis Families of New England*, by Aurie Willis Morrison (n.p., 1973), 111; *Proc.*, 54(1920–1921):2.

Mrs. Stillman Willis (Mahala Wood)

Born in Groton in 1785, daughter of Timothy Wood. Married Stillman Willis* in 1808 and had 5 children. Lived in Boston. Died in Boston in 1865.

ARTIST: Unknown, about 1860. Companion portrait to that of Stillman Willis.

DESCRIPTION: Oil on canvas, 76.1 x 63.3 cm. Head-and-shoulders view, facing front. Brown hair, parted in middle, curls over ears under a lace scarf, brown eyes, slight smile. Black dress with lace collar, matching scarf, cameo brooch. Enveloped in a red cloak. Seated in a red upholstered chair. Plain dark to light gray background.

PROVENANCE: Gift of William Clifford French, 1920.

REFERENCES: *Some Willis Families of New England*, by Aurie Willis Morrison, 111; *Proc.*, 54(1920–1921):2.

John Wilson

Born in Windsor, Berkshire, England, about 1591, son of William and Isabel (Woodhall) Wilson. Studied at Eton and King's College, Cambridge. Married Elizabeth Mansfield in 1615. A minister and poet, he came to Boston in 1630 with John Winthrop. Made several trips back to England, where his wife and children remained

for several years before following him to Boston. Became the first pastor of the First Church in Boston when it was organized in Charlestown in 1632, a position he held until his death. A strong orthodox voice and advocate of the conversion of the Massachusetts Indians, he was considered among the most important of Massachusetts clergymen. Died in 1667.

ARTIST: Unknown.

NOTE: The identity of the sitter has never been authenticated. In 1867 John Appleton, assistant librarian, argued quite persuasively that it could not be John Wilson. He claimed that the date of the portrait was too late, that the dress was unlike what a clergyman of the period in America would have worn, although he would have done so in England. He cites Cotton Mather as asserting that to his certain knowledge Wilson never consented to having his portrait painted.

In December 1880, Josiah Quincy wrote to Robert C. Winthrop: "I find that some doubt has been expressed concerning a portrait of the Rev. John Wilson, the first clergyman of Boston, now in the possession of the Massachusetts Historical Society, which many years since, at my instance, was presented to it. I deem it proper, therefore to state to you, as President of that institution, that the portrait in question was carefully preserved from the earliest times, among his descendants in the Bromfield family, certainly for more than a century."

DESCRIPTION: Oil on canvas, 77.8 x 64.3 cm. Head-and-shoulders view, facing front. Long, dark, curly hair, brown eyes. White clerical bands, black robe. Dark gray background. Painted in an oval.

PROVENANCE: Inherited in the Bromfield family, descended from the sitter through the marriage of his granddaughter Mary Danforth with Edward Bromfield (1648–1734).

Announced as the gift of their grandson, Henry Bromfield, Esq., of Harvard, Mass. (1727–1820), in 1798. Apparently remained with the family until the death of his sister Elizabeth Bromfield (1739–1814), when it was presented to the Society by her nephew, William Powell, at the request of Josiah Quincy.

REFERENCES: *DAB*, 10, pt. 2:336–337; *NEHGR*, 25(1871):329–335, 26(1872):37–43,141–143; *Proc.*, 1st ser., 1(1791–1835):124, 10(1867–1869):41–48, 18(1880–1881):264–265.

Edward Winslow

Born in Droitwich, Worcestershire, England, in 1595, son of Edward and Magdalene (Oliver) Winslow. Twice married—to Elizabeth Barker in 1618 and to Susanna (Fuller) White in 1621. Landed at Plymouth aboard the

Mayflower in December 1620, was active in the administrative and judicial affairs of Plymouth Colony, represented the colony in England, and was for three years its governor. Wrote his observations of early settlements, especially of dealings with the Indians, which were the first published accounts of these events written in America. Died at sea of a fever while returning from the British conquest of Jamaica, in 1655.

ARTIST: Edgar Parker, 1882. After the original, now at Pilgrim Hall, Plymouth, by an unknown artist in London, 1651. Inscribed, upper right: "LON.DON.1651 / AETIS.SVE / 57.

DESCRIPTION: Oil on canvas, 76.2 x 63.4 cm. Half-length view, facing front. Medium-length, brown curled hair, mustache and goatee. Squared white collar, white ruffled cuffs. Dark coat buttoned to neck with metal buttons. Seated. Holding a document in left hand, wearing a ring on little finger, left hand. Plain dark background.

PROVENANCE: Commissioned by the Society, 1882.

REFERENCES: *DAB*, 10, pt. 2:393–394; *Proc.*, 19(1881–1882): 386.

Isaac Winslow

Born in Boston in 1774, son of Isaac and Mary (Davis) Winslow. Married Margaret Blanchard in 1801. Went to sea as a supercargo trading in various Mediterranean ports. Set up his own merchant business in Boston in 1803, and was for many years headquartered on Long Wharf. Member of Boston's first common council in 1822. Died in Roxbury in 1856.

ARTIST: Unknown.

DESCRIPTION: Oil on panel, 75.2 x 60.1 cm. Head-and-shoulders view, turned slightly right, facing front. Short dark hair, brown eyes. High stiff collar and ruffle on white shirt, white stock and waistcoat, high collared black coat. Plain dark gray background.

PROVENANCE: Presumably descended to the sitter's grandson, Erving Winslow of Boston (1839–1922) and to his granddaughter, the donor.

Gift of Miss Anne R. Winslow, of New York City, 1968.

REFERENCES: *NEHGR*, 10(1854):368–369, 12(1856):186; *Proc.*, 80(1968):142.

Joshua Winslow

Born in Boston in 1694/5, son of Edward and Hannah (Moody) Winslow. Married in 1729 Elizabeth Savage,

sister of Margaret Savage* and Thomas Savage, Jr.* Raised a large family of 16 children. Grandfather of Isaac Winslow.* Prominent merchant and shipowner in Boston. A director and subscriber to the Silver Bank of Massachusetts in 1740. Died in Boston in 1769.

ARTIST: Attributed to Joseph Blackburn, about 1756. A similar portrait attributed to Blackburn is at the Yale University Art Museum.

DESCRIPTION: Oil on canvas, 75.0 x 61.4 cm. Half-length view, facing front. Shoulder-length wig, brown eyes, pursed lips. White stock, brown waistcoat and collarless coat, black hat under left arm. Plain, dark background.

PROVENANCE: Gift of Miss Anne R. Winslow of New York City, a descendant, 1968.

REFERENCES: Park, *Major Thomas Savage and His Descendants*, 16; John H. Morgan and Henry W. Foote, *An Extension of Lawrence Park's Descriptive List of the Works of Joseph Blackburn* (Worcester, Mass., 1937), 47–48; *Proc.*, 80(1968):142.

Adam Winthrop (1498–1562)

Born in Lavenham, Suffolk, England, in 1498, son of Adam and Joane (Burton) Winthrop. Grandfather of John Winthrop* (1588–1649), first governor of Massachusetts Bay. Twice married — to Alice Henny in 1527 and Agnes Sharpe in 1534. A warden and master of the Clothworkers' Company of London, resident of London and later lord of Groton Manor, and grantee of the Winthrop coat of arms. Died in Groton, Suffolk, England, in 1562.

I

ARTIST: Charles Osgood, 1837–1838. Copy of the original by an unknown artist of the Holbein school. Original is at John Winthrop House, Harvard University.

DESCRIPTION: Oil on canvas, 53.2 x 43.5 cm. Half-length view, facing slightly right. Dark hair under flat cap, dimple in chin. White ruffle at neck and cuffs. Collarless jacket under brown coat with shawl collar. Hands clasped. Plain, dark brown background.

PROVENANCE: Commissioned by Thomas Lindall Winthrop. Owned by his son Robert Charles Winthrop.

Gift of Miss Clara Bowdoin Winthrop, granddaughter of Robert Charles Winthrop, 1934.

II

ARTIST: Unknown. Copy of the same original noted above.

DESCRIPTION: Oil on canvas, 54.8 x 44.8 cm. Similar to above with darker background.

PROVENANCE: By descent to Bronson Winthrop of New York City (1863–1944). Inherited by his niece, Mrs. Robert L. Fowler (Charlotte Cram), whose daughter, Mrs. Craig Wylie (Angela Fowler) was the donor.

Gift of Mrs. Wylie, 1972.

REFERENCES: Mayo, *Winthrop Family*, 3–5; Winthrop Papers, MHS; Osgood, Record Book; *Proc.*, 65(1932–1936):268, 84(1972): 131.

Adam Winthrop (1647–1700)

Born in Boston in 1647, son of Adam and Elizabeth (Glover) Winthrop, grandson of Governor John Winthrop* (1588–1649). Graduated from Harvard in 1668. Married Mary Luttrell* about 1675. A merchant and ship owner in Boston and Bristol, England; Boston town commissioner, selectman, and General Court representative. Active in the overthrow of Massachusetts Bay Governor Sir Edmund Andros in 1689. Councilor under the 1691 Massachusetts Bay charter. Died in Boston in 1700.

ARTIST: Unknown, 1680. Inscription beside right shoulder: "Aetatis suae 33 / Ano:Dom:1680."

DESCRIPTION: Oil on canvas, 78.2 x 63.3 cm. Head-and-shoulders view, facing front. Wearing a large brown hat over long, dark hair, parted in middle of forehead,

brown eyes. White shirt fastened at neck with a pin, long sleeves, ruffled cuffs. Wrapped in a red shawl held together by right hand. Landscape view in background at left. Painted in a dark oval.

PROVENANCE: The portrait presumably descended through the sitter's son Adam Winthrop (1676–1743) to his son Professor John Winthrop (1714–1779); to the latter's son John (1747–1800); his son John (1778–1819); to his daughter Mrs. John James deWolf (Annette Halsey Winthrop) (1806–1884). Her eldest son, Winthrop deWolf, inherited the portrait and left it to his son Halsey deWolf, father of Mrs. Marshall Fulton (Mary deWolf), the donor.

Gift of Dr. and Mrs. Marshall Fulton, 1975.

REFERENCES: Mayo, *Winthrop Family*, 111–117; Winthrop Papers, MHS; *Proc.*, 87(1975):183; *New England Begins*, 467–468.

Mrs. Adam Winthrop (Mary Luttrell)

Born about 1650. Married Adam Winthrop (1647–1700)* about 1675. After his death, she married Joseph Lynde of Charlestown in 1706. Died in Boston in 1715.

ARTIST: Unknown, ca. 1680.

DESCRIPTION: Oil on canvas, 75.7 x 63.0 cm. Head-and-shoulders view, facing front. Wearing a large hat

with a cluster of pearls at left over dark hair in curls. Low-cut rose dress, pearl necklace, pearl drop earrings, and a cruciform brooch. Blue shawl over shoulders held in front by right hand. Painted in an oval resembling a gilt frame.

PROVENANCE: Same as for Adam Winthrop (1647–1700) (q.v.).

REFERENCES: Mayo, *Winthrop Family*, 113; Winthrop Papers, MHS; *Proc.*, 87(1975):183.

Anne Winthrop

Born in 1709, daughter of John Winthrop, F.R.S.,* and Anne (Dudley) Winthrop*. She died unmarried in 1794.

ARTIST: Unknown. Copy commissioned by Robert Charles Winthrop, Jr., 1872 from an original by an unknown artist then owned by Grenville Lindall Winthrop of New York City.

DESCRIPTION: Oil on canvas, 61.4 x 51.1 cm. Oval. Three-quarter length view of a young girl facing front. Brown hair, dark brown eyes, brown dress with red lining to short sleeve, red belt and shawl over right arm. Dark background.

PROVENANCE: From the estate of Miss Clara Bowdoin Winthrop, daughter of Robert Charles Winthrop, Jr., 1969.

REFERENCES: Mayo, *Winthrop Family*, 137; Winthrop Papers, MHS.

Benjamin Robert Winthrop

Born in New York City in 1804, son of Benjamin and Judith (Stuyvesant) Winthrop. Married Eliza Ann Coles Neilson in 1829. A businessman and man of letters and civic affairs, he was vice-president of Merchants' Mutual Insurance Company and of the Institution for the Savings of Merchants' Clerks. Served as trustee of the Public School Society of New York; a member of the New York Board of Education; a founder of the Society for the Prevention of Cruelty to Animals; and vice president of the New-York Historical Society. Elected to this Society in 1859. Died in London in 1879.

ARTIST: Thomas Hicks, 1858.

DESCRIPTION: Oil on canvas, 84.2 x 66.5 cm. Oval. Half-length figure, facing slightly right. Thinning, short dark hair, graying sideburns and beard. Steel-rimmed spectacles. High stiff collar on white frilled shirt, black tie, white double-breasted waistcoat, black coat. Plain light background.

PROVENANCE: By descent to Bronson Winthrop of New York City (1863–1944). Inherited by his niece,

Mrs. Robert L. Fowler (Charlotte Cram), whose daughter, Mrs. Craig Wylie (Angela Fowler) was the donor. Gift of Mrs. Wylie, 1972.

REFERENCES: Mayo, *Winthrop Family,* 346–352; *Proc.,* 84(1972): 131.

Clara Bowdoin Winthrop

Born in Boston in 1876, daughter of Robert Charles Winthrop, Jr.,* and Elizabeth (Mason) Winthrop.* Deposited numerous portraits (mostly copies) and other Winthrop articles at the Society in 1924, donated them in 1934. Still more items came through her estate. Died unmarried in Manchester in 1969.

I

ARTIST: Unknown, possibly Eastman Johnson.

DESCRIPTION: Charcoal on paper, 48.1 x 37.5 cm. Oval. Portrait as a young child. Head, facing front. Dark curly hair parted in middle, dark eyes, slight smile.

PROVENANCE: Estate of Miss Clara Bowdoin Winthrop, 1969.

II

Double portrait with her mother, Mrs. Robert Charles Winthrop, Jr. (q.v.).

REFERENCES: Winthrop Papers, MHS; *Proc.,* 80(1968):66.

John Winthrop (1588–1649)

Born in Edwardston, Suffolk, England, in 1588, son of Adam and Anne (Browne) Winthrop. Attended Trinity College, Cambridge, and studied law. Married four times: in 1605 to Mary Forth, who died in 1615; in 1615 to Thomasine Clopton of Groton, Suffolk, England, who died in 1616; in 1618 to Margaret Tyndal of Great Maplestead, Essex, England, who died in 1647; and in 1648 to Martha (Rainsborow) Coytmore, sister of his son Stephen's wife. Justice of the peace, lord of the manor of Groton, attorney of the Court of Wards and Liveries in London, and first governor of Massachusetts. Brought the first major fleet of settlers to New England in 1630. His journal is an important source for early colonial history. Died in Boston in 1649.

I

ARTIST: Charles Osgood, 1834. Copy of a portrait in the Massachusetts State House by an unknown artist.

DESCRIPTION: Oil on canvas, 75.3 x 64.8 cm. Head-and-shoulders view, facing front. Dark hair, mustache, and van dyke beard, dark eyes. White ruff, trimmed with lace, dark coat or jerkin. Painted in an oval. Dark background.

PROVENANCE: Commissioned and given by Thomas Lindall Winthrop, 1834.

II

ARTIST: Charles Osgood, 1834. Copy of the same portrait mentioned above.

DESCRIPTION: Oil on canvas, 76.8 x 63.8 cm. Same as above. (*See Color Plate 23*).

PROVENANCE: Gift of Miss Clara Bowdoin Winthrop, 1934.

III

ARTIST: Emeline H. Gordon, 1931. Copy of a portrait owned by Grenville Lindall Winthrop. The original was described as "Not a duplicate of the portrait in the Senate-Chamber of Mass: & much inferior to it." Among the family portraits taken from New London to New York about the beginning of the 19th century. Owned by Mrs. Francis Bayard Winthrop, Sr., in 1827, and by her son Thomas Charles Winthrop of New York City in 1855.

DESCRIPTION: Oil on canvas, 50.8 x 40.7 cm. Head-and-shoulders view. Dark hair, beard, and mustache. White ruff around neck, black coat. Plain dark background.

PROVENANCE: Gift of Mrs. Emeline H. Gordon, 1931.

Adam Winthrop*
(1498–1562)

Adam Winthrop

John Winthrop*
(1588–1649)

John Winthrop*
(1606–1676)

Stephen Winthrop*

Adam Winthrop

Adam Winthrop*
(1647–1700)
m. Mary Luttrell*

John Winthrop*
(1638–1707)

Wait Still
Winthrop*

Mary Winthrop*
m. John Livingston

John Winthrop*
(1681–1747)
m. Anne Dudley*

Mary Winthrop*
m. Joseph Wanton

Anne Winthrop*

John Still Winthrop*

Anne Winthrop
m. David Sears

Thomas Lindall
Winthrop*
m. Elizabeth
Bowdoin Temple*

Benjamin
Winthrop

Elizabeth
Winthrop*
m. Jacob
Sebor*

David Sears*

Robert Charles
Winthrop*

Benjamin
Robert
Winthrop*

Robert Charles
Winthrop, Jr.*
m. Elizabeth Mason*

Clara Bowdoin
Winthrop*

REFERENCES: Mayo, *Winthrop Family*, 11–33; Winthrop Papers, MHS; Osgood, Record Book; *Proc.*, 1st ser., 1(1791–1835):484, 65(1932–1936):268, 64(1930–1932):285; "The Reverend William Bentley and the Portraits of Governor Winthrop," by Ernest J. Moyne, *EIHC*, 110(1974):49–56.

John Winthrop, Jr. (1606–1676)

Born in Groton, Suffolk, England, in 1606, son of Gov. John Winthrop (1588–1649)* and Mary (Forth) Winthrop. Graduated from Trinity College, Dublin. Married twice: in 1631 to his cousin Martha Fones, who died in 1634; and in 1635 to Elizabeth Reade. Scientist and entrepreneur, first American fellow of the Royal Society of London, commissioner to the New England Confederation in the 1650s, governor of Connecticut. As governor he secured the charter of 1662 uniting the Connecticut and New Haven colonies. Developed ironworks in Massachusetts and Connecticut. Died in Boston in 1676.

I

ARTIST: Probably Charles Osgood, 1834. Copy of a portrait by an unknown artist. Original is at John Winthrop House, Harvard University.

DESCRIPTION: Oil on canvas, 76.1 x 63.5 cm. Head-and-shoulders view. Dark hair under cap, brown eyes, cleft in chin. White collar on black coat. Painted in an oval. Dark background.

PROVENANCE: Gift of Robert C. Winthrop, 1856.

II

ARTIST: Charles Osgood, 1834. Copy of same portrait mentioned above.

DESCRIPTION: Oil on canvas, 75.9 x 63.1 cm. Oval. Same as above.

PROVENANCE: Commissioned by Thomas Lindall Winthrop; inherited by his son Robert Charles Winthrop; and by his granddaughter Clara Bowdoin Winthrop.
Gift of Miss Clara Bowdoin Winthrop, 1934.

III

ARTIST: Unknown. Of the school of Sir Peter Lely (1618–1680) or his contemporary William Dobson (1610–1646).

DESCRIPTION: Oil on canvas, 75.1 x 63.2 cm. Head-and-shoulders view, turned slightly left. Shoulder-length dark hair under tight-fitting cap, brown eyes, brown mustache. Shadow of beard showing along jaw and lower lip. White collar on black coat, silk shawl. Dark background.

PROVENANCE: Same as for Benjamin Robert Winthrop (q.v.).

REFERENCES: Mayo, *Winthrop Family*, 34–58; *Proc.*, 1st ser., 3(1855–1858):126, 65(1932–1936):268, 84(1972):131.

John Winthrop (1638–1707)

Born probably in Ipswich in 1638, son of Gov. John Winthrop, Jr. (1606–1676)* and Elizabeth (Reade) Winthrop. Known as "Fitz-John" to distinguish him from his father. Married Elizabeth Tongue of New London. Went to England to join the army in 1658, was commander of Cardross Castle, and promoted to captain in 1660; served as major general of the Connecticut militia; led an ill-starred expedition against Canada in 1690. Was the New London representative in the Connecticut General Court, colonial agent for Connecticut in England in 1693, and the governor of Connecticut from 1698 until he died. Died in Boston in 1707.

ARTIST: Unknown, 1855. Copy of a portrait by an unknown artist that was probably painted in England between 1693 and 1697. Original is at John Winthrop House, Harvard University.

DESCRIPTION: Oil on canvas, 104.6 x 81.8 cm. Oval. Half-length view, facing front. Large wig with long curls over shoulders, double chin. Dressed in armor. Very dark background.

PROVENANCE: Commissioned by Robert C. Winthrop.
Given to the Society by his granddaughter, Miss Clara Bowdoin Winthrop, 1934.

REFERENCES: Mayo, *Winthrop Family*, 56, 81–97; *Proc.*, 65(1932–1936):268.

John Winthrop (1681–1747)

Born in Boston in 1681, son of Wait Still Winthrop* and Mary (Browne) Winthrop. Known as "John Winthrop, F.R.S." Graduated from Harvard in 1700. Married Ann Dudley,* daughter of Gov. Joseph Dudley* and Rebecca (Tyng) Dudley,* in 1707. Managed family properties in Connecticut, and attempted unsuccessfully to exploit his grandfather's graphite mine in south-central Massachusetts. Spent years in litigation—which he took to England in 1726 and won—against his brother-in-law Thomas Lechmere for family land in Connecticut. He never returned to New England. Elected a fellow of the Royal Society of London in 1734. Died in Sydenham, Kent, England, in 1747.

ARTIST: Charles Osgood, 1837–1838. Copy of a portrait by an unknown artist. Original is at John Winthrop House, Harvard University.

DESCRIPTION: Oil on canvas, 76.5 x 63.6 cm. Head-and-shoulders view, facing front. Large, long curly wig, brown eyes, double chin. White neckcloth and scarf. Dark coat with red facings, red shawl over right shoulder. Seated in red upholstered chair. Painted in an oval. Very dark background.

PROVENANCE: Commissioned by Thomas Lindall Winthrop. Inherited by his son Robert Charles Winthrop. Given to the Society by the latter's granddaughter.
Gift of Miss Clara Bowdoin Winthrop, 1934.

REFERENCES: Mayo, *Winthrop Family*, 118–136; *Proc.*, 65(1932–1936):268.

John Still Winthrop

Born in New London, Connecticut, in 1720, son of John Winthrop (1681–1747)* and Ann (Dudley) Winthrop.* Graduated from Yale in 1737. Twice married—to Jane Borland in 1750 and Elizabeth (Shirreff) Hay in 1761. Had 14 children including Thomas Lindall Winthrop*

and Mrs. Jacob Sebor.* Managed business affairs and a family estate in New London. Died in New London, Connecticut, in 1776.

I

ARTIST: Jacob Wagner, 1893. On back of canvas inscribed: "John Still Winthrop / Died 1776 age 56 / copied for R. C. Winthrop Jr. / by Jacob Wagner 1893." A similar copy is at Harvard University. The original was owned by Robert Winthrop of New York in 1948.

DESCRIPTION: Oil on canvas, 91.4 x 71.4 cm. Three-quarter length view, facing front. White wig in curls over ears, double chin. White shirt with stock and ruffled cuffs. Narrow black stand-up collar on gray coat buttoned to neck. Seated in red upholstered chair. Holding black hat with right hand, left hand thrust into coat. Very dark background.

PROVENANCE: Commissioned by Robert Charles Winthrop, Jr., 1893. Inherited by his daughter, the donor.
Gift of Miss Clara Bowdoin Winthrop, 1934.

II

ARTIST: Unknown. Copy of the same original portrait by an unknown artist mentioned above.

DESCRIPTION: Oil on canvas, 80.5 x 66.4 cm. Same as above, with lighter background.

PROVENANCE: Same as for Benjamin Robert Winthrop (q.v.).

REFERENCES: Mayo, *Winthrop Family*, 154–164; *Proc.*, 65(1932–1936):268, 84(1972):131.

Robert Charles Winthrop

Born in Boston in 1809, son of Thomas Lindall Winthrop* and Elizabeth Bowdoin (Temple) Winthrop.* Graduated from Harvard in 1828 as class president. Read law in the Boston office of Daniel Webster and was admitted to the bar in 1831. Married three times: to Eliza Blanchard in 1832, to Laura (Derby) Welles in 1849, and to Adele (Grainger) Thayer in 1865. Whig member of the Massachusetts House of Representatives, of which he was speaker from 1838 to 1840; member of the United States House of Representatives, and its speaker from 1847 to 1849; United States senator in 1850. Harvard overseer; trustee of the Peabody Museum; president of the Harvard Alumni Association and of the Peabody Education Fund trustees. Active in the founding of the Episcopal Theological School. Elected to the Society in 1839; served as its president from 1855

to 1885. Assembled the Winthrop Papers collection, which later came to the Society. Died in Boston in 1894.

I

ARTIST: George Peter Alexander Healy, 1846.

DESCRIPTION: Oil on canvas, 76.4 x 63.9 cm. Half-length view, turned slightly left, facing front. Receding black hair and sideburns, spectacles. High collar on stiff shirt with stickpin, black bow tie, gray figured waistcoat under black coat. Plain dark background.

PROVENANCE: Gift of Miss Clara Bowdoin Winthrop, granddaughter of the sitter, 1934.

II

ARTIST: Daniel Huntington, 1885.

DESCRIPTION: Oil on canvas, 115.0 x 95.1 cm. Three-quarter length view, facing slightly right. Receding white hair and sideburns. Spectacles, stiff high, white collar, wide black tie with stickpin. Waistcoat with watch chain, matching coat and trousers. Seated in an upholstered chair, right arm resting on table, holding documents in right hand. Black drapery in left background.

PROVENANCE: Commissioned for the Society to mark the retirement of the sitter after 30 years as president. Gift of individual members of the Society, 1885.

REFERENCES: Mayo, *Winthrop Family*, 315–345; *Proc.*, 2nd ser., 2(1885–1886):118–119, 393, 65(1932–1936):268.

Robert Charles Winthrop, Jr.

Born in Boston in 1834, son of Robert Charles Winthrop* and Eliza Cabot (Blanchard) Winthrop. Graduated from Harvard in 1855. Twice married: to Frances Pickering Adams in 1857, and Elizabeth Mason* in 1869. Author of a book-length memoir of his father, a genealogist of the Winthrop family, and organizer of the family papers, which he transcribed for three volumes of the Society's *Collections*. Elected to membership in the Society in 1879 and served on its council. Bequeathed a large collection of the Winthrop Papers to the Society. Died in Boston in 1905.

ARTIST: Charles Osgood, 1839.

DESCRIPTION: Oil on canvas, 53.6 x 43.2 cm. Oval. Head-and-shoulders view of a young boy. Short blond hair, parted in the middle. Wide white collar open at neck, black coat. Plain brownish background.

PROVENANCE: Estate of Miss Clara Bowdoin Winthrop, daughter of the sitter, 1969.

REFERENCES: Mayo, *Winthrop Family*, 390–406; Osgood, Record Book.

Mrs. Robert Charles Winthrop, Jr. (Elizabeth Mason) and Clara Bowdoin Winthrop

Born in Boston in 1844, daughter of Robert and Sarah Ellen (Francis) Mason. Married Robert Charles Winthrop, Jr.,* in 1869, as his second wife. Mother of three children including Clara Bowdoin Winthrop.* Died in Boston in 1924.

ARTIST: Unknown, about 1879. Signed, left side: "R.L."

DESCRIPTION: Oil on canvas, 76.3 x 63.3 cm. Mrs. Winthrop in three-quarters view, facing slightly right. Dark hair parted in middle, slight smile. Matching earrings and necklace, low-cut white dress trimmed with black lace, elbow-length sleeves. Seated. Clara in full-length view, standing at her mother's right. Blonde curly hair, necklace, white dress with bow tied in the back. Plain dark background.

PROVENANCE: Estate of Miss Clara Bowdoin Winthrop, 1969.

REFERENCE: Mayo, *Winthrop Family*, 397, 405.

Stephen Winthrop

Born in Groton, Suffolk, England, in 1619, son of Gov. John Winthrop* (1588–1649) and Margaret (Tyndal) Winthrop. Came to Boston with the Winthrop fleet in 1630. Married Judith Rainsborow about 1644. He was made court recorder by the General Court in 1639, became a member of the Military Company of Massachusetts (now the ancient and Honorable Artillery Company) in 1641, and represented Strawberry Bank (now Portsmouth, New Hampshire) in the Massachusetts Bay legislature in 1644. Returned to England several times, joined the Parliamentary army and in 1648 was made "captain of a troop of horse." Became a colonel in 1654, and represented Banff and Aberdeen in Parliament in 1656. Died in England in 1658.

ARTIST: Unknown. Copy of a portrait by an unknown artist. The original is at Harvard University.

DESCRIPTION: Oil on canvas, 76.0 x 63.7 cm. Half-length view, turned slightly left. Dark hair with curls resting on shoulders, brown eyes. White neckcloth tied with rose ribbon, matching rose suit, sleeves slit to show white shirt with large cuffs. Seated with right hand resting on lap. Plain dark background.

PROVENANCE: Commissioned by Robert C. Winthrop, Jr.

Gift of his daughter, Miss Clara Bowdoin Winthrop, 1934.

REFERENCES: Mayo, *Winthrop Family*, 63–67; *Proc.*, 65(1932–1936):268.

Thomas Lindall Winthrop

Born in New London, Connecticut, in 1760, son of John Still Winthrop* and Jane (Borland) Winthrop. Graduated from Harvard in 1780. Married Elizabeth Bowdoin Temple* in 1786. A merchant and public official, he served as a representative in the Massachusetts General Court and the Senate, and as lieutenant governor of Massachusetts. He was president of the American Antiquarian Society, president of the Massachusetts Society for Promoting Agriculture, a member of many other learned societies in the United States and abroad, and a Harvard overseer. Elected to membership in the Society in 1800; served as its president from 1835 until his death in Boston in 1841.

I

ARTIST: Charles Osgood, 1837.

DESCRIPTION: Oil on canvas, 91.5 x 73.8 cm. Head-and-shoulders view, facing front. Short swept-up white hair and sideburns, white eyebrows, brown eyes. White shirt with turned-over collar and ruffle, black waistcoat unbuttoned at top under high-collared black coat. Seated

in red upholstered chair. Holding a book upright with left hand. Dark gray drapery in background.

PROVENANCE: Gift of several members of the Society, 1837.

II

ARTIST: Charles Osgood, 1837–1838. One of two copies of the original (I) made for the sitter at the same time. A similar portrait painted by Osgood in 1837 is at the American Antiquarian Society, Worcester.

DESCRIPTION: Oil on canvas, 92.1 x 76.8 cm. Same as above.

PROVENANCE: Gift of Miss Clara Bowdoin Winthrop, great-granddaughter of the sitter, 1934.

REFERENCES: Mayo, *Winthrop Family*, 209–219; Osgood, Record Book; Catalogue of American Portraits, NPG; *MHS Coll.*, 4th ser., 2:213; *Proc.*, 1st ser., 2(1838–1855):94, 186–187, 65(1932–1936):268.

Mrs. Thomas Lindall Winthrop (Elizabeth Bowdoin Temple)

Born in 1769, daughter of John Temple* and Elizabeth (Bowdoin) Temple* and granddaughter of Gov. James Bowdoin,* in whose home she grew up. Three or four years before her marriage, she made a special impression upon the Marquis de Chastellux, one of the French

officers serving under Rochambeau. "This was neither a handsome child nor a pretty woman, but rather an angel in disguise of a young girl." Married Thomas Lindall Winthrop* in 1786 and had 14 children, including Robert Charles Winthrop.* Died in Boston in 1825.

ARTIST: Gilbert Stuart, 1806. "I have set three times for him [Stuart], as my mother is determined to have all her children taken by him" (Elizabeth Bowdoin Temple to her aunt Sarah, Mrs. James Bowdoin, Nov. 29, 1806).

DESCRIPTION: Oil on canvas, 73.8 x 61.2 cm. Half-length view, facing front. Brown hair in curls over forehead, slight double chin. Lace scarf over head, low-cut white dress. Left arm resting on a high table. Plain dark background.

PROVENANCE: Inherited by the sitter's son, Robert Charles Winthrop (1809–1894) and then by his son, Robert Charles Winthrop, Jr. (1834–1905). After the death of Mrs. Winthrop in 1924, it was inherited by their daughter, the donor.
Gift of Miss Clara Bowdoin Winthrop, 1934.

REFERENCES: Mayo, *Winthrop Family*, 212–213, 217–218; Winthrop Papers, MHS; Park, *Stuart*, 2:831–832; *Proc.*, 65(1932–1936):268.

Wait Still Winthrop

Born in Boston in 1642, son of John Winthrop, Jr. (1606–1676)* and Elizabeth (Reade) Winthrop. Studied at Harvard with the class of 1662. Married twice: to Mary Browne before 1678, and to Katherine (Brattle) Eyre in 1707. A jurist, public official, and amateur physician, he was Connecticut commissioner to the United Colonies Confederation in 1675; active in the overthrow of Governor Andros in 1689; major general of the Massachusetts militia for nearly 30 years; Massachusetts councilor before and after the 1691 charter. A judge in the Salem witchcraft trials; justice of the Massachusetts Superior Court in 1692; and a judge of the Vice-Admiralty Court of Northern New England and New York in 1698. Died in Boston in 1717.

ARTIST: Charles Osgood, 1837–1838. Copy of a portrait by an unknown artist about 1700. The original is at Harvard University.

DESCRIPTION: Oil on canvas, 76.6 x 63.6 cm. Half-length view, facing front. Enormous wig to shoulders ending in a braid over right shoulder. White shirt with looped white tie, black robe. Pointing left with forefinger of right hand. Painted in an oval. Dark background.

PROVENANCE: Commissioned by Thomas Lindall Winthrop.

Gift of his great-granddaughter, Miss Clara Bowdoin Winthrop, 1934.

REFERENCES: Mayo, *Winthrop Family*, 97–111; Osgood, Record Book; *Proc.*, 65(1932–1936):268.

Mrs. Winthrop

Unidentified sitter, probably from the Winthrop family, late 17th- or early 18th-century.

ARTIST: Unknown. Dutch period in England, school of Cornelis Janssens.

DESCRIPTION: Oil on panel, 63.6 x 50.6 cm. Head-and-shoulders view, turned slightly right, facing front. White winged cap over tight-fitting cap, dark eyes. White waist under large white collar trimmed with lace, black dress. Painted in an oval. Plain dark background. (*See Color Plate 24*).

PROVENANCE: Same as for Benjamin Robert Winthrop (q.v.).

REFERENCES: Winthrop Papers, MHS; *Proc.*, 84(1972):131.

Mrs. Winthrop

Unidentified sitter, probably from the Winthrop family, mid-19th century.

ARTIST: Unknown, late 1840s / early 1850s.

DESCRIPTION: Oil on canvas, 76.3 x 63.9 cm. Head-and-shoulders view, facing front. Dark hair, parted in middle under filmy bonnet tied under chin. Dark eyebrows, brown eyes, black choker. Black dress with small white collar. Seated in red upholstered chair. Plain dark background.

PROVENANCE: Same as for Benjamin Robert Winthrop (q.v.).

REFERENCE: *Proc.*, 84(1972):131.

Oliver Wolcott

Born in Litchfield, Connecticut, in 1760, son of Oliver and Laura (Collins) Wolcott. Graduated from Yale in 1778 and studied law. Married Elizabeth Stoughton in 1785. Served as comptroller of the United States Treasury from 1791 to 1795. Succeeded Alexander Hamilton as secretary of the Treasury, serving from 1795 to 1800. Appointed by President John Adams as a judge for the second circuit court. Governor of Connecticut from 1817 to 1827. An early member of the Society, elected in 1796. Died in New York City in 1833.

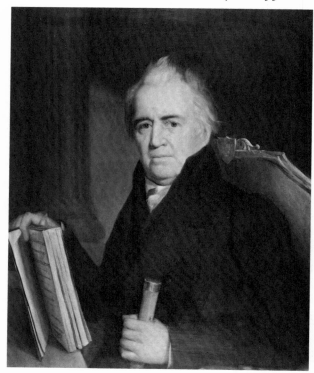

ARTIST: Samuel Stillman Osgood, 1832. Signed, lower left on book page: "S. S. Osgood / Pinx*T / 1832."

DESCRIPTION: Oil on canvas, 92.0 x 73.8 cm. Half-length view, turned right, facing front. Short white hair,

double chin. White shirt under high-collared black waistcoat and black coat. Seated in armchair upholstered in red velvet. Holds a book upright on a table with his right hand, and a cane in his left. Column in right background.

PROVENANCE: Gift of the artist, 1834.

REFERENCES: *DAB*, 10, pt. 2:443–445; *Proc.*, 1st ser., 1(1791–1835):102, 498.

Joseph Emerson Worcester

Born in Bedford, New Hampshire, in 1784, son of Jesse and Sarah (Parker) Worcester. Prepared for college at home and at Phillips Academy, Andover. Graduated from Yale in 1811. Married Amy Elizabeth McKean in 1841. Taught for five years in Salem, where Nathaniel Hawthorne was one of his students. Best known as a lexicographer and contemporary rival of Noah Webster, he was also an editor, geographer, and historian. Elected to membership in the Society in 1827. Died in Cambridge in 1865.

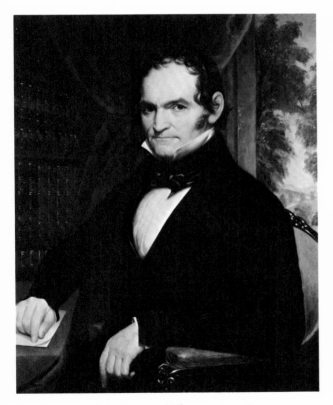

ARTIST: Cephas Giovanni Thompson, 1844.

DESCRIPTION: Oil on canvas, 91.7 x 75.0 cm. Half-length view, turned slightly right, facing front. Dark curly hair and sideburns, brown eyes. White shirt with high,

stiff collar and black tie. Black waistcoat and coat with unbuttoned sleeves. Seated in red upholstered chair. Right hand rests on papers on table. Brown drapery in center, landscape view to left in background.

PROVENANCE: Gift of Mrs. Joseph Emerson Worcester II, 1944.

REFERENCES: *DAB*, 10, pt. 2:526–528; *Proc.*, 1st ser., 18(1880–1881):169–173, 68(1944–1947):475.

Unknown Dutch Gentleman

A man of middle age, probably living at Dordrecht, Holland, in the mid-17th century. Formerly identified as Nicolas Foucquet, superintendent of finances for Louis XIV.

ARTIST: Jacob Fransz van der Merck, 1647. Inscribed, lower right: "AEt. 32 16[] / Merck."

DESCRIPTION: Oil on canvas, 72.0 x 57.1 cm. Head-and-shoulders view, turned left, facing front. Short, dark hair in bangs, mustache, and small beard. Large, square, white collar trimmed with lace. Black coat. Plain background.

PROVENANCE: Bequest of Miss Susan Minns, 1946.
This portrait is on loan to the Colonial Society of Massachusetts, Boston.

REFERENCES: Memorandum of Stewart Mitchell, 1949, MHS; Bénézit, *Dictionnaire*, 6:68.

Unknown Englishman

Once identified as John Coney (1655–1722), a Boston silversmith. The portrait was painted in England, probably for sale in America as an "instant ancestor."

ARTIST: Unknown; formerly attributed to Jeremiah Dummer.

DESCRIPTION: Oil on canvas, 75.6 x 63.3 cm. Oval. Head-and-shoulders view, facing front. Enormous long curly wig parted in middle, brown eyes. White twisted scarf, blue waistcoat under brown coat. Plain dark background.

PROVENANCE: Purchased by Henry Sleeper of Boston from the Copley Gallery, Boston.
Gift of Charles D. Childs, 1975.

REFERENCES: *One Hundred Colonial Portraits* (Boston, 1930), 20; *American Portraits, 1620–1825*, 1:90.

Unknown Englishwoman

Once identified as Mrs. John Coney (Mary Atwater) (1660–?). Like the previous portrait, it was painted in England for the American trade.

ARTIST: Unknown; formerly attributed to Jeremiah Dummer.

DESCRIPTION: Oil on canvas, 75.6 x 63.3 cm. Oval. Head-and-shoulders view, facing front. Light hair piled in curls on top of head with long curl over right shoulder, dark eyes. Low-cut blue dress with white ruffle at neck, red shawl. Plain dark background.

PROVENANCE: Gift of Charles D. Childs, 1975.

REFERENCE: *American Portraits, 1620–1825*, 1:90.

Unknown Gentleman

ARTIST: Unknown, about 1840s.

DESCRIPTION: Oil on canvas, 68.5 x 56.0 cm. Head-and-shoulders view, facing front. Gray-white hair. White shirt with high stiff collar, black tie, black v-necked waistcoat, black coat. Plain, brown background.

PROVENANCE: Unknown.

Wife of Unknown Gentleman

ARTIST: Unknown, about 1840s.

DESCRIPTION: Oil on canvas, 68.5 x 56.0 cm. Head-and-shoulders view, facing front. Dark hair, parted in middle under white bonnet tied with red ribbon. White lace collar on black dress with brooch at neck. Black shawl over arms. Plain brown background.

PROVENANCE: Unknown.

Unknown Young Woman

ARTIST: Attributed to Anton Raphael Mengs. Inscribed on reverse of frame: "R. C. Winthrop, Jr. / Rome Feby 1870."

DESCRIPTION: Oil on canvas, 42.2 x 33.4 cm. Head of a young woman, turned right, facing front. Dark hair and eyes. Low-cut rose-colored dress trimmed with white ruffle at neckline.

PROVENANCE: In a letter to his father written from Rome, February 25, 1870, Robert Charles Winthrop,

Jr., mentioned a portrait he had just purchased of a young girl purportedly painted by Raphael Mengs.

Estate of his daughter, Miss Clara Bowdoin Winthrop, 1969.

REFERENCE: Winthrop Papers, MHS.

Unknown Woman in Bonnet

ARTIST: Unknown, 19th century.

DESCRIPTION: Chalk and crayon on paper, 55.0 x 45.0 cm. Oval. Head-and-shoulders view, facing front. Dark hair, parted in middle under frilly bonnet tied with a white ribbon. High-necked dress with scalloped white collar and cameo brooch at neck. Sepia background.

PROVENANCE: Unknown.

Portrait of a Young Girl

ARTIST: Gretchen W. Rogers, about 1914.

DESCRIPTION: Oil on canvas, 90.9 x 91.1 cm. Three-quarter length view, facing slightly right. Dark hair and eyes. Scoop-necked dress with slit shoulders and short sleeves. Long chain around neck. Seated in a high backed wooden chair, hands folded. Mottled background.

PROVENANCE: Perhaps the portrait of a "Young Girl" exhibited by the artist at the Pennsylvania Academy of Fine Arts in 1914.

Donor unknown.

REFERENCE: *A Dictionary of American Artists, Sculptors and Engravers*, William Young, ed. and comp. (Cambridge, Mass., 1968), 391.

Young Woman in Red Dress

ARTIST: Unknown, 19th century. Companion portrait to "Young Woman with Tilted Head," perhaps the same sitter or her sister.

DESCRIPTION: Oil on canvas, 46.7 x 37.0 cm. Head-and-shoulders view, facing front. Dark turban trimmed with brown ribbon, white shirt buttoned at neck, brown necklace and earrings, red dress with green trimming and fur collar. Plain dark background.

PROVENANCE: Estate of Hermann Jackson Warner (1831–1916) of Boston and Dresden, Germany, 1975.

REFERENCE: *Proc.*, 87(1975):173.

Young Woman with Tilted Head

ARTIST: Unknown, 19th century. Companion portrait to "Young Woman in Red Dress," perhaps the same sitter or her sister.

DESCRIPTION: Oil on canvas, 45.4 x 36.1 cm. Head-and-shoulders view, turned to right, head tipped right, facing front. Close fitting cap with red band fastened under chin. Dark dress, brown coat with fur collar. Plain dark background.

PROVENANCE: Estate of Hermann Jackson Warner (1831–1916) of Boston and Dresden, Germany, 1975.

REFERENCE: *Proc.*, 87(1975):173.

CHECKLIST OF PORTRAITS
Arranged by artist

Ames, Ezra (1768–1836)
　Theodore Sedgwick
Ames, Joseph Alexander (1816–1872)
　William Hickling Prescott, 1844
　Daniel Webster, 1852
　Daniel Webster, prob. 1852
Armand-Dumaresq, Edouard (1826–1895)
　Charles Francis Adams
Badger, Joseph (1708–1765)
　Ellis Gray (I), ca. 1750
　Ellis Gray (II), ca. 1758
　Thomas Prentice, 1755, attrib.
　Samuel Hopkins, ca. 1755, attrib.
　John Joy, Jr., ca. 1758
　John Tudor, attrib.
Beard, William Holbrook (1824–1900)
　Daniel Brown Widdifield
Beckwith, James Carroll (1852–1917)
　George Livermore, 1904
Benson, Frank Weston (1862–1951)
　Alice Bacon, 1891
Benziger, August (1867–1955)
　Curtis Guild, Jr., ca. 1914
Blackburn, Joseph (ca. 1700–1765)
　Benjamin Pollard, 1755
　Joshua Winslow, ca. 1756, attrib.
　Mrs. Nathaniel Dowse, ca. 1757
　Henry Vassall, 1757
　Mrs. Henry Vassall, 1750s
　Mrs. Robert Ball, attrib.
Blyth, Benjamin (1746–post 1787)
　John Adams, prob. 1766
　Mrs. John Adams, prob. 1766
　Eunice Diman, ca. 1774
　John Thomas, ca. 1775
Bond, Charles V. (1825?–　)
　Wendell Phillips, 1849

Boykin, Cloyd Lee (1877–　)
　Franklin Benjamin Sanborn
Boze, Joseph (1744–1826)
　Marquis de Lafayette, 1790
Brewster, John (1766–1854)
　Royal Brewster, ca. 1795
　Isaac Collins, 1796
Bronzino, Agnolo (1503–1572)
　Amerigo Vespucci, attrib.
Calendi, Giuseppe
　Christopher Columbus, 1788
Canova, Dominico (ca. 1800–ca. 1869)
　Mrs. Elbridge Gerry, attrib.
Chapman, John Gadsby (1808–1889)
　Sebastian Cabot, 1838
Clark, Alvan (1804–1887)
　Daniel Webster, 1846
Cobb, Cyrus (1834–1903)
　John Appleton, 1868 (with Darius Cobb)
Cobb, Darius (1834–1919)
　John Appleton, 1868 (with Cyrus Cobb)
　Charles Sumner, 1877
Cole, Joseph Greenleaf (1806–1858)
　John Davis, 1836
Coles, John, Jr. (1776?–1854)
　Robert Treat Paine, 1823 (with Edward Savage)
Coolidge, Baldwin
　Charles Francis Adams II, ca. 1911
Copley, John Singleton (1738–1815)
　Elizabeth Oliver, ca. 1758
　Mrs. John Gray, ca. 1763
　Jonathan Jackson, ca. 1768
　James Allen, 1768–1770
　John Hancock, 1770–1772
　Charles Russell (fragment)
　Nathaniel Wheelwright, attrib.
　Samuel Cooper, attrib. (I)

Samuel Cooper, attrib. (II)
Cranch, Caroline Amelia (1852–1931)
 George William Curtis
Custer, Edward L. (1837–1881)
 Samuel Foster McCleary II, 1875
Damon, Louise Wheelwright (1889–?)
 Helen Appleton, 1940
Davenport, —— ("The Elder")
 James Gunnison, 1856
DeLuce, Percival (1847–1914)
 Katherine Roberts
Doyle, William M. S. (1769–1828)
 Rufus Webb, 1814, attrib.
Earl, Ralph (1751–1801)
 John Callahan, 1785
Emmons, Nathaniel (1704–1740)
 Samuel Sewall, 1728
Fansel?, Daniel
 Wendell Phillips
Frothingham, James (1786–1864)
 Ashur Adams, ca. 1850
 John Low
 Mrs. John Low
 Samuel Foster McCleary, II, ca. 1830, attrib.
Gilbert, Helen Sewall (1835–1921)
 Andrew Leete Stone
Gordon, Emeline H. (1877–)
 Gov. John Winthrop, 1931
Gray, Henry Peters (1819–1877)
 Samuel Worthington Dewey, ca. 1841–1845
Greenwood, Ethan Allen (1779–1856)
 Benjamin Loring, 1813
 Mrs. William Minns, 1818
 John Tileston, 1818
Greenwood, John (1727–1792)
 Patrick Tracy, ca. 1749–1752
 Mrs. Patrick Tracy, ca. 1749–1752
Grundmann, Otto (1844–1890)
 George Dexter, 1887
Gullager, Christian (1759–1826)
 George Washington, 1789
 Samuel Nicholson, attrib.
Hanatschek, Hermann (1873–1963)
 Arthur Lord, 1924
 William Bradford Homer Dowse, 1925
 Worthington C. Ford, 1927
Harding, Chester (1792–1866)
 Caleb Strong, ca. 1822
 Paul Revere, ca. 1823
 Mrs. Paul Revere, ca. 1823
 Daniel Boone, 1820
 Mrs. Daniel Webster, 1827
 Joseph Story, ca. 1828
 Daniel Webster, 1830

 Daniel Webster, ca. 1830
 Charles Lowell, ca. 1833
 Leverett Saltonstall, ca. 1836
 David Cobb
 Redford Webster
Hartwell, Alonzo (1805–1873)
 Helen Ruthven Waterston, 1856
Healy, George Peter Alexander (1813–1894)
 Robert Charles Winthrop, 1846
 James Fowle Baldwin, 1848
 Samuel Appleton, 1857
Hicks, Thomas (1823–1890)
 Benjamin Robert Winthrop, 1858
Hoit, Albert Gallatin (1809–1856)
 William Henry Harrison, 1840
Hopkinson, Charles Sydney (1869–1962)
 E. E. Cummings, 1896
 Edward Cummings, 1897
 Mrs. Edward Cummings, 1898
Hunt, William Morris (1824–1879)
 Lemuel Shaw, 1859
 John Albion Andrew, 1867
Huntington, Daniel (1816–1906)
 Robert Charles Winthrop, 1885
James, William (1882–1961)
 Mrs. E. E. Cummings, prob. 1952–1953
Janssens, Cornelis (1593–ca. 1664), School of
 Mrs. Winthrop
Johnson, Eastman (1824–1906)
 Ellis Gray Loring, ca. 1848
 Clara Bowdoin Winthrop, attrib.
King, Samuel (1748/9–1819)
 John Eliot, 1779
Kneller, Sir Godfrey (1646–1723)
 William Hayley, attrib.
Kupetsky, Johan (1667–1740)
 self-portrait.
Lincoln, James Sullivan (1811–1888)
 Henry Parkman Sturgis, ca. 1860s
Lippoldt, Franz (1688–1768)
 Jonathan Belcher, 1729
Little, Abby Wheaton
 Jean Jacques Rousseau, 1846
McKay, ——
 Charles Chauncey, 1786, possibly
Macnee, Sir Daniel (1806–1882)
 George Combe, 1836
Marston, James B., fl. 1810, Boston
 Caleb Strong, 1807
Mason, Jonathan (1795–1884)
 Jonathan Mason, 1822
Mengs, Anton Raphael (1728–1779)
 Unknown Young Woman, attrib.
Neilson, Raymond Perry Rogers (1881–1964)

Joshua Gee, 1733
 Mrs. Joshua Gee, 1734
 John Endecott, 1739
 Mary Ann Faneuil, 1739
 Peter Faneuil, ca. 1739
 William Cooper, 1743
 Mrs. Ezekiel Lewis, 1743, attrib.
Smibert, Nathaniel (1735–1756)
 Mrs. George Davie, ca. 1750, attrib.
Smith, John Rubens (1775–1849)
 Lynde Minshull Walter, 1813
Smith, Rosamond L.
 Robert Cassie Waterston, 1901
Smyth, Margarita Pumpelly (1873–1959)
 George Lyman Paine, Jr., 1905
Staigg, Richard Morrell (1817–1881)
 Edward Everett
Steward, Joseph (1753–1822)
 Samuel Haven, ca. 1794, attrib.
 John Tudor, attrib.
Stuart, Gilbert (1755–1828)
 Mrs. John Adams, 1800
 Mrs. Thomas Lindall Winthrop, 1806
 John Temple, 1806
 James Sullivan, 1807
 Jeremiah Allen, ca. 1808
 Mrs. Leonard Vassall Borland, ca. 1818
 Edward Everett, 1820
 Israel Thorndike, ca. 1820
 Ward Nicholas Boylston, 1825
Stuart, Jane (1812–1888)
 Lady John Temple
Sully, Robert Matthew (1803–1855)
 Sally Brown, ca. 1842
Sully, Thomas (1783–1872)
 Charles Carroll, 1826
Thompson, Cephas Giovanni (1809–1888)
 Johann Gaspar Spurzheim, 1833
 Joseph Emerson Worcester, 1844
Truman, Edward
 Charles Paxton, 1734, attrib.
 Thomas Hutchinson, 1741
Trumbull, John (1756–1843)
 George Washington, 1783 (with Joseph Wright)
 Grenville Temple, ca. 1797
 Christopher Gore, prob. 1800
Vanderlyn, John (1775–1852)
 George Washington, attrib.
van der Merck, Jacob Fransz (ca. 1610–1664)
 Unknown Dutch Gentleman, 1647
van der Spriett, John (ca. 1700–?)
 Increase Mather, 1688
Vinton, Frederic Porter (1846–1911)
 George Edward Ellis, 1880

Andrew Preston Peabody, 1887
 John Langdon Sibley, 1894
Vivian, Mr. ——
 George Washington, 1874
Vonnoh, Robert (1858–1933)
 Charles Francis Adams, II (I), 1913
 Charles Francis Adams, II (II), 1913
Wagner, Jacob (1852–1898)
 John Still Winthrop, 1893
Wall, William Allen (1801–1885)
 William Cushing Whitridge
 Mrs. William Whitridge
Whitman, Sarah (1842–1904)
 John Williams Quincy, 1892
Whitmore, William Henry (1836–1900)
 Jean Paul Mascarene, 1871
Wight, Moses (1827–1895)
 James Savage, ca. 1850–1855
 Thomas Dowse, 1856
 Josiah Quincy, 1858
Willard, Henry (1802–1855)
 William Jenks, attrib.
Willard, William (1819–1904)
 George Stillman Hillard, 1878
Wilson, Matthew (1814–1892)
 Edwin Lamson, ca. 1858
 Mrs. Edwin Lamson, ca. 1858
 Gardner Swift Lamson, ca. 1858
Wilson, William F.
 William Hyslop Sumner, 1857, attrib.
Woodbury, Mary (ca. 1717–1747/8)
 Pocahontas, 1730s
Wright, Joseph (1756–1793)
 George Washington, 1784 (completed by
 John Trumbull)
Zengo, Nicholas
 Abbott Lawrence Lowell, 1927
Unknown
 Mrs. Ashur Adams
 John Quincy Adams (II)
 Mrs. Stephen Merrill Allen
 John Bailey
 Mrs. Baker, ca. 1674
 William Worman Berry
 Gurdon Bill
 James Bowdoin
 Mrs. John Callahan
 Christopher Columbus (II)
 Hernando Cortez
 Anne Dudley
 Joseph Dudley, ca. 1682–1686 (I)
 Joseph Dudley, ca. 1701 (II)
 Mrs. Joseph Dudley, ca. 1682–1686
 Henry Edes

Mrs. Henry Edes
Alexander Viets Griswold
Thomas Haven
Mrs. Thomas Haven
Abiel Holmes
Joshua Huntington
Thomas Hutchinson (II)
Joshua Johnson, 1796
Mrs. Joshua Johnson, 1796
Samuel Foster McCleary
Nicholas Mitchell
Wendell Phillips (II)
Robert Pike
Mrs. William Pollard, 1721
William Hickling Prescott (II), ca. 1815
Thomas Prince
Dorothy Quincy, 1720s
Samuel Miller Quincy
Nicholas Roberts, ca. 1671
Mrs. Nicholas Roberts, ca. 1674
William Ropes
Jacob Sebor
Mrs. Jacob Sebor
Samuel Shrimpton
William Shurtleff
Mrs. William Shurtleff
Johann Gaspar Spurzheim (II)
Mrs. Tristram Storer, 1830s–1840s
Charles Sumner (II)
Henry Tufts, ca. 1840
James Bradish Whitney Tufts
Nathan Adams Tufts

Mrs. Joseph Wanton
George Washington (IV)
George Washington (V)
Daniel Webster (V)
Mrs. Thomas Wells
William Welsteed
John Wentworth
Esther Wheelwright, prob. 1763
William III
Stillman Willis, ca. 1860
Mrs. Stillman Willis, ca. 1860
John Wilson
Isaac Winslow
Adam Winthrop (1498–1562) (II)
Adam Winthrop (1647–1700), 1680
Mrs. Adam Winthrop, ca. 1680
Anne Winthrop
John Winthrop, Jr. (1606–1676)
John Winthrop (1638–1707), 1855
John Still Winthrop
Mrs. Robert Charles Winthrop, Jr., and Clara
 Winthrop, ca. 1879
Stephen Winthrop
Mrs. Winthrop, 1830s–1840
Unknown Englishman
Unknown Englishwoman
Unknown Gentleman
Wife of Unknown Gentleman
Unknown Woman in Bonnet
Young Woman in Red Dress, 19th century
Young Woman with Tilted Head, 19th century

SHORT-TITLE LIST

Adams, *Descendants of Richard Haven*: Josiah Adams, *The Genealogy of the Descendants of Richard Haven*. Boston, 1843.

Adams, *Henry Adams*: Andrew N. Adams, *A Genealogical History of Henry Adams of Braintree, Mass., also of John Adams of Cambridge, Mass., 1632–1897*. Rutland, Vt., 1898.

American Portraits, 1620–1825: *American Portraits, 1620–1825, Found in Massachusetts*, 2 vols. Boston, 1939.

Ayres, *Harvard Divided*: Linda Ayres, *Harvard Divided*. Cambridge, Mass., 1976. Catalogue for an exhibition at the Fogg Art Museum.

Bénézit, *Dictionnaire*: Emmanuel Bénézit, *Dictionnaire . . . des Peintres, Sculpteurs, Dessinateurs et Graveurs . . .*, 8 vols. Paris, 1960.

Bolton, *Portraits of the Founders*: Charles Knowles Bolton, *Portraits of the Founders*. Boston, 1919.

Bourne, *History of Wells and Kennebunk*: Edward E. Bourne, *The History of Wells and Kennebunk*. Portland, Me., 1875.

Burroughs, *Greenwood*: Alan Burroughs, *John Greenwood in America, 1745–1752*. Andover, Mass., 1943.

Cambridge Vital Records: *Vital Records of Cambridge, Massachusetts*, 2 vols., compiled by Thomas W. Baldwin. Boston, 1914–1915.

Catalogue of American Portraits, NPG: Catalogue of American Portraits, National Portrait Gallery, Washington, D.C. Unpublished database.

Cokayne, *Complete Baronetage*: George Edward Cokayne, ed., *Complete Baronetage*, 4 vols. Exeter, Eng., 1900–1906.

Crawford, *Famous Families*: Mary Caroline Crawford, *Famous Families of Massachusetts*. Boston, 1938.

DAB: *Dictionary of American Biography*, 26 vols., 2d ed., Dumas Malone, ed. New York, 1964.

DNB: *Dictionary of National Biography*, 22 vols., Leslie Stephen and Sydney Lee, eds. London, 1921–1922.

Dows, *Dowse Family*: *The Dows or Dowse Family in America*, Azro Milton Dows, comp. Lowell, Mass., 1890.

EIHC: *Essex Institute Historical Collections*, 1859– .

Foote, *Smibert*: Henry Wilder Foote, *John Smibert, Painter*. New York, 1969.

Foster, *Colonel Joseph Foster*: Joseph Foster, *Colonel Joseph Foster, his Children and Grandchildren*. Cleveland, 1947.

Harvard Portraits: *Harvard Portraits: A Catalogue of Portrait Paintings at Harvard University*, comp. Laura M. Huntsinger. Cambridge, Mass., 1936.

Jefferson, *Papers*: *The Papers of Thomas Jefferson*, ed. Julian P. Boyd et al. Princeton, N.J., 1961, 1971.

Knox, *Sharples*: Katharine M. Knox, *The Sharples*. New Haven, 1930.

Lipton, *A Truthful Likeness*: Leah Lipton, *A Truthful Likeness: Chester Harding and His Portraits*. Washington, 1985.

Locke, *Book of the Lockes*: John Goodwin Locke, *Book of the Lockes*. Boston, 1853.

Mason, *Life and Works of Gilbert Stuart*: George C. Mason, *The Life and Works of Gilbert Stuart*. New York, 1879.

Mayo, *Winthrop Family*: Lawrence Shaw Mayo, *The Winthrop Family in America*. Boston, 1948.

MHS: Massachusetts Historical Society.

MHS Coll.: *Collections of the Massachusetts Historical Society*. Boston, 1792– .

NEHGR: *New England Historical and Genealogical Register*. Boston, 1847– .

New England Begins: *New England Begins: The Seventeenth Century*, 3 vols. Boston, 1982. Catalogue for an exhibition at the Museum of Fine Arts, Boston.

New-York Historical Society Portraits: *Catalogue of American Portraits in the New-York Historical Society*. 2 vols. New Haven, 1974.

Notable American Women: *Notable American Women, 1607–1950*, Edward T. James, Janet Wilson James, Paul S. Boyer, eds. Cambridge, Mass., 1971.

Oliver, *Faces of a Family*: Andrew Oliver, *Faces of a Family: An Illustrated Catalogue of Portraits and Silhouettes of Daniel Oliver, 1664–1732 and Elizabeth Belcher, His Wife, their Oliver Descendants and their Wives made between 1727 and 1850*. n.p., 1960.

Oliver, *Portraits of John and Abigail Adams*: Andrew

Oliver, *Portraits of John and Abigail Adams*. Cambridge, Mass., 1967.

Oliver, *Portraits of John Quincy Adams and His Wife*: Andrew Oliver, *Portraits of John Quincy Adams and His Wife*. Cambridge, Mass., 1970.

Osgood, Record Book: Record book of paintings done by Charles Osgood as kept by the artist. Typescript, Massachusetts Historical Society.

Park, *Stuart*: Lawrence Park, *Gilbert Stuart: An Illustrated Descriptive List*, 4 vols. New York, 1926.

Park, "Joseph Badger": Lawrence Park, "An Account of Joseph Badger, and a Descriptive List of His Work," *Proceedings of the Massachusetts Historical Society*, 51(1918):158–201.

Park, *Major Thomas Savage and his Descendants*: Lawrence Park, *Major Thomas Savage of Boston and His Descendants*. Boston, 1914.

Parker and Wheeler, *Copley*: Barbara N. Parker and Anne B. Wheeler, *John Singleton Copley: American Portraits in Oil, Pastel and Miniature*. Boston, 1938.

Perley, *History of Salem*: Sidney Perley, *The History of Salem, Massachusetts*, 3 vols. Salem, Mass., 1924–1928.

Prime, *Temple Family*: Temple Prime, *Accounts of the Temple Family*, 4th ed. New York, 1899.

Proc.: *Proceedings of the Massachusetts Historical Society*. Boston, 1859– .

Proceedings of the AAS: *Proceedings of the American Antiquarian Society*. Worcester, Mass., 1912– .

Prown, *Copley*: Jules David Prown, *John Singleton Copley in America, 1738–1774*. Cambridge, Mass., 1966.

Roberts, *Ancient and Honorable Artillery Company*: Oliver Ayer Roberts, *History of the Military Company of the Massachusetts now called The Ancient and Honorable Artillery Company of Massachusetts, 1637–1888*, 4 vols. Boston, 1895.

Savage, *Genealogical Dictionary*: James Savage, *A Genealogical Dictionary of the First Settlers of New England*, 4 vols. Boston, 1860–1862.

Sibley's Harvard Graduates: John Langdon Sibley and Clifford K. Shipton, *Biographical Sketches of Graduates of Harvard University*, 17 vols. Cambridge, Mass., 1873–1975.

Smibert, *Notebook*: *The Notebook of John Smibert*. Boston, 1969.

Sprague, *Annals of the American Pulpit*: William B. Sprague, *Annals of the American Pulpit*, 9 vols. New York, 1857–1869.

Suffolk Co. Probate: Probate Records of Suffolk County, Mass., Suffolk County Court House, Boston, Mass.

Sumner, *History of East Boston*: William H. Sumner, *History of East Boston*. Boston, 1858.

Thwing, *Livermore Family*: Walter Eliot Thwing, *The Livermore Family in America*. Boston, 1902.

Thwing Catalogue: Annie Haven Thwing, Inhabitants and Estates of the Town of Boston, 1630–1800. Unpublished collection at the Massachusetts Historical Society.

Wyman, *Charlestown Genealogies*: Thomas B. Wyman, *The Genealogies and Estates of Charlestown*. Boston, 1879.

INDEX

Prentice, Rebecca (Austin), 79
Prentice, Thomas (d. 1709), 79
Prentice, Rev. Thomas (1702–1782), portrait, 79
Prentiss, Elizabeth Vassall, 107
Prentiss, Elizabeth Vassall (Pearce), 107
Prescott, Catherine Greene (Hickling), 79
Prescott, Elizabeth, 26, 79
Prescott, Susan (Amory), 79
Prescott, William, 79
Prescott, William Hickling (1796–1859), 26; portraits, 79–80
Prince, Deborah (Denny), 81
Prince, John, 80
Prince, Margaret (——), 80
Prince, Martha (Barstow), 80
Prince, Mercy (Hinckley) (1662/3–1736), 80, 81; portrait, 80–81
Prince, Rev. Thomas (1687–1758), 80; portrait, 81
Prince, Samuel (1649–1728), 81; portrait, 80
Prior, William Matthew (1806–1873), artist, 24
Providence Athenaeum, 10

Quin, Bettina Fellmore, 41
Quincy, Abigail (Phillips), 82
Quincy, Anna Cabot Lowell, 82, 112
Quincy, Dorothy (1708/9–1762), 54; portrait, 81–82 (color plate 20)
Quincy, Dorothy (1747–1830), 47
Quincy, Dorothy (Flynt), 81
Quincy, Edmund, 81
Quincy, Eliza Susan (Morton), 82
Quincy, Elizabeth, 7
Quincy, John Williams (1868–?), portrait, 82
Quincy, Josiah (1744–1775), 82
Quincy, Josiah (1772–1864), 43, 112; portrait, 82
Quincy, Josiah (1802–1882), 82, 121
Quincy, Josiah P., donor, 112
Quincy, Lucretia Deming (Perkins), 82
Quincy, Mary Jane (Miller), 82
Quincy, Mary Perkins, donor, 82
Quincy, Samuel Miller (1832–1887), portrait, 82–83
Quincy, William Williams, 82

Rainsborow, Judith, 130
Rainsborow, Martha, 125
Ralph Waldo Emerson House, Concord, 27
Ramsden, Ann, 88
Rantoul, Mary, 73
Reade, Elizabeth, 127, 131
Reed, Fanny Lee, 34
Reed, Martha, 86
Reiss, Jacob, donor, 75
Rembrandt vanRijn, 88
Revere, Deborah (Hichborn), 83
Revere, Joseph Warren, 83, 84
Revere, Paul (1702–1754), 83
Revere, Paul (1735–1818), portrait, 83
Revere, Paul, Jr., donor, 83
Revere, Pauline, 83
Revere, Rachel (Walker) (1745–1815), 83; portrait, 83–84
Revere, Sarah (Orne), 83
Reynolds, John P., Jr., donor, 21
Rhode Island School of Design, Providence, R.I., 70
Rhodes, Ann (Card), 84

Rhodes, Daniel Pomeroy, 84
Rhodes, Mrs. Daniel Pomeroy, donor, 84
Rhodes, James Ford (1848–1927), portrait, 84
Rhodes, Sophia Lord (Russell), 84
Richards, Elise Bordman, donor, 109
Richardson, Caroline Mackay, 44
Richardson, Elizabeth, 13, 14, 85, 94
Richardson, Mary Neal (1859–), artist, 96
Richardson, Sarah (Roberts), 14
Ridgway, Henrietta B., donor, 92
Rivière, Marie Louise Julie de la, 57
Rivoire, Apollos, 83
Robbins, Rev., 80
Robbins, Chandler, donor, 27, 42, 44, 116
Robbins, Karen J., 80
Roberts, Catherine Whipple, 73
Roberts, Elizabeth (Baker) (d. ca. 1700), 13, 14, 84, 93; portrait, 85–86
Roberts, Elizabeth, 13, 14, 85, 86, 93; putative portrait, 86
Roberts, Katherine (1660–1675), 14, 86; portrait, 84–85
Roberts, Mary, 14
Roberts, Nicholas (d. 1676), 13, 14, 84, 86, 93; portrait, 85
Roberts, Sarah, 14
Robertson, Rhodes, donor, 106, 107
Robinson, Sarah Jane, 47
Rochambeau, Jean Baptiste Donatien de Vimeur, comte de, 57, 131
Rogers, Gretchen W. (1881–1967), artist, 134
Rogers, Sarah (Mrs. Ellis), 37
Rogers, Sarah (Mrs. Gee), 41
Rolfe, John, 77
Rolfe, Mrs. Rebecca (1595–1617), portrait, 77
Ropes, Martha (Reed), 86
Ropes, Mary Anne (Codman), 86
Ropes, Samuel, 86
Ropes, Sarah (Cheever), 86
Ropes, William (1784–1869), portrait, 86
Rosenthal, Albert (1863–1939), artist, 110
Rourke, Ella, 76
Rousseau, Jean Jacques (1712–1778), portrait, 86–87
Royall, Elizabeth (Eliot), 107
Royall, Isaac, 107
Royall, Penelope (1724–1800), 87, 107; portrait, 107–108
Rumbold, Maria Augusta Dorothea, 101
Rush, Dr. Benjamin, 48
Russel, Rebecca, 66
Russell, Betsey, 56
Russell, Catharine (Graves), 87
Russell, Charles (1739–1780), 91, 107, 108; portrait, 87
Russell, Elizabeth (Vassall), 87, 107, 108
Russell, Elizabeth (Watson), 101
Russell, Ellen, 87
Russell, James, 87
Russell, Katharine, 87
Russell, Moses B. (ca. 1810–1884), artist, 53
Russell, Penelope, 87, 91
Russell, Rebecca, 107
Russell, Mrs. Robert S., 44
Russell, Sarah, 87
Russell, Sophia Lord, 84
Russell, Thomas, 101

Salter, Margaret Manning, 17
Salter, William (1804–1875), artist, 115